D0898200

Risk and Uncertainty in the Art World

Risk and Uncertainty in the Art World

Edited by Anna M. Dempster

B L O O M S B U R Y

LONDON • NEW DELHI • NEW YORK • SYDNEY

First published in Great Britain 2014

Editor's Introduction and Chapter 1 Copyright © Anna M. Dempster, 2014
Chapter 2 Copyright © Tom Christopherson, 2014
Chapter 3 Copyright © Anders Petterson, 2014
Chapter 4 Copyright © Olav Velthuis, 2014
Chapter 5 Copyright © Tom Flynn, 2014
Chapter 6 Copyright © Neil De Marchi & Hans J. Van Miegroet, 2014
Chapter 7 Copyright © Marina Bianchi, 2014
Chapter 8 Copyright © Rachel A. J. Pownall, 2014
Chapter 9 Copyright © Steve Satchell & Nandini Srivastava, 2014
Chapter 10 Copyright © Elroy Dimson & Christophe Spaenjers, 2014
Chapter 11 Copyright © Laurent Noël, 2014
Chapter 12 Copyright © Arjo Klamer, 2014

Bloomsbury Publishing Plc
50 Bedford Square
London
WC1B 3DP
www.bloomsbury.com

Bloomsbury Publishing
London, New Delhi, New York and Sydney

A CIP record for this book is available from the British Library.

ISBN: 9-781-4729-0290-0

Design by Fiona Pike, Pike Design, Winchester
Typeset by Hewer Text UK Ltd, Edinburgh
Printed in the United Kingdom by CPI Group (UK) Ltd, Croydon CR0 4YY

Contents

Editor's introduction

Discussions of risk and uncertainty are completely pervasive in today's society. Every day we are inundated with information which summarises what we don't know and the risks associated with each event. Risk, and the nature of underlying uncertainties, are critical because they are linked with the decisions we make. Decisions lead to actions and actions to consequences. Many decisions are critical because they affect us and our communities; some have immediate impacts and others have long-term consequences. What *is* certain is that these decisions will affect our future: what we have, what we can (and can't) do and how happy we are. So understanding risk and uncertainty, whether you are an art and antiques dealer or an equities trader, is central to modern life.

When trying to unpack the different dimensions of risk and uncertainty, the story of the Tower of Babel comes to mind. It is as if, in our attempt to tame the natural forces of uncertainty, we have built a great city of debate with a tower of knowledge that reaches up to the heavens. The punishment for this ambition is the emergence of many different perspectives with their own dialects and discussions – the engineer, the scientist, the economist, the historian and the artist each have their take on the topic – which ultimately confounds and confuses the conversation, making communication difficult and a common understanding nearly impossible.

This book attempts to bridge the divide across disciplines, not by imposing a universal language, nor even by asking everyone to speak the same language, but simply by narrowing the scope of the conversation and focusing attention on one field of study – the art world. In this book the economist is represented alongside the sociologist and art historian, the art practitioner alongside the academic. All are drawing on their own knowledge to contribute to a conversation which aims to understand risk and uncertainty specifically in the art world: its sources, consequences, participants, structures and dynamics.

In compiling the chapters for this book, I have tried to provide a snapshot of some of the most exciting developments both in the world of art and in research in risk and uncertainty. As with all edited volumes, the choice of what content to include is a very difficult one. The aim is to strike a balance between the academic (theory) and practice (application); in terms of level (introductory or advanced); content (perspectives from consumers, producers and intermediaries); and style (formal and informal). In spite of the sophisticated nature of the material and an ambition to present content of the highest quality and novelty, the book is written in a readable and accessible way.

From the perspective of the art world, an explosion has taken place in participation and interest, contributing to the breadth, depth and diversity of activities. Alongside century-old ways of doing things, the art world has recently witnessed the emergence of new consumers, new business models and new modes of production. People are looking further afield for ideas and examples of best practice, and there is room to learn from areas where the management of risk is more sophisticated and systematic. By the same token, the scholarly disciplines and existing practices of risk management are ripe for re-invention. The recent financial and economic crisis has underlined the dangers of over-reliance on a small number of models, an unquestioning faith in dominant methods and an over-homogeneous management culture. As existing attitudes to risk have been questioned, there is room to learn from the unexplored terrain of the arts and culture. The timing of this book coincides with these developments and provides opportunities for cross-fertilisation and learning. The content included here has lessons for the risk manager working in a bank as much as for the dealer based in a gallery. I hope this book will encourage an exchange of ideas; that practitioners will learn from relevant and cutting-edge academic research, while academics will learn from the applied work that makes use of real-world examples and experiences in the field.

This book should be of interest to both the general public and the seasoned professional or research specialist, with a balance of rigour and relevance. Hopefully, any reader with even a passing interest in the arts will become more engaged by this world's diversity and richness, and want to explore it further. To be read not as a recipe book, but as a collection of ideas, I hope that the chapters presented here will inspire

readers and provide a rich selection from which individuals can pick and choose, given their own interests and needs.

Although much of the cutting-edge work on risk management and decision-making under uncertainty is highly technical, because this is ultimately a book about the art world, the non-quantitative reader will still find much that is accessible and useful. All the contributions presented here aim to provide an intuitive and understandable introduction to key concepts and ideas. Although some of the chapters are based on advanced techniques and theory, the reader should not be daunted by the occasional appearance of mathematical formulas; they should be read in the context of a wider story!

The art world does indeed present a remarkable story of change and growth. Profound socio-economic and cultural developments internationally have fuelled the art world's transformation in modern times. From the dramatic fall of the Berlin Wall in 1989 to the revolutionary protests of the Arab Spring in 2010, region after region has witnessed a remarkable opening-up of its borders and a re-assessment of its values and beliefs. If the great sociologist Emile Durkheim was right, it is precisely such periods of revolt and upheaval that provide the perfect conditions for artists to do their greatest work and for art to prosper. As the shackles of a dominant system are overthrown, experimentation and a search for alternatives can begin.

The extraordinary transformation witnessed in the art world is undoubtedly linked to changes in global society. Over the past three decades shifts in the balance of power – socio-economic and cultural – have given rise to the much discussed 'Asian Tigers'[1] and then the 'BRIC' countries.[2] The growing importance of natural resources has seen attention shift to the oil-rich countries of Southwest Asia and the Middle East[3] and the less-noted but increasingly prosperous post-Soviet Central Asian countries or '-stans'.[4] Together, they provide ample alternatives to a view of art and culture dominated by Anglo-Saxon, Eurocentric or Western perspectives and practices. Importantly, developments in these regions have created significant new opportunities for trade, cultural exchange and innovation. We certainly live in interesting times!

In spite of a historical lack of transparency and significant difficulties in obtaining reliable economic and financial data, there is ample evidence to suggest that since at least the 1980s the art market has witnessed a period of substantial expansion and resilience. Of course, the 'art market' really consists of many smaller markets and any detailed analysis differentiates between fundamentally different sectors – such as Old Masters, Impressionist or Contemporary art – and across geographic areas. Nonetheless, aggregate estimates for the asset size of the art market hover around €50 billion, with the market doubling in size in the 25 years to 2011 and growing over 575 per cent from its lowest point during this period in 1991 to its highest in 2007.[5] The volume of transactions in the global art market has seen significant year-on-year increases, with implications for liquidity, global trade and the balance of imports and exports. Although the art market took almost a decade to recover from the recession of the early 1990s, the contraction of 2009, which went hand in hand with the global financial crisis of the same period, has been remarkably short-lived, with art and antiquities out-performing many traditional asset classes. As well as connoisseurs and collectors, a new breed of investors has taken note of these developments.

But this is not just a story of economic growth and the marketplace. As profound changes in society have affected the art world, they have in turn left a deep impression on communities – with an increasing number of people taking part at the local level, as well as the international one. This includes a fuller spectrum of consumers, from those who enjoy Picasso in the world's growing number of public and private museums, to those who buy Picasso for their home; all types of buyers and sellers, overlapping across many styles of art, antiquities and collectibles; as well as people employed in the art world and those studying in the hope of one day becoming a part of it. Estimates of employment generated by the art trade, for example, now range from 2 to 3 million globally and must take into account not only the direct jobs created but also the many part-time, event-based and volunteer workers, as well as those in ancillary services and external support services. There are more art schools than ever, graduating ever more artists. Alongside their traditional counterparts in subjects like curatorial practices, restoration, archival and museum studies, there are now

educational options focused on commerce, including art business, law and finance with the education market also witnessing unprecedented growth.

With these developments, the art world has been subject to fundamental structural changes. Across all the players whose interactions shape this world, no set of relationships has been left unaffected. What was previously largely a cottage industry, with many small, often family-run firms catering predominately to trade, specialists and connoisseurs, has now become a global industry with the rise of major retail spaces and super-brands. Galleries like Gagosian and White Cube secure market dominance through global operations embedded in the highest levels of international trade and society. Celebrity artists, who have captured the popular imagination enough to become household names, command both press column inches and extravagant prices in a world that often seems obsessed with 'stars' and is characterised by an economics of 'the best and the rest'. Traditional distinctions between intermediaries have blurred as auction houses increasingly carve into dealers' territories by conducting private sales and sourcing art directly from artists as in the (in)famous Sotheby's 2008 auction of Damien Hirst's works, entitled *Beautiful Inside My Head Forever*.

At times, the forces of change seem to pull the art world in competing directions. As the feared power of the expert art critique has waned, the influence of mass-market media, online recommendations and search engines, enabled by information technology, has arguably democratised the art world and encouraged access. The unprecedented amount of information available online about objects and transactions has revolutionised the way business is done and who can do it. At the same time, ever-escalating prices and the economic power of those who can pay the winning bid have made the art world more exclusive by raising the stakes and the barriers to entry and access to objects for both people and institutions, including museums. As old gatekeepers lose their influence, new gatekeepers, such as art fairs and websites, have grown in importance. The art world's client base has also become more diverse and geographically dispersed as wealth from 'emerging' economies and new industries, such as finance and high-tech, enable oligarchs to compete with entrepreneurs and hedge-fund managers for the most fashionable objects. As consumer demographics change, a younger,

more international clientele with omnivorous tastes and an army of advisors are happy to place antiquities alongside contemporary artworks in their homes, their foundations and private museums around the world.

In terms of the style and structure of this book, we have not tried to achieve uniformity across chapters but rather to introduce key topics in a lucid and engaging way. The book aims to address both the most fundamental (and long-lasting) questions facing the art world as well as more recent ones – as chosen by specialists and based on their evidence and expertise. It is not a textbook in the traditional sense in that it does not provide a (seemingly) comprehensive list of topics in a standardised format. It is rather an organic and intuitive exploration which I believe, over the volume as whole, covers a full spectrum of issues facing the art world today. Moreover, we believe, these are the issues which will be critical going forward. Important topics include (although not exhaustively) the role, function and impact of:

- consumers (e.g. collector or investor)
- producers (e.g. artist)
- intermediaries (e.g. the auction house or dealer)
- networks, social institutions, relationships
- globalisation and international trade
- authenticity and reproduction
- legal and taxation frameworks
- technology and virtual environments
- collectibles and luxury goods and services
- fashions, fads and conspicuous consumption
- reputation, cultural and social capital
- emotion, personal preference and taste
- structure and dynamics of markets
- regulation and policy

The co-ordination and consolidation of diverse information from a range of scholarly disciplines and practical perspectives is no easy task. It would not be remotely possible without the deeply informed and imaginative approach taken by the authors represented here. All of the contributors are actively engaged in the art world, whether as consumers (in both the public and private spheres), consultants, practitioners

or policy-makers. They are thought-leaders in their fields with long-standing engagement in the arts, who are also involved in leading academic institutions around the world helping to inform students and shape tomorrow's practitioners.

Given the expertise of the contributing authors, they have been given free reign to choose the topics they feel are most relevant, today and in the future. Drawing on their own interests and in-depth knowledge, they have woven a tapestry of ideas which reflects the subtleties and complexities of individual and organisational life in the art world. The result has been to cover a broad range of issues while providing an original and nuanced view of the linkages, interdependencies and dynamics which shape this world.

None of the chapters published in this book has been published elsewhere. Although they represent in many cases the synthesis of a great deal of prior research, they are novel contributions and are likely to lead to further research and analysis.

The link with practice is entirely clear in some cases and implied in others. This is not a 'how to' book in the sense of providing a pre-determined recipe for solving specific problems. Because the art world is so dynamic, ever-changing and unpredictable, such a book would be out of date before it was published. Rather this is a 'how to' book in which the authors have attempted to bring to the fore and illuminate key issues of which managers should be aware and to offer unobvious, counter-intuitive solutions. Individual chapters provide alternative ways of thinking about a problem which involves asking a different set of questions that ultimately enable a novel set of answers. As such, the book is both a culmination of efforts and the beginning of new concerns; a reassessment of the situation and an initiation of new discussions and debates. Ultimately the contents aim to provide suggestions for solutions to managerial and real-world problems.

The structure of the book broadly moves from a general introduction to the topic, across macro perspectives towards more micro approaches and ends once again with an overview which mirrors the beginning. The first five chapters set the scene, both from the perspective of the intellectual history of risk and uncertainty (Chapter 1) to mapping out a typology of key risks (Chapter 2) and a summary of the critical players

who interact and structure the landscape (Chapter 3). This is followed by a discussion of the location and context of risks and uncertainties, in terms of space, place and geography, not just physical but also virtual and technological (Chapter 4) and the implications and challenges of cultural differences and cross-border trade, including their impact on individual artists and their practices (Chapter 5).

In the second half of the book we move into specifics. A historical example provides an important reminder that many aspects of the art world with which we associate contemporary practices, including manipulation of markets, have, in fact, historical precedent (Chapter 6). A detailed exploration of consumption, fads and fashions (Chapter 7) and what drives different types of consumers in the art world including emotional engagement (Chapter 8) highlights the idiosyncratic nature of art and its markets. The complementarities on the one hand and differences on the other between related fields, including luxury goods, are explored (Chapter 9), while comparisons between art and other collectibles are made in detail (Chapter 10). In a case study of the Art Deco market, the entire life-cycle of a particular segment of the art world and its marketplace is explored (Chapter 11) with lessons for understanding the critical role of uncertainty in all art markets and their implications for both policy-makers and practitioners outlined (Chapter 12).

Below, I provide a more detailed summary of the various chapters, highlighting aspects of their content, inter-relationships and relevance for practitioners, scholars and students.

As noted above, attempts to understand the role and impact of uncertainty and associated concerns with the management of risk, its structure and behaviour, are undoubtedly one of the core concerns of modern society. In the first chapter, I provide a brief introduction to the extensive literature on risk and uncertainty in an attempt to sketch an overview of the intellectual foundations of these ideas. The chapter summarises a number of perspectives on risk which range from negative views focused on its minimisation and eradication, through to more balanced perspectives concerned with the trade-off between risk and return. In this chapter, I suggest the existence of a third perspective uncommon to the risk management literature, but one which is highly

appropriate to the arts and cultural spheres. Here uncertainty is conceptualised *positively*, as critical to creative endeavour, and risk-taking is seen as necessary for the creative process. The chapter is designed to provide an introduction to key concepts in risk management and also to suggest a novel approach to understanding, treating and managing risk informed by what is done in the arts. As such, it aims to be of relevance both to students of risk and practitioners in the art world who must understand it.

In a unique insider's view of the world of art and auctions, the second chapter by Tom Christopherson provides a comprehensive overview and guide to the key risks in art markets. Based on a wealth of experience at the heart of the art world, Christopherson provides a categorisation of the main types of risk and underlying uncertainties present in the business of buying and selling art. He gives guidance as to how systematic in-house risk management might be structured, as well as outlining the importance of rapid response and necessity for adaptation in a landscape which is not only highly complex but constantly evolving, demanding successful players change with it. Christopherson highlights the international nature of the art market, the balance of local and global concerns and the need for co-ordination across many different legal and regulatory regimes as well as for sensitivity to national and cultural standards. Specifically, he discusses in detail three broad categories of risk to which art market participants are exposed: property risk, legal and regulatory risk, and financial and market risk. The chapter provides a coherent overview for the newcomer as well as a comprehensive framework against which the seasoned professional can check their own risk management strategies.

In Chapter 3, Anders Petterson describes and discusses the contemporary art market and explains what determines which artists are successful and why. Petterson argues that economic value (including price) is generated and reinforced by social relationships and structures determined by key players. He suggests that to be able to navigate this space and manage the risks inherent in this market, it is critical to understand the dynamic interplay between key people, organisations and institutions. Petterson provides a schematic of both who the different players are and how they interact. Only with a holistic perspective, he argues, can the market's dynamics be understood and managed. The

balance of players, he suggests, is best appreciated as an ecosystem in which there is a need for diversity in order to create resilience in the face of change and uncertainty. Throughout his discussion, Petterson details the role of the taste-maker and the process of endorsement which allows for identification, selection and retention of some artists above others. A novel perspective on Damien Hirst is presented as a case study to illustrate these dynamics. The chapter provides invaluable insight into key players from the viewpoint of someone who has been actively involved and witnessed the growth and development of the contemporary art market from a cottage industry into a global player.

Olav Velthuis explains how globalisation has fundamentally transformed the art world in Chapter 4. He discusses the impact on traditional businesses models and existing players, including art galleries and dealers. Changes which he outlines include the emergence of new contexts for the viewing, consumption and trade of art, and in particular two very important developments – the international art fair and online forums. The highly socialised and tangible experience of the international fair presents a setting where collectors, commentators and other art world players rub shoulders to browse the specially selected stock of carefully vetted dealers. This is in contrast to the virtual experience of a broad range of online offers which facilitate an intangible, yet highly accessible, experience of objects via the Internet. Building on extensive prior research as well as new findings, Velthuis provides insight into how gallery spaces are intricately tied up with a dealer's identity and what this means as commercial practices migrate to other highly symbolic spaces such as fairs and websites. In the context of an art world that is highly international, indeed increasingly global in its structure, Velthuis discusses the opportunities 'in a market without borders' and the new set of risks for consumers, producers and intermediaries that have been introduced as a consequence of the changing business landscape.

In Chapter 5, Tom Flynn explores contrasting cultural attitudes towards the notions of authenticity and originality in a rapidly globalising art world and considers the risks – moral and financial – associated with this development. In what is often seen as the 'dark side' of a globalised art market, the issue of unauthorised copying of artworks is discussed with implications for both the original artist and the

craft-based system of reproduction. Avoiding the pitfalls of moral judgement, the chapter shows how different attitudes to copying and reproduction persist and suggests that while this introduces significant uncertainty into the system, attitudes and value systems can be conceptualised both in terms of the risks and opportunities they provide. In either case, this is part of a new art world reality and must be taken into account. To illustrate his main points, Flynn refers to a recent and important case involving the unauthorised copying by Chinese artisans of a number of large-scale contemporary sculptures by living American artists. The case shows how the international art market is increasingly required to negotiate cultural differences and reassess the core concepts upon which the Western art market has traditionally relied and which have hitherto allowed investors and other market participants to assess risk and return.

In a departure from the contemporary setting, in Chapter 6, Neil De Marchi and Hans J. Van Miegroet present an historical study of a dealer ring operating in Paris in the 1780s. They provide evidence for how prominent dealers colluded, by agreeing not to outbid each other in the context of public art auctions, in order to squeeze out lesser dealers and private buyers and to raise prices on selected lots. While bidding on art in the context of escalating prices might be seen as highly risky (speculative) behaviour, this study argues that the case in fact presents an example of a way in which dealers attempted to manage the uncertainty of art auctions and their exposure to risk. By guaranteeing higher and higher prices through their dominance of auctions and actively courting new (amateur) collectors, members of the ring were able to control prices and actually eliminate risk. Dealers were also able to engage in purchases abroad for resale at enhanced prices at home: riskless arbitrage. This historical example has some fascinating parallels with the contemporary art world, given widespread speculation in the public domain that prices in some contemporary art markets have been fuelled by the co-ordinated activity of a few dealers and/or artists and that the public auction setting is not free from market manipulation or vested interests. The case is also a stark reminder that there is significant historical precedent for treating art as an asset class with a focus on its economic value, especially when the risks of trade can be effectively managed. Although history does not exactly repeat itself, such cases

hold important clues to understanding the current market while providing lessons for the future.

Chapter 7 by Marina Bianchi treats art from the consumer perspective by considering the impact of demand uncertainty and what drives consumer choice of creative goods. The chapter analyses the importance of fashions and longer-term trends as well as fads and shorter-term changes and how they impact the formation of collective tastes and market value. Along with other authors in this volume, Bianchi argues that uncertainty is inextricably linked to art, which she innovatively characterises as depending on the core factors of novelty, variety and complexity – each discussed in detail here. She draws on recent research in economics and consumer behaviour as well as in the dynamics of aesthetic preferences from experimental psychology to provide a new theoretical framework for understanding what art is in relation to how it is consumed. Given that extremely uncertain demand is one of the key challenges facing all participants of the art world, this chapter provides important insights into the sources and structure of consumer decision-making with implications for how uncertainty, and its risks, might be managed. This is relevant for a range of art world consumers, from investors who are systematically trying to manage their risk exposure, to collectors who are more interested in the intrinsic pleasures of the artwork itself.

In Chapter 8, Rachel A. J. Pownall considers the spectrum of people who are engaged in the art world and the variety of reasons for their acquiring and owning art, ranging from investment-driven 'rational' reasons to aesthetic or 'emotional' ones. While drawing on real-world practices, the chapter provides a theory and formal economic model of the trade-offs experienced by different types of consumers – including holding art in a diversified portfolio of assets as opposed to outright ownership of works, for example in the context of a collection. The chapter explains in detail the specifics of what can be termed 'emotional assets', of which art is a prime example. It draws upon psychology and marketing literature as well as cutting-edge research in economics and finance which analyses non-standard assets. Pownall elucidates how assets such as art have particular qualities which distinguish them from many other goods and commodities. She aims to provide a framework in which the emotional or affective

value of such assets can be understood and appreciated and the risks associated with holding such assets can be managed. As well as implications for risk management, the chapter has some interesting lessons regarding the needs of different consumers and how these can be balanced.

Steve Satchell and Nandini Srivastava in Chapter 9 discuss the link between art and risk through a conceptualisation of art as a luxury good. Using the principle of decreasing absolute risk aversion, they argue that art, like other luxury goods, is demanded by rich individuals whose wealth corresponds to high risk tolerance, and they explain how and why this is the case. Luxury goods are described using microeconomic theory by considering how demand for these goods changes with respect to changes in income. This provides insight into the type of 'conspicuous consumption' which is often associated with art and high-net-worth individuals. The increasing commercialisation of the art world and convergence of the art and luxury sectors has been a widely debated phenomenon of recent decades and this chapter presents a rare and novel theoretical and empirical treatment of the topic using microeconomic methods and systematic modelling. The theory that art is a luxury good is tested using UK art auction data with the results providing support for their propositions and the existence of wealth effects in art markets.

In an interesting extension to the art world discussion, Elroy Dimson and Christophe Spaenjers assess, compare and contrast a number of collectible sectors, including stamps, violins, wines and jewels, with art in Chapter 10. They explain what makes collectibles, including art, particularly attractive as investments and discuss the unique risk characteristics, including price volatility, which exist in different markets. Dimson and Spaenjers also provide useful comparisons on performance with other (more common financial) assets including Treasury bills, government bonds and equities. They argue that when choosing an investment horizon, one needs to trade off high transaction costs and the risk of short-term underperformance on the one hand, with the risk of longer-run shifts in the tastes of the dominant collectors and investors, on the other. The chapter makes an important contribution to the ongoing performance debate, including measuring returns for different assets over different time periods. It is relevant from an

investor perspective, but also provides insight into the dynamics of collectible markets which can have idiosyncratic qualities including limited supply of goods, high transaction costs and lower liquidity. This is relevant to anyone interested in collectible objects.

In Chapter 11, Laurent Noël presents a comprehensive study of the Art Deco style and its marketplace, which emerged in the early 20th century. By considering the entire life cycle of this sector, from birth through development and into maturity, Noël is able to illustrate, using a real-world example, the complicated interplay of individuals, events and institutions that shape a market and determine its structure and dynamics. He argues that the evidence suggests that markets for art present a challenge to traditional neo-classical economists' models since few of the conditions of perfect competition are respected in them. For example, the lack of transparency and information can hinder and even prevent transactions. This study also illustrates the relationship between various actors at different levels, including artists, dealers, auctioneers, experts, collectors and museums, each with their specific role in the social construction of this marketplace. Relations between actors are complex and ambiguous. Their actions can be in competition or complementary and they may act independently or co-operate. The case highlights how a range of uncertainties must be managed to enable the market to operate as efficiently as possible. The chapter has clear implications for the management of risk and under-standing of uncertainty as an ongoing process in the context of a complex set of interactions. This is highly relevant for different art markets today and in the future.

In the final chapter (Chapter 12), Arjo Klamer proposes the axiom that *without uncertainty there is no art market* and returns to the big picture with a discussion of the general principles that should guide any inves-tigation of risk and uncertainty in the art world. This contribution mirrors Chapter 1 and brings together themes recurrent throughout the book. It warns of the dangers of an overly narrow interpretation of risk and of the misapplication of classical (economic or other) theory without due consideration of the idiosyncrasies and specific qualities of culture and the arts. Klamer argues that any assessment must take into account social relations and cultural values intrinsic to this sphere. He makes the case that we need not only a tailored toolkit but also an

appropriate mindset and a distinct vocabulary or 'language'. These can impact the generation of meanings which in turn has consequences for the way in which the art world is understood, treated and ultimately performs. Uncertainties in the art world and their associated risks have to be understood in their own terms. The chapter provides some real-world examples relevant to policy-makers as well as practitioners. Critically, Klamer argues that we should put *what people do* at the heart of any analysis. The dialogue should include the analysis of organisations, institutions and markets but also an assessment of the actual people involved – the artists themselves – without whom there would be no art, and therefore, no art world.

Acknowledgements

My personal and passionate interest in risk and uncertainty in the arts, culture and creative industries dates back to the mid-2000s and was developed in a number of journal articles, conference papers and presentations over the years. The current volume builds directly on a conference entitled *Exploring Risk and Uncertainty: Metaphors from the Art Market* which was held in 2011 at Sotheby's Institute of Art, London, in collaboration with the Centre for Risk Studies at the Judge Business School, University of Cambridge.[6]

The conference would not have been possible without the generous support of the Centre for Risk Studies and Sotheby's Institute, both of which made a significant departure from their standard activities. During this time the Centre for Risk Studies benefited from a new Executive Director, Michelle Tuveson, whose enthusiasm and inclusiveness attracted many people and ideas. The thought that it might be fun to bring together risk managers and art dealers took shape over a series of meetings in Cambridge. Like many good ideas it seemed a little offbeat to start with but ended up spot-on by tapping into contemporary concerns of both risk professionals and art people. The initial idea may never have matured into a full-fledged event were it not for Michelle's organisational talents and practical, as well as passionate, approach. A big thank you to her for the time and energy she contributed. Thank you also to the Centre for Risk Studies Directors, Daniel

Ralph and Andrew Coburn, for giving us the freedom to give the idea a try and the generous financial support to make it a reality.

A warm thank you must go to Jos Hackforth-Jones, Director, and Megan Aldrich, Academic Director, of Sotheby's Institute of Art London for making it such an inspiring and engaging place to work and for co-sponsoring the conference. My thanks too to colleagues at Sotheby's Institute and my alma mater, Cambridge University, with whom I've shared ideas and made plans and especially colleagues in Art Business, David Bellingham and Laura Harris, who are consistently open to and supportive of new and risky initiatives like this one. Thank you also to our New York colleagues at the Cambridge Information Group, David Levy, Michael Chung and Jonathan Friedlander, for their support of the conference and this book project and for stimulating exchanges on topics of art, culture and education.

Given the many things competing for one's attention in London, I would like to thank everyone who participated in the original conference leading to this work and to the speakers who gave up their time to contribute cutting-edge ideas to the discussion and debate. Alongside the authors in this volume, they include: Payal Arora (Erasmus Universiteit Rotterdam), Richard Bronk (London School of Economics), D'Maris Coffmann (University of Cambridge), Jeremy Eckstein (ArtBanc International), Margaret Iversen (University of Essex), Michael Jacobides (London Business School), Joseph Lampel (Cass Business School), Clare McAndrew (Arts Economics), Phanish Puranam (INSEAD), Mary Rozell (Sotheby's Institute of Art) and Filip Vermeylen (Erasmus Universiteit Rotterdam).

The significant efforts made and the time given by a number of anonymous subject-specialist reviewers, who so generously read, commented and provided detailed feedback for chapters of this book, are amply reflected in this volume – for which I thank them. This book would not have been possible without the kind introduction of Stephen Rutt, considerate support of Alana Clogan and the exemplary efforts of the team at Bloomsbury Publishing.

I would like to thank my dear friends in London, Cambridge and abroad – old university friends as well as recent graduates, many accomplished writers, historians, art historians, business people and of course, artists

– who continually provide intellectually challenging conversations. A final and enormous thanks goes to my parents and dear husband, who provide the continued and unwavering support which makes multi-tasking possible.

The dialogues associated with our investigations in this project and the book itself would not have been possible without a great many people taking a big risk; it required of them a 'leap of faith' in time, energy and enthusiasm in exchange for a highly uncertain reward. I hope that their efforts have, in terms of friendships forged, fun had, ideas exchanged, and new avenues created, paid off at least in some small way.

Finally, I hope this book will herald the start of a continued and broader debate on risk and uncertainty which will create a more rewarding experience for all those who love the art world.

Anna M. Dempster
Cambridge, UK
9 September 2013

1 Hong Kong, Singapore, South Korea and Taiwan.

2 Brazil, Russia, India and China.

3 Including Iran, Iraq, Syria, Kuwait, Saudi Arabia, Bahrain, Qatar, United Arab Emirates (UAE), Oman and Yemen.

4 Kazakhstan, Kyrgyzstan, Tajikistan, Turkmenistan and Uzbekistan.

5 See TEFAF Report 2011: McAndrew, C. (2011), The International Art Market in 2011: Observations on the Trade over 25 Years, for more details.

6 For details on the conference see: http://www.risk.jbs.cam.ac.uk/news/events/other/2011/110923_sothebys.html

About the Authors

Marina Bianchi
Marina Bianchi is Professor of Economics at the University of Cassino, where she teaches Industrial Economics, and a course on The Creative Economy. She has written on topics related to the theory of the firm and consumer theory, with a specific focus on the problems of change, learning and the emergence of social rules. In a number of articles and two edited books (*The Active Consumer: Novelty and Surprise in Consumer Choice*, 1998, and *The Evolution of Consumption: theories and practices,*2007) she has analysed the characteristics of creative goods and the limits of the traditional economic framework in explaining choices concerning goods and activities of this type. More recently, her interests have focused on the role of curiosity and exploratory behaviour in shaping aesthetic preferences.

Tom Christopherson
Tom Christopherson shares his working time between the Sotheby's Institute of Art in London as Head of Art and Law Studies, and Sotheby's auctioneers as Senior Director, Special Projects and Business Education. Tom is a solicitor specialising in art law and was Sotheby's European General Counsel for over a decade, having been a commercial lawyer at the international law firm Freshfields beforehand. In his time at Sotheby's, Tom has dealt with a wide range of legal and ethical issues surrounding the art market in Europe and Asia, and served for several years on the Committee of the British Art Market Federation and the Society of Fine Art Auctioneers and Valuers, of which he is now an Honorary Associate. Tom is the current Renter Warden and a Charitable Trustee for the City of London Company of Arts Scholars.

Anna M. Dempster
Anna M. Dempster is Senior Lecturer (Associate Professor) in Art Business at Sotheby's Institute of Art, London where she leads the Art

Business and Research Methods Units and teaches strategic management, finance and entrepreneurship, all specially tailored for the art world. She was previously Director of Research at the Creative Industries Observatory, University of the Arts, London and the founding director of the MSc/MA in Creative Industries at Birkbeck College, University of London. She holds a BA and MPhil in History, and a PhD in Management Studies from the Judge Business School, University of Cambridge. She has published widely and her current research interests focus on the creative industries and visual arts. She has had a long-standing fascination with the role of risk and uncertainty in human endeavour and their effects on decision-making, organisational behaviour and – as represented in this volume – creative markets.

Neil De Marchi

Neil De Marchi is Professor of Economics at Duke University, where he teaches a course on The Contemporary Art Market. His early research interests were in the areas of economic methodology and history of economics, though for the past two decades he has focused on the history and functioning of art markets. His current focus is on experts, especially auction house experts, and the role of pre-sale estimates. He splits his time between Durham, North Carolina and Rome.

Elroy Dimson

Elroy Dimson holds a professorial appointment at Cambridge Judge Business School where he co-directs the Centre for Endowment Asset Management. He is also Emeritus Professor at London Business School. His publications include Triumph of the Optimists, the Global Investment Returns Yearbook and Endowment Asset Management, and articles in scholarly and professional journals in finance. A co-designer of the FTSE 100 index, Elroy is past president of the European Finance Association, and Honorary Fellow of the Institute of Actuaries and the CFA Society of the UK (FSIP). His research focuses on long-term investment strategy, endowment asset management and financial market history.

Tom Flynn

Dr Tom Flynn is Senior Lecturer (Associate Professor) at Kingston University, London where he is director of the RICS-Accredited Masters

course in Art Appraisal and Professional Practice. A Fellow of the Royal Institution of Chartered Surveyors, he holds degrees in art history, design history and a doctorate in the history of sculpture from the University of Sussex. A former auctioneer, he has held senior board positions in art data and print-retailing companies and writes and lectures widely on Art & Business, cultural heritage and art crime. His books include *The Body in Sculpture* (1997); *Colonialism and the Object: Empire, Material Culture and the Museum* (1998, co-edited with Tim Barringer) as well as a number of monographs on contemporary sculptors.

Arjo Klamer

Arjo Klamer is Professor of Cultural Economics at the Erasmus University and Professor of Social Innovation at Fontys in Tilburg. Prior to that and after acquiring his PhD at Duke University, he taught for many years at several universities in the US, including Wellesley College and George Washington University. His research focuses on the relationship between culture (including the arts) and the economy. He is developing a cultural monitor to provide an evaluation of the artistic and social impacts of artistic organisations. With former students he is running the Atelier in Creativity and Cultural Entrepreneurship. The objective of this organisation is to assist cultural organisations in their adaptation to new circumstances. Furthermore, he conducts workshops on his value-based approach to cultural economics all over the world.

Laurent Noël

Laurent Noël is Associate Professor of Cultural Economics at Audencia Nantes School of Management. He received his PhD in Economics from Paris 13 University and holds an MA in Art History and Business from the *Institut d'Etudes Supérieures des Arts* in Paris. At Audencia Nantes, Noël is responsible for two programmes: a major in cultural management and an artistic project incubator. His research focuses on the art market. Prior to his academic career, he worked for five years as a financial analyst at Dexia Bank before spending 10 years working in the art market, firstly with the Ader auction house and then as an art dealer.

Anders Petterson

Anders Petterson is the founder and Managing Director of ArtTactic Ltd, a London-based art market research and analysis company set up in 2001. ArtTactic has been a pioneer in using crowd-sourcing techniques for gathering and processing intelligence on the art market. Petterson previously worked at JP Morgan and was responsible for debt capital market and structured products for banks and corporates. He also worked as an independent research and evaluation consultant for Arts & Business in London between 2002 and 2007, and has been involved in a number of large research and evaluation projects in the cultural sector. Anders Petterson is lecturing on the topic of 'Art as an asset class' for CASS Business School and Sotheby's Institute in London. He is a board member of Professional Advisors to the International Art Market (PAIAM) – www.paiam.org.

Rachel A. J. Pownall

Rachel works as an Associate Professor at the University of Maastricht and TiasNimbas Business School. Her work covers the areas of behavioural finance, risk management, and sustainability, and is published in a number of leading international journals. She completed her PhD at Erasmus University, Rotterdam in 2001. Her research interests broadly cover the realm of understanding investor behaviour. Rachel has a particular focus on art markets and assets with an emotional attachment and is interested in the behavioural issues of how emotions and psychology influence individuals' financial decision-making involving risk. Her passion for research stems from a belief that through a better understanding of how individuals make risky decisions and how incorporating non-pecuniary returns to investment into decision-making will help promote a society that makes more sustainable investment decisions in future.

Steve Satchell

Steve Satchell is an academic and advisor in the broad area of quantitative asset management; he has numerous interests in books and journals and has published extensively. He was born in Dunedin, New Zealand which he left at a young age. He has academic posts at Trinity College, Cambridge, Royal Holloway, University of London and is a Professor of Finance at Sydney University. He has PhDs from the

London School of Economics and the University of Cambridge. He has published approximately 200 articles and 12 books. He is very proud of his 43 PhD students.

Christophe Spaenjers

Christophe Spaenjers is an Assistant Professor of Finance at HEC Paris. He received his PhD from Tilburg University in 2011. His research interests include alternative investments, investor behaviour, international finance and financial history. He has published in journals such as the *Journal of Financial Economics, American Economic Review* (Papers and Proceedings), and *Management Science*. He teaches in the MBA programmes at HEC Paris.

Nandini Srivastava

Nandini Srivastava completed her PhD at the Faculty of Economics, University of Cambridge in 2013 and is now an Associate at Global Asset Allocation Research at JP Morgan, London. Her role involves analysing the impact of macroeconomic and financial developments across a range of asset classes and develop strategies towards portfolio allocation. She has been a referee at the Journal of Asset Management and Journal of Hedge Funds and Derivatives. She continues to research the econometrics of the art market.

Hans J. Van Miegroet

Hans J. Van Miegroet is a Professor in Arts & Markets at Duke University, Chair of Art, Art History & Visual Studies, Media Arts & Sciences, and heads the Duke Art, Law and Markets Initiative (DALMI). With Neil De Marchi, he has adopted a scientific collaborative model to conducting research on emerging art markets, legal questions related to market constraints and media culture as a commercial pursuit. This approach has made it possible to create, and sustain, a variety of new research initiatives, strategies and modes of interpretation, attractive to a new type of hybrid scholar working at the interface of humanities, the sciences, law and the social sciences.

Olav Velthuis
Olav Velthuis is Associate Professor at the Department of Sociology and Anthropology at the University of Amsterdam. Before, he worked for several years as a Staff Reporter Globalization for the Dutch daily *de Volkskrant*. He is currently studying the emergence and development of art markets in the BRIC-countries (Brazil, Russia, India and China). Velthuis is the author of among others *Imaginary Economics* (NAi Publishers, 2005) and *Talking Prices, Symbolic Meanings of Prices on the Market for Contemporary Art* (Princeton University Press, 2005) and co-edited the volume *Contemporary Art and Its Commercial Markets* (Sternberg Press, 2012).

Perspectives on risk and uncertainty

Anna M. Dempster, Sotheby's Institute of Art

Introduction

Risk and uncertainty are pervasive in modern society and yet a universal understanding of the role and function of these key concepts remains elusive. The lack of a generally accepted definition is due in part to the fact that these ideas span a number of different fields and disciplines. Furthermore, examples and empirical findings are informed by, and embedded in, different real-world contexts and settings. The result is that there exist different perspectives on risk and uncertainty. The discourses and debates surrounding them depend subtly, but critically, on conceptualisations of what risk and uncertainty mean and also on what they imply and what can or should be done about them.

This chapter will briefly summarise a number of key perspectives and the extensive literature on risk and uncertainty which result in different approaches and treatments. This review provides evidence for why definitions can neither be decoupled from their setting nor divorced from the real-world contexts in which they are found. It summarises core ideas and findings from both the sciences and social sciences, in particular economics and sociology and the applied fields of finance, business and management. The chapter compares these more common and widespread notions of risk and uncertainty with those found in the creative industries, specifically in the art world.

Negative perspectives

Perhaps some of the most straightforward and commonly held conceptualisations of risk simply equate it with *hazard*. For example, risk is seen as the outcome of underlying uncertainties as 'the potential for realization of unwanted, negative consequence of an event' (Rowe, 1977: 24). This is akin to the approach commonly found in engineering and science-based disciples, where risk is defined simply as *the probability of an accident multiplied by the losses per accident*. This definition is adopted by authors in other fields, including both sciences and social sciences, and is common to many perspectives and treatments of risk. For example, many studies of risk and its analysis are aimed at identifying, measuring and evaluating the outcomes resulting from natural and technological hazards (Lowrance, 1976; Crouch and Wilson, 1982; Lave, 1982; Mitchell, 1990). Indeed the term 'risk' itself is often used interchangeably with not just 'hazard' but all its synonyms – danger, lack of safety, peril, threat, accident, and so on.

Many of these perspectives are rooted in scientific discussions concerned with the negative impact of uncertainty – man-made or natural – on larger systems; for example, the effect of technological developments on the natural environment. This might include either a concern with measurable 'objective' risk or a consideration of perceived or 'subjective' risk, such as the emotional impact that extreme unpredictable events have on people and organisations (Rowe, 1977). In either case, there is an implicit belief that 'in spite of the complexity and imprecision of risk analysis, formal assessment of risks is both desirable and possible' (Rowe, 1977). Furthermore, this assessment should be carried out so that uncertainty about outcomes is reduced and associated risks are minimised.

Social scientists have also considered scientific and technological innovation from a risk perspective. The sociologist Ulrich Beck, for example, describes the late modern world as 'the world risk society' (Beck, 1992). He is concerned with the emergent global order of 'manufactured uncertainties' which includes ecological threats resulting from technological advances underpinned by socio-political systems that enable nuclear, biological and chemical contamination and destruction. Antony Giddens also differentiates between 'external risks', as those

that come from nature and are done to us, and 'manufactured risks', which are more about what we have done to nature. According to Giddens (1999), 'as manufactured risk expands, there is a new riskiness to risk'. Since manufactured risks are new by definition, no prior data exists which might be used to estimate their size, impact or dynamics, making them impossible to predict and therefore to control. Such risks and uncertainties can penetrate the very fabric of society, and shake the foundation of complex social institutions such as friendship, kinship and marriage.

For Beck, one of the great 'dilemmas of modernity' is that the techno-logical innovations which have brought about unprecedented material wealth in society have also introduced the new risks which require further technological responses and these, in turn, result in more risks. This new world order is in fact defined by risk, hazard and danger (which are often used synonymously in Beck's work). The thesis might seem extreme if it were not for the mounting evidence on environmen-tal change as a result of global warming or the visibly extreme and long-lasting impact of nuclear disasters such as Chernobyl in 1986 or Fukushima in 2011.

While such perspectives are largely concerned with risk and uncertainty on a global scale with universal consequences, their application to the arts and culture is not so far-fetched if one considers the impact of both real and perceived uncertainties on individuals and social institutions. For example, Beck argues that 'the disintegration of certainties' has led to a need to invent one's own certainties and an 'individualization' within society. This is in turn associated with the breakdown of social institutions (such as the family) as well as of frameworks (for example, government laws) which regulate social and economic interactions. The fear of uncertainty exposes individuals more acutely to 'the turbulence of the risk society' (Beck, 1992). An example in the arts includes the gradual disappearance of long-term employment contracts and the emergence of 'flexible' or casual employment practices. Initially these were seen as harbingers of opportunity and enfranchisement, but the lack of institutional or regulatory protection for workers (such as unions) and the focus on opaque transactions and handshake deals are increasingly seen as an opportunity for exploitation and mistreatment of workers in the creative industries (Hesmondalgh and Baker, 2011).

In summary, across both the natural and social sciences, scholars have concluded that the existence of uncertainty, whether natural or man-made, real or perceived, results in risks which harm social systems, institutions and ultimately people. From this perspective, risk is perceived as predominately negative. As such, the key aim of under-standing uncertainty and its associated risks is to minimise them as much as possible and ideally eradicate them altogether.

Balanced perspectives

An alternative perspective on risk and uncertainty is not altogether negative and can be described as a more balanced approach. Here risk is decoupled from uncertainty and seen as only one side of the coin; the other being reward. Risk and reward are assessed in relation to each other in that the probability of an upside gain is weighed against the potential for downside loss. The 'risk-return trade-off' suggests that potential return rises with an increase in risk so the more return is sought the more risk must be taken. This can be summarised by the popular saying, 'nothing ventured nothing gained'.

For this approach an important starting point is understanding the difference between risk and uncertainty. In his seminal work, Frank Knight (1921) carefully distinguished between *uncertainty*, which is by its very nature *immeasurable*, with possible outcomes neither knowable nor predictable, as compared to *risk* which is *measurable* and associated with a specific probability or likelihood of an outcome. Knight was referring in part to modelling uncertainty in classic insurance markets, such as life, trade or fire insurance, where the future is often assumed to be a reflection of the past. Here possible outcomes can be grouped or classified with probabilities of their occurrence calculated statistically using data gathered on past events. The important issue is that the abil-ity to measure risk critically shifts it away from the bounds of the unpredictable towards the predictable, and implies that the entrepre-neur or financial practitioner can make calculated decisions based on information and their assessments. It opens up the possibility that a toolkit can be developed which enables the systematic management of risk. The emergence and rise of a risk management industry in the 20th

century, the proliferation of particular models like Value at Risk (VaR) and their use by a new professional group of 'risk managers' can in part be attributed to an increasing ability to differentiate and extract this measurable risk. If risk management is used by cultural entrepreneurs or creative practitioners, then creatives and artists also move from the realm of being passive partakers in fate's fortunes to active managers of future possibilities (Dempster, 2007: 2009).

In fact, the preoccupation with taming uncertainty and risk is not new. Peter Bernstein (1996) argues that the serious study of risk began during the Renaissance when the foundations of probability theory were discovered by mathematicians and gamblers (who were often the same people) and is associated with the growth in international (seafaring) trade commonly represented by the goddess Fortuna. Echoing this, Giddens (1999) suggests that while 'in the Middle Ages there was no concept of risk', by the 16th and 17th centuries the word seems to have entered the English language through Spanish or Portuguese, where it was used to refer to 'sailing in unchartered waters'. For Bernstein, the attempts and accomplishments in controlling uncertainty can be seen as the foundations of today's society in which 'the revolutionary idea that defines the boundary between modern times and the past is the mastery of risk: the notion that the future is more than the whim of the gods and that men and women are not passive before nature' (Bernstein, 1996: 1). The measurement and mastery of risk is what enables (economic and social) man, including the entrepreneur, to do their job, innovate and drive society forward.

Yet it is the increasing complexity of risk management techniques developed over the 20th and 21st centuries that also account for the downfall of social and economic systems. A trend seems to have emerged for more sophisticated and integrated models, more powerful computing in ever-larger simulations and increasingly complicated and difficult-to-understand mathematics on the one hand, based on overly generalised assumptions on the other. These have been blamed for leading financial practitioners and their (risk) advisors to over-estimate the effectiveness, quality and precision of their models and their ability to capture the true complexity of idiosyncratic and immeasurable uncertainty. Critics argue that this growing confidence, coupled with a technological and cultural reliance on dominant risk management

methods, has led to a mono-vision and dependence on a limited set of tools that resulted in blind-spots in both policy and practice. According to Michael Power (2007), the emergence of a 'grand narrative of risk management' adopted across entire countries and regions within both the commercial and public spheres has resulted in a myopic viewpoint and a dangerous illusion of control. This, in turn, has created a dangerously homogenous social world order and an international economic marketplace that is unable to adapt or respond when the environment changes (Bronk, 2009). It is argued that the convergence on a few dominant approaches and an overriding belief in their effectiveness by institutions such as banks has led to very high correlations in economic trading activity and a herding behaviour in the marketplace which has contributed to the global economic and financial crises of the mid- to late 2000s.

Nevertheless, significant progress has clearly been made in our understanding of risk and uncertainty. With the substantial growth of the art market in recent years, the fact that sophisticated investment and associated risk management models developed in other fields may have potential application to art has been causing much excitement amongst new and potential investors and art world players. However, lessons from the recent past also suggest that a balance needs to be struck between expectations from the formal modelling of uncertainty and its ability to deal with the unknown. It seems that any robust and successful social and economic landscape, including the art market, must allow for multiple and appropriately modified approaches that ultimately enable variation, adaptation and responsiveness in the face of unknowable uncertainty and unpredictable change.

Economists have for more than a century considered how uncertainty and risk affects the 'entrepreneur'. This is perhaps most relevant for art practitioners operating every day in an uncertain world fraught with risk. In his seminal work, Marshall theorised that as well as co-ordinating the factors of production – land, labour and capital – the entrepreneur differentiates himself and is defined by his ability to understand the environment, foresee changes (in supply and demand), and be willing to act upon risky forecasts in the absence of complete information (Marshall, 1920). Frank Knight (1921) proposed that the principal role of the entrepreneur is, in fact, to bear risk for the chance of profit.

Joseph Schumpeter (1934) celebrated entrepreneurs as 'wild spirits' taking part in a natural cycle of 'creative destruction'. Their willingness to take on the risks results in innovation and ultimately drives progress, innovation and change. The influential management theorist Peter Drucker (1977) believed risk-taking was an inescapable part of business activity because economic activity is itself defined as the commitment of present resources to an uncertain future. In many ways, entrepreneurs in the creative industries and the art world, such as dealers, auctioneers and art consultants, embedded firmly in their own marketplace, are no different from their counterparts in other industries. For both, a critical component of their activity and ultimately success, is the ability to recognise and respond, assess, analyse and *manage* risk.

While risk and risk-taking is associated with potentially hazardous outcomes, the balanced perspective paints a more sympathetic picture of risk-takers themselves. They are seen as performing a useful, even necessary and valuable, function in society. Indeed, aspects of risk-taking are viewed as highly positive. This is mirrored in the popular literature, the press and media which celebrate enterprise and glorifies risk-taking alongside the individuals who take it. For example, the past few decades have seen an abundance of books that portray maverick characters in business, industry and finance who, because of their willingness to take big risks, reap massive rewards for themselves as well as for their organisations. Although spectacular failures are seen, they are often portrayed either as anomalies or one side of the coin of success in a culture which seems comfortable with notions of gambling by 'investors' (see, for example, Lewis, 1989; Burrough and Helyar, 1990; Partnoy, 1997 as examples of this popular literature).

A number of sociological perspectives on risk also involve a more contextualised view of it. Sociologists stress the need to appreciate risk as a social construct, not simply as the measurement of objectifiable and quantifiable values associated with some degree of probability (Douglas and Wildavsky, 1982; Tierney, 1999). They are concerned with contextualising risk and estimates of risk are treated as socially constructed notions (Hilgarten, 1992) that are framed and shaped by different societal actors and institutions (Johnson and Covello, 1987; Diaz *et al.*, 1989). In their pioneering work on Cultural Theory (of risk), Mary Douglas (1970) and Douglas and Wildavsky (1982) suggest that

the way in which risk is perceived – and therefore acted upon – is not guided by objective measurement but rather determined by subjective opinion within a highly politicised and social process. People's perspectives on risk are shaped by the social and cultural forces of the environment in which they find themselves, and these subjective risk judgements can deviate substantially from 'objective' measurements. People make choices about which risks are acceptable and which are not and therefore about those which they will face and manage over others.

In summary, economic theory has elucidated the need for risk-taking by entrepreneurs in their contributions to economic growth and development. Perspectives stemming from applied fields like finance, business and management also often treat risk as a necessary component of the practitioner's activity and as only one side of the opportunity generation and value creation equation. Risk is not seen as necessarily negative and in many instances risk-taking can be celebrated as necessary for innovation, performance and development. On the other hand, sociological perspectives have stressed that an appreciation of risk, whether it be big or small, acceptable or not, should be seen as part of a negotiated social and political process in which people continually re-assess what is and what is not acceptable and therefore what should be acted upon. In both perspectives a more balanced view of risk is taken in which the downside is weighed against the upside.

Critical perspectives

While many approaches to risk and uncertainty suggest a balanced and in part positive approach, I will argue that what can be broadly classed as a third category of perspectives sees risk as an absolutely critical or necessary component and often in an altogether more positive light. Although this perspective surfaces in discussions of the role of creativity and innovation across disciplines, including both sciences, technology and social science, it is most often associated with radical (as opposed to incremental) innovation, unusual events or disruptive change which creates opportunities for new players, often at the expense of established ones. However, I will suggest that

seeing risk as a critical component is most important for the arts and creative industries.

Uncertainty, creative industries and the art world

Although a systematic study of risk or its management is not currently a developed theme in relation to creative enterprise, and even less in the art world, there has been some interest in the notion of 'uncertainty', particularly in the more market-driven creative industries (De Vany and Walls, 1996; Caves, 2000; De Vany, 2004). For example, studies of the film and music industries (Faulkner and Anderson, 1987; Miller and Shamsie, 1999; De Vany and Walls, 1996) have considered the dynamics, structure and characteristics of uncertainty and the size, structure and effect of risks faced by entrepreneurs in these sectors. Although the parallels may not be immediately obvious, some of these findings could inform a deeper understanding of the art world.

For example, De Vany and Walls (1996) suggest that the film industry can and should be understood as an information industry where 'word of mouth' recommendations from viewers act as the main signal of a product's quality. Unlike standard microeconomic theory, the use of an information economics perspective suggests that people 'discover' their preferences through the process of consumption rather than 'revealing' something that they know already. It is this informal, somewhat random, process which drives demand and leads to 'wild uncertainty' both in terms of consumer demand and product performance. The largely unpredictable (stochastic) nature of demand makes it very difficult, if not impossible, to predict which movies will be blockbusters and which will be flops, resulting in a significant management challenge.

Because the consumption of highly idiosyncratic creative goods (like books, music and movies) and unique goods (such as art works) is embedded in an experience which is highly personal, the whole process is very subjective and depends on a unique object–viewer interaction. This makes it very difficult to categorise or group such experiences and ultimately to measure or model them in the aggregate. Furthermore, in such settings consumers are notoriously fickle and their choices are difficult to predict, making risks even more difficult to manage.

Looking at the film industry, but with relevance to all creative products and services, Faulkner and Anderson (1987) identify a number of distinct 'sources of variance'. These include (1) the uncertainty of combining financial and artistic talent; (2) the uneven nature of investment flows; and (3) the stochastic nature of market demand (1987: 884). Drawing on Milliken (1987), three different types of uncertainty – state, effect and response – Miller and Shamsie (1999) attempt to provide evidence for the existence of distinct historical periods in which it is possible to predict the variability (i.e. variance) of product offerings for the Hollywood film industry from 1935 to 1965. They also suggest that uncertainty can exist at three levels of analysis – industry, environmental and individual. But perhaps most interestingly, they convincingly argue that it is very important to differentiate between types of uncertainty within the sector which is being studied because 'different kinds of uncertainty have very different effects on strategy' (1999: 98). In related work, I have considered sources of underlying uncertainty in the performing arts, mapping their evolution over the course of a theatre production's lifespan highlighting the strategies employed by the production's entrepreneurs to manage their risks over time (Dempster, 2006).

Caves (2000) also remarks on the different types of uncertainty found across the creative industries including the art world. Informed by industrial organisational economics and contract theory, he explains how many creative industries deal with extreme uncertainty on both the demand and supply side and why they are structured in the way that they are. By developing a range of contracts, both formal but also informal, implicit or 'handshake' deals, these allow for rapid adaptation and exist in response not so much to asymmetric information (found in many other industries) as to the 'symmetrical ignorance' that characterises the creative sectors.

In spite of these attempts to explain the structure and dynamics of uncertainty in a number of different creative industries, a great deal of work remains to be done. In the academic literature, there is a lingering notion that creative industries are somehow different or unique (Hirsch, 1972; Lampel, Lant and Shamsie, 2000), although the empirical evidence is inconclusive on this point. Amongst practitioners there still exists the underlying belief that not much can be done about the

uncertainties that remain. This is most aptly summarised by William Goldman's (1989) often quoted phrase 'nobody knows anything' in his description of the Hollywood film industry. While this saying might be catchy and reflect a widely held belief, it is dangerous in encouraging a shoulder-shrugging attitude from industry participants which elicits a sort of blind acceptance of high levels of risk, rather than a conscious and active attempt to identify and manage it.

Risk, chance and the creative process

Although there has been very little research done on risk and its management in the creative industries – and almost nothing specifically in the art world prior to the publication of this volume – there are some striking parallels between the world of the entrepreneur as described by classical economists and sociologists and that of the 'creative' or 'artist'.

The artist (in the most general sense) or creative, much like the classical entrepreneur, operates in a world where uncertainty is pervasive and risk-taking is central to their function and raison d'être. Taking risks is considered an intrinsic and necessary part of creative endeavour, the creative process and production of creative goods and services. Artists and creatives often define themselves as risk-takers, rule-breakers, boundary-destroyers. This is reminiscent of the economist Joseph Schumpeter's description of entrepreneurs as wild spirits which through the process of creative destruction enable progress and drive society forward. Throughout the 20th and 21st centuries, it has become increasingly easy to find literary references from and about artists where uncertainty, risk and risk-taking are treated as *critical*. For example, in effect commenting on the importance of uncertainty the cubist painter, Georges Braque (1882–1963) explained that 'Art is made to disturb. Science reassures. There is only one valuable thing in art: the thing you cannot explain' (Braque, 1957). In the same vein, the French abstract painter and leading modernist Jean Hélion (1904–1987) equated art with risk-taking when he said, 'Art is, from any point of view, the greatest of risks'. Similarly, Graham Vivian Sutherland (1903–1980), an English artist who painted abstract landscapes, commented on the risky process of artistic creation: 'In painting, you have to destroy in order to gain . . . you have got to sacrifice something

you are quite pleased with in order to get something better. Of course, it's a risk.'

The positioning of risk at the core of the creative process briefly surfaced in the public policy discourse on the 'creative industries' with the publication of Brian McMaster's report *Supporting Excellence in the Arts* in the UK in 2008. The report is unusual in that it couples 'excellence' with risk-taking in the arts. McMaster suggests that creative and cultural excellence can be achieved only through constant innovation, which is understood as 'the introduction of something new' (2008: 10). He goes on to explain that 'risk-taking is about experimentation and pushing boundaries in ways which artists and practitioners themselves may not be sure will work. It demands courage, curiosity and desire, and a degree of spontaneity' (2008: 10). He tempers an outright promotion of risk-taking with the comment that it should 'be informed by skill and sense and be managed, but not avoided'. The report adds a newly legitimised dimension to the discourse on risk-taking within the creative industries but unfortunately for the practitioner, it falls short of specifying which risks are particularly relevant or precisely how they can and should be managed.

The taking of risks can therefore be seen as a necessary condition for participation in the world of art. As Mark Rothko eloquently put it in his Manifesto on Art, 'Art is an adventure into an unknown world, which can be explored only by those willing to take risks' (Rothko and Gottlieb, 1943). The very act of taking risks, great risks, risking everything, empowers artists and sets them apart from the common man who (by implication) is either unwilling or unable to take such risks. The creative process itself can be interpreted as a type of risk-taking.

There are ample historical and contemporary examples where artists consciously create opportunities for unexpected occurrences, in effect accentuating and making use of uncertainty in order to take risks that might enhance their creativity. 'Chance' events and conscious and active risk-taking by artists can be seen in a broad range of creative practices, methods and media. The interest in making use of uncertainty within artistic practice has increased in modern times with the emergence of the ready-made or the found object (*objet trouvé*), the most famous example of which is Marcel Duchamp's *Fountain* (1917), an everyday urinal, designated by the artist to be a work of art, signed 'R. Mutt' and displayed on a pedestal.

Iversen (2010) describes the difference between a notion of art which is laborious, largely skill-based and with outcomes known in advance, and another, in which art is much more about accident and either waiting to see what will happen or making something unexpected happen. She describes the way artists uses formal methods in a sort of mock experiment which, within a predetermined structure, allow for the occurrence of chance events that can be observed and recorded and become part of the artwork. An early example of this might the way in which Jean Arp, one of the founders of Zurich Dada, reportedly created his collages by tearing up pieces of paper, letting them fall from a height and gluing them wherever they fell, thereby literally 'arranged according to the laws of chance'.

However, Iversen differentiates this sort of 'systematic use of chance' (2010: 13) from artistic strategies which involve what she calls 'high risk spontaneity', which has an unbridled and somewhat dangerous quality. Various performance pieces might fall under this latter category including Maria Abromovic's *Rhythm 10* (1973) which involved her rhythmically stabbing a knife between splayed fingers in a variant of a widely known 'knife game'. In another work, *Rhythm O* (1974), Abromovic exposed herself to the unstrained whim of an audience, placing in front of them 72 objects and herself with the instructions "I am an object, you can do whatever you want to do with me and I will take all responsiblity for six hours". In such works, the exposure to hazard is tangible. In another example, Dutch conceptualist Bas Jan Adler performed 'staged accidents', which included riding a bike into a canal, falling off a roof and eventually resulted in his being lost at sea as he attempted to cross the Atlantic in a small sail boat in his final piece *In Search of the Miraculous II* (1975).

Applying the economist's lens (described above), the use of 'chance' in the creative process can be interpreted as concerned with uncertainty per se, while the treatment of 'risk' in both economic theory and the art world is distinct in that it must be associated with danger, an identifiable downside which adds to the thrill (upside) for the spectator. In the context of performance art, the artists might subject themselves to danger; a sort of sacrificial risk. The obvious parallel here is the acrobat or circus artist, the thrill of whose performance is enhanced by the associated degree of danger they put themselves in.

More broadly, the willingness to take risk relates to the artist's conscious opening up to the possibility of failure on the one hand, but the greater opportunity for success on the other. This was clearly apparent in the experimental photography of Man Ray where, for example, the accidental double exposure of a photograph resulted in the now iconic portrait of *La Marquise Casati* (1922). The recognition that 'mistakes' can have aesthetic and conceptual value led technically skilled artists like Man Ray both to experiment and explain that he had learned 'to produce accidents at will' (Baldwin, 1988, cited in Iversen, 2010).

Risk-taking and the artist in society

The notion of unleashing the power of creativity through uncertainty and unbridled risk-taking parallels the conceptualisations dominant in the early 20th century and developed by theorists like Carl Jung (1875–1961) and Sigmund Freud (1856–1939) that some mistakes are not really mistakes at all but, like dreams, reflections of the subconscious. Relatedly, in his analysis of the artist within society, Emile Durkheim (1858–1917), credited as the father of the discipline of sociology, suggested that art existed outside the standard moral sphere and in a sense was even free from it, thriving when it broke down. He described historical periods of great unrest and uncertainty (like revolutions) which witnessed the collapse of the social order, as well as its constraints and institutionalised, accepted norms of behaviour, as being associated with the greatest periods of creativity. Durkheim described the notion of 'collective effervescence' in these times of great uncertainty when group action took place and the greatest art, creativity and innovation were born (Durkheim, 1912[1965]).

In summary, enquiries focused on the creative industries have a distinct perception of uncertainty, risk and its management. Extreme uncertainty is recognised by both practitioners and scholars as ubiquitous across the creative industries, including the art world. Furthermore, there is significant anecdotal evidence that the taking of risk is central to the creative process. The fact that these sectors are characterised by extremely high levels of uncertainty can translate into both substantial opportunities and significant losses. This often leads to winner-takes-all type outcomes and a star-based system where there are a few big

winners and many losers. There is an implicit celebration of risk and it can be generally associated with innovation and artistic excellence. Some attempts have been made to understand the uncertainty within the creative industries and to model it formally, most notably in the film and music industries, for which there is more plentiful and transparent data. However, studies of industry-specific risks in the art world, which is not only smaller but much more opaque than other sectors, are very rare. Nonetheless, I argue that it is absolutely critical to understand the main sources of uncertainty and their associated risks in the art world, not least because entrepreneurs or practitioners in this space have to deal with it, just as they do in other industries and sectors. Furthermore, understanding risk in the art world is critical because it can and has been conceptualised as the artist's central raison d'être and a necessary condition of participation. While economic and sociological perspectives on risk and uncertainty can be used to some extent to understand it, the art world is distinct in that risk is a critical component of the creative process.

Conclusions

The different perspectives on risk and its management and practice are summarised briefly in Table 1.1 below.

This chapter aims to provide a broad introductory review of the significant literature on risk and uncertainty which spans a range of disciplines and settings. Although there is no clear consensus, different scholarly fields have contributed to a multi-layered understanding of both risk and uncertainty, drawing on evidence from different settings and contexts. The need to adequately contextualise risk discourses and distinguish between empirical settings and findings can, to a large extent, help explain the difference in approaches, aims and findings. It is interesting to see how and why such a broad range of attitudes exist. This includes perspectives which take a largely negative view of risk and uncertainty, resulting in the ultimate aim of minimising or eradicating them completely. In more balanced perspectives, (unpredictable) uncertainty is in part decoupled from measurable, and therefore manageable,

Perspective	Focus of discourse	Aims and propositions	Example of evidence base and empirical context
Negative			
Risks stem from unwanted developments (man-made or natural).	Risk is associated with hazards, accidents and disasters.	Risks should be minimised as much as possible and ideally eradicated completely (although this may not be possible in all cases).	Found across science and social science theories. Applied areas largely including the natural sciences, technology and engineering. Often involve large-scale, global concerns (such as the environment)
Balanced			
Risks include both negative (downside) outcomes as well as positive (upside) aspects. They should be differentiated from uncertainty and can be actively managed.	Taking risks is associated with entrepreneurial activity, innovation, change and social development.	Risks must be balanced with returns. While 'downside risk' should be minimised, risk should not necessarily be eradicated since it is linked to returns, 'upside risk' and opportunity creation.	Theories in economics and sociology. Found in applied fields including finance, business and management.
Critical			
Risk is a critical component of the creativity process. Much risk-taking can be conceptualised in a positive way.	Risk is associated with challenging the norm and status quo, enabling innovation, creativity and artistic production.	Risk-taking should be learned and attempted. At most it should be managed but risks should not be avoided or minimised. In certain settings, risk-taking should be maximised and encouraged.	Few theories to date. Implicit in practices in the arts and creative industries (including the art world).

Table 1.1

risk and compared to reward. Alternative perspectives emphasise the need to appreciate risk not primarily as an objective quantity but as part of a social and cultural process which balances individual political needs within environmental realities. These perspectives are the ones most commonly used across the sciences and social sciences, as well as in the development of theories and tools that might inform and influence practice.

Much less commonly or systematically discussed are perspectives of risk and uncertainty which focus specifically on the creative industries and, even more rarely, the art world. How are they perceived, treated and ultimately managed? This chapter suggests some fundamental differences, not least of which is a more positive attitude to both risk-taking and the role of underlying uncertainty, but one that treats them as critical for artistic endeavour and central to the creative process. Unlike many other sectors of social and economic life, attitudes in the art world can perhaps best be summed up by the saying, 'the biggest risk all, of all, is taking no risks at all.'

References

Baldwin, N. (1988) *Man Ray: American Artist.* New York: Da Capo Press, p.158.

Beck, U. (1992) *The Risk Society: On the Way to an Alternative Modernity.* Newbury Park, CA: SAGE Publications.

Bernstein, P.L. (1996) *Against the Gods: The Remarkable Story of Risk.* New York: Wiley.

Braque. G. 'The power of mystery' (12 January 1957), a *London Observer* interview with John Richardson, as quoted in *Braque: The Late Works* by John Golding. London, *Royal Academy of Arts*, 1997, p.10.

Bronk, R. (2009) *The Romantic Economist: Imagination in Economics.* Cambridge: Cambridge University Press.

Burrough, B. and Helyar, J. (1990) *Barbarians at the Gate: The Fall of RJR Nabisco.* New York: Harper & Row.

Caves, R.E. (2000) *Creative Industries: Contracts between Art and Commerce.* Cambridge, MA: Harvard University Press, p.368.

Chapman, R.J. (2006) *Simple Tools and Techniques for Enterprise Risk Management.* Chichester: Wiley, p.466.

Crouch, E.A. and Wilson, R. (1982) *Risk/Benefit Analysis.* Cambridge: Ballinger.

De Vany, A. (2004) *Hollywood Economics: How Extreme Uncertainty Shapes the Film Industry.* London: Routledge.

De Vany, A. and Walls, D.W. (1996) 'Bose–Einstein dynamics and adaptive contracting in the motion picture industry.' *The Economic Journal,* 106(439): 1493–1514.

Dempster, A.M. (2006) 'Managing uncertainty in creative industries: Lessons from *Jerry Springer the Opera.*' *Creativity and Innovation Management,* 15(3): 224–233.

Dempster, A.M. (2007) 'Risky business: The art of managing creative ventures.' In Eisenberg, Gerlach and Handke (eds), *The Cultural Industries: The British Experience in International Perspective.* Berlin: Humboldt University.

Dempster, A.M. (2009) 'An operational risk framework for the performing arts and creative industries.' *Creative Industries Journal*, 2(2): 151–170.

Diaz T., Frey, S.R., and Rosa, E. (1989) 'Definitions of conflict and the legitimation of resources: The Case of Environmental Risk.' *Sociological Forum*, 4: 47–70.

Douglas, M. (1970) *Natural Symbols: Explorations in Cosmology*. London: Barrie & Rockliff.

Douglas, M. and Wildavsky, A. (1982) *Risk and Culture*. Berkeley, CA: University of California Press.

Drucker, P.F. (1977) *Management*, An abridged and revised version of *Management: Tasks, Responsibilities, Practices*, first published in Great Britain 1979, by Pan Books Ltd., London.

Durkheim, E. (1912, 1965) *The Elementary Forms of the Religious Life* (English translation by Joseph Swain: 1915) New York: The Free Press.

Faulkner, R.R. and Anderson, A.B. (1987) 'Short-term projects and emergent careers: Evidence from Hollywood.' *American Journal of Sociology*, 92(4): 879–909.

Giddens, A. (1999) *Runaway World*, Lecture 2: Risk, BBC Reith Lectures, http://news.bbc.co.uk/hi/english/static/events/reith_99/week2/week2.htm

Goldman, W. (1989) *Adventures in the Screen Trade: A Personal View of Hollywood and Screenwriting*. New York: Grand Central Publishing.

Hesmondhalgh, D. and Baker, S. (2011) *Creative Labour: Media work in three cultural industries*. London: Routledge.

Hilgarten, S. (1992) 'The social construction of risk objects.' In J.F. Short and L. Clarke (eds.) *Organizations, Uncertainties and Risk*. Boulder, Colorado: Westview Press, pp.40–53.

Hirsch, P.M. (1972) 'Processing fads and fashions: An organization-set analysis of cultural industry systems.' *The American Journal of Sociology*, 77(4): 639–659.

Lampel, J., Lant, T. and Shamsie, J. (2000) 'Balancing act: Learning from organizing practices in cultural industries.' *Organization Science*, 11(3): 263–269.

Iversen, M. (2010) *Chance*. Cambridge, MA: The MIT Press.

Johnson, B.B. and Covello, V.T. (1987) *The Social and Cultural Construction of Risk: Essays on Risk Selection and Perception*. Dordrecht: D. Reindel.

Knight, F.H. (1921). Risk, Uncertainty and Profit. Washington, DC: Beard Books.

Lave, L. (ed.) (1982) *Quantitative Risk Assessment in Regulation*. Washington, D.C.: The Brookings Institution.

Lewis, M. (1989) *Liar's Poker: Rising through the Wreckage on Wall Street*. New York: W.W. Norton.

Lowrance, W.W. (1976) *Of Acceptable Risk: Science and the determination of Safety*. Los Altos: William Kaufman.

March, J.G. (1991) 'Exploration and exploitation in organizational learning.' *Organization Science*, 2(1): 71–87.

Markowitz, H.M. (1952) 'Portfolio selection.' *Journal of Finance*, 7(1): 77–91.

Marshall, A. (1920) *Principles of Economics*. 8th ed. London: Macmillan.

McMaster, B. (2008) *Supporting Excellence in the Arts: From Measurement to Judgement*. London: Department for Culture, Media & Sport.

Miller, D. and Shamsie, J. (1996) 'The resource-based view of the firm in two environments: The Hollywood film studios from 1936 to 1965.' *Academy of Management Journal*, 39(3): 519–543.

Milliken, F.J. (1987) 'Three types of perceived uncertainty about the environment: State, effect, and response uncertainty.' *Academy of Management Review*, 12(1): 133–143.

Mitchell, J.K. (1990) 'Human dimensions of environmental hazards: Complexity, disparity and the search for guidance.' In A. Kirby (ed.) *Nothing to Fear: Risks and Hazards in American Society*. Tucson: University of Arizona Press, pp.131–175.

National Audit Office (2000) 'Supporting Innovation: Managing Risk in Government Departments.' Report by the Comptroller and Auditor General. London: The Stationery Office.

Power, M. (2007) *Organized Uncertainty: Designing a World of Risk Management*. Oxford: Oxford University Press.

Partnoy, F. (1997) *F.I.A.S.C.O.: Blood in the Water on Wall Street*. London: Profile Books.

Rothko, M., and Gottlieb A. (1943) 'Manifesto on Art.' *New York Times*.

Rowe, W.D. (1977) *An Anatomy of Risk*. New York: Wiley.

Schumpeter, J.A. (1934) *The Theory of Economic Development. An Inquiry into Profits, Capital, Credit, Interest and the Business Cycle*. New Brunswick, NJ: Transaction Publishers.

Tierney, K.T. (1999), 'Towards a critical sociology of risk.' *Sociological Forum*, 14(2): 215–242.

Art market risk and complexity: An insider's view

Tom Christopherson, Head of Art and Law Studies, Sotheby's Institute of Art, London

Introduction

This chapter looks at risks and opportunities in the art market from the perspective of the people who operate within it, as a framework and context for the discussions and contributions that follow.

Diversity is a fundamental theme of the art market and both a key risk factor and key opportunity for participants and external analysts. By way of illustration, Sotheby's employs some 20 full-time practising lawyers in-house around the world in different fields. These lawyers are engaged in various roles concerning the evaluation and management of risk, be it in the negotiation of contracts for the sale or financing of art transactions, in dealing with art related disputes, in researching provenance (legal and cultural status as well as import/export history) or in assisting clients' advisors with chattels-based taxation issues. A major auction house will also employ a range of experts in other fields who are involved in managing potential risk, such as property and chattels insurance, security of art in transit and on its premises and in matters related to reputation and brand protection. This list of activities provides some indication of the diversity of issues encountered by participants in the art market, some of which are specific to the art market and others of which are faced by any business, but which nevertheless have particular characteristics in the art market.

Some of the issues to be addressed are, and always have been, inherent to the art market. Others however are more recent developments, arising from:

1 the growth of regulation of the market;
2 the way the market has become more sophisticated in its processes; and
3 the expansion of the market into more diverse cultural and geographical territories.

To understand art market-related risk, one needs to understand market process

A starting point is the fact that the market constitutes a wide range of sales processes and practices and a high volume of single, rather than multiple, transactions. These transactions involve the transfer of a wide assortment of individual and often unique objects. There is therefore an absence of long-term contracts for the supply of multiples or product ranges, as might be the case with other markets, and each transaction is a one-off event. These transactions are conducted in an array of locations, in each of which different economic and cultural influences are at work. These transactions also involve a very wide variety of different individuals and entities. Some transactions are business-to-business, and therefore subject to a legal and economic framework that reflects the commercial nature of the process. Other transactions are business-to-consumer, and operate under a different set of legal requirements and economic imperatives. An unusual feature of the art market is that the same parties can conduct both types of transactions, with dealers purchasing for their private collections while also purchasing for their business stock as well as directly for their clients. The distinction between the two classes of activity is not always clear, even to the participants. Some transactions – principally auctions – are reported publicly, while private sales by dealers and galleries tend not to be. That said, dealers also hold selling exhibitions that entail a slightly higher level of transparency, and auctioneers undertake private sales which are not transparent.

The market is therefore highly diverse in terms of the type of participant, location, culture, subject matter and process. This level of diversity is rare in other markets (or is at least not commonly seen to this extent), and the first and fundamental risk for an external analyst or investor is in applying to the art market algorithms and patterns derived from other, more homogeneous markets. Identification of an apparent pattern in the art market can be dangerous if the variety of underlying processes and influences is not also identified and understood.

Market participants on the other hand, tend to take the market's diversity for granted and see this as an opportunity rather than a risk. Participants often focus on a particular aspect of this widely diversified market in order to capitalise on that opportunity. This underlines the difficulty for outsiders aiming to draw themes from across the market and can mean that external analysts or investors can view it from quite a different viewpoint than that of regular participants.

The fact that many participants operate exclusively in a relatively narrow part of the art market – a region, a field of expertise or a method of operation – does not mean that the analyst can comfortably subdivide the market into more easily understood segments. A market analysis must take account of the degree of overlap or competition between categories or activities.

For example, auctioneer A might take goods on consignment for sale from dealer B. At the same time, dealer B might be looking to purchase other goods at A's auction. In both cases B would be a form of client of A in an example of a classic vertical trading relationship, but the relationship in each case would be very different. An auctioneer is in legal terms the agent for the seller, so A's primary obligations are to B where B is their seller or principal, but would be to another seller where B is the buyer and therefore not the auctioneer's principal. A and B could also and at the same time be in a horizontal trading relationship, as direct competitors to win another consignment of works of art from a third party, or alternatively, acting in partnership in order to offer that third party a more advantageous deal, for instance by combining A's financial resources with B's trade contacts. B could also be competing with another dealer, C, for that item of property, while also acting in partnership with dealer C to purchase yet another work from auctioneer A, and so on. These

different relationships between A, B and C frequently run concurrently. The complexity of these relationships introduces a set of market and legal risks for new and unwary participants.

The expansion and development of the market over the last 20 years has seen a more varied and sophisticated approach by the major participants. This has given rise to significant opportunities and also to two types of potential market-related risk, one for participants and another for external parties (be they analysts or potential investors). For the less sophisticated participants, there might be the risk of misunderstandings and at worst potential conflicts of interest. The diversity of market roles requires careful analysis with a sound understanding of each relationship and the rights and obligations to which each gives rise. For the external analyst or potential investor attempting to evaluate the market, their analysis must take into account the complex interrelationships that constitute the market, which can make it challenging to assess the impact of market forces on different participants.

A common approach in reviewing the art market's overall health, risks and opportunities is to focus on public auctions as a guide to developments across the market as a whole. Sales at public auctions are the most visible transactions in the art market, with widely available pre-sale catalogues, press coverage, published prices and archival information made available by the larger auction houses and independent databases. However, a true view of the overall market should try to take account of other market activities, including selling exhibitions where there may be some transparency about asking prices and the fact of sale (if not the final price), as well as private sales. Private sales, whether by auction house or dealer, form a very significant part of the art market and the participants in these compete directly to sell the same items as those conducting public auctions (as well as being participants as buyers and sellers in those auctions). To obtain a true view of the market, these activities have to be assessed as part of one overall picture, even if parts of that picture are more easily identified and analysed than others.

To what extent is the market global? At the higher value levels, the art market is clearly international, with buyers and sellers competing directly from across the world. A high-value Impressionist or contemporary painting can be sold most successfully in London or New York

and could be bought by a purchaser from anywhere in the world. The chosen location for sale will have as much to do with timing and the preferences of the seller as it might with matters such as sales tax or resale right levies, not to mention the value or location of the artwork itself.

As values decrease, one might think the market would become increasingly national or domestic. To an extent this is true, but not necessarily in a consistent manner. With the rise of the Internet and better communications, the market can be genuinely international at much lower transactional values where buyers can operate with relatively low transport costs, such as for the sales of stamps or coins. The same applies where there are fewer legal and regulatory barriers to cross-border trade, as is the case for contemporary art. The reverse tends to apply for sales of furniture or larger decorative arts, where transport costs become more of an issue. A particular segment of the art market can also be international in terms of buyers, but less so for sellers. While a mid-value Impressionist painting could be sold in New York, London or Paris, a high-value item of tribal art of similar value might attract a better buying audience in Paris than in London, even though top buyers could come from around the globe, reflecting the tradition and taste for sales of tribal art at all levels in Paris. Market participants will say that 'this is where the market is' for tribal art, even if the highest level buyers may come from around the world.

Even at the top of the value range, where the art market is clearly international in scope, it nevertheless can operate under a range of domestic influences. There follows an example, fabricated for this purpose but not unusual for this segment of the market. Imagine an international auction in London, to which is consigned a painting estimated at £20 million. It had been stored in Switzerland, but owned by a resident of Germany. The painting is exhibited before sale in Hong Kong, Paris and Geneva, and at the London auction attracts bidding from around the world before being sold to a bidder on the telephone from New York who, it transpires, has made the purchase on behalf of a buyer living in Brazil. At that price level, the market is clearly international. Nevertheless in this example the transaction chain potentially involves at least 5 different countries, with 5 cultures, 5 cultural export regimes and 5 legal and tax regimes. This can be more complicated if the transaction

includes additional art advisors, introducers, selling agents, family representatives, joint owner/sellers residing in different countries, and so on. The transaction remains a sale on the 'international market', but it retains any number of different domestic links.

For the market participant, the potential for uncertainties in this regard makes it important to tie down as many factors as possible in structuring a transaction, starting with who the participants are, where that transaction is to take place and identifying the applicable law and tax regime(s). While many of these issues may take care of themselves for a properly conducted auction, they require particular care when negotiating a private treaty in which the 'place of sale' can be less obvious. For the analyst and potential investor, the characteristics of a single transaction may never come to light, but they need to be aware that this great diversity exists for many of the individual transactions which collectively underpin the market they are analysing.

Some categories of risk in the art market

Seen from the participants' perspective, one might characterise art market risk as follows:

A. 'Property risks', which relate directly to the nature of the individual items bought and sold.
B. 'Legal and regulatory issues', which govern the market and market processes, and the effects of cultural diversity.
C. Financial and market risks.

Property risks

This section addresses the categories of risk that directly relate to the individual object being sold. These concern legal title and legal or ethical claims, issues of authenticity and attribution, condition and insurance, as well as matters relating to valuation.

Legal title

Does the seller own the item or have the unimpeded right to sell it, and is there any legal restriction to that right? Legal issues of this type may arise in many different circumstances: a divorce, a family dispute as to

who inherited what or who has the authority to act for whom, or an argument between co-inheritors as to whether a sale is advisable. Alternatively, a legal title claim could be based upon allegations of an earlier theft or exist in relation to the disputed terms of a previous sale, or alternatively an earlier joint purchase or a business partnership where the parties have since fallen out. Sometimes a title claim may arise as the result of a disputed gift for which there was little or no evidence. A lack of evidence might appear at first glance strange or even suspicious, until one realises that few of us leave evidence of the gifts we have made or received, or items we have purchased, particularly if at the time the item was acquired it was not particularly expensive or we were unaware of its present or potential value.

A related category of risk relating to the item may not necessarily be a legal claim as such, but might constitute a moral or ethical claim that the item should not be sold at all, or should not be sold by the person seeking to sell it. The restitution of art looted during World War II is one example and some of the claims made by nation states to protect cultural property (in the absence of applicable laws or treaties) may be another. In such cases, there may be clear legal title and the right at law for the possessor to sell the work (for example, because statutory limitation periods have expired or certain evidential or international treaty requirements for a valid legal claim have not been met), but there may nevertheless be or be considered to be an ethical claim which is (or becomes) sufficiently widely recognised to affect the marketability of the work. These cases can attract considerable publicity and it is ill-advised to mount claims on this basis without a very clear supporting case. They do, however, remain an important property-related risk for certain classes of items which can nevertheless be lawfully bought and sold.

Market practitioners will try to avoid, or at least mitigate, these risks through securing title and related warranties from the seller, and by seeking to undertake appropriate due diligence into the history and background of the artwork. Due diligence is the key to identifying and addressing the risks of potential claims against the sale of the work, as well as potentially uncovering its true value; it generally involves considering the information provided by the seller as well as other known circumstances surrounding the object and its known history and, where appropriate, checking the item against available databases of stolen

artworks. For more well known and valuable works, exhibition and published sales histories are also important.

Due diligence is not an off-the-peg, one-size-fits-all activity. It has to be appropriate to the work of art and its circumstances (including its value and the extent to which it is separately identifiable). Relevant historical information will often be piecemeal and each stage in the process requires assessment as to whether to continue, whether the information provided to date is sufficient, whether it opens new avenues requiring investigation and whether further investigation is likely to bring results. Due diligence is therefore an interactive process rather than a single 'cut and dried' exercise.

Sometimes these are not clear-cut issues. Some cultural objects – particularly but not exclusively in the lower value range – will, with the best will in the world, have left very little traceable historical record and thus the available information for due diligence will be limited. The owner who inherited a clock from a deceased aunt may not know, and may never be able to find out, where or how the aunt had obtained the clock; in fact, he may not even have any information proving that he did inherit the clock from the aunt if, for instance, there was no inventory of property with her will and his insurance policies are no more specific in their descriptions of cover than 'household contents'. The trail can very easily run cold. Similar issues can arise for items that today carry very high value, but which in the past were regarded as commonplace and therefore not worthy of independent record.

Sound and careful judgement is required. In the absence of available information and clear answers, is the item of a type requiring further enquiry or do the circumstances of its appearance on the market give rise to particular concerns? Where there is no or insufficient information about the item being consigned, how can the practitioner narrow down the gaps and minimise the risk of a claim or dispute? On occasion there is also the risk of new information subsequently becoming available, either through the discovery of records or through records being made available when previously unavailable, which appears to undermine a decision previously made. Unforeseen title claims remain a market risk which, though capable of reduction through good practice and careful due diligence, cannot be extinguished.

Authenticity

In practice, determining that a work is authentic has always been a balance between the expert's eye and the historian's endeavour with – where time, money and the nature of the piece allows – the assistance of scientific tests. This remains the case in spite of scientific advances and the availability of new processes. In addition to the elements making up his personal artistic opinion about the work, the expert will assess the available history of the piece and whether there are external elements of proof for its existence in the past, such as old sale and exhibition catalogues. The expert also has to satisfy himself that the piece is indeed the piece referred to in the old catalogues, as it has been known for new works to be produced to match the descriptions of works sold and lost many years before. Where available, the expert will consider both published and unpublished views in the market. This can involve considering different opinions and assessing the relative weight given to different experts and schools of thought (all of which requires a sound understanding of the parties providing the opinions) so that the practitioner is able to assess the experts' own backgrounds and potential interests.

Use of scientific analysis requires a thorough examination of what the test results say and what they do not. In some cases a test may point to the existence of an element in an item that could not have been present at the time the original work is thought to have been created, thereby apparently producing a clear result indicating forgery. In many cases, however, the test result may point only to the *possibility* of forgery, without being (on its own) definitive. For example, the foreign element might have appeared in the work as a result of restoration, without intention to deceive. Alternatively, the test results might point to elements that require further explanation, either scientifically or through examining the history of the work and its creation. On the other hand, it is rare that test results can definitively prove a work to be authentic, beyond indicating the absence of factors that would suggest a work is inauthentic. Scientific analysis therefore remains a useful tool in the process to establish authenticity, but it is not the only one.

In most countries, when addressing these issues the courts also balance the credibility of different experts in assessing their evidence, whether it

be scientific or artistic. Some countries however, such as France, delegate to the heirs of artists a substantial degree of influence over matters of authenticity, in that they have a statutory right *(droit morale)* to declare a work authentic or to bring about the seizure and destruction of a work they consider inauthentic. Similar influence over authentication lies with the authors of the artist's recognised record of works *(catalogue raisonné)*. This more definitive approach works well where the *droit morale* holder or *catalogue raisonné* author is universally respected, but carries considerable risks when they are not.

Issues of attribution compared with authenticity

While the processes of assessing both authenticity and attribution involve the proper identification of an artwork, the former is seeking to expose a work which is a deliberate attempt to imitate and mislead, whereas the latter is seeking to identify the true creator, often in the absence of clear (or any) information. Such works are sometimes described as *sleepers*. The important point for both the buyer of art and the analyst of the art market is to understand the different legal consequences for these two related but distinct issues, and to understand which legal remedies might be available in each case.

In some cases the two issues can appear difficult to separate – how is it that one copy of a painting can be accepted as a 'genuine' copy described as 'after the artist', while another copy is deemed a forgery, when they are both copies? The answer lies in the perceived intention of the person producing the copy and in the development of art itself, in that artists have learned their craft for millennia by practising copies of earlier artists, without any intention to deceive or pass themselves off as the original. These copies are works or versions in their own right and are treated very differently from the copies made with the deliberate aim of passing them off as the original and misleading potential buyers.

In the UK, authenticity is often covered by a specific contractual guarantee to rescind or undo a contract and to take back proven forgeries within a specified time. The definition of forgery for these purposes generally hinges upon identifying something in the work or the circumstances surrounding its creation that demonstrates a conscious intention to deceive and a deliberate attempt to make the work appear what it is not. The intention of the contractual guarantee is to restore the

buyer and seller to the position in which they would have been, had all the parties not been deceived by the forgery when they conducted their transaction in the forged work.

However, attribution of artworks is a wider and less definite concept and in the absence of deliberate forgery is not always covered by an express guarantee. In the UK, and in the absence of an express guarantee of attribution (separately from one relating to authenticity), the general legal principals will apply, by which the parties will attempt to assess whether the attribution was negligent – thereby giving rise to legal redress – or whether it was not negligent (even if ultimately considered incorrect) – giving rise to no legal redress.

The lack of an implied guarantee of attribution in the UK is based upon the recognition by the courts that attribution is a matter of the professional practitioner's expertise and opinion, which can produce different and irreconcilable conclusions. As the judge remarked in the leading attribution case of Luxmore-May v Messenger May Bavistock ([1990] 1 All ER 106):

> A number of experts, however . . . have taken a contrary view. As with many other 'sleepers', perhaps the mystery will never be conclusively solved.

Cataloguing also customarily reflects the subtle variations in the type of attribution given, through the use of carefully defined terms such as 'by the artist', 'attributed to the artist', 'studio of the artist', 'manner of the artist', 'after the artist' etc. A clear market risk for the new entrant or potential investor would be to fail to appreciate the limitations in artistic attribution and the precise meanings and consequences of the different forms of attribution employed.

As attribution is a matter of expert opinion and (unless the valuer specifically says otherwise) not a matter of fact, it does not follow that an incorrect attribution automatically gives rise to legal redress: the court would have to decide that the opinion and research underlying the attribution was negligent. The relevant circumstances for assessing the attribution would include the status and expertise of the auctioneer or valuer, the information and resources available to him at the time of the attribution and the reasonable expectations of the client. Each case

will be different. Furthermore, circumstances and generally held opinions can change with development of scholarship or science. If a work of art was attributed to a given artist in 1950 but demoted in 1970, it does not necessarily mean that anybody has made a mistake, but may mean that opinions and knowledge (both artistic and scientific) have developed in the interim. It also does not guarantee that the same work may not be once again deemed the work of the artist in 1990.

Practitioners will sometimes look for a sufficient body of support from various recognised authorities for a 'market view' to emerge. The consensus-driven approach to attribution is extremely important in the art market, but can lead to uncertainty if the experts cannot agree, or if opinions change. Even after the consensus approach has led to the general adoption of one or two opinion leaders or recognised experts, they can of course disagree, 'lose their eye' or go off the boil over time. This can and does lead to a difficult period where parts of the market disagree with and do not follow the judgment of an expert previously considered to be determinative.

These periods of interregnum present difficult choices for market participants and for the courts. For the auctioneer or dealer, whose opinion should they follow and quote to potential buyers, in the knowledge that such opinions will have a material impact on value? In cases of irreconcilable differences of expert opinion, the prudent approach would be to quote both sides and leave the market to decide. However, market confidence underpins value, and a seller may be uncomfortable with taking the risk of market uncertainty through referencing both opinions unless the counter-opinion appears to bear sufficient weight. The courts have recognised that it is a matter for the market practitioner to decide how much weight to attribute to an expert opinion, and therefore whether it need be disclosed in a catalogue or brochure. However, this judgement can be a fine one carrying both legal and financial risk, and becomes particularly difficult where established experts are considered to be past their best. Their reputation makes it difficult for their opinions not to be shared with potential buyers, but market practitioners are faced with a dilemma if they believe that the current opinion is weak or unfounded and that referring to it would unfairly dampen the market for that work.

In such cases the courts are also faced with a dilemma. They are tasked with assessing all the evidence and opinions available to the dealer or auctioneer at the time of sale, and with deciding whether the practitioner's attribution and cataloguing was reasonable in light of what they could and should have known at the time. How should the court assess a case when the market is disunited in its assessment of a formerly pre-eminent expert? Hindsight is a wonderful and tempting thing and this analysis is complicated by the declining independent expert phenomenon described above: at what point did the sale occur on the trajectory of the independent expert's reputation and eye? These questions are as difficult and subjective as the matter of art attribution itself, but are of crucial importance in deciding whether a disputed attribution was negligent in order to give rise to a claim, or whether the attribution was reasonable at the time and gives rise to no such claim.

Condition

Items for sale on the art market are often unique. They may have been unique or at least extremely rare in their manufacture, or may have become unique in their survival – even widely produced items can become effectively unique in terms of their age and individual condition and provenance. This degree of individuality influences value and gives rise to legal risk in terms of dispute resolution. An example is the operation of standardised consumer protection legislation, which in many circumstances gives consumers the right to change their mind and return goods to the seller or require a replacement. These regulations may work for modern, mass-produced products which can be easily returned and resold, but can be problematic for items for which there is no direct replacement, and whose value may relate directly to the circumstances of their sale as well as to their intrinsic characteristics. A uniquely identifiable object coming back to the market after a short delay can be difficult to resell at its previous price if it is no longer seen as 'fresh to the market' and if potential buyers suspect (regardless of the truth) that its return suggests some defect or problem in the object. If the original price reflected in part the circumstances of sale – for instance a high-tempo, high-celebrity, single-owner auction – the original sale price may be extremely difficult to repeat.

Items for sale are also often fragile. Refer back to the scenario described previously with the sale in London of the painting previously housed in Switzerland to the buyer in Brazil, with the possibility of pre-sale exhibitions in Paris, Geneva and Hong Kong. Failure to maintain an appropriate process for assessing, recording, packing, shipping and unpacking the work at each stage of its journey would lead to a significantly enhanced risk of loss or damage, with disputes over liability for such damage. Even where such extensive arrangements for international travel are not contemplated, the art market routinely has to address condition issues in the receiving, cataloguing, exhibiting, selling and then delivery of fragile artworks. These issues and associated risks are more prevalent now than ever before as a result of the global expansion of the market through telephone and Internet bidding, increased reliance upon condition reports and online images, and with delivery of works often arranged by the seller or their agent. It is a prerequisite for art market practitioners to ensure that risk of loss or damage is clearly covered by applicable contractual provisions and relevant insurance policies at all stages of the transaction, and that both are properly understood. It is equally important that all parties to the transaction understand the process at each stage, and that a proper record is kept of each step. Cover in the best contracts and insurance policies can be undone by misunderstanding the practical steps for transferring artworks from one place to another or from one ownership to another.

Valuation

Two threads of risk arise with regard to valuation. First, there is the risk that the artwork could be incorrectly valued through an incorrect assessment of intrinsic value (misattribution) or financial value (market assessment). Second, there is the risk of misunderstanding or misuse of the (otherwise correct) valuation. This may have become a more material issue in a wider and more complex market. As has always been the case, valuation documentation should seek to set out the levels of responsibility accepted or disclaimed in the exercise of a valuation, and should address specifically the potential liability for mistake or negligence. However, today the need for clarity in the valuation itself has never been greater, given the different ways the valuation can be used, misused, understood and misunderstood.

Art and antiques can have more than one estimated monetary value at any given time, depending upon the terms and purpose of the valuation. This is not to say that valuations are manipulated for different purposes, but it is the case that an estimation of value should reflect the circumstances in which that value might be realised.

By way of illustration, a valuation could be required for insurance purposes to cover the replacement value of the item in the event of loss or damage. A valuation for insurance purposes will therefore seek to estimate the likely purchase price of the item on a replacement basis, including estimated auctioneer's fees or dealer's margin. An insurance valuation would often also attempt to take into account the likelihood that the owner would be looking to replace the item as soon as possible, rather than waiting an indefinite period for a bargain to appear. This could (in the case of jewellery, for instance) mean purchasing a replacement at a 'high-end' jewellers as opposed to waiting in the hope that a comparable item appears at some point at auction. Therefore the valuation would include a degree of uplift to reflect a purchase made from a relatively weak bargaining position. High-end jewellery or silver retail prices tend to be considerably higher than those at auction and this uplift is generally reflected in an insurance valuation for such items.

On the other hand, a valuation providing a 'current' or 'fair' market value would usually involve an assessment of the item's likely sale value, which would not take into account the purchase costs and opportunity costs included in the insurance valuation. It may or may not reflect any costs of sale, such as auctioneer's commission or transport costs; generally these are not taken into account in such valuations.

Potentially different again, 'pre-sale estimates' made in the expectation of an imminent sale would reflect the strength or weakness of the market at a precise place and point in time, and might additionally be pitched conservatively at the lower end of the potential range, as part of a sale strategy to entice potential bidders in the hope of a better ultimate sale price. Other factors affecting pre-sale estimates might be the circumstances of the proposed sale. For example, an attractive provenance for an item might be reflected as an uplift in the estimates for its sale, as would be the case if it was being sold as part of a particular collection with, for instance, particular historical or celebrity interest.

In contrast to insurance valuations, pre-sale estimates generally refer to anticipated hammer prices and do not include costs of purchase such as buyers' premium.

Valuations for tax purposes have their own bases and regulations, prescribed by HM Revenue and Customs' regulation and practice. They may therefore be constrained in the degree to which they take into account the factors described above, thereby potentially producing another level of valuation, accurate on its own terms.

The above examples demonstrate that these forms of valuation could each be correct and properly carried out, but produce very different results. A significant risk for market participants (owners, potential lenders or purchasers, or even third parties such as tax authorities) is therefore that a valuation is not properly understood, or alternatively is used for a purpose at odds with the basis on which it had been provided. For example, relying upon an insurance valuation for the purposes of taking art as security for a loan could be misleading and could materially increase the level of risk for the lender. Similarly, expecting the sums quoted in an insurance valuation to be realised on a sale of the item could give rise to considerable disappointment for the seller.

For the practitioner having correctly assessed the artwork, the key issue is communication and the key risk is miscommunication. It is important to ensure that the purpose, circumstances and terms or limitations of a valuation are as clear and as unambiguous as possible. It is also important to explain the assumptions and terms of art commonly used; these may be clear to the practitioner but may be less clear (or completely unknown) to the client and third parties to whom the valuation is subsequently given. The introduction of new parties to the market (such as external investors) and the expansion of the art market to new territories and participants, has materially increased this need for clarity in the description of the market's services and processes.

More general legal and regulatory risks

The art market, like any other, can be prone to contractual disputes beyond those specific to the artwork itself in the manner described above. In light of the high volume of individual transactions involving unique and fragile items, the number of disputes reaching a formal

stage involving lawyers is actually remarkably low. However, disputes can arise concerning a number of issues related to promises made and either misunderstood or not properly performed, and the potential for such disputes has arguably increased with the growing complexity and international nature of the market.

With historical art markets being substantially domestic and conducted by small numbers of participants frequently well known to each other, the possibilities for misunderstandings were perhaps more limited than today, and the opportunities to find a commercial resolution between the parties were greater. Recent developments have begun to change that. The world is sadly a more litigious place. Additionally, as the art market has grown in value, complexity and international scope, the risks of misunderstanding and legal dispute have also grown. Written contracts and terms of business have therefore become much more common in the art market over the last 20 years or so, although outsiders are sometimes still surprised at how much business can be conducted outside these formal arrangements. This phenomenon might reflect the surviving attitudes of the old guard, but perhaps also recognises the practicalities of dealing in the market described at the opening of this chapter: a market consisting of a high volume of fast-moving and very individual transactions at a wide range of price points.

Even though it has no specific regulatory body, the art market is now regulated to a much higher degree than ever before. It would be misleading to talk (as some do) about this being one of the last surviving 'unregulated markets'. Examples of directly applicable regulation include: data protection legislation; intellectual property rules (copyright, moral rights and Artists Resale Rights); anti-money-laundering legislation; consumer protection legislation; customs and cultural property regulations and anti-corruption regulations such as the Foreign Corrupt Practices Act in the US and the Bribery Act in the UK. These regulations operate over and above the legal framework already described, and materially influence the operation of the market. They may apply in some areas of the world and not others, or may be applied in different ways in different countries. This creates another area of risk in an increasingly global market: cultural diversity. Complying with the various forms of regulation on an international basis can be a challenge.

In an increasingly global market, international sellers and buyers may tend to a different view of the market, with different expectations. Frequently the seller wants to be local, in terms of dealing in a local law and language and in local processes with which he is familiar, and yet with access to global buyers and the prices that the international buyers create. However the international buyer tends to expect a global and uniform approach, meaning that he can purchase an item on familiar terms and using a familiar process wherever he makes the purchase. The agent or auctioneer can find himself placed in the middle. 'Global versus local' and diversity against consistency are significant tensions at the top or international end of the art market. If one is involved in a single series of negotiations for a sale of art involving representatives from (say) the Middle East, China, the US and France respectively, one is likely to find some very different expectations from buyer, seller and intermediaries as to how that process is going to work.

Financial and market risks

One could categorise financial and market risks, from the perspective of an art market participant, in three ways:
1 the state of the market in response to the wider economic environment;
2 external regulatory factors;
3 the structure of the market in terms of its participants and its processes.

Practices and processes within the art market have long reflected the impact of the wider economic environment. These changes have in turn influenced and characterised the financial and market risks taken by participants. For example, the traditional *modus operandi* for art dealers was buying art as stock for resale, hopefully at a profit, and thereby taking a financial position or financial risk in the sale. More recently – and in response to current economic and banking conditions – it appears that art dealers have moved further towards taking a higher proportion of art on a consignment basis, thereby reducing their financial risk in carried stock levels and resale prices, (presumably) for a lower return.

Over the last 20 years or so, as the major auctioneers diversified their businesses they on occasion appeared to move in the opposite direction

by taking more of a principal position in art sales. An example of this would be the offering of financial guarantees to consignors of the most attractive works, whereby a minimum sale price at auction is guaranteed to the seller in order to compete directly with a firm offer from a dealer to purchase the item outright. In the last 3 or 4 years, again in response to the prevailing economic conditions, many if not most of these guarantees have in turn been backed by reciprocal arrangements with third parties, allowing the auction house to hedge the financial risk of the guarantee.

These contrary directions of travel – dealers undertaking more artworks on consignment rather than for purchase and resale, and auctioneers being prepared to offer financial guarantees on consignments – sit alongside the significant growth of private sales on consignment by auction houses, and the grouping of dealers at art fairs in order to increase their collective marketing impact to compete with auction houses. Such initiatives are symptomatic of the fundamental development of the market to one of more complexity, integration and sophistication, with market participants competing and collaborating in many different spheres. Another area of growth in the market has been in loans secured by art, either as advances of sale proceeds (not a new concept) or as a form of lending in its own right. These developments have supported the growth and profitability of the market, while also increasing the complexity and risk involved (financial, reputational and commercial). The key question is how well those risks are understood and managed.

Conclusions

The diversity of items for sale and of sales processes makes the art market a different animal from (say) the stock or bond markets, and this in some respects makes the art market more difficult for the outsider to read. Additionally, the art market is distinguished from other more traditional investment markets by the range of factors driving liquidity, and particularly the relationship between time and value. Imagine if you will, a testosterone-fuelled bond trader grabbing an

opportunity in his market and barking instructions in haste to buy or sell down the telephone. Contrast him with the patient antique dealer of a certain age and experience who waits, *possibly for years*, for the right buyer to appear for a particular object which he knows that the person will be unable to find elsewhere – if only the dealer can find the right buyer to appear. This may be to caricature the two roles in order to make the point, but in the art market the timing and circumstances of a sale can be almost as important as the intrinsic attributes of the object being sold. This is widely understood within the art market, but its implications for value and risk may not be so widely understood outside the art market. The diversity and volume of objects sold, and diversity of the persons, entities and processes involved with each sale, have increased materially with the expansion of the art market into new territories and new concentrations of wealth. This constitutes a new and significant challenge for the art market, and also its most exciting opportunity. However, this diversity and the unique attributes of the art market can make the application of investment models from other markets a somewhat hazardous business.

Value, risk and the contemporary art ecosystem

Anders Petterson, Founder and Managing Director, ArtTactic Ltd

Introduction

The last 10 years have seen an exponential growth in the market for contemporary art: turnover at Christie's and Sotheby's increased from $270 million in 2000 to $2.7 billion in 2012. Contemporary art has become the biggest selling auction category for both firms, accounting in total for 41 per cent[1*] of their main sales categories (Old Master, Impressionist, modern, contemporary and Chinese art).

However, the auction market is of limited relevance to the large majority of contemporary artists, as only a very small number, less than 10 per cent[†], of contemporary artists have an active auction market (which means no or limited price transaction data exist for most contemporary artists). How can one understand and analyse price and market risk of these non-publicly traded artists?

A more holistic approach is needed, and a fundamental understanding of how economic value originates for contemporary art is called for to provide it. This why I prefer to look at the art market as an ecosystem in which economic value is largely a function of a process of endorsement by tastemakers within that ecosystem. To understand the inherent risk in the art market is to study and monitor the actions, relationships and dynamics within this ecosystem.

* Source: ArtTactic Research
† Source: Artfacts.net

The first part of this chapter looks at the art market ecosystem and its different constituents, describing how they contribute to the under-standing of value creation and risk in the contemporary art market. I have used a practical example of the Damien Hirst market to illustrate this dynamic. The second part of the chapter looks at how changing motivations among buyers, as well as technology and the Internet, has the potential to change the endorsement process of contemporary art, giving increasing power to new types of players as well as to the informed art public, potentially at the expense of the art insider (existing 'tastemakers').

The role of the 'tastemaker' in the contemporary art market

What is good art and who decides? This is a question that many people ask themselves when confronted by contemporary art today. The notions of skill and craftsmanship, although still relevant, have been challenged by another strand of the contemporary art market that focuses on ideas and concepts, often questioning the very nature of art itself.

Now, in a world where craftsmanship or makers has been replaced by idea generators and thinkers, the traditional tools of evaluating what is good and bad art have for most people become increasingly redundant. The language and context required to understand many of these works have moved from a largely aesthetic language to become a matter of philosophy and art theory – knowledge that few people in the art market can claim they genuinely have.

So the art market needs translators (or experts), people and institutions that can guide potential buyers and help them understand the context and meaning of art today. And, because of the subjective nature of art, these 'translators' are not merely translating facts and figures, they are adding their own personal interpretations and understanding of art today. From this point on, I will describe them as 'tastemakers', as many of these individuals and institutions have a significant influence on what we consider to be good and bad art.

Tastemakers could be individuals or institutions within the art marketplace that have been granted (or have earned) a 'rank' or status by their peers. This allows these individuals or institutions to exercise their tastes and preferences to influence the perceived cultural value of an artist. As an example, if an artist is chosen to exhibit in a group show of young emerging talents at Tate Modern, then the reputation (and the cultural importance) of that artist is elevated as a result of the Tate's role as one of the world's most eminent cultural institutions for modern and contemporary art. Equally, if someone like the French businessman and art collector, François Pinault, starts buying the work of a contemporary artist, and is likely at a later point to exhibit that work through his private museums in Venice, it sends a signal to the rest of the art world about his preferences and taste. Such actions by tastemakers are increasing the probability that this artist will be successful in the future. An accumulation of cultural value frequently translates to an artist's higher economic value [see Hutter & Frey 2010], as the demand for these artists will increase as a result of their elevated cultural status (or reputation).

The art market ecosystem

Why can we not simply say that value or price of art is a matter of demand and supply? Well, there is no doubt that demand and supply have a direct impact on value, but it tells us very little about how the demand was created in the first place. What makes an art work desirable?

I believe that taking an interdisciplinary approach would give us a better understanding of many of these issues, which brings me to ecology. Why use the ecosystem analogy? Partly because it allows us to take a multidisciplinary approach to the issue of how value is created in the art market, and leads to a better understanding of the interaction between the different players and 'tastemakers' in art and their relation to the environment in which they live. I will borrow two concepts from ecological systems theory as developed by Urie Bronfenbrenner:

- **Microsystem.** Refers to the institutions and groups that most imme-
diately and directly impact the artist's development, including art
school, museum institutions, collectors, critics, galleries and peers.
- **Macrosystem.** Describes the culture in which artists live. Cultural
contexts include developing and industrialised countries, socio-
economic status, political environment and level of technological
advance.

Although the macrosystem will define the conditions for how an art
market might evolve, to better understand risks in the contemporary
art market and the risks associated with the probability of market
success or failure of a contemporary artist, I would argue that it is
essential to understand the microsystem in which the artist operates
and the nature and diversity of the network of tastemakers that support
the artist.

We can define the contemporary art market as an international ecosys-
tem (the global contemporary art market), which consists of a subset of
national, regional and local submarkets. Each national or regional art
ecosystem will have different structures, diversity and complexity,
depending on the maturity of the localised art market. In this chapter I
will focus my attention on the participants of the Western contempo-
rary art market ecosystem (the US and Europe), although I will make
references to other art market models relevant to less mature contem-
porary art markets such as India, the Middle East and China.

The Western art market ecosystem is composed of different groups of
tastemakers which fall broadly into the following categories:

- Producers (artists)
- Educators (art schools, academics)
- Media and commentators (art critics and reviewers, art magazines,
general media, blogs)
- Market intermediaries (auction houses, dealers and art advisors)
- Cultural intermediaries (museums, kunsthalle, biennales)
- Agents and promoters (commercial galleries, artist-run spaces)
- Interpreters (art historians, curators, art critics)
- Consumers (private buyers and collectors, corporate collections and
public institutions)

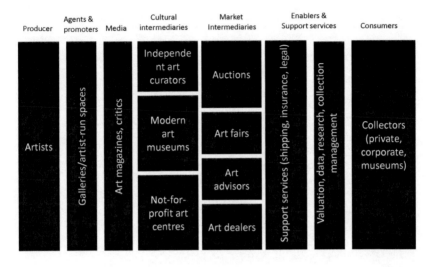

Figure 3.1 The art market ecosystem

The endorsement process

In many ways, the market for contemporary art has similarities with markets for hi-tech start-up companies. The company valuation is based on the expectations of success and future cash-flow generation rather than the underlying cash flows that these businesses are currently generating. In contemporary art we have a comparable situation where the value is linked to the perceived current and future success of the artist, rather than the long process of historic validation.

The key question is: how this perception is created? What constitutes success? Ostensibly this might seem to be a function of random actions (luck and timing), although more often it is the result of a set of carefully orchestrated events, which we define as the endorsement process.

I have split the potential trajectory of an artist's market evolution into three phases (formation, expansion and consolidation), and plotted these potential events against two axes of 'cultural' and 'economic' value.

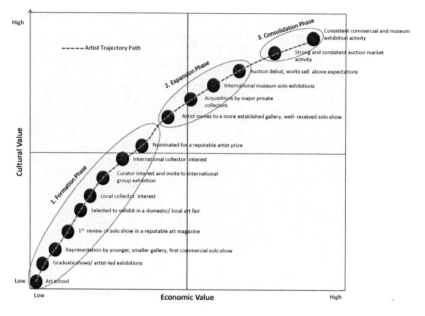

Figure 3.2 Contemporary artist market trajectory: relationship between cultural and economic value

Formation

This process typically starts at the point when the artist graduates from art school. Although some artists get picked up by a commercial gallery straight after their graduation show, it is more likely that the young artists will rely on their peers in the first years, exhibiting in artist-run spaces and in smaller commercial group exhibitions. The art students' networks are very important in promoting and endorsing their individual talents, as galleries commonly use artists as scouts for other promising artists.

The next big step for an artist is to be represented by a gallery. From a management and commercial point of view this could be a major development for the artist's career, depending on the reputation of the gallery and its network of contacts. The gallery acts as an agent or intermediary between the artist and other market participants, such as art critics and reviewers, private collectors, curators and museums. The

debut solo show is particularly important as it functions as the official launch of the artist's works and career, which until then has largely been seen in the context of other artists. The commercial success and critical reception of this solo exhibition will very much dictate how quickly the artist will progress from this point.

If the feedback from the first gallery show is favourable, it is likely that the gallery will work hard to provide opportunities for the artist to get more exposure, particularly through participation in art fairs and also in public, non-commercial exhibitions in foundations, art centres and museums, which I define as *institutional validation*. Major exhibitions in a museum or museum acquisitions of their work would have a significant impact on the reputation of an artist (a sign of recognition or approval) and consequently also on their economic value. The strategy for anyone operating in this market is to ultimately 'place' an artist and their work in a museum context, and a gallery's reputation is closely related to its ability to achieve this. Curators, critics and collectors often play important roles as mediators (or promoters) in this process, and their actions and opinions often have an impact on the museums' decision-making process.

This process will typically start locally and then gradually become more international. At the time when the artist moves from being a locally or domestically known artist to becoming increasingly recognised in the international art market, the artist is potentially ready for the next market phase.

Expansion

As the international reputation of the artist increases, commercial galleries in other international markets will start to pay attention, and the artist is likely to be represented by a number of different galleries in different key markets such as London, New York, Paris and Hong Kong. Some artists move to a bigger and more established gallery as part of the expansion phase. What characterises this period is a broadening of the international art network (as it becomes a more diverse ecosystem), and ultimately a wider endorsement of the artist's work and career (higher cultural value). On the commercial side, one would expect a significant rise in prices and the economic value of the artworks as demand increases among collectors and institutions such as museums. It is at the point

when demand outweighs supply that an artist's work is likely to experience the first auction sale. Again, similarly to galleries, different auction houses will influence the market differently. A debut auction sale at Christie's, Sotheby's or Phillips would carry more weight or importance than a sale through a smaller, domestic or local auction house.

As soon as works by the artist are regularly featuring in local and international auction sales, a new type of validation or endorsement becomes relevant; it is what I will call *market validation*. Market validation, contrary to institutional validation, is confirming quality and success through a market mechanism (observable prices at auction) and not necessarily through the accumulation of cultural value, although in most Western art markets there is a strong relationship between cultural and economic values, as illustrated in Figure 3.2. An example of this is the German artist, Gerhard Richter, a contemporary artist who has been highly acclaimed by curators, historians and museums around the world, and is often considered among the most important and influential artists living today. However, it was really not until after the auction market started to elevate his prices in 2011 and 2012 that his 'position' in art history was firmly solidified. This shows that market validation often plays a critical role in giving the ultimate blessing to an artist's reputation and standing.

However, with the influx of recently acquired wealth, art collectors and consumers new to the contemporary art market are using the auction market as the ultimate arbiter of taste; price or economic value become the leading indicator for an artist's importance and for the quality of his or her work. This strong dependency on the commercial market as a validation mechanism is having a significant influence on what type of art is considered important today. We describe this in more detail in the last section of this chapter.

Consolidation

Although price volatility is a major short-term risk factor in contemporary art, particularly for artists whose success has been built on auction performance, the biggest risk in the contemporary art market remains changing tastes and preferences among tastemakers, which can have a significant impact on the perception of cultural and economic value of modern artworks.

An initial flurry of auction sales and exhibitions is not enough to maintain and consolidate the status, value and reputation of artists. In order for contemporary artists to remain relevant and increase their chances of becoming part of the art cannon, one needs to see a sustained activity both in the commercial market (gallery exhibitions and auction sales) as well as curatorial interest and museum exhibitions.

During the art market boom that took place in New York in the 1980s, a group of artists (including Julian Schnabel, Eric Fischl and David Salle) exploded on to the scene backed by art dealers such as Mary Boone and Leo Castelli. At the time, their prices could match those of Andy Warhol. However, today, a silkscreen painting by Andy Warhol would easily sell in the $10 million plus range, whilst a painting by Schnabel would struggle to get $100,000 at auction. The art market crash in 1990 brought an abrupt end to many of these artists' careers, and they have struggled to find a commercial voice ever since. This illustrates the fickleness of the market and the influence of changes in perception (and taste) on both the cultural and economic value of contemporary art.

So is it possible to measure and monitor risks associated with changes in taste and preferences among tastemakers? It is with the aforementioned ecosystem in mind that ArtTactic in 2005 decided to develop a methodology to track the sentiment and opinions of a carefully selected group of art market participants. We believed that the analysis based on historic auction data conducted in the art market at the time was often an unsatisfactory indicator of future performance, as the 'price-anchoring' and 'herd' effects often led the art market to over-shoot in a positive market and under-shoot in a negative market and that in any event, available auction data was too limited to support useful analysis. We felt that by capturing the sentiment and opinion of a wide range of tastemakers from the contemporary art market, we might be able to come closer to the insider's perception of value and risk. The survey is now conducted every six months and includes questions about the overall contemporary art market, perceptions about risk and speculation, as well as sentiment towards individual artists' markets.

Case study: Damien Hirst

This particular market analysis looks at events between 2007 and July 2013, and will attempt to provide the reader with a framework to better understand the Damien Hirst market during this period. We will augment the auction analysis with an interpretation of the results from ArtTactic's Confidence Survey to assess whether there were any signals suggesting a change among tastemakers during this period.

Damien Hirst (b. 1965) became the most prominent member of the group known as the Young British Artists (or YBAs), which dominated the British art scene during the 1990s and the early 2000s. The artist quickly moved through the formation and expansion phases in the 1990s up until 2006, and reached the consolidation phase described above around 2007.

Today, Hirst is arguably Britain's most internationally renowned living artist. His art and his market have always been surrounded in controversy, and in September 2008, he took an unprecedented move by organising an auction of new works, entitled 'Beautiful Inside My Head Forever' together with Sotheby's, effectively bypassing his long-standing galleries. Despite taking place on the eve of Lehman Brothers' collapse, the auction exceeded all expectations, raising £111 million ($198 million) and breaking the record for a single-artist auction. Although the auction itself was a success, the aftermath of the sale has proven more problematic, with auction prices and sales volume of Hirst works dropping significantly (see next page).

Now how did the experts view the Damien Hirst market at the time? Did they think that the extraordinary sale at Sotheby's was a good idea? What have been the implications for the Hirst market in the period 2009–2012?

If we take a closer look at the ArtTactic Confidence Indicator for Damien Hirst between 2005 and 2008, it reached its peak between November 2006 and June 2007, coming in at an average reading of 94 in this period. This signalled a strong, bullish sentiment towards Hirst's market at the time, and clearly set up the artist as one of the contenders for the most important artist in Britain, and maybe even in the world,

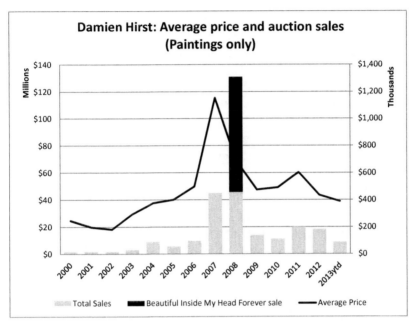

Figure 3.3 Damien Hirst: Average price and auction sales (paintings only): Focus on large paintings and sculptures. Source: ArtTactic

in the last 20 years. This was supported by rising prices and sales volume at auction, with several new records established by the artist's work, as well as rumours about a possible major retrospective exhibition already starting to circulate.

However, between June and November 2007, the ArtTactic Confidence Survey registered a sudden 19 per cent drop in the Damien Hirst Confidence Indicator, followed by a further 7 per cent decrease between November and June 2008. ArtTactic noticed that a number of key collectors and other market participants in the sample were getting increasingly concerned about the rapidly soaring prices, particularly as the early stages of the banking crisis (such as the collapse of Northern Rock and Bear Stearns) were starting to unfold during this period. So at the time of the Hirst sale, on 15 September 2008, a significant number of experts had already become increasingly negative on the short-term outlook of this market (from 7 per cent in May 2007 to 31 per cent in May 2008). Although the sale itself turned out to be a resounding success, the

months and years that followed have had a severe impact on Hirst's auction market, and so also on his reputation in the marketplace. In November 2008, two months after the sale, Hirst's Confidence Indicator dropped to an all-time low of 11, with the majority of experts now taking a dim view of the short-term outlook for Hirst's market. Since November 2008, the Confidence Indicator for the Damien Hirst market has been hovering in bearish territory (between 11 and 45). This bearish state is also apparent in the auction market where auction sales in 2011 were 55 per cent less than 2007 and 85 per cent lower than 2008. Even the long-awaited retrospective exhibition at the Tate Modern between April and September 2012 did little to restore confidence in the auction market.

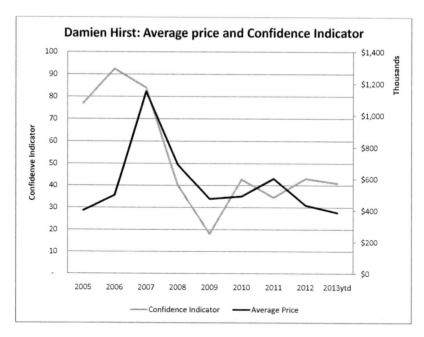

Figure 3.4 Damien Hirst: Average price and Confidence Indicator.
Source: ArtTactic

From a market research perspective, the Confidence Indicator based on expert polling has enabled ArtTactic to better understand the consensus opinion among tastemakers and its likely impact on the market for individual artists. As market analysts we are concerned mainly about two things. First, a 'shift' in consensus among experts, particularly as the majority of

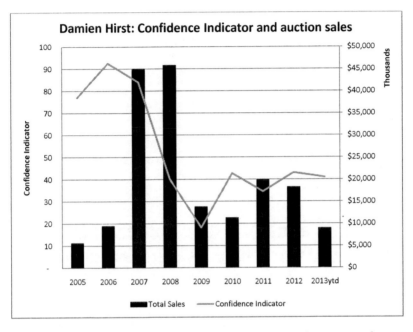

Figure 3.5 Damien Hirst: Confidence Indicator and auction sales.
Source: ArtTactic

opinions (or opinions among key players) move from a bearish to a bullish stance, or the other way around. This can signal a possible performance shift in the market, as the sample (mostly insiders with privileged access to information) starts to take certain actions that the general 'herd' of art buyers could be picking up on at a later stage (which was clearly illustrated in the case of Damien Hirst). Second, we pay attention to the relative position vis-à-vis other artists (relative ranking), as this allows us to point out specific artists whose performance contradicts the general sentiment.

It is clear that there are certain contradictions in the Hirst market at the moment. On the one hand, we have an auction market which has contracted considerably since 2008, and the sentiment among taste-makers remains below 50, indicating a significant amount of uncertainty (more than half of the respondents remained negative to the Hirst market for the next six months). On the other hand, Hirst's main gallery, White Cube, sold over £100 million in private sales in 2012 (four times

the auction sales), which shows us the limitation of using the auction market as an indicator for performance and risk. Hirst's retrospective at Tate Modern in 2012 was Tate's most visited solo exhibition ever, with more than 463,000 visitors over a five-month period, which illustrates the strong public interest in the work of the artist and in his brand. Although public opinion rarely matters with regard to cultural and economic value in the world of contemporary art, I will in the next section argue that technology, new audiences and new business models could potentially change the role and influence of existing tastemakers.

The emergence of a new contemporary art ecosystem: a new risk perspective

In the last five years, the existing art ecosystem described earlier in this chapter is being challenged by new developments in the global art market and new types of tastemakers and influencers. I describe some of these below and the potential implications of their emergence.

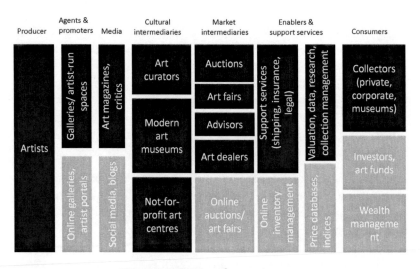

Figure 3.6 New market ecosystem

The online art buyer and seller

Since 2010, the online art industry has been experiencing rapid growth. There are now more than 300 online art market players world-wide*. These cover segments such as data, information and research, social communities, auctions and galleries, business-to-business and consumer-to-consumer art transaction platforms. In addition, social media platforms such as Twitter, Facebook, Pinterest and ArtStack are changing the way that we communicate and share our interests around art.

At the forefront of the online art market revolution are companies such as Artnet (US). Artprice (France) and Paddle8 (US) have launched their own online auctions. In the primary market, websites such as s[edition] (UK), Artspace (US), Artfinder (UK), 1stdibs (US), Exhibition A (US) and Art.sy (US) have invested heavily in an attempt to make inroads into the lower-priced segments of the art market. In August 2013, Amazon also announced its entry into the art market through its Amazon Art Market section, kicking off with more than 40,000 artworks by over 4,500 artists offered by in excess of 150 galleries.

A recent study done by Hiscox and ArtTactic on the online art trade suggests that the barriers to buy art online (sight unseen) are much lower than one might expect, with 72 per cent of the survey respondents† saying they had bought art based on looking at a JPEG image only. It is clear that art consumers and their behaviour are changing. Existing business models in the art market will have to adapt to survive, and we would expect a new, modified art ecosystem to evolve in the future.

The art investor

The growth of emerging art markets in Africa, Asia, Latin America, the Middle East, Russia and the Commonwealth of Independent States (made up of former Russian republics) in the last decade have seen the emergence of a new breed and type of collector. In the late 1990s and early 2000s, art markets in China and India grew and markets in Southeast Asia began to emerge. Most of these markets were driven by burgeoning wealth creation and rapidly growing economies, creating the right environment for new art sales platforms, such as auction houses and art

* Source: Art & Finance Report 2013, Deloitte and ArtTactic
† Source: The Online Art Trade 2013, Hiscox and ArtTactic

galleries, to cater for the new-found interest and demand for modern and contemporary art. Although many of these markets had been covered by international auction houses such as Sotheby's and Christie's since the 1980s, it was the local auction houses and galleries that acted as the catalysts for the market growth in the decade to follow. In India, Saffronart, an online auction house established in 2000, became one of the first domestic auction houses to capture the interest among both non-resident Indians (NRIs) in the US and Europe as well as local art buyers. In China, domestic auction houses, such as Poly Auction, rapidly gained market share from their international competitors catering for the growing love of art as an investment among Chinese buyers.

The common factor among most of these new art markets was that the art ecosystem lacked diversity. The early formations of these markets were based on the market-validation mechanism described earlier in this chapter, in which artistic quality and value were largely determined by how well the artist did in the auction market. The lack of a non-market infrastructure, such as contemporary art museums, galleries, curated exhibitions, art publications and critical writing, meant that there was no alternative context available to validate the quality of the art and artists outside the market place. This environment created a new breed of art buyers: the art investors and speculators. Compared to traditional art collectors, these art investors were impatient, short-term speculative buyers looking to profit from the growing interest in art as an asset class. Their strategy was to take advantage of a non-regulated market place, where both insider information and market manipulation could be exercised with few consequences, as well as of the inflating values of art works, increasing the risk of a new type of asset bubble. India's art market collapsed in 2009 in the wake of the global financial crisis; a number of the art funds that had emerged ran into trouble, triggering a rapid deflation in prices and market activity. The Chinese art market faced a similar situation in May 2012, when auction sales dropped 43 per cent[2] from May 2011. Again, speculative buying and the emergence of art investment funds meant that the Chinese contemporary art market had become ruled by a much more volatile market dynamic than that typically witnessed in a traditional collectors' market.

I believe this trend will continue. Art investors have become a new type of breed in the global contemporary art market ecosystem, and the

market must learn to live with them. In the coming years, we are likely to see the motivations around buying art changing; there will be a gradual calibration between art as a collectible and art as an asset class, something which is supported by the fact that 77 per cent of collectors surveyed by ArtTactic in 2012 said that their motivations for buying art can be ascribed to emotion and/or passion as well as investment potential. We believe the art investor will become a hybrid between the traditional art collector and the art speculator, and will have an increasingly important influence on the market.

The art wealth manager

The rapidly growing art market and the increasing value of art have also triggered a growing interest among wealth managers and the private banking community, who are increasingly considering offering financial services and products that complement their clients' art-related wealth. These services range from general art advisory services to tax planning and loans against art. In the years to come, we are likely to see increased involvement of private bankers and wealth managers in the art market.

With low interest rates and the equities market experiencing significant volatility, ever more high-net-worth individuals (HNWIs) are looking at tangible assets as a way of diversifying their existing portfolio and protecting their wealth against inflation. Since 2010, the market has experienced an increasing interest in art as an asset class and the art fund market has been growing steadily since 2006. According to the Deloitte ArtTactic Art & Finance Report 2013, it reached an estimated $1.62 billion under management in 2012.

The art services company

The growth of the online art market combined with a larger, and more complex, global contemporary art market has given rise to another breed of players – the *art service intermediaries*. Here I refer not to the brokers who facilitate the transactions between buyers and sellers, but rather new types of service companies aimed at helping buyers and sellers to find, share, assess, analyse and manage their art collection and art wealth.

Market transparency

In the late 1990s, a number of companies such as Artnet and Artprice, launched their online fine art auction databases, providing a significant increase in price transparency. Whilst past auction data was published in annual book volumes, the online databases provided instant and easy access to historic art auction prices, reducing the inefficiencies and level of asymmetric information that typically existed between buyers and sellers in the art market. In 2005, ArtTactic, the company I founded officially in 2011, launched its first art market 'Confidence Index' described earlier in the chapter. In recent years, a number of players have entered the market for art analysis and analytical tools, such as Beautiful Asset Advisors, Tutela Capital and Skate's. Artnet also launched its art market analytics product in 2010.

Data, analysis, research and market commentary are becoming important tools for the new group of buyers and sellers that have entered the market of late, including the emergence of the art and finance industry mentioned above. With a growing number of followers, the opinions and analysis of these companies are likely to start having a greater influence on the marketplace.

Collection management

With the advent of improved software, Internet and cloud computing, collection management tools are rapidly evolving and can now provide users with instant access to their collection online. As more collectors and galleries are starting to use these services, these companies will have more information on individual collecting habits and patterns. The move from being a service provider to a transactional platform – where these businesses can act as matchmakers between galleries and collectors or between collectors themselves – is not unthinkable.

Social media

The incredible growth in social media has also had an impact on the art market. Facebook and Twitter are actively being used by artists, galleries, museums and auction houses as new communication and marketing tools. In addition, new start-ups such as ArtStack have captured large audiences that want to share their art and their interest with others. The

aggregate voice of social media and the large audiences it attracts could have a significant impact on how we form our perception and opinion about art in the future. Again, the interesting fact is that these opinions are currently driven by art enthusiasts and the informed public – and not necessarily by those previously viewed as 'tastemakers'.

Although one might assume that the above operators are solely there to support the existing art market, the future might see several of these operators evolve into becoming something else. In fact, this is already happening: both Artnet and Artprice have set up their own art sales platforms, aiming to offer their clients more than just information; also the actual art itself.

Conclusions

In the next 10 years, the contemporary art market is likely to undergo a radical change, a transformation that will revolutionise the way we experience, learn about, promote, transact and value art. The existing ecosystem could move from a relatively small, insider- and expert-driven model towards a more open infrastructure, where the informed public is likely to play a more important role.

Due to the nature of the market and the subjective characteristics of art, tastemakers will remain critical of how perceptions are formed and of our understanding of risks and opportunities in the market place. However, the existing tastemakers will be challenged, and in many cases substituted by a new type of guru representing a larger public voice, taste and opinion. Maybe Amazon will become the new Gagosian or Christie's? Maybe Facebook will become the new art critic, and Google Analytics the new Artnet? It is far from certain that Amazon will succeed in the art market, but ignoring the emergence of these new players could be hazardous.

In order to understand the risks in the contemporary art market in the future, it is no longer sufficient to track and monitor the tastemakers of the past 10 years, as their relevance will gradually diminish. New approaches and tools are needed to understand how taste itself is formed in this new environment.

1 Source: ArtTactic Research

2 Source: ArtTactic Research

The impact of globalisation on the contemporary art market: The traditional gallery model at risk

Olav Velthuis, University of Amsterdam

Introduction[1]

Since the late 1990s, markets for contemporary art have globalised rapidly (see e.g. McAndrew, 2008; Artprice, 2008). While this has allowed for diversification of art business on the one hand, globalisation has also introduced a new set of risks to the traditional gallery model: at the top end of the market, a small group of galleries has managed to cater to the demands of new middle classes in China, Brazil or India (for example) by opening up satellite spaces in those countries or in the art centres that are frequented by new economic elites. The Gagosian Gallery, for instance, now operates 12 gallery spaces all around the world. These top-end galleries have also become global players through their presence at the world's most prestigious art fairs in established art markets (such as Art Basel, Frieze in London, FIAC in Paris) and in emerging ones (such as SP Arte in São Paolo, ART HK in Hong Kong). Moreover, since these galleries – as well as the artists they represent – function like brands, they have increasingly been able to sell art through the Internet.

For others, however, globalisation poses new risks: they do not have the financial means to participate in many fairs or simply lack the economic and artistic prestige to gain access to them. Likewise, they cannot exploit online sales channels significantly since potential clients are not

able to find their websites. Moreover, given information asymmetries in the art market, potential clients face the risk of buying a work of inferior quality, which makes them even more cautious about buying works online from galleries who lack brand value. At the same time, globalisation has led to changes in buying practices that have eroded the traditional gallery model: art dealers report that it is becoming more difficult to attract art lovers and collectors to their gallery spaces, principally because it has become too time-consuming. The fairs, by contrast, have presented an efficient way for the public to see a lot of art and fit well into a more general 'event' culture.

This chapter looks at how cultural globalisation has impacted standard business practices of galleries (cf. Velthuis, 2005), what risks and opportunities it poses and to what extent it has changed the role of the gallery space in marketing art. This focus is motivated by large strands in globalisation literature which have equated the process with 'deterritorialisation', the process in which 'the constraints of physical space lose their hold on social relations' (Lechner and Boli, 2008: 4; see also e.g. Appadurai, 1996; Held and McGrew, 2003). Players within the art market subscribe to a layman's version of this claim, as I will show: they frequently use terms like 'global village' to characterise their business, claim that physical distance no longer matters in their trade and insist that the nationality of the artists they represent and the collectors they 'work with' is a non-issue. This discourse has been further cemented by the rise of institutions which seemingly weaken the importance of physical distance, such as the contemporary art auction, art fairs and the commercial Internet portals for art such as Artnet. All three potentially bring together global demand and supply of art.

Although art dealers have stressed the opportunities which this new global playing field offers, they simultaneously stress the importance of their local gallery space. The latter is the main stage for a set of firmly institutionalised commercial practices, and is intricately tied up with each dealer's identity. It is here that the risks of globalisation become apparent. Although globalisation has indeed resulted in a waning importance of the local gallery space, this has not entailed deterritorialisation, but rather a relocation of commercial practices to other highly symbolic spaces.

This article is based principally on interviews with art dealers in Amsterdam and Berlin. Twenty Dutch dealers and 39 German dealers were randomly sent an interview request in the spring, summer and autumn of 2009, which was just after the market crashed and before sales at the top end of the market picked up again from 2010 onwards. In total 24 art dealers responded of whom 21 were interviewed (14 in Berlin, seven in Amsterdam).[2] Semi-structured interviews were conducted which lasted between 30 and 90 minutes, and were usually conducted on the premises of the gallery.

Opportunities in an art market without borders

The art dealers interviewed for this study invariably emphasised the many opportunities, both artistically and commercially, which globalisation provides. They argued that the Internet had transformed their trade, making deals with collectors hitherto unknown possible and facilitating contacts with artists in distant regions. They told numerous anecdotes to illustrate how borderless the art market had become, such as the one about a piece by a Japanese artist they represented in Berlin, which they transported to an international art fair in Miami, where it was bought by a collector from Puerto Rico, who had it shipped to his vacation apartment in Paris. My respondents recounted how they had tried their luck at art fairs in Dubai or in Shanghai, which provided new commercial opportunities for their enterprise. Metaphors like 'global village' and 'global community' were used frequently to characterise the social world they inhabit. For instance, one Berlin dealer claimed:

> It is still not a big scene ... in the past four or five years it has become bigger, but it is still really small. If you walk through Venice [the dealer refers to the Venice Biennial, which is considered one of the most important overviews of contemporary art], it is 'hello', 'hello.' It is this global village which is travelling from Venice to Basel, from Basel to London and then to Miami. (Birgit Ostermeier, Berlin)

Most importantly, the dealers claimed that they did not care about the nationality of the artists they represented. They saw themselves as gate-keepers to the art world, who are solely interested in quality. As they claimed:

> The principle is that all of them have to be of the highest quality possible.
> (Vous Etes Ici, Amsterdam)

> Whether they are German or not makes no difference to me. I am just interested in their artistic position and artistic concept.
> (Buchmann Galerie, Berlin)

> My roster is a programmatic roster, so if an artist fits into the family, nationality does not matter.
> (Art Affairs, Amsterdam)

Nationality is not considered a legitimate criterion because it would conflict with the rules of the field of cultural production. As the French sociologist Pierre Bourdieu has argued in detail, one of the main rules of art is that economic interests should be denied. In order to accumulate symbolic capital, one needs to pretend that artistic values are the only ones that count. Embracing the idea of the 'global', and showing their willingness to represent any artist regardless of nationality, provides art dealers with a means of accumulating symbolic capital (Bourdieu, 1993). By contrast, nationality is perceived as a marketing tool, which means that art dealers regard it as overtly commercial and therefore something to distance themselves from.

The question of whether the quality they were looking for could be found in all regions of the world, not only those close to home, was answered affirmatively by most respondents. Stylistic peculiarities, artistic traditions or references to local contexts which might not be appreciated by an audience in Amsterdam or Berlin, hardly existed, these dealers maintained. They emphasised that a global ecumene was coming into being (Hannerz, 1995): artists from all over the world are studying and further expanding on similar artistic traditions such as modernism. Moreover, the dealers insisted that 'their' artists' identities were post-national and deterritorialised, since their outlook on the world and artistic repertoire were shaped by a single global body of high and low

culture. As one of them, a Dutch-born art dealer who had had her training in France before moving to Germany in the late 1980s, put it:

> One of the great things about the art world is that no matter where you go to, you find people speaking the same language, in a metaphorical way. (. . .) It can be spoken in Guangzhou as well as in Rio or Berlin. (. . .) If you go to China, you are not saying, 'oh, but this artist needs to be painting in the old traditional Chinese way'. These people understand perfectly all the semantics of what makes contemporary art interesting and readable. (. . .) The development of this language has certainly to do with a media language which is completely global, and with the fact that we are all working in the same kinds of systems which are media and digitally based. We all see the same films, we listen to the same music.
> (Esther Schipper, Berlin)

The structure of the field of cultural production encourages dealers to be indifferent to the nationality of artists and to develop an international orientation. Art dealers claim that having an international programme is not only necessary to live up to their own artistic standards, it is also what their peers expect. It has a signalling function to other actors in the field. As *The Economist* put it in a recent article on the art market: ' "local artist" has become a synonym for insignificant artist and "national" damns with faint praise. "International" is now a selling point in itself.'[3] A global orientation is perceived as a source of prestige, which may facilitate sales to collectors, attract attention from public art institutions and help in persuading upcoming artists to move to the gallery.

Risks of the contemporary art fair

In spite of this *discursive* embracement of globalisation, art dealers turned out to be more ambiguous when it came to the two organisations that have become the main symbols of the globalisation of the contemporary art market since the 1990s: the art fair and the Internet. While both have introduced a significant set of new opportunities related to spotting new talent and getting access to a new clientele, they have also introduced new risks.

The first art fair was established in Cologne in 1967 in order to reinvigorate the German art market and as a response to the growing dominance of American art (Mehring, 2008). The basic format of the fair has not changed since then, and resembles the format of the general trade fair. In fact, the two founders of Art Cologne, the gallerists Rudolf Zwirner and Hein Stünke, acknowledge that they copied the fair's design from the antique book fair (Mehring, 2008): every year the fair brings together a large number of galleries, nowadays between 100 and 300 (Quemin, 2008). Each gallery rents a booth at the fair, where it usually mounts group shows of the best known of its artists.

For many years, fairs were few and far between (Art Basel was established three years after Art Cologne). They did not attract large crowds nor garner much attention, and predominantly catered to the demands of already established collectors. From the 1990s onwards, however, art fairs became the key exhibition and sales venues of the contemporary art market, attracting both important collectors and curators and contributing to the setting of new trends within the market. Many new fairs were established, including the Armory Show in New York (1999) and Frieze in London (2002), and these are now, after Art Basel and Art Basel Miami Beach, considered the world's main fairs. Emerging markets, for instance in Shanghai, Beijing, New Delhi, São Paolo and Moscow, have been quick to set up art fairs of their own. Art fairs can therefore be seen as the main engine of the global art market.

Over the past 20 years, dealers have become keener on participating in fairs, and have started seeing them as an opportunity to expand their client list and to add new artists to their roster. According to some estimates established dealers now generate more than half of their annual revenues at these fairs, but they have to pay for the privilege: exhibitors' fees may run up to $40,000 for a 100m^2 booth at a fair which generally lasts five or six days (Thompson, 2008: 188–189). The winner-take-all models so prevalent in the cultural industries can also be seen operating at the fairs: attending them poses significant risks for less established art dealers since it is very hard to predict if (and how much) revenue will be generated. In fact, in my interviews many respondents complained that they were frequently not able to sell enough art to cover their costs. They nevertheless continue to go to the fairs in order to be seen and to maintain their reputation.

Within a relatively short time frame, then, art fairs have transformed from inward-looking occasions into outward-facing social events.[4] They have started attracting larger visitor numbers, including celebrities from the movie and pop industries, Russian oligarchs as well as super-rich sheiks from the Middle East. Art dealer Jay Jopling of London's White Cube is rumoured to have spent £50,000 on champagne alone at one art fair party he threw.[5] As a result of the fairs, the market is increasingly turned into a festival, which draws large crowds of people who may not have the money or the insider information to make smart acquisitions, but who nevertheless enjoy the spectacle. With programmes chock-full of lectures, artistic acts, guided tours and cafeterias, the fairs have turned the art market into what Pine and Gilmore termed 'the experience economy' (Pine and Gilmore, 1999).

The design of the fairs is highly meaningful. With their white booths, the frequent absence of price tags next to the works on display or other commercial apparatuses such as cash registers or credit card machines, the art fair follows the symbolic layout of the gallery space (see Velthuis, 2005). This is a space which reflects the dual logic of the art market, where overtly commercial business practices, as many studies have shown, are considered illegitimate (see e.g. Horowitz, 2011; Coslor, 2010).

The fair can moreover be interpreted as a social space, which has proven its usefulness in marking a macro-level boundary *between* the contemporary art world and the remainder of society: the most prestigious fairs such as Art Basel, Art Basel Miami Beach or TEFAF, Maastricht render the global economic and cultural elite, who convene in their private jets on which the popular media eagerly report, temporarily visible. Thus the social status of this superclass is reconfirmed. On a micro-level, art fairs have developed a fine-grained apparatus to establish social hierarchies *within* the art world (Moeran and Strandgaard Pedersen, 2009; for a vivid description, see Thornton, 2008): the VIP openings and pre-VIP openings to the fair, the many after-parties, dinners or access to the houses of art collectors who live in the vicinity of the fair all present opportunities for inclusion and distinction. They come with gossip, anger for those who fail to get access or desperate attempts to make their way into these social events. Some collectors

leave directly after the VIP opening in order to avoid having to mingle with the crowd.[6]

But in spite of the commercial, social and reputational importance of the art fair for contemporary galleries, my respondents were highly critical of the institution and emphasised its risks as well. One established Berlin dealer argued:

> I do not like fairs. I do fairs because I have to. And I have to because you make a very high percentage of your turnover at the fairs. Over the past five years, the fairs turned into something really gross. (. . .) Overnight Frieze [one of the main contemporary art fairs which takes place in London] was about making money, attracting more people and catering to the interests of the wealthy, really well-known galleries, rather than looking at the next generation. Plus Frieze is about seeing celebrities. I love seeing celebrities, but you don't do an art fair for that. It's not that satisfying after the first time. (Klosterfelde, Berlin)

Others classified fairs as 'the wrong direction' for the art market, leading to a 'very unconcentrated' atmosphere within the art world, and even to a specific genre of commercial art:

> a lot of pieces were created for art fairs . . . 'I need a piece, make me one for the art fair', and then you get one. The whole idea is wrong.

Even an art dealer who had been in the highly prestigious selection committee of Art Basel, widely considered as the world's most important art fair, had her doubts. Because of the prestige of the fair, the large numbers of dealers who apply but are turned down and the strong reputational effects of being accepted as an exhibitor at Art Basel, the members of the selection committee are considered one of the art market's most important gatekeepers. Nevertheless, this art dealer argued:

> I think that art fairs are very important but we must not forget that the gallery work is even more important. A frame that an art fair can give you can be as professional and pristine and well thought through as the services offered by Art Basel, but still it is a venue open for just six days. It is not at all the same thing as an exhibition. For me, defending a generation of artists for whom

the exhibition is one of the main media, an art fair is a contradiction in itself because you can never show a work in the same kind of contexts as we do in an exhibition.

Or, as Barbara Gladstone, an established New York art dealer specialising in hard-to-commodify art such as video, puts it: 'You feel like a prostitute in Amsterdam. The space is too small and you have no privacy whatsoever' (Thornton, 2008: 109).

Apart from the risk of not being able to gain access to the most prestigious fairs or the financial losses which participation in a fair entails, galleries claimed that they risk alienating part of their customer base who themselves increasingly suffer from 'art fair fatigue', and worry about the quality of art presented at fairs (pejoratively referred to as eye-catching and easy to sell 'art fair art'). Moreover, fairs would have a negative impact on the art market's culture, which would in their eyes become too commercial.

New fairs in emerging markets were considered especially problematic. The dealers complained about problems with customs departments, which in China needed to be bribed to get the art works released at the border. They also argued that the quality of the other exhibitors would be hard to predict; one could find oneself amidst an art crowd that might at best not be in line with the gallery's reputation, or, worse, damage that reputation. Furthermore, they complained that it would be difficult to establish relationships with local collectors in that context or that, in China and the Middle East, they would not always be able to show politically controversial works or paintings depicting nudity because of censorship by local governments. Dealers were therefore very hesitant to go to fairs outside of Europe or the US, and often would not return after an unsuccessful experience. One of the directors of Contemporary Fine Arts, which since its founding in 1992 quickly became one of Berlin's most successful contemporary art galleries, expressed his scepticism as follows:

> We have this fair now in Dubai, and of course there is a lot of money there, but they have no idea how to look at these things. At these fairs there is even censorship. We could not show a painting like this by Baselitz [points at a large oil painting of a naked woman which is hanging behind him in the office space]. They

have some rules. There are certain people who might have money and who are well educated and know something about the Western culture. They might like Warhol and some other blue-chip artists. But they buy these things more for decoration.

The art dealers did not consider themselves passive victims of the growing dominance of art fairs, however, and actively responded to the risk they pose to their operations. In 2005, in a rare moment of success-ful co-operation, 30 to 40 of the most important Berlin art galleries organised a 'gallery weekend' in order to lure collectors away from the fair and back to their permanent spaces. The gallery weekend is now an annual event. Galleries tend to plan openings of exhibitions of their main artists on Friday evenings and even stay open on Sunday and Monday; to make the city even more attractive for art collectors from out of town, all kinds of art events take place in non-profit venues. In my interviews, the gallery weekend was invariably raised as a successful response to art fairs. As one of them put it:

> It was two things coming together at the same time. Collectors were extremely tired of going from one art fair to the other; art fairs are not always the best context to see art. Then we really felt at some point that there was some contradiction in the fact that we all have these beautiful spaces here in Berlin and having so many primary galleries here, galleries working intensely with the artists, and being the home of most of these artists, yet not having the audience (. . .) So it was also a way to say: this is where the work is, this is the place you have to go to if you really want to know more about what we are doing. (. . .) That's why we started the gallery weekend, there is no better place to see art than in properly installed exhibitions by profes-sionals and the artist.

My interpretation of this resistance against the fair is not only that it poses risks to the traditional, institutionalised gallery model; art dealers also associate global market practices with a commercial ethic. The fairs (as well as the Internet, which will be discussed below) are the venues of collectors who possess, on average, more economic than cultural capital. As a rich tradition of sociological studies of art markets has shown, such a commercial ethic is considered illegitimate (Velthuis, 2005; Plattner,

1996; Moulin, 1967 [1987]). Instead, commerce, as Bourdieu put it, needs to be negated in the field of cultural production (Bourdieu, 1993). The fair, by contrast, emphasises by its very nature the commercial side of the gallery. It strips art dealers of the instruments which enable them to frame their business as non-commercial and focused squarely on the promotion of artistic values. For that very reason, artists by and large seem to avoid the fair. As Sarah Thornton states in her recent popular monograph on the art world: 'For an artist seeing what goes on at an art fair is like witnessing your parents having sex: You know it happens but you just don't want to see it!' (Thornton, 2008).

In short, from the dealer's perspective art fairs offer many opportunities, but they also risk reducing the status of artworks into mere commodities. Moreover, the fair could negatively affect the dealer's own symbolic capital (too commercial or bowing for political pressures), which, Bourdieu argues, has repercussions for their economic capital as well.

Selling from JPEGs

The other symbol of a globalised art marketplace is the Internet. Like the fairs, the Internet has contributed to what art dealers and collectors themselves have called a revolution within the art, antiques and collectibles market. Data providers on auction prices for art such as Artprice and Artnet, as well those offering information on career patterns of contemporary artists such as ArtFacts.Net, have provided increased transparency to a world that is notorious for its opaque, secret character (for more on the art market's increased transparency, see Velthuis and Coslor, 2012). In turn, this increased transparency resulted in a new online market for contemporary art where artworks could, in principle at least, be bought without any physical contact between the buyer and the dealer. Establishing this online market has not been easy, however. In 2003, for example, Sotheby's had to close down its online auction site, which was hosted by eBay, because of lack of collector interest. In 2000, Artnet decided to concentrate on its role as an information provider when its own foray into online auctions failed.[7] However, more recently the online market seems to have been taking off.

In my interviews, established art galleries emphasised that the Internet had become important for marketing art. It provided them with new opportunities to sell to hitherto unknown customers without having to engage in time-consuming and costly customer relations management. The Internet also enabled them to expand their customer base geographically in a significant way. Referring to the boom in the market in the mid-2000s, they noted:

> It is so usual now, all this sending around of JPEGS, we also have people writing to us, even anonymously, asking whether this or that they have seen on Artnet is available.
> (Galerie Barbara Weiss, Berlin)

> During the big frenzy time of 2006 and 2007, JPEG selling through the website was suddenly much more important . . . that was almost [sufficient for the gallery to survive on] (Esther Schipper, Berlin)

Online transactions of this type would mainly focus on expensive works of art made by artists with an established reputation. The artistic and economic value of these works, was in other words, at least to some extent established (see e.g. Moulin, 1994; Beckert and Rössel, 2004). The artists may have exhibited in museums and their work may regularly be sold at auction, which functions, as one art dealer put it, as a 'barometer of value'. Others referred to this class of art as 'blue-chip'. During the interviews they said that they frequently sold these works after having emailed a JPEG to an anonymous buyer. The buyers could risk spending four or five-figure sums on pieces they had never seen in person since they had a good idea of what the piece would be like and what its value is. As the co-owner of Berlin's most established art gallery put it:

> People who know an artist and have seen some works in the flesh . . . they felt that they are able to decide from a JPEG. It hardly ever happens when they have never seen a work by that artist in the flesh. Then they are more suspicious and want to get a better sense of how he, for instance, is using the colours. (Contemporary Fine Arts, Berlin)[8]

But just as the art fair cannot be seen as an instance of the art market's straightforward deterritoralisation, neither can the Internet. Instead,

this online traffic has been made possible by, and further stimulated, the development of galleries' websites and the homepages they have at Artnet, long considered to be the main website for commerce in consecrated contemporary art (Bourdieu, 1993). These virtual spaces are, like the art fair and the gallery space itself, highly symbolic. Their minimalist design signals to the audience that these are not commercial but predominantly artistic sites. The message seems to be that no contextual noise, and certainly no commercial information such as prices, are allowed to interfere with the aesthetic experience. Also, some galleries have constructed their websites as social spaces, creating a division between a public part of the site, which can be viewed by anybody surfing the Web, and a private section for which a password is needed. Only collectors who are known to the gallery are provided with such a password. It gives them access to more sensitive information such as the price of the work, and may also allow them to see works of art which have been pre-selected by the dealer specifically for them.

In spite of the fact that art dealers engage in this practice of selling through JPEGs, if only for the lower costs and high profits that these sales can generate, they had mixed feelings about the practice. One of them stressed that she felt uncomfortable about buyers approaching her anonymously about works of art she offers for sale on Artnet.com.

> I don't like it. Mostly it is very weird. You never know what the people are like. And then if you ask who those people are, they respond: 'well, you should not be on Artnet if you don't want to have this.
> (Galerie Barbara Weiss, Berlin)

While neoclassical economists tend to assume (either implicitly or explicitly) that market exchange takes place on an anonymous basis (cf. Hirschman, 1982 [1986]; Hodgson, 1988; Etzioni, 1988), this dealer instead insisted on getting to know the people she did business with, even when the business channel – the Internet – did not require such relationships to be in place. This concern about the identity of the buyer is linked to risks which the Internet poses for the dealer's own identity. They do not see themselves predominantly as salespeople, but as temporary custodians of art. This means that they should take care of the artworks not only at the moment they are exhibited in the gallery,

but also after they have left the gallery and their future 'biography' evolves (cf. Kopytoff, 1986). The dealers say they feel responsible for who owns the work and how they treat it, as if, as one of them put it, 'you are putting your child in somebody else's hands'.

Internet sales, in other words, pose the risk of not only devaluing the work of art itself by eroding its aura of a unique, artistically valuable good and turning it into a 'plain vanilla' commodity, but also may undermine the very role dealers play in marketing a work of art, establishing its economic value and controlling its future biography.

The post-hoc resistance against 'selling through JPEGs' is intricately related to a wider resistance against an era within the art market which has recently ended. Looking back at the decade of the 2000s, art dealers characterised this era by steeply rising prices for contemporary art, the increasing encroachment of auction houses, the influx of new money from consumers such as hedge-fund managers and emerging market billionaires, the desire of celebrities to affiliate themselves with the art market and the rise of superstar artists such as Damien Hirst. The dominance of the art fair and anonymous Internet sales exemplified this – in the dealers' eyes – overtly commercial, superstar era (see Velthuis, 2005 for another, highly comparable superstar era in the art market: the 1980s). When this decade came to an end because of the financial crisis – with Hirst's successful sale at Sotheby's of large chunks of his own inventory as the *finale* on the same day that Lehman Brothers filed for bankruptcy in September 2008 – these practices waned as well:

> Now that the market has slowed down, it is nearly impossible to sell through email. People don't feel as attracted as when they stand in front of a painting. (Contemporary Fine Arts, Berlin)

> Times are now back again to a lot of talking and thinking and getting back [to the gallery]. People are not saying: 'Oh, I take this [work of art], and just put that [piece] on top.'
> (Esther Schipper, Berlin)

Remarkably, the art dealers claimed that they hardly regretted the end of this era and its concomitant commercial practices. Of course they suffered from the loss of revenue (the interviews were conducted in

2009, so the art market had not yet witnessed its subsequent strong recovery), and sometimes even had to lay off one or two of their small group of employees. But they saw the end of the era as a 'purification', as one of them put it (see Velthuis, 2013b for a more developed treatment of this issue). It meant that people who (according to them) would not accept the proper role definitions of artists, dealers and collectors, and who they considered too commercial, left the industry. It also meant they could concentrate their own efforts again on the space which enabled them to fulfill their own role at best: their gallery space, which they meaningfully tended to refer to as their 'home base'.

For them, the gallery space is and was the locus where social ties between artists, dealers and collectors are forged and gift relationships are enacted. Art dealers see it as their role to create a community of critics, collectors, fellow artists and other members of the art world around the artists they represent. In order to do so, every exhibition starts with an opening party, where among others artists and collectors affiliated with the gallery and gatekeepers within the art world are invited. A Berlin dealer explains the importance of these openings:

> Also with the artists not living close by, I try to get them in the gallery as often as possible. We do openings, and to have your own artists here is just an advantage in terms of communication, between the artist and the press, curators, collectors. For instance we will soon have the opening of Joel Steinberg [an American photographer who became established in the 1990s] and he will be here. (. . .) It is Joel's night, but also for the other artists and for the gallery, it is important to have them here, because there is communication about the work and among the artists. This is what brings about unification.
> (Buchmann Galerie, Berlin)

These opening parties are not the only occasions for meetings, however. Artists may drop by occasionally in the gallery space to chat with the dealer, while collectors who 'follow' the gallery may return after the opening (or, if they are seriously interested in buying a work which is in high demand, before the opening) in order to look at the exhibition more quietly, and have the dealer talk about the work's meanings. Indeed, as noted above, many art dealers understand their own identity

more as curators of exhibitions and educators of the public and promoters of artists than as salespeople.

Such face-to-face interaction in the gallery space – or, in the case of the artist, in his own studio – is important for several reasons. First, the gallery's survival may depend on these interactions. While established galleries, representing artists with an international reputation and charging four- or five-digit prices for their works, can afford to have several (or in rare cases, dozens of) employees, easy access to financing in order to buy works for inventory, and a cash flow that is stable and large enough to pay for various professional services, the financial challenges for start-ups are steep, so much so that artists need to provide practical services to safeguard the survival of the new businesses. During one of the interviews I conducted, for instance, which took place in a new space a gallery was about to relocate to, two artists were painting the walls. My respondent, like other dealers, emphasised that his gallery was a 'communal enterprise' in which 'every helping hand' is welcome (Velthuis 2013a).

Second, for collectors, it is these very interactions and the social circuits they are part of that provide an added value to acquiring art. As cultural economist Michael Hutter put it, acquiring art from a gallery 'is an act that not only confers the property rights on an object, but also grants access to a club distinguished by a specific aesthetic quality' (Hutter *et al.*, 2007). One of the main ways of creating these communities or clubs is organising social events, such as visits to the artist's studio or dinners to which artists and collectors of the gallery are invited. One dealer said:

> Ideally, I imagine some kind of situation where the gallery is really some kind of mediator between the artist and the collectors, who are sitting at the same table and having a good time talking about art and getting further with their own ideas about art and their own life.

Third, the relationships fostered in the gallery space have a functional character: although standard, legally binding contracts exist for consignment relationships, they are often conducted without them (see e.g. Plattner, 1996; Bonus and Ronte, 1997; Moulin, 1967 [1987]). Alternatively, dealers often try to engage in long-term, trust relationship with their artists, which serve as an alternative for imperfect

contractual relationships (Caves, 2000). In turn, to establish these trust relationships, meeting frequently in the gallery space as well as the artist's studio is crucial (cf. Storper and Venables, 2004: 356).

Finally, these meetings, wherever they happen, also help improve communication between parties. For instance, at some point, the dealer may want to persuade the artist to make subtle changes in his output, whether in terms of style, material, subject matter or number of works produced. Given the high value placed within the art world on the artist's autonomy and the sensitive nature of outside influences on his output (see e.g. Velthuis, 2005), such changes can more easily be communicated face to face.

The importance of the gallery space may differ between various circuits within the art market. For example, a small group of established, 'consecrated' art dealers – including the Gagosian Gallery or David Zwirner in New York, White Cube in London, Contemporary Fine Arts in Berlin or Hauser and Wirth in Zurich – has developed a global network of collectors and curators. They meet these collectors and curators at various international venues such as the fairs and the biennials and transact with them through the Internet. For actual sales, the gallery space is probably not all that important in these cases. But these sales would not be possible without the symbolic capital they have managed to accumulate over the years. This reputation can, in turn, be partly ascribed to their large, pristine, museum-like spaces, which have a public role in the art scenes in which the galleries are embedded: the exhibitions may have a museum-like quality, are widely written about, and frequented by many visitors who may not have the slightest intention of acquiring an artwork, nor the means to do so.

For the vast majority of the galleries, who lack such global networks, well-heeled clientele and abundant financial backing, the gallery space has the more (seemingly) mundane function of hosting daily interactions between artists, collectors and their intermediaries. However, it is in this space that the identities of these participants in the industry are reconfirmed, role models are created and the rituals of the market become visible.

Conclusions

The art market is another instance where globalisation does not result in what has been called 'deterritorialisation' or a waning importance of physical distance. Instead globalisation here leads to an emphasis on local ties and a re-evaluation of physical distance (see e.g. Cox, 1997; Sassen, 2000; Storper and Venables, 2004; Faulconbridge *et al.*, 2007). This serves as a contrast with media representations of art markets in the last decade: the topoi of multimillion dollar works of art created by Chinese and Indian artists, newly rich collectors from Russia snapping up pieces at auction and established Western art institutions such as the Guggenheim Museum and the Louvre expanding into the (culturally) virgin territories of the Middle East.

My findings also contrast with the ideology of the 'global' which Western art dealers and other actors in the contemporary art world have long embraced. My respondents in Amsterdam and Berlin, for instance, invariably claim to disregard nationality and to focus on quality exclusively when selecting the artists they represent. From a Bourdieu-ian perspective, this shared ideology is hardly surprising: the 'global' – equated here with selecting art on the basis of quality exclusively – can be understood as an opportunity for players within the art world to deny the economy, to express their distance from branding art based on nationality, and by doing so, to accumulate symbolic capital.

This article does not deny that globalisation has provided many new opportunities for marketing contemporary art, and may contribute to a democratisation of the art market, in which access to art is no longer restricted to those who have accumulated the right type and amount of symbolic capital (Bourdieu, 1993). But what has been absent in current discussions of globalisation in the art market is an examination of the many different types of risk which it simultaneously poses: the traditional gallery model has, since its emergence in late 19th-century France, been able to establish and stabilise the economic value of art in an era in which artistic values and artistic canons have become increasingly instable. To make that model work, close social relationships between dealer, artist and collector were essential. What this article has sought to demonstrate is that the global market and its key institutions

(the art fair, the Internet and the auctions) may not lead to deterritorialisation, but to a less personalised market in which the aura of art will increasingly be under pressure. While the outcome of globalisation of art markets is hard to predict, we can already see that there will be winners and losers. Traditional galleries, with their dense social interactions, intricate 'rituals' and their symbolically charged business practices, may belong to the latter category.

References

Appadurai, A. (1996) *Modernity at Large*. Minneapolis, MN: University of Minnesota Press.

Artprice (2008) *The Contemporary Art Market. The Artprice Annual Report.* Paris, Artprice.

Beckert, J. and Rössel, J. (2004) 'Kunst und Preise. Reputation als Mechanismus der Reduktion von Ungewissheit am Kunstmarkt.' *Köllner Zeitschrift für Soziologie und Sozialpsychologie,* 56(1): 32–50.

Bourdieu, P. (1993) *The Field of Cultural Production: Essays on Art and Literature.* Cambridge: Polity Press.

Caves, R. (2000) *The Creative Industries.* Cambridge, MA: Harvard University Press.

Clark, G.L. and O'Connor, K. (1997) 'The informational content of financial products and the spatial structure of the global finance industry.' In K.R. Cox (ed.) *Spaces of Globalization: Reasserting The Power of the Local.* New York: Guilford Press.

Coslor, E. (2010) 'Hostile worlds and questionable speculation: Recognizing the plurality of views about art and the market.' *Research in Economic Anthropology,* 30: 209–224.

Cox, K.R. (ed.) (1997) *Spaces of Globalization. Reasserting The Power of the Global.* New York: Guilford Press.

Etzioni, A. (1988) *The Moral Dimension. Towards A New Economics.* New York: Free Press.

Faulconbridge, J., Engelen, E., Hoyler, M. and Beaverstock, J. (2007) 'Analysing the changing landscape of European financial centres: The role of financial products and the case of Amsterdam.' *Growth and Change*, 38(2): 279–303.

Held, D. and McGrew, A. (2003) 'The Great Globalization Debate. An Introduction.' In D. Held and A. Mcgrew (eds) *The Global Transformations Reader*. Cambridge: Polity Press, pp.1–50.

Hirschman, A.O. (1982 [1986]) 'Rival views of market society.' In *Rival Views of Market Society and Other Recent Essays*. Cambridge, MA: Harvard University Press, pp.105–141.

Hodgson, G.M. (1988) *Economics and Institutions. A Manifesto for a Modern Institutional Economics*. Cambridge: Polity Press.

Horowitz, N. (2011) *Art of the Deal. Contemporary Art in a Global Financial Market*. Princeton, NJ: Princeton University Press.

Hutter, M., Knebel, C., Pietzner, G. and Schäfer, M. (2007) 'Two games in town: a comparison of dealer and auction prices in contemporary visual arts markets.' *Journal of Cultural Economics*, 31(4): 247–261.

Kopytoff, I. (1986) 'The cultural biography of things: Commoditization as process.' In A. Appadurai (ed.) *The Social Life of Things. Commodities In Cultural Perspective*. [1990 ed.] Cambridge: Cambridge University Press, pp.64–91.

Lechner, F.J. and Boli, J. (2008) 'General introduction.' In F.J. Lechner and J. Boli (eds) *The Globalization Reader*. 3rd ed. Oxford: Blackwell, pp.2–5.

McAndrew, C. (2008) *The International Art Market. A Survey of Europe in a Global Context*. Helvoirt: The European Fine Art Foundation.

Mehring, C. (2008) 'Emerging market. On the birth of the contemporary art fair.' *Artforum*, April: 322–328, 390.

Moeran, B. and Strandgaard Pedersen, J. (2009) 'Fairs and festivals: Negotiating values in the creative industries.' *Creative Encounters Working Paper*. Copenhagen, Copenhagen Business School.

Moulin, R. (1967 [1987]) *The French Art Market. A Sociological View*. New Brunswick, NJ: Rutgers University Press.

Moulin, R. (1994) 'The construction of art values.' *International Sociology*, 9(1): 5–12.

Pine, J. and Gilmore, J. (1999) *The Experience Economy*. Cambridge, MA: Harvard Business School Press.

Plattner, S. (1996) *High Art Down Home: An Economic Ethnography of a Local Art Market*. Chicago: Chicago University Press.

Quemin, A. (2008) 'International contemporary art fairs and galleries: An exclusive overview.' *The Contemporary Art Market. Annual Report*. Paris: Artprice.

Sassen, S. (2000) 'The Global City: Strategic Site/New Frontier.' *American Studies*, 41(2)3: 79–95.

Storper, M. and Venables, A.J. (2004) 'Buzz: Face-to-face contact and the urban economy.' *Journal of Economic Geography*, 4(4): 351–370.

Thornton, S. (2008) *Seven Days in the Art World*. New York: Norton.

Velthuis, O. (2005) *Talking Prices: Symbolic Meanings of Prices on the Market for Contemporary Art*. Princeton, NJ: Princeton University Press.

Velthuis, O. (2013a) 'Globalization of markets for contemporary art: Why local ties remain dominant in Amsterdam and Berlin.' *European Societies*, 15(2): 290–308.

Velthuis, O. (2013b) 'Markets.' In A. Dumbadze and S. Hudson (eds) *Contemporary Art: Themes and Histories, 1989 to the Present*. Chichester: Wiley-Blackwell, pp.369–378.

Velthuis, O. and Coslor, E. (2012) 'Financialization of art markets.' In K. Knorr Cetina and A. Preda (eds) *The Oxford Handbook of the Sociology of Finance*. Oxford: Oxford University Press, pp.471–487.

1 Some sections of this article were adapted from Velthuis (2005) and Velthuis (2013a). The major part of the data was collected while the author was a Visiting Scholar at the Wissenschaftszentrum Berlin. The support of WZB and in particular of Michael Hütter, director of the research group on Cultural Sources of Newness, are gratefully acknowledged. Thanks to Anna Dempster, Jérôme Bourdieu Marie-France Garcia-Parpet and to participants in the seminar on *market places* at the École des Hautes Études en Sciences Sociales (Paris, 2010) for useful comments. This work is part of the research project 'The

Globalization of High Culture', which is financed by a VIDI-grant of the Netherlands Organisation for Scientific Research (NWO).

2 In the Netherlands, interviews were conducted by MA student Janus de Visser, for which he is gratefully thanked.

3 'Global frameworks; contemporary art', *The Economist*, 26.6.2010.

4 Art writer Anthony Haden-Guest locates the moment of transformation in 1994, at the Gramercy, a new fair at New York's Gramercy Park Hotel, where parties were organised in order to attract collectors. See Anthony Haden-Guest, 'Art House Blues', *Weekend Australian*, 5.10.2008.

5 Aida Edemariam, 'All the fun of the fair', *The Guardian*, 3.10.2009.

6 See also: Julia Chaplin, 'Pre-Partying with the Jet Set of the Art World', *The New York Times*, 8.6.2008; Emilyn Ang, 'Art fairs – a high-wire act?', *The Business Times Singapore*, 10.10.2008; Anthony Haden-Guest, 'Art House Blues', *Weekend Australian*, 5.10.2008; 'Global frameworks; Contemporary art', *The Economist*, 26.6.2010; Lisa Orkin Emmanuel, 'Art Basel Miami Beach galleries expect collectors', *Associated Press*, 1.12.2009.

7 See Sara Silver, 'Online art information company stands out after industry shakeout', *Associated Press*, 30.8.2001.

8 This division between types of interaction related to evaluating the quality of the works of art and gathering knowledge about them is akin to financial markets, where geographers have made a distinction between the trade in transparent assets such as 'blue-chip' stocks, which can take place anywhere, and opaque assets such as private equity stakes, where proximity and strong relationships between trading partners are needed (Clark and O'Connor, 1997; Faulconbridge *et al.*, 2007: 286–287).

Negotiating authenticity: Contrasting value systems and associated risk in the global art market

Tom Flynn

It is now widely acknowledged that the steady globalisation of the art market in recent decades has brought new risks into art business. Due to the ever-rising prices for 'investable' art, the discussion of risk in the art market tends to be confined to its implications for investors and wealth managers. Philip Hoffman, Chief Executive of the Fine Art Fund Group, one of the world's leading fine art investment vehicles, defines 'investable' art as works that are 'rare and in diminishing supply' and estimates the annual value of investable art to be worth $10 billion annually (within an overall market estimated at $30–50 billion).[1] Interest in this 'investable' sector has given rise to a burgeoning conference circuit where delegates convene to pore over portfolio diversification techniques and other strategies for minimising or eliminating downside risk in art investment. The growth of this approach to risk assessment can be seen in the context of the recent crisis in international banking and the unprecedented wealth generation that continues apace as ever more high-net-worth individuals seek safe alternative stores of value for surplus capital.[2] Meanwhile, somewhat overlooked are the risks to which artists are exposed within an increasingly globalised art market.

One of the more notable aspects of contemporary art in recent decades has been the role played by professional 'fabricators' of one kind or another, those who construct or manufacture art objects on behalf of artists. These manufacturing operations – which have come to the fore

as the importance of individual creativity has been steadily downgraded by an uncritical market – often take place at some remove from the hand of the artist who conceived the idea. As I go on to explain below, that distance between the artist/conceiver and the finished object can present opportunities for others to fabricate replicas since the 'original' object being copied often bears little or no trace of individual authorship, its commercial value now deriving more from the 'brand name' of the artist whose name is attached to it than from some trace of 'craft-authorship', so to speak.

This chapter momentarily shifts the focus away from the ostensible financial concerns associated with portfolio management and structured investment vehicles to look more closely at the position of the artist in the global art market. The chapter uses a recent case study to explore contrasting cultural attitudes towards concepts of authenticity and originality that are bringing new risks to the art market and exposing unforeseen vulnerabilities in the moral rights of the artist. Here we might acknowledge the difference between risk and uncertainty, one defining characteristic of the former being that it can be measured (Fischoff and Kadvany, 2011: 10; Knight, 1921). The extent to which the moral rights of the artist can be measured in quantitative terms is obviously at the heart of how those rights might be assessed when the need arises and, to some extent, conditions cultural attitudes towards them.

One of the most noticeable consequences of the wealth generated by the rapidly developing nations of Brazil, Russia, India, China and the Gulf States has been the creeping 'financialisation' of the art market. As a consequence, many of the market's traditional trading patterns and behaviours are now giving way to sophisticated new forms of investment and speculation and to exotic financial arrangements that many believe militate against the notional transparency brought about through digital information and communication technologies. The complexities of today's high-end fine-art auctions in which third-party investors are invited to participate in secretive guarantees and 'irrevocable bids' to control outcomes and limit auction house risk is just one example of the diverse processes of 'financialisation' that are fast becoming commonplace in the art market. As the 'wealth gap' between so-called 'ultra-high-net-worth individuals' (UHNWIs) — 'those having

investable assets of $30 million or more, excluding primary residence, collectibles, consumables, and consumer durables' – and everyone else grows ever wider,[3] so art is inexorably being subsumed into the rarefied networks of global banking and high finance. Thus sculptures, paintings and decorative objects are now commonly referred to as 'alternative assets', their new economic importance in such matters as portfolio allocation tending to obscure aesthetic considerations which, by contrast, are increasingly presented as facile and irrelevant. The steady marginalisation of art criticism can also be seen as a by-product of this shift in emphasis away from aesthetic considerations towards economic imperatives. Not for nothing is that tension now described in terms of a clash of two 'hostile worlds' (Velthuis, 2007).

One of the most notable aspects of the recent shift in the axis of the international art market from West to East, so to speak, has been the exponential rise in prices for imperial Chinese works of art. As recently as 10 or 15 years ago, it would have been relatively unusual to attend a provincial antiques auction in the UK to find Asian buyers in attendance, even if the auction in question included many lots of Chinese jade or porcelain. Such objects would have been contested by predominantly British or Continental European bidders before being sold on to dealers or collectors higher up the art market 'food chain', be they other Europeans, North Americans or indeed Asian buyers resident in Hong Kong or mainland China. Today, however, even a relatively small provincial saleroom located deep in the English countryside is likely to have a room full of Asian dealers in attendance whenever imperial objects of any quality are up for sale in any number. This is in part due to the impact of the Internet, but it is also a direct consequence of the wealth generated in mainland China as increasing numbers of newly minted millionaires compete to collect examples of their ancient cultural patrimony.

The desire to repatriate objects from European collections is lent added impetus by the knowledge that a significant number of Chinese imperial treasures were looted by the European powers during the age of empire. Thus some Chinese buyers see their activities as both a personal quest to enhance their own collections and a symbolic redressing of a historical wrong. The most extreme instances of this particular motivation have been the occasions when Chinese buyers have bid for imperial

works of art at European auctions but then refused to pay for them. The signal instance of this was the controversy arising from the sale at Christie's in Paris in 2009 of two bronze sculptures of a rat and rabbit that had been looted from the Summer Palace in Beijing during the Anglo–French invasion of the 1860s. When they appeared at the sale of the Yves St Laurent/Pierre Bergé collection, a bid for both items was made up to a total of €31.4 million by Cai Mingchao, director of the Xiamen Harmony Art International Auction Company and a Chinese government adviser, who afterwards refused to pay. This was followed by another case in December 2010 when a Chinese bidder attended a sale at Bainbridge's West London auction rooms and offered the unprecedented sum of £51.6 million ($83 million) for a Chinese Qing Dynasty porcelain vase. The bidder was believed to have been acting on behalf of a Beijing-based collector, who also refused to pay. The vase was re-sold in 2013 by London auction house Bonhams to an anonymous collector in a private treaty sale. The unspecified sum was believed to be less than half Bainbridge's original price.[4]

The failure on the part of Asian buyers to pay for works 'bought' at auctions has become a critical issue for European auction houses, prompting some salerooms into requesting deposits from bidders prior to accepting bids. However, non-payment for high-value lots has also become so widespread in China itself that one can no longer reasonably attribute the problem to ideological issues over the imperial past. Instead, the issue may be characteristic of a Chinese market growing too fast for its own good and which, in its unregulated state, is vulnerable to manipulation and exploitation by opportunists.

As recent sale reports have indicated, one immediate impact of the new involvement of Asian buyers at European auctions has been an exponential rise in prices for Asian works of art; this may, in turn, be stimulating the production of objects of questionable authenticity. While Bainbridge's experience remains the most high-profile illustration of a UK auction house falling prey to anomalous trends in the Chinese art economy, other problematic instances involving Asian material have gone almost unnoticed. Some months after Bainbridge's auction, another UK auction house – Canterbury Auction Galleries – was consigned a vase strikingly similar to the item that appeared at Bainbridge's. The nationality of the Canterbury consignor was never

revealed, but the auctioneers later confirmed that the object itself originated from China. Whether it was hastily made in the hope of tapping into the demand that propelled Bainbridge's vase to such a stratospheric price remains unclear, although speculation centered on that possibility. In the event it failed to sell, but the Canterbury vase nevertheless provided another illustration of the risks that now beset the European market for Chinese cultural heritage.

The financialising process referred to above has also had an impact on contemporary artists. A notable by-product of the influx of speculative investment in the art market has been the tendency of many artists to embrace the market by adopting commercial strategies that contradict the oppositional stance traditionally associated with the creative temperament. This is most apparent in a willingness to comply with the demand for a certain kind of contemporary art. Among the defining characteristics of this kind of art are: that it makes few intellectual demands on the viewer; that it has immediate visual impact through its size or the luxury materials from which it is made; or because it draws on readily recognisable celebrities (representations of pop stars such as Michael Jackson, supermodels such as Kate Moss or pop culture icons such as the Pink Panther). The utility value of this kind of work is generally assessed by the extent to which it communicates its owner's financial status; if it bears the stylistic imprimatur of a known brand-name artist, so much the better.[5] The use of art to signify one's wealth has been a familiar trope of the art market for generations. However, the conspicuous consumption of art is now also used to facilitate easier access to capital, as was illustrated by the case of convicted New York attorney Marc Dreier, who was sentenced to a 20-year prison term in 2009 for fraudulently securing $750 million in unsecured loans. Prior to sentencing, Dreier told a documentary film team how he had bought works by Damien Hirst, Andy Warhol, Roy Lichtenstein and Mark Rothko to give an impression of financial success in order to continue his fraudulent Ponzi scheme: 'I leveraged these things to the hilt. The artwork I used to collateralize a loan for about three times the value of the artwork, so I was using these properties to enable me, in a very direct way, to sustain the fraud.'[6]

Recently, global demand has moved art towards methods of fabrication that eschew concerns over 'facture' – 'the way the artist's hand expresses

its possessor's temperament' (O'Connor, 2004:11) – in favour of the impersonal economics of luxury branding. An obvious question arising is this: if the artist's brand name is what sells the work, does it matter who makes it? The artist's compliance with this new economic reality manifests itself in a variety of ways, the most obvious being a readiness either to outsource the material realisation of an idea, or to build warehouses and employ armies of anonymous craftspeople to make the object, or series of objects, to precisely specified criteria (Petry, 2011). As Marjorie May Haight has shown, the fact that prices for 'series works' still increase despite increases in supply 'suggests that there is value to producing enough similar work so that a style becomes recognized as iconic of an artist, in other words, a brand' (Haight, 2011: 78–85). In such cases, the commissioning artist becomes the 'author' of the work, with the artisan craftspeople or fabricator remaining anonymous. (In some cases the craftspeople are contractually obliged not to divulge their involvement.) The most frequently cited instances of the outsourcing approach include Damien Hirst, Takashi Murakami and Jeff Koons, but they are merely the most successful and high-profile examples of a now pervasive culture of art manufacturing. History also provides us with numerous examples of artists acting in this way, including Bernini, Rubens and Rembrandt, to name just a few. As their fame grew, it became impossible to meet the rising demand for their work without employing assistants. However, most of these historical examples involve artists who were themselves renowned for their craft and skill, who had already forged their own individual idiom and who worked to exacting standards which they personally set and supervised. In most cases, a premium was also placed on specially commissioned works that had been made entirely by their own hand. By contrast, many of today's most successful contemporary artists have no demonstrable skill at painting or sculpture, or indeed any art or craft, and would be incapable of creating the works that carry their name and for which they are credited as author. That in itself has few historical precedents.

While the practice of outsourcing has become a hot topic in art criticism, the risks associated with it have been somewhat overlooked. It seems almost too obvious to state that an artist who makes her work using her own hands might be in a better position to pronounce on the authenticity or otherwise of putative fakes or copies of her work when

required to do so.[7] However, a recent case revealed how even this apparent verification process can be undermined when a work emerges from the concatenation of a corporate commissioning process and conflicting cultural attitudes towards authenticity in an unregulated global art market (Flynn, 2011).

In 2011, the California-based sculptor Don Wakefield was strolling through Newport Beach near his home, when his eye was drawn to an abstract sculpture standing in the grounds of 7 Corporate Plaza, a large office building (Figure 5.1). He entered the premises and on approaching the work was taken aback to discover it was a replica of a unique 6ft by 4ft work in granite that he and a friend, Joseph 'Chick' Glickmann, had created in 1991/92 and which was later installed in the Chicago garden of Glickmann's son. Closer inspection of the replica work revealed a brass plate attached to the base, engraved with the unfamiliar title *Human Natures: Many Faces* (sic), but with no artist's name included (Figure 5.2). Disconcerted by this seemingly unauthorised copy of his own work, Wakefield ventured further into the grounds only to find yet another version of the same sculpture, this time with a section cut away to allow for the insertion of a stainless steel 'teardrop' form suspended from the top (Figure 5.3).

Knowing these copies would not have been initiated or approved by his friend and associate Joseph Glickmann, nor by Glickmann's son (in whose garden the original still resided), Wakefield entered the building to inquire into the origin of the works. He was told they were the property of Igor M. Olenicoff and the Olen Properties Corporation, which owned the building. Wakefield then recalled having sent Olenicoff an introduction to his work in 2004, together with a link to his website in the hope that a commission might arise. He received no response from Olenicoff or Olen Corporation staff.

Shortly after finding the replica work, Wakefield discovered further copies of the same work located at another Olen Properties development at 6 Pointe Drive in the nearby city of Brea. Wakefield went home and began to research the owner of the buildings.

Igor M. Olenicoff is a Russian-born, Florida-based billionaire property developer, convicted tax felon and the president of Olen Properties Corporation, which has real estate holdings across California, Arizona and Florida.[8] Wakefield wrote to Olenicoff, requesting an explanation for how the replicas of his work had been acquired. After some delay, Olenicoff claimed that he had bought several from an 'edition' of nine he had seen at a sculpture park in Beijing during the 2008 Olympic Games. He later confirmed that he had commissioned the adapted version from the same source, but declined to divulge the identity and location of the Chinese craftsman responsible. When told that they were unauthorised replicas of Wakefield's original work, Olenicoff countered that Wakefield must have copied the works on display outside his building and demanded that Wakefield remove his own version from his website. After extensive email exchanges, Olenicoff finally refused to co-operate any further and ceased all communication.

This may look like a relatively straightforward case of copyright infringement. One might imagine that Wakefield would have little difficulty arguing that the replica works were in breach of most of the key clauses of the Fair Use doctrine on copyright (concerning the purpose and character of the use of the works; the nature of the original work; the amount and substantiality of the replicas in relation to the original; and their effect on the potential market or value of Wakefield's original work).[9] However, it is often very difficult for relatively unknown working artists to affirm their rights in such cases let alone to seek redress, be it symbolic or financial. This is invariably on account of the marked imbalance between the parties concerned in terms of financial resources and the legal wherewithal flowing from those resources. However, in this particular case, under US copyright law the identity of the Chinese fabricator or 'copier' would not be a prerequisite to initiating a copyright suit.[10]

There is another issue here which concerns the public good. The City of Brea, (where further alleged replicas of Wakefield's work and of works by another American sculptor were discovered on Olen Corporation premises), runs the 'Percent for Art' ordinance for public sculpture. Under this scheme, property developers are required when erecting a new building to set aside a percentage of the total development budget for the purpose of installing publicly accessible sculpture in the grounds. The scheme requires the developer to provide precise details of the artists responsible for the sculpture, their nationality and biography, the materials used, techniques of manufacture, and so on. One of the requirements states: 'The Artist represents and warrants that . . . the Sculpture is unique and original . . . and does not infringe upon any copyright or other intellectual property right.'[11] Enquiries made to the City of Brea confirmed that in the case of Olen Corporation development these requirements were not fully met. The document submitted to the City of Brea by the Olen Corporation refers to the artist responsible for *Human Natures: Many Faces* and the adapted version, (titled *A Tear Must Fall*) as Zhou Hong and includes the following information:

> His works are so highly respected that Zhou Hong was asked to display several pieces demonstrating his artistic abilities in the Olympic Garden during the 2008 Summer Olympics. Zhou Hong has many sculptures that are currently displayed in public buildings and specific outdoor locations throughout China.[12]

It is often said that artists are the best connoisseurs of their own work. Had Don Wakefield not made the original work himself with his own hands, but instead outsourced it to an anonymous craftsman in the manner preferred by many contemporary artists today, it might have been more difficult for him to claim authorship of the original work allegedly copied by Zhou Hong. However, not only did Wakefield make the original, unique work himself in 1992, he also documented the process in a series of date- and time-annotated photographs (Figures 5.4, 5.5, 5.6). As Francis V. O'Connor has pointed out in another context, 'There is nothing more useful to validate the judgement of the connoisseur's eye than a photograph of the artist making the work.' (O'Connor, 2004: 17).

The unauthorised copying of American artists' work may be more widespread than the Wakefield case indicated. In 2010, Igor Olenicoff flew the Massachusetts-based American sculptor John Raimondi to California, obtained photographs of his sculptures from him and informed the City of Brea that he would be purchasing a Raimondi work called *Dian* for $200,000 for installation at the Olen Properties residential development called The Pointe. Some time later, Olenicoff told Raimondi and the City he had changed his mind. Nearly a decade on, however, he installed an almost identical copy of Raimondi's *Dian* – allegedly made by a Chinese artist – at The Pointe.

These cases raise a number of important questions. What might the implications be if any of the replicas of Wakefield's or Raimondi's works were to find their way to market at some future point? Who would be presented as the 'author' of these works? What impact could this have on Wakefield's and Raimondi's own work and careers, since the appearance of many reproductions, to use Walter Benjamin's phrase, 'substitutes a plurality of copies for a unique existence' (Benjamin, 1936)? How many other replicas fabricated by anonymous Chinese craftsmen are standing unrecognised in corporate grounds across North America, and what are the costs in lost commissions to the US artists whose works have been copied? (It should not be forgotten that Wakefield originally approached Olenicoff in the hope of securing commissions.) As noted above, the Olen Corporation has real estate holdings across California, Arizona and Florida. According to Forbes, Olenicoff owns more than six million square feet of office space and 11,000 residential units in California, Nevada, Florida and Chicago.[13] These represent potentially significant opportunities for artists supplying work for Public Art schemes. However, the economic incentive to commission copies of an artist's work for such schemes is not difficult to identify. Why pay a recognised artist full price for a work when the same work

can be replicated by an anonymous craftsman at a fraction of the cost in materials and labour? Whether this was the case with the Olen Corporation works remains unclear since all attempts to clarify how and where the replicas were made have thus far been unsuccessful. In researching this chapter, a number of Beijing stone-carving companies were approached for an estimate of costs in copying a sculpture from a given image. One company stated that to make a single copy in granite of Wakefield's original sculpture based on a photograph would cost $1,250, with the price dropping to $950 per unit for three. According to Wakefield, for him to make an original, unique work in granite today of the kind he and Glickman made in 1992 would cost around $35,000 and would likely retail at around $150,000. None of the Chinese companies approached by this writer required any confirmation of authorial rights or good title to the photographed work presented to them.

The trade in fake Chinese antiquities has been going on for decades, but how common is the faking of contemporary sculpture by Chinese artisans?

It is possible that the Chinese stone-carver who made the Olen sculptures was unaware that he was making unauthorised copies of another artist's work. The thought may not even have occurred to him or her. Nor perhaps was he or she trying to fool anyone. Instead, what seems to be at issue here are differing cultural attitudes towards authorship and originality as applied to fine art.

James Cahill has observed how suspicion regarding Asian attitudes towards authenticity has long been a trope of Western criticism of Chinese culture. In an address in 2001 to the American Academy of Arts and Sciences at the Asian Art Museum in San Francisco, Cahill quoted a *New Yorker* article of 15 June 1998 which concluded that: 'Recognizing the importance of the original hand of the artist places a value on individualism that is foreign to Chinese culture.' In his address, Cahill went on to caution against such simplistic interpretations of Chinese attitudes towards authenticity:

> To be sure, the identity of 'the original hand of the artist' plays no part in evaluations of architecture, sculpture, bronzes, ceramics, and others that correspond, for the Chinese, with what we would call the applied arts. But for those that correspond roughly to our

concept of 'fine arts', primarily painting and calligraphy, the hand of the maker, and his or her original style, are absolutely central to appreciating them.
(Cahill, 2001: 1–11)

Sculpture has historically been considered a core discipline within Western academic formulations of the fine arts. More recently, however, the original hand of the artist has been de-privileged in both the making and evaluation of sculpture as conceptual strategies have gained ever greater traction. Traditional techniques of making – the teaching of which have long since been abandoned by most British art colleges – are now outsourced to anonymous craftspeople. Despite these cultural changes, a certain value continues to accrete to whether a work was authorised by the artist, or is from the artist's authorised edition.

The history of the art market is also in a sense a history of attempts of one sort or another to develop a range of tools for differentiating between authentic objects and honest copies (such as authorised editions of a work) on the one hand, and between authentic objects and deliberate fakes on the other. The alterations in working practices referred to above are having an impact on the processes of authentication that evolved in tandem with the development of the European art market. In Holland in the 17th century, lesser-known artists were occasionally employed by dealers to paint copies of works by artists of greater renown, a practice that brought a new element of risk to the culture of collecting. During the 18th century, the European art market evolved connoisseurial criteria for assessing authenticity and for identifying the signature hand of the artist. While connoisseurial expertise and other forms of verification are by no means infallible, many scholars agree that they remain critical to a successful art market. (Spencer, 2004: xi)

As China asserts itself in a rapidly globalising art market and as prices for ancient and contemporary works continue to rise, increasing attention is being drawn to a notional mismatch in cultural attitudes towards authorship and authenticity, as the Wakefield/Olenicoff case illustrates. At the heart of this are issues of ethics and regulation. The art market is often described as the last unregulated market, and yet despite

its implicit informality and attendant irregularities, there is a broad consensus that if regulation were to be imposed from without, a powerful economic generator would be immeasurably damaged.[14] Whether China's accelerating art market can find an equilibrium between growth and self-regulation remains to be seen. Meanwhile, its business structures and institutions continue to be dogged by accusations of corruption and the industry in fakes and forgeries is proliferating (Esman, 2012). It should, perhaps, be noted that art forgery continues to be a problem in Western art markets as well; as prices rise, the incentive to produce fakes and forgeries increases accordingly. Forgery is detrimental to all markets and has always been a source of risk in the art world since it discourages participation and erodes public and professional trust.

It might be tempting to conclude from the outsourcing discussion above that the surest way for artists to avoid the likelihood of their work being copied would be to make the work themselves, thereby leaving some individual stamp of authorship on the object. However, the Wakefield/Olenicoff case makes clear that even artists who make their own original, unique works using their own hands and tools, are not immune from unauthorised copying.

In conclusion, then, several questions arise. Will the rigorous Western tradition of attaching importance to authenticity need to be relaxed to take into account the seemingly ungovernable boundaries of a global art market and to bring the West into line with its more fluid market structures? Or will the next generation of collectors in emerging economies demand the sort of assurances that Western connoisseurship has traditionally sought to offer? Should industry professionals operating in the European and North American art market be reaffirming the importance of the Western connoisseurial tradition to ensure that its values survive the inexorable shift in power and influence taking place from West to East? And finally, what is to be done to protect artists from exploitation by corporations availing themselves of anonymous artisans to satisfy Public Art ordinances?

Paradoxically, perhaps, Wen C. Fong's words, offered at a 1999 symposium on issues of authenticity in early Chinese painting, provide a suitable note on which to conclude: 'There can be no real understanding of an individual work, either as art or material object, without our first

ascertaining, as accurately as possible, the date and circumstance of its production' (Fong, 1999: 260).

References

Cahill, J. (2001) 'Chinese art and authenticity', paper delivered to the American Academy of Arts and Sciences Western Center programme, Asian Art Museum, San Francisco. 3 March, 2001.

Deloitte (2011) Deloitte/Art Tactic: Art & Finance Report.

Dempster, A.M. (2014) 'Trading places: Auctions and the rise of the Chinese art market.' In C. Jones, J. Sapsed and M. Lorenzen (eds) *Oxford Handbook of the Creative Industries.* Oxford: Oxford University Press.

Esman, A. (2012) 'China's $13 Billion art fraud: And what it means for you', *Forbes* online, available at: http://www.forbes.com/sites/abigailesman/2012/08/13/chinas-13-billion-art-fraud-and-what-it-means-for-you/ (Accessed 12 September 2012).

Fischoff, B. and Kadvany, J. (2011) *Risk: A Very Short Introduction.* Oxford: Oxford University Press.

Flynn, T. (2011) 'Sculptor finds alleged copies of his work in corporate collection', *The Art Newspaper* online, 14 July 2011. Available at:

http://www.theartnewspaper.com/articles/Sculptor-finds-alleged-copies-of-his-work-in-corporate-collection/24330 (Accessed 6 September 2012).

Fong, W.C. (1999) '*Riverbank*: From connoisseurship to art history.' In Judith G. Smith and Wen C. Fong (eds) *Issues of Authenticity in Chinese Painting.* New York: Metropolitan Museum of Art.

Haight, M.M. (2011) 'Value in outsourcing labor and creating a brand in the art market: The Damien Hirst business plan.' *The American Economist,* 56(1): 78–85.

Knight, F.H. (1921) *Risk, Uncertainty, and Profit.* Boston, MA: Schaffner & Marx.

McAndrew, C. (2010) *Fine Art and High Finance: Expert Advice on the Economics of Ownership*. New York: Bloomberg.)

McAndrew, C. (2012), *The International Art Market in 2011: Observations on the Art Trade Over 25 Years*. Maastricht: The European Fine Art Foundation and Arts Economics.

Novack, J. and Seraphin, T., 'The billionaire with the empty pockets', *Forbes* online, available at: http://www.forbes.com/forbes/2006/1009/042.html (Accessed 9 September 2012).

O'Connor, F.V. (2004) 'Authenticating the attribution of art: Connoisseurship and the law in the judging of forgeries, copies and false attributions.' In Ronald D. Spencer (ed.) *The Expert versus the Object: Judging Fakes and False Attributions in the Visual Arts*. Oxford: Oxford University Press.

Petry, M. (2011) *The Art of Not Making: The New Artist/Artisan Relationship*. London: Thames & Hudson.

Reyburn, S. (2013), 'Chinese vase resold for less than half $83 million record', *Bloomberg News* online, available at: http://www.bloomberg.com/news/2013-01-14/chinese-vase-resold-for-less-than-half-83-million-record.html Accessed: 3rd December 2012

Spencer, R.D. (ed.) (2004) *The Expert versus the Object: Judging Fakes and False Attributions in the Visual Arts*. Oxford: Oxford University Press.

Velthuis, O. (2007) *Talking Prices: Symbolic Meanings of Prices on the Market for Contemporary Art*. Princeton, NJ: Princeton University Press.

1 Skate's Insider's Club panel discussion: 'Art Securitisation: All Systems Ready' held at Shore Club Hotel, Art Basel Miami Beach, 2 Dec 2010, video available online at http://skatesartinvestment.com/category/art-fairs/ (Accessed 6 September 2012)

2 'World Wealth Report 2011', Cap Gemini and Merrill Lynch, quoted in Deloitte/Art Tactic Art & Finance Report 2011, p.8.

3 'World Wealth Report 2011', Cap Gemini and Merrill Lynch, quoted in Deloitte/Art Tactic Art & Finance Report 2011, p. 8. For comments on the broader implications of the widening wealth gap for the global art market, see Clare McAndrew, *The International Art Market in 2011: Observations on the Art Trade Over 25 Years*, The European Fine Art Foundation and Arts Economics, 2012, p.20.

4 Scott Reyburn, 'Chinese vase resold for less than half $83 million record', *Bloomberg* online, published 15 January 2013, http://www.bloomberg.com/news/2013-01-14/chinese-vase-resold-for-less-than-half-83-million-record.html (Accessed 12 February 2013). See also Dempster, A.M. (2014), 'Trading Places: Auctions and the Rise of the Chinese Art Market.' In C. Jones, J. Sapsed and M. Lorenze (eds) *Oxford Handbook of Creative Industries*. Oxford: Oxford University Press.

5 *Storyville: The $750 Million Thief* directed by Marc H. Simon, Stick Figure Productions for BBC Four, broadcast 5 September 2012 (first shown as *Unraveled* at the Toronto 'Hot Docs' Film Festival, 2011).

6 Ibid.

7 Sculpture has always been produced in serial form through bronze casting, hence the problems associated with authenticating editions, as the recent case of the Degas bronzes makes clear.

8 In 2007, Olenicoff found himself at the centre of a legal storm involving allegations that the Swiss private bank UBS had used Swiss banking secrecy to hide assets of wealthy US investors (including Olenicoff) from the Internal Revenue Service. According to Forbes, Olenicoff pleaded guilty to tax felony in 2007 'for stashing more than $350 million in Europe. He paid $52 million in fines and was sentenced to 2 years probation and 120 hours community service'. Source: http://www.forbes.com/profile/igor-olenicoff/ (Accessed 6 September 2012).

9 For Fair Use copyright doctrine as applied to visual culture, see Daniel McClean and Karsten Schubert (eds) *Dear Images: Art, Copyright and Culture*, Ridinghouse, London, 2002.

10 At time of writing, copyright suits were being prepared against Igor Olenicoff and Olen Properties Corp. for breach of copyright in the Wakefield case.

11 City of Brea, Art in Public Places Policy Manual: http://brea.granicus.com/MetaViewer.php?view_id=3&clip_id=763&meta_id=60360. (Accessed 12.09.2012)

12 'Artist Information Art Application: Art in Public Places: Olen Apartments' (Provided by the City of Brea following a request for clarification of the Olen application documents.) Extensive web searches conducted by this writer for an artist named Zhou Hong proved fruitless.

13 Janet Novack and Tatiana Seraphin, 'The Billionaire with the Empty Pockets', *Forbes* online, published 22 September 2006: http://www.forbes.com/forbes/2006/1009/042.html (Accessed 9 September 2012).

14 'Globally, the employment generated by the art trade amounts to 2.4 million, including 2 million direct jobs and 400,000 jobs generated in ancillary sectors.' Clare McAndrew, *The International Art Market in 2011: Observations on the Art Trade Over 25 Years*, The European Fine Art Foundation and Arts Economics, 2012, p.13.

Containing Uncertainty: A dealer ring in 1780s Paris auctions

Neil De Marchi and Hans J. Van Miegroet,[1]
Department of Economics and Department
of Art & Art History and Visual Studies, Duke
University

A ring to control winning bids, but with the unwitting connivance of private buyers

Recent scholarship has established that a relatively small group of dealers in paintings seems to have exercised unusual control over art auctions in 1780s Paris. We are not aware of any documented accounts describing exactly how this control was exercised but, in terms of results, a recent study by Charlotte Guichard of fully annotated, surviving catalogues from 31 sales in the 1780s of which we may be sure that they were organised by the prominent dealer Jean-Baptiste Pierre Lebrun (1748–1813), shows that 55 per cent of the winning bidders were dealers. Moreover, the same eight dealers attended more than 20 of these sales, and another 13 dealers more than 10. Only occasionally in a sale did private buyers predominate among the winning bidders. These findings might point to a dealer ring, a possibility strengthened by evidence Guichard has found of a credit circuit among a sub-group of identified dealers.[2]

There is in fact a description of a dealer ring by a contemporary observer of the Paris scene, Louis-Sébastien Mercier, a counsellor to the Paris

Parlement. Mercier makes particular mention of something that might help explain the high propensity to win of a tight circle of dealers as observed by Guichard, namely, that the members of the ring were willing to bid *up* in order to squeeze out private buyers.

That in itself would have been unusual. Rings typically seek to keep winning prices below truly competitive levels. By internal agreement, all ring members except the one designated bidder for each lot of interest simply hold back, causing the bidding to be less intense and winning bids to be below their freely competitive level. Then, after the public sale, the ring holds its own private auction at which members bid their true valuations. Assuming the winning true valuation exceeds the winning bid at the public sale, the (positive) difference is shared among the members by some formula of the ring's devising. Symmetric reasoning would suggest that, by deliberately bidding up, the ring would incur losses. Mercier noted this but minimised the apparent irrationality of the strategy by suggesting that any losses, when shared, would be small. He seems not to have considered that winning bidders might have had particular rich collectors waiting in the wings and willing to pay a high price for specific paintings possibly in the expectation that the price might be still higher at a future re-sale.

By combining Mercier's description with Guichard's analysis we shall try to supply a single rationale for both the bidding up he mentions and the credit circuit she has identified. We assume that the ring implicit in Guichard's findings and the one Mercier actually observed were one and the same. Of key importance to the construction we place on Guichard's evidence is that the dealers comprising a ring were not the final buyers; they had to have bid up in the reasonable conviction that they could pass on their acquisitions to their collector clients, their high winning bids being fully incorporated into their asking prices. Before exploring this further, here is an extract from Mercier's description of Paris's paintings auctions in the 1780s, the same decade for which detailed auction records were available to us:

> In these [public] auctions there is a private feature . . . It consists of a 'ring' of dealers who do not outbid each other . . . because all of those who are present at the sale are interested, but when they see a private buyer anxious for the article, they bid up and raise the

price against him, supporting the loss, which becomes a small matter when divided amongst the members of the 'ring.' These sharpers thus become masters of the situation [*maîtres des prix*] for they manage matters so that no outside buyer can bid above one of their own . . . When a thing has been run up sufficiently high to prevent any outside bidder making a profit, the ring meets privately, and the article is allotted to one of the members. This arrangement accounts for the high prices which surprise so many persons of experience . . . This conspiracy against the purse of private persons has driven many buyers [*un nombre infini*] from the auction room.[3]

Mercier had many complaints about Paris dealers, but we suspect that he might have exaggerated the conspiratorial element and the damage done to the population of private buyers. Our sense is that the real purpose of bidding up was less to eliminate private buyers than to signal to the clients of the dealers comprising the ring that paintings were a strong investment. Their argument? That winning bids may be high, but collector-investors could rest assured that the market value of older works of the quality desired by them would rise still higher, not least because of growing scarcity. Of course, the public sales were only one location for acquiring paintings, and scarcity just one component of a case for considering them a sound investment. The full argument will be addressed below. For the moment, all that needs to be emphasised is that opting to outbid private buyers was a choice by the ring to engage selectively in truly competitive bidding in the expectation that the resulting high prices could be passed on to collectors. Bolstering this expectation was the feeling that their clients would have less reason to baulk at high prices if winning bids were public knowledge. Which they were; not only did the auctioneer call the bids, bring down the hammer and submit an official record, but there were independent on-the-spot observers, the private buyers themselves.[4] Contrary to Mercier's indirect allegation, it was not at all in the ring's interest to seek to decimate, much less eliminate, these buyers.

A credit circuit as an additional means of control

If the members of the ring could pass on high and even rising prices at auction with the ordinary margin added, its members' profits in absolute terms would strengthen over time. But it was not a given that, able and willing in principle though their collector clients might have been, they would passively accede to whatever heightened prices their dealer suppliers asked of them. It is more likely that they needed to be persuaded that acquiring at heightened prices was consistent with paintings being a sound investment. It should be no surprise therefore that the ring also actively promoted fine older paintings. Such promotion, to be discussed below, was a second aspect of control adopted by members of the ring, complementing their selective competitive bidding against outside buyers. And there was a third.

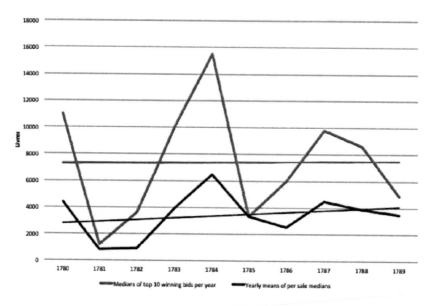

Figure 6.1 Top 10 winning bids and trends, Lebrun sales 1780s

Dealers, including members of the ring, faced all manner of uncertainties. These included the timing of deaths among an earlier generation of collectors, and thus the flow of older paintings coming on to

the market from that source. Nor, since collections were of very uneven quality, was this flow just a matter of numbers. In addition, the dealer-organiser of a sale could not predict who might attend or assign an agent, and what their particular interests might be. The combined effect of these three elements – unpredictable timing, uneven quality, unknown attendance and specific interests represented at individual sales – was considerable volatility in winning bids, both across and within sales. Upper-end winning bids in 29 of the 31 sales we are sure were directed by Lebrun in the 1780s show this volatility very clearly.

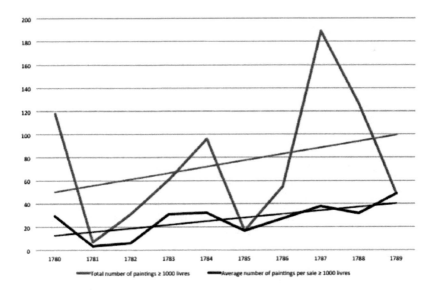

Figure 6.2 Winning bids at or above 1,000 livres and trend, Lebrun sales 1780s

Volatility of course mattered in that it meant that a dealer's cash flow was uncertain, and cash-flow problems could cause bankruptcy. Bankruptcy did not necessarily put a dealer out of business permanently, but it was disruptive and costly, involving legal fees, public embarrassment and time-consuming and often complex settlement procedures with creditors.[5] One impetus for the ring to set up a credit circuit was the desirability of lessening somewhat the potential negative consequences of uncertainty.

Guichard has adduced circumstantial evidence for believing that a credit circuit was a deliberate creation of the ring. She points out that Lebrun's 'for cash' sales were held only towards the end of a year when, conventionally, reckonings were held. This suggests that sales at which credit was available to (selected) winning bidders were the norm. The dominance of sales 'for credit' plus the timing of sales 'for cash only' point to the credit circuit's having been deliberately contrived and put in place.

Again, as to why the ring might have done this, sales for credit conferred not one but two degrees of freedom on its dealer members. First, as noted, credit constituted a buffer against the immediate negative consequences of cash-flow problems. And this seems to have worked: Guichard points out that outsiders were more affected by bankruptcies than were members of the ring.[6] Second, credit enabled purchases to be made at the public sales on a larger scale and at higher prices than in a strictly cash-only regime. Of course settlement had to be made at some point, but postponing it even by a few months enhanced the chance of finding a buyer in the meantime.

In terms of who was at the centre of the credit circuit, Guichard has examined 33 surviving, fully annotated catalogues out of the 51 Lebrun-organised sales in the 1780s. Full annotation here means that the names of and amounts paid by winning bidders were recorded; typically too an address was given for each winning bidder. In addition, frequently there was an indication as to whether that person was indebted to Lebrun or he to them, or that an earlier debt had been cleared. Lebrun was the largest winning bidder (measured by total amount committed) in two thirds of sales he organised, in line with what Patrick Michel reports in his *Le Commerce du Tableau à Paris*, namely, that Lebrun could be an unrestrained bidder and was frequently in need of credit.[7] These mutually reinforcing pieces of evidence in turn strongly suggest that Lebrun was at the centre of both the bidding ring and its complementary credit circuit.

In a strictly historical account it would be satisfying to be told at this point how large the ring was and who were its members. But the ring operated just outside the law and it is unsurprising that no list of members has been found. Plausible guesses can be made as to the *core*

membership, based on known long-term associates of Lebrun. In part too it was a family affair; his younger brother Joseph-Alexandre and his stepfather (after his father died in 1771), Nicolas Lerouge, both dealers, were regulars at his sales. Family and known close associates aside, we can add a few other dealers whose signatures appear on short-term notes (letters obligatory) uncovered by Guichard. Such notes were transferable and payable to the bearer. At a transfer it was common therefore for a letter obligatory to be endorsed in favour of the new owner. In terms of likely participants in the ring and the credit circuit, all told it seems likely that the core may have comprised as few as the eight dealers who attended most of Lebrun's sales.[8] As Charlotte Guichard emphasises, the worlds making up the Paris paintings market were small.

Two additional observations of hers reinforce this characterisation. First, among the annotations on catalogues Lebrun owned (which she estimates at over 1,000), few names are unfamiliar. Second, new dealers only rarely appeared.

Such circumstantial reasoning is not entirely satisfactory, but our concern is less with the precise composition and history of the ring than with exploring its likely economic rationale. The most important remaining aspect of that is the relationship between the ring and its probable clientele.

The dealers and their clients

In this context Patrick Michel speaks of the rise during the decade of the 1770s, not just of the dealers we associate with the ring, but of 'a new clientele of collectors'.[9] They were wealthy and, according to Michel, the 'most active' among collectors in our decade.[10] We may safely conjecture that a major component of this new clientele came from the class of *financiers*.

Financiers are sometimes called bankers, though mostly they were not that. First and foremost they were tax farmers, who contributed to the king's finances by purchasing for limited periods the rights to collect specific taxes in a particular location, out of which they were

committed to transfer to the king some annual amount. As economic historian Roger Price explains, very few of them invested their net gains either in banking or in industrial enterprises. Instead, most engaged in commerce and, in an era of sharply rising commodity prices, many participated in short-term commodity price speculations. This was a natural counterpart to the tax farmers' constant pursuit of ways to extract more for themselves in the exercise of their taxing rights; for both immediate wealth enhancement and potentially profitable investments were necessary to support their lavish in-town style of living. Paintings were part of a lavish décor rather than contributors to an income stream, though, as we shall see, Lebrun made a strong case for fine paintings as both a source of pleasure and a good investment, the later, however, only over the medium to long term. He did not try to sell paintings for their speculative potential – to be bought and flipped (re-sold) quickly.[11]

One alleged difference between the 'new clientele of collectors' of the 1780s and those they replaced, is that the new were richer. Certainly the incomes of aristocrats among the preceding generation of collectors were more fixed, being tied mainly to inherited rights. By contrast, the financiers, as will emerge from our summary of the analysis of French tax farming by contemporary moral philosopher and economist Adam Smith, had both the incentive and opportunity to increase their personal wealth and therefore were capable of filling the role we are ascribing to them, namely, that they were able and willing to pay high and even rising prices for choice paintings supplied to them by the dealers of the Paris ring.[12]

Smith's account of French tax farming was that of an observer who lived in France from February 1764 to October 1766. During this period he became acquainted with the leading physiocrats and their writings, and with the reforming free-market advocate and later *Contrôleur Général des Finances* Anne-Robert-Jacques Turgot. Smith also frequented the home of financier/philosophe Helvétius and was close to the physician ThéodoreTronchin. Tronchin had two brothers: Robert, a banker who in 1762 became a tax farmer *générale* and François, banker/collector and steady client of Lebrun and his close associates. It is unclear whether Smith knew either Robert or François, but his understanding of the French tax farming system came from direct observation and

familiarity with the very best of living and written sources. The account itself can be found in Smith's *Inquiry into The Nature and Causes of the Wealth of Nations* (1776), but it was drafted in France in 1766, a draft that survives in Goldsmiths Library, London.[13]

Smith noted two features of the French system of leasing out taxing rights. First, this method of collection was inefficient: it involved costs far in excess of a system in which there is a state apparatus to do the same job. The tax farmer had to make a profit on top of his own outlays and obligations, and these were substantial. They comprised the initial successful bid for the taxing rights, the annual amount to be transferred to the crown, the salaries of the collection officers and the cost of a whole administration. These unavoidable costs were so great that very few had the capital necessary to enter the tax farming business in the first place. That low number in turn fed into the farmer's interest in maximising his private net gain. With only a few bidders for the taxing rights, it was easy for those few to form and act as a ring, which often, Smith implies, they did, causing the rights to be acquired at auction for less than their 'real value'. This is one way in which the tax farmers appropriated undue amounts to themselves.

Second, tax farmers, although they did not make the tax laws, had a lot of leeway in specifying what had to be paid. They did so, Smith says, as oppressors, with ever-increasing severity, since they did not identify with the people and their whole interest ceased the day after the expiration of their purchased rights to farm, even if a universal bankruptcy among the payers should occur on that very day.

The tax farmer's power to exact ever more for himself may have rested in part on a threat of physical violence, but it also flowed from the fact that often he held the monopoly over taxed goods. Where this applied, as in the case of tobacco (addictive) and salt (a necessity), the power of exaction became well nigh absolute.[14]

The effect of the conditions and incentives described by Smith was that the tax farmer in France during the second half of the 18th century had the freedom progressively to enhance his starting capital.[15] That freedom might last only as long as the period for which taxing rights were originally obtained – originally six years for the rights enjoyed by tax farmers-general – but then he might bid for a new lease, or he could

relinquish his rights to another member of his class, while he, having grown his own capital handsomely, would be free to invest in speculative schemes. Thus the composition of the group enjoying increasing wealth might change over time but the numbers at any one time were limited – 40 or so for tax farmers-general. This made them easy to identify and engage by dealers in paintings.

And indeed, Lebrun appealed directly to this group of collectors. In prefatory remarks entitled *Réflexions sur la peinture et la sculpture* in his printed catalogue for the paintings in the sale in 1780 of the important collection of M. Poullain, *Receveur générale des Domaines du Roi*,[16] he argued for paintings as a secure asset and one likely to rise in value over time. His argument focused on the medium to long run – hence not on speculation in the strict, economic sense – and on fine paintings collectively. That is to say, he did not pretend that the price of any specific painting in a particular sale could be predicted; nor did he deny that prices might sometimes fall.

In the first place, Lebrun noted, each fine painting is unique – more so than other objects of curiosity, such as books, porcelain, shells and diamonds, for which comparables can always be found. This uniqueness, he added, holds also for any two paintings by the same artist. The consequence of uniqueness is this: whatever valuation is put on a fine painting, its uniqueness makes that price more secure, less liable to change and especially less liable to fall, since in all strictness it can never be challenged by another. Such a comparison, which for other objects of curiosity might well lead to a loss of esteem, was simply out of the question in the case of fine paintings. This greater assuredness concerning the value of such paintings made them more attractive – a more 'certain' possession – than, not only any other 'object of curiosity,' but any item of merchandise. This last remark was perhaps directed at true commodity speculators among the financiers.

Lebrun invoked, in addition to this ground for assured value, the small number of truly fine paintings in existence plus the numbers regularly destroyed by inappropriate handling on the part of ignorant persons and by accidents and natural disasters (he mentioned specifically two collections lost at sea within recent memory). This growing scarcity made it likely that the prices of truly fine paintings would rise for the

foreseeable future. Price reductions, he conceded, do occur, but they are likely to be relatively small.

Besides his arguments from uniqueness and the diminishing numbers of fine paintings, Lebrun inferred that the diffusion of good taste and rising wealth (this last true at least for tax farmers) – both demand-side factors – would also cause prices to rise for all objects of taste and luxury. And, on top of these three factors, he stressed that there is pleasure in owning and living with one's acquired paintings. This personal return would be enhanced if a man felt that the paintings he had acquired represented wealth well managed, a feeling – we infer – that could only be reinforced if the market value of the paintings were to rise and if his selections elicited approval from 'polished' persons in his circle.[17]

Lebrun's practical contribution to spreading the taste for fine pictures was to acquire for himself a relatively deep knowledge of various national 'schools' of painting and their respective artists – Italian, Flemish, Dutch and French in particular. This informational advantage he might then use to comment comparatively upon each painting in a sale in which he was involved, and on the artists represented, to the end of establishing a plausible basis for valuation. For example, for the Poullain sale (1780) he prepared just such a discursive and evaluative catalogue. It ran to 126 pages, not counting 16 prefatory pages largely taken up with his *Réflexions* on value, both artistic and commercial.

Having laid a basis for informed valuation in his discursive catalogue, Lebrun set up the actual Poullain sale as a series of mini-auctions which took place on successive business days, the actual lot order being specified separately from that in the discursive catalogue, on printed *feuilles de vacation*. Usually, such mini-auctions began with Italian works and ended with French. Flemish, Dutch and German works occupied the middle.

This sequencing roughly corresponded to an ordering by declining price. In the Vaudreuil sale of 1784, for example, the very first painting, an Italian piece ascribed to Beretini and Cortona, fetched far and away the highest price of the whole sale, though the correspondence was indeed rough, since a major part of Lebrun's business strategy was to promote Flemish and Dutch works. This he did with some success,

achieving substantial prices for individual Netherlandish artists.[18] A recent study of lot order by price in 98 Paris sales with vacation sheets, 1767–1779, including sales organised by Lebrun, found a strong inverse relation between lot order by declining price and sale revenue. This accords with modern economic thinking about the best way to sequence lots by price so as to maximise revenue.[19]

This recent finding is relevant to the question as to what exactly the ring could claim to control. We have suggested that the ring might have served its member-dealers chiefly by establishing a public record of high prices that they could pass on to their clients, with the usual margin added. This ability in turn rested on the ring's members being able to convince their collector-clients that the prices were warranted. But that was just the point of Lebrun's multi-pronged argument invoking uniqueness, scarcity, wealth and taste. Prices for fine paintings, on his reckoning, should rise over the medium term, any fall being limited and temporary.[20] But, in spite of his apparent awareness of the relation recently identified anew between sale revenue and lot order by declining price, and as noted, Lebrun offered no guarantee as to how a specific painting would fare on a particular day. It is salient that he understood paintings and the market (of which lot order by declining price is one not unimportant element, and volatility another), yet felt he could be reasonably sure only about the *trend* of prices. We postulate that the dual facts that Lebrun distanced himself from speculative – strictly short-term – trading yet knew how to secure the most revenue from a sale, must have made his remarks on valuation convincing to contemporaries. And in that regard a probe into realised prices and prior price history is suggestive.

Towards testing Lebrun's carefully expressed argument and throwing some light on the trend lines in Figures 6.1 and 6.2 above, we selected a sale held in late 1784, the paintings section of which was organised by him. This was the (voluntary) sale of the collection of the Comte de Vaudreuil, *Grand-Fauconnier de France*. We focused in particular on re-sales and even more specifically on paintings for which a three-sale history can be traced and on cases where the period between initial and third price was at least five years.

12 lots qualified. The average time between first and third appearance at sale was just under 10 years. Thus these 12 instances serve to test Lebrun's

notion about assured value over the medium to long term; 10 years certainly is much longer than a 'flipper', or true speculator, would be willing to hold a painting acquired for its potential resale or investment value alone. In all but one instance the starting valuation was above 1,000 livres and the average was about 7,000 livres, meaning in addition that our small-scale test captures strictly high-end paintings, the very sort that Lebrun had in mind in making his argument about their likelihood to retain market value and even rise in price.

Of our 12 test observations, eight involved a gain in price between first and third appearance, while there were four instances of loss. Dividing average gain by the average number of years from first to third appearance yields average annual gain and this in turn, divided by average starting price among gainers yields the average annual percentage gain, here 3.5–4.0 per cent. The average starting price among the gainers was 7,424 livres. By contrast, all but one of the losses came on paintings whose starting price was less than 3.500 livres, still no mean sum. And, the average end price among gainers was 10,500 livres, for an average gain of 3,076 livres. Dividing this by the average number of years from first to third appearance for gainers (10.5) yields 293 livres. And dividing this by 7,424 (the starting price among gainers) yields 0.04, or 4 per cent, as the annual average percentage gain.

A number of objections can be made to our probe. Chief among them may be that the end-sale, that of Vaudreuil, happens to have been one at which the dealer Paillet was appointed to bid as agent to the king, giving an artificial fillip to the gains category.[21] At the same time, this sale followed a period in the late 1770s and early 1780s when, according to one recent scholar, the Paris market was saturated with paintings, tending to keep prices down.[22] Moreover, Paillet was the winning bidder in just three of the eight instances of registered gains in our small sample. Thus the upward bias introduced by royal patronage in this sale may not have been sufficient to destroy its value for our purposes.

We draw from our small exercise the conclusion that the prices of top paintings registered medium-term gains, though these were very modest.[23] That there was modest net gain is in line with what Lebrun claimed, while its having occurred over a term of 10-plus years on average clarifies that he was appealing to investors rather than speculators

or flippers. Moreover, it subsumes some middle-appearance dips in price, exactly as he allowed might happen, sensibly so in the light of the uncertainties we noted earlier as to what any particular sale might bring.

Lebrun's position was not only distant from that of a speculator, it was also more restrained than that taken by Diderot who, in 1767, averred that buying paintings by contemporary French artists was deemed by financier-collectors to be money 'placed at a high interest'. For the artist will die, and the owner (or at any rate he and his children), having enjoyed the work for several years, will find that its value at that point jumps 20-fold, just because the stock of that artist's work can no longer be enlarged.[24] Lebrun, recall, put French paintings as a group at the rear in his mini-auctions, broadly speaking arranged by declining price.

The impression of the ring that emerges, partly by contrast with alternatives, is that it was a level-headed, informed and flexible appendage put in place to mitigate the risks of dealing in art and to strengthen its members' bona fides with serious collectors by assisting to sustain high and rising valuations, selectively, for fine paintings at auction. As viewed through Lebrun's words and actions the ring was neither as predatory towards the private bidder as Mercier implied nor did it exist to encourage speculative buyers. It also had staying power, coming to an end not from internal defection or failure in its efforts, but because of the Revolution and the radically changed circumstances for collectors and dealers that it ushered in.

Even then, as late as 1793 we find Lebrun boasting that he could control the revenue, not individual price, outcome of any sale he organised. This may have been extravagant but is not out of line with his attention to lot order by declining price in his mini-auctions.[25] Moreover, indefatigable as he was, and ever confident that well-chosen collections of fine paintings were bound to retain their value even if other investments suffered, we also find him, in 1792, advocating a new sort of Monte di Pietà – he called it a 'Lombard des Arts' – to provide ready loans against paintings as surety.[26] This is precisely what we would expect as a practical extension of his remarks in the Poullain catalogue of 1780.

Low-risk, cross-border arbitrage in paintings

To this point we have focused on Paris auctions, but in one important respect the ring was part of a larger scheme even in the 1780s. For many decades Lebrun and some of his contemporaries made repeated trips to other countries, buying up paintings relatively cheaply which they then resold in Paris at higher prices. Lebrun was not alone among dealers in making such trips; nevertheless, the 43 such excursions he claimed to have made in a letter to Napoleon in or around 1802, was unusually high.[27]

This sort of activity may be thought of as low-risk arbitrage. For Lebrun, certainly in the 1780s, it was low risk in that, with the backing of the ring, he could exercise selective control of the prices attained in Paris sales, especially those he himself directed. It was arbitrage in the strict sense that in each transaction the same asset (indeed, the very same painting) was involved, though at two locations, such as Brussels and Paris, where there was a reasonable expectation that a difference in prices – purchase price in the one location, sale price in the other – would prevail.

The general potential for this sort of arbitrage can be illustrated for the period up to the mid-1770s, using a database constructed from the Hoet-Terwesten annotated records of 18th-century auctions, complemented by sales of the Parisian dealers Gersaint, Remy and Lebrun (father and son). If sales in Paris and Amsterdam are isolated, as in Figure 6.3 below, there is a marked difference in moving average prices per sale between the two locations. While this particular database for Amsterdam ceases just as 'our' Lebrun (the son) was emerging as an independent force in the market, it is highly likely that the price difference captured in Figure 6.3 was sustained, especially given the position of influence he carved out for himself, and because he kept up his buying trips prior to and after 1789. These trips are known to have encompassed Brussels, Antwerp and Amsterdam.

Still, our illustration is only an aggregative one: the summary price lines are averages. What really is needed is a database of price histories

for individual paintings, including price at a foreign source and in a subsequent sale in Paris. As with his promotion of paintings as an asset, so in the case of foreign paintings, Lebrun backed his trading practice with persuasive views about the particular properties of these paintings

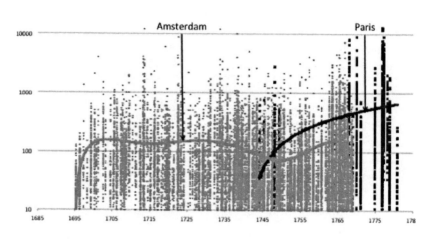

Note: Prices in guilders
Source: Sales data HOET-TERWESTEN; GERSAINT 1744-1750; REMY & LEBRUN 1755-1780; Elliott HAUSER, Kiril ZUGANOV, Sandra VAN GINHOVEN & Hillary Coe SMITH. Duke Art, Law and Markets Initiative (DALMI) Database, Duke University, 2011.

Figure 6.3 Actual and average prices per lot, Amsterdam and Paris sales, 1695–1780

and their desirability.[28] Limitations notwithstanding, the underlying reality behind Figure 6.3 is that dealers such as Lebrun had complete control over what they chose to bid for *abroad*, and the maximum bids they would submit in foreign auctions, not merely reasonable control over lot ordering and revenue and, though in lesser degree, prices, at re-sale in Paris. Thus returns on repeat sales where foreign purchases were part of the transaction ought to have been markedly above and more certain than those turned up in our probe, reported earlier, where both initial price and re-sale prices were for paintings auctioned in Paris.

Conclusions

We have argued, largely on the basis of evidence found by Charlotte Guichard, and in part Mercier's contemporary observation, for the existence in 1780s Paris of a close-knit ring, with a complementary credit circuit (overlooked by Mercier, who had other complaints against the dealers). This ring, with its credit arm, made possible prices higher than in a cash-only sales environment. An additional necessary condition for higher prices to have prevailed – and for already high prices to have risen even further, namely the presence of wealthy collectors open to considering painting also a profitable investment opportunity – was also fulfilled, certainly in the case of financiers. A third precondition, a leader able to elicit and cultivate a taste for fine paintings among that group, all the while orchestrating revenues at public sales, was met in the person of Lebrun.

None of these necessary conditions, singly or together, allows us to claim that we can explain prices in Paris in the 1780s. Nor does our limited exploration of price histories of individual paintings enable us to set very much store by Lebrun's claim that paintings were a good investment, except in the case of paintings bought in the Low Countries and re-sold in Paris, the particulars relating to which, however, have not been assembled. In all strictness, then, we may claim only that prices in the 1780s ought to have been and probably were a little higher with the ring than without. Unfortunately, that counterfactual is untestable; nevertheless, much may be learned by narrowly focused further research on the cross-border movement of paintings at auction.

Postscript

Despite its limitations our narrative resonates in intriguing ways with aspects of behaviour in present-day markets for Old Master, Post-Impressionist, and Modern and Contemporary paintings. Not that history repeats; we note some similarities as a matter of interest, though more to highlight differences than to suggest replication of the 1780s in current markets.

Several parallels exist, including the influence, (a) of *rarity* (not surprisingly most evident in the Old Masters market, though also in other markets, especially in the case of pieces recognisable by a deceased artist of established reputation) and (b) of *wealth*. Just as we assume financiers dominated the resale market in Paris in the 1780s, so high-net-worth individuals have disproportionate influence over prices at the high end of whatever contemporary markets they enter.[29] There is also, (c) *increased blurring* – though in different ways, then and now – of the roles of dealers and auctioneers. In 1780s Paris, the blurring was at the initiative of dealers; recently it has involved auction houses taking over dealerships and in other ways (e.g. increased numbers of exhibition sales; and a larger share of revenue sought through private treaty sales) fashioning themselves more like dealers. Differences aside, however, the motivation is the same: to increase control and thus chances of survival.

It is also striking how close Lebrun and his associates came to recent efforts to promote paintings as an asset. The credit arm of the ring enabled those involved to trade on a larger scale than if purchases required cash and to win by bidding up against private buyers, as well as, in principle, establishing a public record of high current and rising prices at resale. The same control also contributed, at the Paris end, to implementing the conditions for low-risk, cross-border arbitrage. Efficient global markets have virtually eliminated that sort of opportunity, but there is a closer parallel between Lebrun's *Lombard des Arts* scheme and the recently increased willingness of banks to lend against paintings, albeit, probably, on terms less favourable than he envisaged. The attempts by contemporary auction houses to secure third-party guarantors is another risk-containing move, though limited to lessening the downside risk at auction rather than giving auction houses the same control over winning bids at the high end as Lebrun and the ring sought to procure. Recent moves to the end of securitising paintings, including art funds, are still in their infancy but go beyond anything imagined, much less implemented, in the 1780s.

An ironic aspect of the differences between control over costs and returns then and now is that perhaps the oldest surviving of contemporary art funds, The Fine Arts Fund, lowers costs and raises returns precisely by focusing almost exclusively on private purchases and sales, bypassing dealers and auctions. More ironic still is that, as noted,

private treaty sales are increasingly favoured by auction houses themselves.

In relation to Lebrun's actual pitch to investors, we find no support from resale prices in one – albeit important – auction he organised, for the claim that paintings could be relied upon to generate an attractive, *short run* return, though we found modest evidence for gains in the medium term, just as he argued should occur. Control over purchase prices abroad should have strengthened the claim, a possibility testable if data were assembled on repeat sales directly involving paintings required abroad. High-end dealerships now established in multiple countries, in principle also constitute test cases, though not in fact as long as purchase and sale prices are not revealed.

Interestingly, the pleasure dividend as compensation for modest invest-ment returns in fine paintings is once again attracting attention, attested to both by the declared motivations for buying stressed in answers to questionnaire surveys addressed to wealthy collectors and in terms of what a plausible reading of US trade data reveal.[30] Art funds that both display paintings acquired and allow participants to rent them supply yet another link back to Lebrun's focus on the pleasure of living with paintings, quite independent of any asset return potential they may have.

1 We are grateful, for constructive conversations and preliminary data analysis, to Donna Budman, Sandra Van Ginhoven, Jean-Marc Goguikian and Genevieve Werner. Thanks also to Hilary Coe Smith for allowing us to use her database of 29 annotated catalogues of Lebrun sales in the 1780s. Anna Dempster, Sophie Raux and Christophe Spaenjers gave us helpful comments on draft versions. Special thanks to Charlotte Guichard for allowing us to draw freely on her unpublished research and to Federico Etro and Ben Mandel for a series of probing questions, not all of which we were able to answer with the available information, but which made us re-think multiple aspects of our narrative.

2 Guichard's findings in part confirm things long sensed, but she is the first to make available a structured account based on an expanded pool of evidence. See her 'Small Worlds: The Auction Economy in the late Eighteenth-Century Paris Art Market,' forthcoming in Neil De Marchi and Sophie Raux (eds) *Moving Pictures:The European Trade in Visual Imagery, 1400–1800* (Turnhout: Brepols, 2014).

3 Louis-Sébastien Mercier, 'Ventes par arrêts de la Cour. Encan'. *Tableau de Paris*, modern edition [order of pieces rearranged] (Paris: Mercure de France, 1994 [1781-1788]), vol. II, pp.109-112. The English trans-lation is from Brian Learmount, *A History of the Auction* (Frome and London: Barnard and Learmount, 1985, p.60), italicised phrases in the original.

4 Some private buyers must have been formidable competitors. One such identified by Guichard as a regular at the sales was François-Pascal Haudry (1728-1800), President of the Orleans Chamber of Finance, Administrator of the Orleans School of Design and Director of the *Manufacture de Sèvres*.

5 Haudry attended 10 of Lebrun's sales in the 1780s and left a collection of 158 meticulously annotated sale catalogues.

6 Mercier also gives an overview of bankruptcy: *Tableau de Paris*, vol. II, pp.52-56.

7 For details of how this could work to the advantage of one dealer, Jacques Lenglier, see Patrick Michel, *Le Commerce du tableau à Paris dans le seconde moitié du XVIIIe siècle* (Villeneuve d'Ascq: Presses Universitaires du Septentrion, 2007), pp.67-68.

8 Ibid.: pp.85-86. Lebrun was not alone among dealers in being frequently in need of credit.

9 Guichard counts among core members Lebrun, his brother and stepfather, Jacques Lenglier and Vincent Donjeux, the former at least often in debt (ibid.:69) and both, together with Lebrun, said by Michel to have been joint masters of the art market from the late 1770s on (ibid.: pp.85). The 'masters' list also includes Alexandre-Joseph Paillet, Lebrun's main rival, but also, like him, often in financial difficulties and dependent on credit (ibid.: pp.93-94). Although he was also a rival, Paillet was financially supported by Lebrun plus his stepfather, Lenglier and Donjeux, in an early misconceived investment, a partnership with the younger brother of Mercier (ibid.: p.61). To this short list probably should be added the dealers Hamon, who attended most of Lebrun's sales, and Jean-François Debérreyter, whose signature is on credit notes of the ring. Michel's *Le Commerce* contains useful details on all these persons.

10 The larger context is that Paris collections grew from 150 in the period 1700-1720 to more than 500 in the four decades preceding the Revolution. See Krysztof Pomian *Collectors and Curiosities: Paris and Venice, 1500-1800* (Cambridge: Polity Press, 1950, pp.159-160).

11 *Le Commerce*, pp.37, 86 and 'Le tableau et son prix à Paris, 1760-1815,' in Jeremy Warren and Adriana Turpin (eds), *Auctions, Agents and Dealers. The Mechanisms of the Art Market 1660-1830* (Oxford: The Beazley Archive and Archaeopress, 2007, pp.53-68).

12 For a classic characterisation of the financiers see Henri Sée, *Economic and Social Conditions in France During the Eighteenth Century*, trsl. Edwin H. Zeydel (New York: Crofts, 1935), Ch. X. For a more recent overview, stressing the speculative aspect of many of the investments of *financiers*, see Roger Price, *An Economic History of Modern France, 1730-1914* (New York: St Martin's Press, 1981), especially pp.142-146 and 153-154.

13 Sée, *Economic and Social Conditions*, p.196, alludes to the links between the financiers and collecting (or, more broadly, the material evidences of good living), noting that Rousseau had shown that 'the arts were practiced *only* in the interest of this wealthy class' (italics added). Michel adds that Lebrun tried to conquer this new clientele in part by matching them in their extravagant lifestyle: *Le Commerce*, p.86.

14 Ian Simpson Ross, *The Life of Adam Smith* (Oxford: Clarendon Press, 1995, pp.210, 214).

15 Smith, *The Nature and Causes of the Wealth of Nations*, vol.II of the Glasgow edition of the Works and Correspondence of Adam Smith, R.H. Campbell, A.S. Skinner and W.B. Todd (eds) (Indianapolis: Liberty Classics, 1981 [1776], pp.902-903, paragraphs 73-75).

16 Smith records that the tax farmers, as a class, were 'the richest in the country'. See *Lectures on Jurisprudence*, vol. V of The Works and Correspondence of Adam Smith, R.L. Meek, D.D. Raphael and P.G. Stein (eds)

(Indianapolis: Liberty Classics, 1982, p.517, paragraph 275). See *Catalogue Raisonné des Tableaux, Dessins, Estampes, Figures de Bronze & de marbre &morceax d'Histoire naturelle . . . de feu M. Poullain* (Paris, 1780, vii–xvi).

17 Benjamin R. Mandel, 'Art as an investment and conspicuous consumption good,' *American Economic Review* 99 (2009): 1653–1663, analyses the consumption return from paintings. His focus is on the envy value of owning costly paintings, but his model allows for other forms of consumption dividend, including the pleasure of living with them.

18 See De Marchi and Van Miegroet, 'The rise of the dealer-auctioneer in Paris: Information and transparency in a market for Netherlandish paintings,' in Anna Tummers and Koenraad Jonckheere (eds), *Art Market and Connoisseurship: A Closer Look at Paintings by Rembrandt, Rubens and their Contemporaries* (Amsterdam: Amsterdam University Press, 2008, pp.148–17). There we misleadingly referred to dealer-auctioneers, meaning dealers who also held auctions. But Lebrun was an *expert*, free to organise sales and run them, but not an *huissier-priseur*. For details see Guichard, 'Small Worlds,' and Michel, *Le Commerce*, esp. Chs 2 and 5.

19 Amaan Mitha, 'Optimal Ordering in Sequential English Auctions,' Duke University, Department of Economics, thesis for Honors with Distinction, 2012.

20 In supply and demand terms, Lebrun's case for increasing prices of fine paintings over the medium-to long term is very clear. It comes down to a leftward shift in the supply curve (vertical for unique objects) plus a rightward shift in the (normally shaped, downward-sloping) demand curve, so that the equilibrium moves northwest with respect to its starting position and the market-clearing price rises.

21 See Jolynn Edwards, 'The Conti sales of 1777 and 1779 and their impact on the Parisian art market'. *Studies in Eighteenth Century Culture*, 39: 77–110 (see p.79 and note 8 in particular).

22 This is strongly emphasised in Edwards' 'The Conti Sales'.

23 We used simple annual average gains because paintings generate no re-investible dividend.

24 Cited by Patrick Michel, 'Le Tableau et son prix,' pp. 63 (in French) and 67 (in English).

25 In an appearance before the revolutionary Temporary Committee on the Arts, at a moment when artists were questioning the need for intermediaries, Lebrun, referring to a case he treated as illustrative, boasted that he had obtained 33,000 livres for some heirs in a sale when they hoped for no more than 12,000. Guichard recounts the story in full in 'Small Worlds'.

26 Michel, *Le Commerce*, p. 182.

27 The letter is cited by Francis Haskell, *Rediscoveries in Art: Some Aspects of Taste, Passion, and Collecting in England and France* (Oxford: Phaidon, 1980), p.29; see also note 44, p.184.

28 For a typical entry from one of Lebrun's catalogues see De Marchi and Van Miegroet, 'The Rise,' p.155, right-hand photograph.

29 Perhaps the most striking result to emerge recently is that based on a long-term study of (mainly) UK art prices, and UK incomes (as proxy for wealth). William N. Goetzmann, Luc Renneboog and Christophe Spaenjers, 'Art and Money,' *American Economic Review, Papers and Proceedings*, 101 (2011), pp.222–226, find that, historically, a 1 per cent rise in the top 0.1 per cent of incomes generated a 10 per cent increase in art prices.

30 See, respectively, Barclay's *World Wealth Survey* for 2012 and Benjamin Mandel, 'Investment in visual arts: Evidence from international transactions,' November 2010 version of a Working Paper, Division of International Finance, Board of Governors of the Federal Reserve System, Washington DC.

The allure of novelty and uncertainty in art consumption

Marina Bianchi, Professor of Economics, Department of Economics and Law, University of Cassino

Introduction

The high uncertainty associated with the production, distribution and consumption of art products and, more generally, of creative products and activities, seems to be one of the their distinctive characteristics; a characteristic, moreover, that appears to be ineradicable. Why is that so?

The answer we find in Caves (2000) is that, for creative products, which include art – but also popular music and advertising, design, films, media and toys – demand is uncertain. Any attempt to predict that demand through research and prior testing, or worse, to force it, tends to be ineffectual.

The reason is that for a product to be creative it must provide novelty, variety and complexity. Unlike a run of the mill product, then, its success can rarely be explained even *ex post* by the satisfaction of a pre-existing need. This feature of uncertainty is what Caves calls the *nobody knows* characteristic, a state of affairs that signals the existence, not so much of asymmetric knowledge as of symmetric ignorance (ibid.: 3). This form of radical uncertainty that surrounds creative products is also the source of potential monetary losses that are obviously greater the more irretrievable (or 'sunk') are the costs needed to produce them.

It is not difficult, however, to point to the factors and strategic devices that might mitigate this symmetric ignorance. Any factor that increases the knowledge of a creative good, and helps its users to identify and interpret it, can also help somewhat to dissipate uncertainty. Styles, genres, identifiable trends, authorship, fashions, reputation and historical pedigree are, as we shall see, all tools in the hands of consumers, producers and experts that can help single out the characteristics that may orientate choice and make it more informed.

Yet Caves is right. No amount of knowledge will ever wholly free a creative good from the uncertainty that characterises it: uncertainty is not simply a necessary evil that should be taken care of, but a necessary *good* that should be constantly recreated if it disappears. Increasing the knowledge and familiarity of a creative product cannot be brought to the point of eliminating the novelty, variety – and uncertainty – surrounding it, for it is precisely these properties that make it what it is.

I shall argue that the hedonic value of creative goods – the reason why they are sought after and enjoyed – lies in their ability to generate novelty. Tastes for creative goods are the result of a precarious balance between novelty and the capacity to assess it without destroying it. The problem then becomes how to maintain this balance and transform it into economic value.

This chapter is organised as follows. First, I analyse, through the findings of recent work in experimental aesthetics, the role that novelty and cognition play in the formation of aesthetic preferences. Next, I argue that the novelty distinguishing the creativity of a specific product is socially mediated: both the domain to which the product belongs and the field – defined by the gatekeepers of the domain – are part of the process of assessing and contextualising novelty. Lastly, I address the role played by fashions in the formation of collective tastes and the opportunity they offer for social learning and the creation of market value.

My aim is to show that in order to understand the role played by uncertainty in art and creative products generally, we have to understand how aesthetic preferences work, what triggers them and what shapes them into enduring interests. What we shall see is that they are neither

purely objective – and therefore assessable with certainty – nor simply subjective – and therefore not assessable at all. Rather, they arise from our active engagement with goods and activities. In order to allow for this active engagement, goods must be open-ended, providing for both understanding and exploration, for legibility and complexity, for familiarity and novelty.

De Gustibus

The belief that preferences and tastes are highly subjective and inscrutable is well captured by the Latin phrase *De gustibus non est disputandum* – it is fruitless to quarrel about tastes. In economics this proposition has been taken a step further, as support for the view that it is fruitless also to analyse and to try to understand tastes, to uncover the reasons for the likes and dislikes that guide individual choices. There are reasons behind this attitude, principally a fear that the analysis of preferences could easily transform from being descriptive to prescriptive, thus threatening the assumption of consumer sovereignty. In matters of taste – so economists conclude – it is enough to know what is revealed by individuals' actual, free choices.

More recently, however, some psychologists and economists have moved beyond their traditional disciplinary boundaries, and have started to analyse the underlying decision rules involved in individual choices. Some results of this research have been taken as challenging the assumption of economic rationality, since they seem to show that in their decision-making processes, people are prone to systematic errors as a result of issues such as framing, myopia or social influences (Kahneman and Tversky, 1979; Thaler,1991). Other models give accounts of tastes that, while reinforcing the traditional assumption of rationality, nonetheless try to explain the interdependencies of consumption choices over time and some apparently irrational choices such as those that lead to addictions (Becker, 1996). Even these alternative approaches, however, despite their positive contributions to our understanding of decision-making processes, tend to leave preferences and their triggers substantially unanalysed. They leave us therefore with an unhelpful analytical alternative: to regard preferences either as

'clouds' – fundamentally unpredictable and subjective – or 'clocks' – as given and as stable as basic human needs.

If we want to understand the nature of our likes and dislikes of creative goods, we must explore what other disciplines have to offer. One of the more interesting results of recent experimental research on aesthetic preferences is that it allows us to show that individual preferences, though not entirely predictable, are nevertheless understandable and analysable. This research is important because, although we are used to thinking that aesthetic preferences are peculiar to art, that is not actually the case: they have more general valence and throw new light on how the hedonic value of goods in general, and art in particular, can form and change.

Aesthetic preferences

The pre-eminent modern pioneer in studies of aesthetic preferences was the experimental psychologist Daniel Berlyne, whose development of a 'new experimental aesthetics' (1971, 1974; also Berlyne and Madsen, 1973), is still the starting point of much contemporary research on the subject.

Berlyne identified a specific group of variables that appeared to be responsible for our emotional responses to art. A dance, a piece of music, a drawing or a poem all have a stimulus potential, a power to engage and attract that depends on their complexity, novelty, uncertainty, ability to surprise and ambiguity. Berlyne called these variables 'collative' since they always involve the 'collation' or comparison/contrast between two or more sources of stimulus, as when, for example, something contradicts our previous experience and we perceive it as novel, or when something does not match our expectations and we perceive it as surprising.

Yet our pleasure in novelty and other collative variables is not unbounded: novelty that is too close to the familiar can be boring, while it may be threatening if too far removed. Thus, empirically, the relation between the hedonic value of an event and collative variability traces an inverted U-shape, reflecting that both highly new, complex and

surprising events and familiar, simple, wholly anticipated events, are perceived as unpleasant. Pleasure is maximal for intermediate levels of the stimulus potential provided by such collative variables. (Bianchi, 1998, 2003).

The introduction of this new set of variables, and the way Berlyne showed them to be connected to pleasurable feelings, was a breakthrough in the study of aesthetic preferences. He supplied a new empirical basis for earlier, merely intuitional, analyses of aesthetic responses, and opened the way to more sophisticated experimentation. There was of course some early dissent and resistance to Berlyne's views, not least because of the difficulty of applying measurement to collative variables. Nonetheless, in the past 15 years there has been a resurgence of studies in the psychology of aesthetics that tend to support his original findings.

Much of the new literature appropriately underlines the relative and contextual nature of novelty and complexity and the cognitive processes that are involved in an aesthetic experience, the latter an aspect that was present in Berlyne's analysis although not fully explored by him. Appraisal theories in particular have analysed the specific cognitive assessments that elicit aesthetic responses. The result of this new approach, however, has been that when disentangling the appraisal structure of what specifically affects our response to art, the two primary components are a novelty check – appraising something as new, unfamiliar, uncertain, complex, inconsistent, inchoate, mysterious – and a coping-potential check, the ability to understand the new, unfamiliar, complex thing identified by the first appraisal (Silvia, 2006; Leder et al., 2004).

The relevance of these two dimensions of an aesthetic experience – understanding and collative variability – is shown in a number of recent experimental studies. In some of these, understanding is linked to the ability of the subject to decode the meaningfulness of an event. What these studies show is that, given an appropriate methodology, shared by participants in a study, information that heightens the meaningfulness of an experience – in this case, of paintings – translates into an increase in its hedonic value (Russell, 2003). In other studies, an aesthetic experience is a function of the perceiver's processing fluency,

and depends on all the variables that facilitate the processing of a stimulus, including both the objective features of an object (such as, in the case of visual stimuli, symmetry, figure/ground contrast and clarity) and the subjective experience of it (such as repeated exposure and expertise) (Reber *et al.*, 2004; Hekkert *et al.*, 2003).

Interestingly, confirmatory findings come also from the field of evolutionary psychology, and in particular from studies focused on the formation of landscape preferences, such as those of Kaplan and Kaplan (1989) and Kaplan (1992). In their experiments, subjects were presented with sets of images of different natural settings, and four variables emerged as systematic predictors of preference: coherence and legibility (allowing for understanding), and complexity and mystery (allowing for exploration). Natural settings that presented uniform and unmarked configurations – highly legible but low in mystery – as well as intricate, dense and impenetrable settings – high in mystery but low in legibility – ranked poorly in preference orderings. The most consistently liked were those environments with open, but partially screened views, incorporating winding and bending paths that suggested mystery and elicited further exploration but short of inducing fear and insecurity (Bianchi, 2008).

This experimental research has been extended also to features of urban spaces, housing locations, architecture and landscape paintings (see Orians and Heerwagen, 1992). Again, the environments that balance opportunities of both protection and openness with perspective views seem to be the ones that generate more positive responses. They 'evoke the feeling that there is always more to be learned' (ibid.: 572 and 573).

The results of these findings on aesthetic preferences are relevant because they help dispel the unhelpful dichotomous representation of preferences as either clocks or clouds. Goods that present the characteristics of novelty and familiarity, that balance the known and the unknown, and that leave room for new paths to be explored and learned, are the ones that trigger pleasurable responses and interested engagement. This happens for every good but mostly for those goods, such as creative goods, whose core rests on generating novelty.

These results mark real progress in our ability to understand the relationship between novelty and preferences and, correspondingly, the

role played by uncertainty in art. At the same time, it is not difficult to pinpoint certain limitations in this potential explanation.

So far we have dealt with *individual* preferences and these inevitably differ from one person to another. Assessing and responding to novelty depends strongly, as we have seen, on different, individually accumulated experience, the time and duration of the exposure, and so on. What is novel and exciting for one person may be familiar to someone else. Despite all the progress, then, we seem still to be left with an anarchy of tastes and the uncomforting earlier conclusion that when dealing with art 'nobody knows'.

The problem is actually one of co-ordination: whether there exist some social processes through which dispersed individual knowledge may converge on some shared codes of understanding and assessment. In economics, the problem of co-ordinating individual tastes has been solved by assuming that individuals respond to price signals according to their different preferences, with the market then providing overall co-ordination and balance. Here in the art world, since preferences respond not only to changes in relative prices but also to differential novelty, the issue is whether there exist some common rules through which this differential novelty can be appraised and understood so that it becomes the basis of some form of social communication and learning.

Assessing the aesthetic of creativity

In fact we begin to find an answer to the problem of shared rules for assessing/judging the creativity of a good in the literature on the social dimension of creativity. In the early psychological studies of creativity, the focus of attention was all on the person. This is how Teresa Amabile, a leading scholar in the field, describes the state of the art in the first two decades of creativity research:

> In the 1950s, 1960s, and early 1970s, the predominant impression that a reader of the literature would glean was something like this: creativity is a quality of the person; most people lack that quality; people who possess the quality – geniuses – are different from everyone else, in talent and personality; we must identify, nurture,

appreciate, and protect the creatives among us – but, aside from that, there isn't much we can do.
(Amabile, 2012: 30)

Subsequently this purely individualistic, person-based and exceptionalist view of creativity was abandoned and attention shifted to the social processes that might allow for creativity to emerge and be assessed. In order to be creative, a product must not only be novel, original or complex, but also effective and adequate to the goals and purposes it is intended to achieve. To identify and assess this combination in a creative good requires the existence of a shared system of concepts as well as an ability to communicate them to others.

The first anchor of this process of social mediation and selection of creativity is represented by what has been called the 'domain', which comprises all the creative products a specific discipline has produced in its past (Csikszentmihalyi, 1996). Indeed, it is through the internalisation of and interaction with the domain that the creative person both receives and transmits new knowledge. Correspondingly, it is against the domain that a work must be judged creative, i.e. as novel and effective. In fact, this stress on the importance of the domain highlighted a result that was already well established in the antecedent studies of creativity. Personality and cognitive studies had all shown that creativity, far from being spontaneous, innate or untrained, required intense and time-consuming investment in the knowledge of the specific and adjacent domains of application.

If the domain then represents the background of socially accumulated knowledge with which the creative person has to interact, what has been called the 'field' represents the social medium through which creativity can be selected, stimulated and diffused (Csikszentmihalyi, 1996, 1999). The field consists, at its core, of a complex network of experts with different degrees of expertise and influence. Critics, authorities and reviewers confer or withhold legitimation of a work as creative and, if they concur, also help disseminate it to the public through transmission agents such as gallery owners and auction houses, bookstores, advertisers and opinion leaders. Surrounding this core there are connoisseurs and mediating reviewers and still larger numbers of consumers (Sawyer, 2006).

This way of representing creativity as the result of a triadic interaction between the person who creates, the 'field' that selects and the domain which serves as the repository of agreed knowledge, has led many scholars to emphasise that creativity is the result of a consensual process. According to this view, creativity can be regarded as the quality of products judged to be creative by expert raters – those familiar with the domain to which the product is assumed to belong. To this end Amabile (1982) developed the Consensual Assessment Technique (CAT), a process used in experimental settings where a jury of experts was asked, on the basis of some common indicators, to rate the creativity of products and tasks from domains that included art, writing and musical composition, but also various forms of problem-solving. The results showed a high level of agreement across raters in their assessment of creativity. This approach has since been applied in experiments examining also the social and environmental elements that affect creative outcomes, and, importantly, the motivational bases of creativity.

Later developments broadened the scope of CAT. The consensual method has been used to identify the possible factors that demarcate differences in judgments between experts and non-experts (Hekkert et al., 1996). Some studies have shown, for example, that in rating artworks experts tend to equate creativity with originality (Kozbelt and Serafin, 2009) and – unsurprisingly – are able to discriminate more finely between typicality and novelty than are non-experts (Hekkert et al., 2003). Interestingly, some additional studies were completed outside the tightly controlled conditions of an experimental setting, suggesting an extension of the method to include already existing collections of creative works, such as teenagers' essays, poems and stories (Baer et al., 2004).

More recently, a new and potentially complementary approach has been advanced which [not that], unlike CAT, does not depend on a panel of experts. Particularly in cases in which special expertise is not strictly necessary, this new method nonetheless may be reliable even when used by non-experts or untrained judges (Haller et al., 2011; Cropley and Cropley, 2008). Based on clearly delineated indicators, this method – which builds on previous bases such as the creative product semantic scale (CPSS) of Besemer and O'Quin (1999) – can be applied to a variety of products and yields well-articulated assessments.

Along these lines, Cropley and Cropley (2008) have distinguished four general criteria as measures of creativity: effectiveness, novelty, elegance and generality (genesis). Each criterion was then further specified by adding indicators of different properties, including the capacity of a product to master or problematise existing knowledge, to add or produce new knowledge, and to be harmonious – as when ideas fit well together – or to have the character of generalisability. Affective impact on the beholder was also taken into account. Based on this fine-grained specification of measures, Cropley and Cropley's experimental results showed a greater rate of agreement between experts and non-experts in judging the creativity of a product and provided a technique that, according to them, could be applied in a variety of disciplines that included engineering as well as to the visual and plastic arts, and music.

Such studies help us clarify two important points regarding aesthetic preferences. The first reiterates what emerged from Berlyne's and later work, namely, that the hedonic value of a creative good rests on identifiable characteristics that comprise (1) understanding, acquired through legibility, clarity and experience, and (2) exploration, which might range from mystery to complexity, novelty and variety. The second is that the identification of these characteristics on which preferences are based is socially mediated. It is through a process of social interaction, with its articulation of institutions and conventions, that common codes of understanding can emerge and adapt to changes.

And it is through these common and shared codes that radical uncertainty is mitigated and transformed into new interpretive tools.

Fashions

There is an additional social dimension of novelty that it is important to investigate. Novelty often takes the form of major shifts in trends, styles and identifiable characteristics. This aspect of novelty belongs both to the production of creative goods and to the formation of collective tastes for them, and is what is usually understood under fashion.

There are three features of fashions that make them particularly challenging to explain. Fashions are short-lived and cyclical and, surprisingly,

these cycles are synchronised. This means that they display co-ordination, as do social conventions; unlike social conventions they are impermanent, like fads. However, contrary to fads, fashions embody strong elements of historical continuity (for a discussion of this point, see Andreozzi and Bianchi, 2007, and Bianchi, 2002).

It is probably due to this analytical complexity that only the most obvious element of fashion, that of being short-lived, captures the attention of researchers. As a consequence, fashions are often represented in economic and sociological literatures as social phenomena where people abdicate their own judgement and simply follow what the majority is doing. Set in motion by the desire for distinction among elites, so these explanations hold, fashions propagate through emulation only to be abandoned and replaced by new trends when the old ones have lost their original distinctive prestige. Fashions, then, are caught in an endless chain of mutual actions and reactions that seem completely disconnected from any form of intrinsic value in the objects of choice (see for example models of informational cascades described by Bikhchandani *et al.*, 1992). Curiously, this view of imitative preferences is the opposite of the view of individual preferences as purely subjective and unquestionable. Yet the result is the same, since in both cases changes are arbitrary and we can say nothing about their transformation.

The first element that such representations of fashion fail to recognise is that the domain of fashion is not restricted to the periphery of consumption, such as trends in female apparel, but it is quite extensive and encompasses, as we might expect, trends in art and design, in the forms and themes of entertainment, in business practices and even in science (Blumer, 1969). The idea that in fashions people passively conform to others' expectations and judgement may be true in some cases but it is doubtful that mere following can properly account for such a vast and differentiated realm of human behaviour and creative endeavour.

Additionally, and importantly, seeing fashions as a pure expression of social conformism implies, as Mumford correctly notes, that people attribute equal weight to all sources of information, as if all judges were the same, and there were no differences of expertise entering into

appraisal (Mumford, 1995: 406–407). It is more plausible to think that one abdicates one's own judgement only in the absence of any other source of information, and that the larger our individual expertise, the less we tend to conform to social cues and the more instead we prize intrinsic quality (ibid.: 410; see also McDermott, 2012: 248).

Finally, this common view of fashion overlooks the fact that the social shifts that demarcate the passage from one fashion to another are not arbitrary, but are anchored in recognisable creative features. Contrary to fads, fashions have historical continuity; the thread of fashion changes runs through, and often anticipates, the various changes that domains themselves undergo as a result of their social interaction with person and field.

In fact, it is the *terminal* points of fashions, those that signal the inversion of a cycle, that are of particular interest and in need of that explanation so lacking in the prevalent models of fashion (Blumer, 1969: 283). My earlier discussion of the role played by novelty in the formation of aesthetic preferences, adjusted to include the historical dimension of fashions, helps us to isolate and supply what is missing.

These terminal points emerge when the explorable new possibilities that a given trend can offer –and, correspondingly, its ability to engage and stimulate interest – tend to be exhausted. Sometimes these endpoints are simply dictated by the nature of the medium, as when, for example, modernist style in furniture had reached such a degree of spareness that any additional subtraction would destroy the medium itself, or when the dynamics of special effects in movies reach a maximum point beyond which they become disturbing. But more generally the terminal points of fashion cycles are determined by the fact that a specific style/genre/trend – with its identifiable admixture of diverse mediums – has reached such a degree of diffusion, recognisability and predictability, that its novelty and power of engagement is exhausted. It is at this point that, thanks to that triadic interplay of social creativity, new trends emerge, trends that often dig into as yet unexplored dimensions of the domain, or, more boldly, into different domains.

The convergence towards collective tastes that we witness in fashions is important because it shows how fashions represent a form of social learning that allows for the exploration and relative duration of the

new. Without it, any new artistic, and more generally creative, production could never reach that degree of permanence and understanding that allows the multiple investment costs that foster innovation to be covered. Fashions instead are the tool that gives emerging movements or movements that have already emerged but which are still young, a stable basis for being recognised and experimented with, thus allowing them to be exploited economically through the creation of market value.

Conclusions

In his *Analysis of Beauty* (1753 [1955]) William Hogarth discussed the internal properties of an object that might be associated with our perception of beauty. In so doing, he discarded any objectivist foundation that identified beauty with specific features such as harmony, balance or symmetry. He turned instead to those properties that are able to engage our senses and mental faculties with the joy of pursuit and variety. Hogarth concluded that there are three requirements for an object to be called beautiful: it must be fit for use, pleasing to the eye and not displeasing to the mind. Fitness and beauty, he noted, are so intertwined that often they are thought erroneously to be the same. As soon as the purpose for which the object was intended has been realised, the eye rejoices in seeing it turned and shifted and hence varied in all the aspects of its appearance. It is variety, Hogarth said, that has the power to engage the mind with the love of pursuit, and to lead the eye on 'a wanton kind of chace (sic)'. Along with variety so too quantity and intricacy are involved, since any difficulty encountered adds spring to the mind and enhances pleasure (Hogarth, 1753 [1955]: 32–38, 42; see also on this point Bianchi, 1999).

Hogarth's metaphor of the chase, and in particular his insistence that variety and uncertainty – 'wantonness' – might be viewed as positive rather than undesirable, summarises well the points discussed so far. To reiterate, first, the hedonic, affective value of a creative good rests on both understanding – through legibility and clarity – and exploration/ pursuit – through complexity, novelty and variety. Second, aesthetic preferences are interactive: they are not purely objective or simply

subjective but arise from our active engagement with goods. Third, creative goods are open-ended. Thanks to their complexity, flexibility and associative characteristics, they are open to a variety of operations that provide both the cognitive and affective qualities conducive to new interests and exploration.

This interactive view of aesthetic preferences is not only person-based but needs also a process of co-ordination and social mediation. It is through an articulated process of social interaction, with its network of institutions and conventions that common codes of understanding can emerge, and be learned and adopted. These processes disentangle extant novelty and uncertainty but also prepare for new variants.

I began by insisting that uncertainty seems to be a core element among the properties of creative goods that cannot be eliminated without eliminating the creativity itself. I then elaborated upon the recent strands of psychological enquiry that have confirmed that creativity stimulates collatively, in complex mixes of the familiar and the strange, the repeated and the varied, and so on. And I drew from this elaboration also that social and contextual dimensions are necessarily involved in our affective responses to creative goods, while at the same time these are consensual and thus discussable and analysable to a degree that a long-held conviction in economics has simply denied.

My intention here has been to show that we can better understand the role of uncertainty and risk in a market context if first we try to disentangle the role they play in the behaviour and choices of the actors, in particular of consumers, both at the individual level and in their social interactions. Only then can the enquiry usefully be broadened to other sorts of market actors and the functioning of art markets per se. I hope to have supplied a background to the first of the two-phase explorations that I see as being desirable.

References

Amabile, T.M. (1982) 'The social psychology of creativity: A consensual assessment technique.' *Journal of Personality and Social Psychology*, 43(5): 997–1013.

Amabile, T.M. and Pillemer, J. (2012) 'Perspectives on the social psychology of creativity.' *Journal of Creative Behavior*, 46(1): 3–15.

Andreozzi, L. and Bianchi, M. (2007) 'Fashion: Why people like it and theorists do not.' *Advances in Austrian Economics*, 10: 209–230.

Baer J., Kaufman J.C. and Gentile, C.A. (2004) 'Extension of the consensual assessment technique to nonparallel creative products.' *Creativity Research Journal*, 16(1): 113–117.

Bagwel, L.S. and Bernheim, B.D. (1996) 'Veblen effects in a theory of conspicuous consumption.' *American Economic Review*, 86(3): 349–373.

Becker G.S. (1996) *Accounting for Tastes*. Cambridge, MA: Harvard University Press.

Berlyne, D.E. (1971) *Aesthetics and Psychobiology*. New York: Appleton Century Crofts.

Berlyne, D.E. and Madsen, K.B. (eds) (1973) *Pleasure, Reward, Preference*. New York: Academic Press.

Berlyne, D.E. (ed.) (1974) *Studies in the New Experimental Aesthetics. Steps Toward an Objective Psychology of Aesthetic Appreciation*. Washington, DC: Hemisphere.

Besemer, S.P. and O'Quin, K. (1999) 'Confirming the three-factor Creative Product Analysis Matrix model in an American sample.' *Creativity Research Journal*, 12(4): 287–296.

Bianchi, M. (ed.) (1998) *The Active Consumer: Novelty and Surprise in Consumer Choice*. London: Routledge.

Bianchi, M. (1999) 'Design and Efficiency. New capabilities embedded in new products.' In P. Earl and S. Dow (eds), *Knowledge and Economic Organization: Essays in Honour of Brian Loasby*. Cheltenham: Edward Elgar, pp.119–138.

Bianchi, M. (2002) 'Novelty, preferences, and fashion: When goods are unsettling.' *Journal of Economic Behavior and Organization*, 47(1): 1–18.

Bianchi, M. (2003) 'A questioning economist: Tibor Scitovsky's attempt to bring joy into economics.' *Journal of Economic Psychology*, 24: 391–407.

Bianchi, M. (2008) 'Time and preferences in cultural consumption.' In M. Hutter and D. Throsby (eds) *Value and Valuation in Art and Culture.* Cambridge: Cambridge University Press, pp.236–260.

Bikhchandani, S., Hirshleifer, D. and Welch, I. (1992) 'A theory of fads, fashion, custom, and cultural change as informational cascades.' *Journal of Political Economy,* 100(5): 992–1026.

Blumer, H. (1969) 'Fashion: From class differentiation to collective selection.' *The Sociological Quarterly,* 10(3): 275–291.

Caves, R.E. (2000) *Creative Industries: Contracts between Art and Commerce.* Cambridge, MA: Harvard University Press.

Cropley, D. and Cropley, A. (2008) 'Elements of a Universal Aesthetic of Creativity.' *Psychology of Aesthetics, Creativity, and the Arts,* 2(3): 155–161.

Csikszentmihalyi, M. (1996) *Creativity: Flow and the Psychology of Discovery and Invention.* New York: Harper Collins.

Csikszentmihalyi, M. (1999) 'Implications of a systems perspective for the study of creativity.' In R.J. Sternberg (ed.) *Handbook of Creativity.* New York: Cambridge University Press, pp.313–335.

Haller, C.S., Courvoisier D.S and Cropley, D.H. (2011) 'Perhaps there is accounting for taste: Evaluating the creativity of products.' *Creativity Research Journal,* 23(2): 99–108.

Hekkert, P., and Van Wieringen, P.C.W. (1996) 'Beauty in the eye of expert and nonexpert beholders: A study in the appraisal of art.' *American Journal of Psychology,* 109(3): 389–407.

Hekkert, P., Snelder, D. and Van Wieringen P.C.W. (2003) 'Most advanced, yet acceptable: Typicality and novelty as joint predictors of aesthetic preference in industrial design.' *British Journal of Psychology,* 94: 111–124.

Hogarth, W. (1753 [1955]) *The Analysis of Beauty.* J. Burke (ed.). Oxford: Clarendon Press.

Kahneman, D. and Tversky, A. (1979). 'Prospect theory: An analysis of choice under risk.' *Econometrica,* 47(2): 263–291.

Kaplan, R. and Kaplan, S. (1989) *The Experience of Nature: A Psychological Perspective*. Cambridge: Cambridge University Press.

Kaplan, S. (1992) 'Environmental preferences in a knowledge-seeking, knowledge-using organism.' In J.H. Barkow, L. Cosmides and J. Tooby (eds) *The Adapted Mind. Evolutionary Psychology and the Generation of Culture*. Oxford: Oxford University Press, pp.581–598.

Kozbelt, A. and Serafin, J. (2009) 'Dynamic evaluation of high- and low-creativity drawings by artist and non-artist raters.' *Creativity Research Journal*, 21(4): 349–60.

Leder, H., Belke, B., Oeberst, A. and Augustin, D. (2004) 'A model of aesthetic appreciation and aesthetic judgments.' *British Journal of Psychology*, 95: 489–508.

Martindale, C. (1990) *The Clockwork Muse: The Predictability of Artistic Change*. New York: Basic Books.

McDermott, J.H. (2012) 'Auditory preferences and aesthetics: Music, voices, and everyday sounds.' In R. Dolan and T. Sharot (eds) *Neuroscience of Preference and Choice: Cognitive and Neural Mechanisms*. London: Elsevier, pp.227–257.

Mumford, M. (1995) 'Situational influences in creative achievement: Attributions or interactions?' *Creativity Research Journal*, 8(4): 405–412.

Orians, G.H. and Heerwagen, J.H. (1992) 'Evolved responses to landscapes.' In J.H. Barkow, L. Cosmides and J. Tooby (eds) (1992) *The Adapted Mind. Evolutionary Psychology and the Generation of Culture*. Oxford: Oxford University Press, pp.555–579.

Reber, R., Schwarz, N. and Winkielman, P. (2004), 'Processing fluency and aesthetic pleasure: Is beauty in the perceiver's processing experience?' *Personality and Social Psychology Review*, 8(4): 364–382.

Russell, P.A. (2003) 'Effort after meaning and the hedonic value of paintings.' *British Journal of Psychology*, 94: 99–10.

Sawyer, R.K. (2006) *Explaining Creativity: The Science of Human Innovation*. New York: Oxford University Press.

Silvia, P.J. (2006) *Exploring the Psychology of Interest*. New York: Oxford University Press.

Thaler, R.H. (1991) *Quasi Rational Economics*. New York: Russell Sage Foundation.

Art price risk, emotional and aesthetic value: Investing in boutique art funds

Rachel A. J. Pownall Maastricht University and TiasNimbas Business School

Introduction

We buy art and other types of emotional assets for a variety of reasons. Collectors derive a high level of emotional value from these items and they may purchase such assets solely for their aesthetic value and the pleasure gained from owning them. The return on these objects for collectors is purely aesthetic and emotional. Other social and psychological benefits that the owner may accrue are represented in the form of social status, social acclaim and prestige factors. At the other end of the spectrum, investors buy assets purely for financial return and choose items which maximise the expected price appreciation for the level of associated risk. However, many individuals like to invest for financial returns and also like to reap the additional benefits from the aesthetic and emotional value from the object invested in.[1]

Investing in art markets is not new. Direct investment into art is naturally as old as art is itself. The possibility to *indirectly* invest in art markets, however, is becoming increasingly attractive. There has been a growth in the number of boutique funds specialising in emotional assets and in fine art in particular. These boutique funds have a unique selling point in that they offer investors more direct access to many aspects of the art market without all the risk of holding only a small number of artworks.[2] This is similar for funds specialising in wine, stamps and photography. A few of these funds claim to invest solely for financial reward, but

investors in them are still able to signal that they have a certain level of income, wealth or social status by being able to afford the high entry level required to be part of the arts investment scene. Until shares in art or other emotional assets are offered and continuously traded, this currently constitutes the most indirect access to these markets for investors.

Although it is difficult to gauge exactly the extent to which individuals buy artworks for the emotional and/or aesthetic return or for the financial return, in this chapter I use the concept of the marginal utility of consumption as a means of distinguishing between collectors and investors. The implications of this approach highlight why boutique funds have gained in popularity in recent years. Whilst maintaining a degree of aesthetic or emotional value from owning in part a number of artworks, the collection of artworks as a whole carries less idiosyncratic risk. It becomes more attractive from a financial point of view than holding a few choice pieces. In terms of risk and return, individuals are willing to take on risk only if they obtain emotional and aesthetic return from directly holding the artwork (collector) or additional financial return (investor).

In this chapter I analyse art price risk and the opportunity to diversify an art collection or portfolio by holding a number of different artworks. I argue that there is an optimum choice to either investing indirectly into an art fund or holding, directly, an undiversified art collection consisting of a small number of artists. This choice is a function of the aesthetic and emotional value attributed to the owner. The value captures the aesthetic, psychic or emotional importance to the owner of holding art. By trading off financial idiosyncratic risk for emotional value, we derive some interesting conclusions on the apparent dichotomy between buying art as collectors or investors.

Indirect investment in art and emotional assets

The case for investment into art and the development of art indexes has been at the forefront of the evolution of investing into alternative assets, which are specifically categorised as emotional assets. See Stein (1977), Baumol (1986), Goetzman (1993), Mei and Moses (2002), for

art indexes and the case for art investment in Campbell and Pullan (2006) and Campbell (2008a). Other emotional assets, such as investment into violins and violin price indexes have been looked at in Campbell (2008b) and again more recently by Graddy and Margolis (2011). Likewise, the market for stamps is discussed in Dimson and Spaenjers (2011), and for wine by Ashenfelter (1989).

The widely held belief in the arts establishment, including dealers, auction houses, galleries and art collectors, is that investing in emotional assets for purely financial gain is inappropriate. That some funds encourage and motivate their investment by entirely financial means – apparently value-free from any morals or standing – is even perceived as distasteful in some circles. Indeed many investment vehicles whose underlying asset base can be classed under the generic term 'emotional assets' blatantly state that they are interested only in the financial gain, and fervently promote investment from a purely profit-driven perspective. This attitude is fuelled by the predominate belief in the mechanisms of a market-based system by which capital markets allocate resources by correctly being able to price efficiently through the interaction of the channels of demand and supply, without any desire to take on the responsibility or consequences of their actions. This has naturally widened the gap between those in the financial services sector who have entered the arena of investing in emotional assets, and the firmly established traditional players in these markets.[3] A better understanding of the various reasons to hold art and other investments of passion will increase the appreciation between investors and collectors and help to close this currently widening gap between the financial services industry and the arts industries.[4] Indeed the motives to hold investments and collections overlap to a certain extent and most individuals would feel hard-pressed to consider themselves a pure collector or investor. The majority of buyers of emotional assets have an intrinsic appreciation of the investment of choice.

The art market has been at the forefront of this development in the offering of financial services for emotional assets with a number of funds having been established over the past decade.[5] The market for such services has not grown as quickly as some may have anticipated, however, and several external factors have limited its expansion and prevented other players in the financial services industry from

becoming involved. First, the number of participants has been limited simply by the relatively small size of the market. With total transactions in the art market being an estimated $50 billion internationally,[6] the scale-up needed to entice larger players from the financial services industry to compete has rendered the art investment field currently inadequate. Second, the lack of regulation and systematic market-wide risk management practices play a restrictive role in preventing the art market from growing too large. For example, financial institutions require daily 'mark-to-market' accounting because, for the purpose of meeting margin requirements on capital, the assets within an investment portfolio and the price or the value of the fund needs to be measured on a daily basis. Without sufficient liquidity and transparency of prices, the means are not in place for financial institutions to be able to meet their regulatory requirements. These two factors have been sufficient to curtail any further growth and flourishing emotional asset funds by financial institutions. However, these two factors alone are not sufficient by themselves to prevent the growth in the market for such funds. Needless to say, financial markets are inherently creative at innovating products that circumvent limiting or restrictive practices. For emotional assets, however, the picture is more complex. In terms of risk and return, the investment profile for these items has simply not been high enough to compensate for the risk of investment, and thus the wider development of the industry has been hampered.

A substantial body of literature points to the issue of the financial rate of return on paintings being lower than that of other types of investments in financial assets over comparable periods. Frey and Eichenberger (1995) discuss the issues surrounding the determinants of the additional psychic returns for art above the financial return, thus reconciling the risk-to-return ratio by implying an additional positive return to the art investor. They propose measuring the psychic benefit of art from either 'rental fees', or from 'the marginal willingness to pay for viewing art in museums'. De Roon et al. (2013) infer the size of the emotional dividends for a variety of emotional assets, including stamps, art and violins.

Despite moderately low risk-adjusted returns for many investments of passion, there has been a continued growth in the demand for these 'emotional' assets. The rise in the numbers of high-net-worth

individuals and in income levels globally have fuelled the demand for such assets and the market value has grown at an unprecedented rate. As long as society continues to place such a high value on such cultural items, people will be willing to pay high prices for them. If this changes, then the sums obtained for holding such artifacts will probably fall. There is a large element of trust in putting a value on our cultural heritage when valuing such pieces. For contemporary work, the uncertainty surrounding who will go down in art history as the key artists of today is unknown, or at best debatable. For this reason alone, contemporary art markets will fluctuate more in terms of price; prices may soar or they may drop drastically. The context of the discussion here focuses more specifically on the art market but can be generalised to all other types of investments in treasure, cultural or emotional assets.

In general, as long as art holds its cultural value in society, art prices will appreciate over time, reflecting a general increase in consumer prices in line with the rate of inflation. Artworks with a rich history will tend to maintain their values well, with less variability in price movements over time. Such paintings tend not to be affected by fashion and the co-movement with overall prices is higher. In short, the risk is less. For artworks carrying greater market-specific risk (for example, the rise and fall of Impressionist paintings in the 1980s and 1990s and contemporary art in the last decade), the price variability is often much greater.[7] Artworks with a proven track record maintain their cultural and economic value, and the likelihood of falling prices is lower, so they are considered as less risky. However, for paintings that fall out of fashion and whose sale prices suffer as a result, the picture can be very different. The financial risk can be much greater: the financial return over the holding period can, in some cases, be negative, even before inflationary effects are taken into account.

What is art price risk?

The future value of artworks depends on their sales prices at an undetermined yet forthcoming point in time. The market value at that unspecified future date cannot, of course, be accurately predicted. This uncertainty often results in the owner or collector being susceptible to

art price risk. The overall movement in the art market and its variability will affect that risk. An estimate of the *market price* risk can be made by first estimating an index of overall price changes over a period of time and then assessing how widely dispersed these prices are.[8] The art price risk is estimated by the volatility of this index over time. This is a comparable approach to the indexation of equity markets, such as the S&P500, or the Dow Jones Industrial Index, and similar in construction to commercial real estate markets, which also trade heterogeneous non-diversifiable goods. Indeed real estate assets offer the most useful comparison to artworks in that both are heterogeneous goods that typically have long holding periods between sales and non-continuous trading. A number of academic studies address the issue of art price movements over time and estimate the annual variation in art price movements over similar periods. The time periods used as samples differ between studies, but all highlight that the market price of art risk is significantly larger than the risk associated with government debt and more in line with equity markets. The dealer market is not represented in these studies, as the lack of data from galleries is very limited. The higher transaction costs associated with the dealer market, however, indicate that the returns made by collectors who buy and sell through the private dealer market are indeed likely to be lower than those recorded from auction sales data. Recent research has highlighted that annual volatility is estimated accurately using either the repeat sales or hedonic regression methodologies when the frequency for the index estimation is on an annual basis. For data samples using quarterly or monthly data, the methodology suggested by Bocart and Hafner (2012) would be more appropriate.

Art market risk and artwork-specific risk

When valuing an artwork as an individual item, the risk to the owner is even greater than just the market risk. Greater uncertainty is involved as there is also risk specific to the change in price stemming from the particular artwork. This artwork-specific risk (or idiosyncratic risk) depends on factors such as the particular artist and the genre of the artwork. Taste and fashion play an important role here and can cause substantial variation in price movements over time. In theory, it should

be possible to diversify away this idiosyncratic risk, since it is specific to the particular artwork. If a large enough portfolio, or typically a large enough collection of artworks is held, then the overall collection will move in line with the overall art market. Similar to holding equity in the stock market, firm specific risk can be diversified away by holding at least 30 stocks in a portfolio. For artworks, the idiosyncratic risk will also be partially diversified away by holding a mixture of artworks across genres and artists. However, relatively small collector portfolios are highly unlikely to be diversified sufficiently for the idiosyncratic risk to be fully diversified away. In addition, the lack of indivisibility of artworks in a collection will mean that they will need to be substantial in number (and hence the total wealth of the portfolio augmented) for full diversification to happen. Wealth needs to be reasonably substantial to reduce idiosyncratic risk significantly. Indeed this depends on the average price of the artists' works, and the variation in the price range in which the artists' artworks sell for.

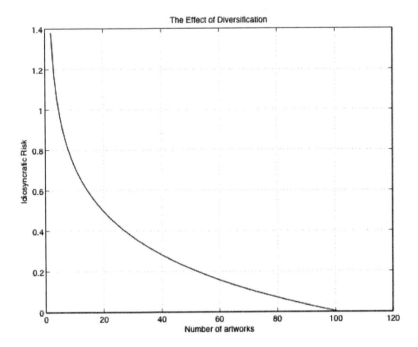

Figure 8.1 Idiosyncratic risk diversification

In fact the converse case more often occurs, and collectors remain undiversified as a result of collections typically having a particular theme or aspect that is common to all artworks; the idiosyncratic risk to the owner of such a collection is then large. The *overall* price risk derived from taking idiosyncratic and market risk together is much greater than simply accounting for market risk alone.[9]

Boutique funds as a means of reducing idiosyncratic financial risk whilst maintaining some aesthetic and emotional value

When an investor chooses to invest in a fund, a diversified portfolio of emotional assets reduces the objective financial risk on the fund. This is the basic premise behind diversifying across a number of assets or securities; the financial risk on the portfolio risk should decrease. Such a portfolio can be in the form of a diversified fund comprised of a number of emotional assets: it could involve investing in gemstones, art or wine; it could operate across sectors but stay within one type of emotional asset, such as investing in diamonds, rubies and opals, or operate across genres, such as Impressionist, modern and Old Master artworks. A fund (or fund-of-fund structure) enables a greater degree of portfolio diversification and reduces idiosyncratic financial risk. Since the average price of each item or unit of emotional assets tends to be much higher than for other types of investments, a fund able to raise sufficient capital is at a natural advantage for being able to diversify than an individual collector. A fund, therefore, needs to be of a sufficient size to start realising significant benefits from diversification. Compare the average stock price on the FTSE with the average artwork which goes for sale at auction. Securitisation of emotional assets would reduce this issue, but is still a long way off.[10] For investors who have little attachment to the emotional assets themselves, the financial risk and return profile would need to be sufficient to warrant investment into such items in the first place. For those who place a greater weighting on the emotional value of owning the piece, the gain from the reduction in

financial risk obtained through diversification may not make up for the loss in emotional value that selling a much-loved piece would bring – for these people, there is no benefit in investing in such a fund; they prefer to collect directly.

The dichotomy between collectors and investors as measured by marginal utility

The extent to which one defines him or herself as a collector or an investor when buying art will depend on the marginal utility of consumption for art. If we can think for a moment in terms of 'units' of art, generally the satisfaction gained from an additional unit of art is worth less than the previous unit. Our satisfaction generally becomes slowly satiated, so the marginal increase in utility from consuming a further unit is valued at less than the previous. Generally the marginal utility of consumption for goods diminishes per unit of the good consumed. If utility is solely a function of aesthetic and emotional value, then we can portray this function as low (in the limit zero) for investors and high (in the limit insatiated) for collectors. This is depicted by the various curves in Figure 8.2 below. In the extreme case of non-satiation, the marginal utility could even be increasing; this occurs when the addition of a particular artwork to a collection increases the total utility by a greater amount than the previous additional unit. Indeed for some collectors this may not be so uncommon as a particular piece completes a collection. Broadly, however, at some point the marginal utility from an additional artwork will start to diminish; for the collector, this may occur at quite a high level of art consumption. In Figure 8.2 we represent the pure collector as having constant marginal utility, as someone who appreciates additional pieces with a constant level of satisfaction (constant marginal utility is indicated by the straight black line).

Being both investor and collector may resonate with most people, but to differing degrees. A variety of curves are presented in Figure 8.2 depending on the time at which satiation starts to become prevalent, moving clockwise from collector to investor type. Those who are observed as having a low marginal utility of consumption from owning the artwork directly are classed more as investors than collectors (such

as depicted by the dashed line). In the event that the utility from the aesthetic element is zero (as shown by the horizontal line) the pure investor would class himself as having no emotional attachment to the asset.

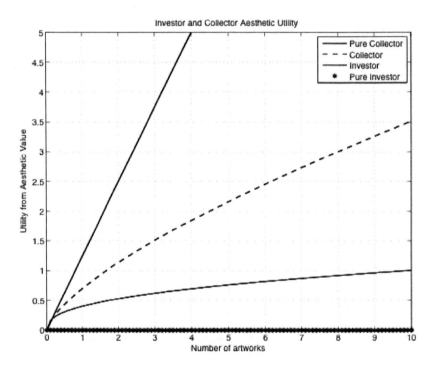

Figure 8.2 Investor and collector utility functions

Aesthetic value and indirect investment

Mean-variance portfolio theory[11] provides a separation between preferences and capital-market opportunities. Whereas capital market opportunities are summarised in the feasible mean-variance opportunity set, for returns and risks accordingly, preferences are shown by a set of indifference curves. Portfolio theory assumes that investors prefer higher expected mean returns for a given level of risk as measured by the standard deviation or variance of the return distribution. Investors therefore

trade off expected return for risk: in order to obtain higher expected returns, they are required to bear greater risk. The overall utility function represents individuals' preferences. In financial theory, we model the investor as caring only about risk-adjusted returns. His indifference curve defines the points, which he is willing to exchange these two 'goods': in this setting the properties of 'risk' and 'return'. The slope of the indifference curve therefore represents the rate at which he is willing to bear higher risk for a higher level of expected return. People with a higher aversion to risk require a higher return on their investment.

To introduce aesthetic and emotional return, we depart slightly from this general case where individuals only care about risk and return. If we assume that a collector also receives a positive aesthetic emotional return when buying art, the overall utility he receives will be higher. This can be represented by a multi-attribute utility function, such as in Bollen (2007). Higher risk reduces utility.

Utility = function (risk, financial return, aesthetic return) (1)

If we assume that the collector buys for aesthetic purposes and the investor for financial returns, we have two divergent and extreme cases. Many people will buy art for both aesthetic pleasure and also its investment value. Assuming for a moment that both investors and collectors have the same utility from the financial return and that only the collector receives a positive utility in the form of an aesthetic value, when the risk is zero, all else being equal, the collector will by definition have a higher level of overall return (aesthetic *and* financial) than the investor (financial only). We can say that the certainty-equivalent is higher for the collector as he is able to obtain a positive aesthetic return from owning and consuming the items at the point where the outcome is certain (when the risk is zero). This is shown in Figure 8.3 below, where the indifference curves for the collector intercept with the y-axis at a higher point than for the investor. On bearing risk, the investor requires a greater amount of financial return to compensate for the additional increase in unit of risk (as measured by the standard deviation) than the collector who maintains the aesthetic return. The collector is less willing to forego aesthetic return for a reduction in risk.

If we introduce a wealth constraint and assume that in order to buy a large number of artworks, the individual is required to move from

a direct to a more indirect form of investment, then even for the collector utility is marginally decreasing. The rate of decrease in utility is dependent on the rate at which the gain in utility occurred: the increase in utility from the reduction in idiosyncratic risk is offset by the loss in utility from the reduction in the emotional and aesthetic return. For the first few artworks added to the collector's portfolio, the increase in marginal utility is generally large; due to the effect of diversification, there is a substantial reduction in idiosyncratic risk. As the number of artworks in the collection increases, then this marginal gain in utility from the reduction in risk will gradually reduce. By assuming that the investment becomes more indirect in nature, we are able to ensure that the overall marginal gain in utility is diminishing: the loss in emotional and aesthetic return always being sufficiently offset by the gain in utility from the risk reduction. This prevents the case of increasing marginal utility occurring. The result from formulating the utility functions in this way is that the investor substitutes risk for return at a greater rate than the collector. The collector is more willing to bear greater risk, but also loses aesthetic return from the move to a more indirect form of investment. Remember, this loss in aesthetic return comes either through increasing satiation or through the move to a more indirect form of investment because of wealth constraints. The result is that the collector trades off risk for return at a lower rate. The slope of the indifference curve is thus less steep for the collector than the investor. The investor appears to be more averse to risk than the collector. This is an important result and is depicted in Figure 8.3 below, in grey for investors and in black for collectors. The dotted lines represent lower indifference curves for both sets of investors and collectors respectively.

Investing in an art fund reduces the aesthetic or emotional dividend accruing from an artwork, but comes at the benefit of being exposed to less art-price-specific risk. The optimal choice of investor or collector role depends on the individual's marginal utility of consumption and the corresponding level of risk aversion. Collectors whose marginal utility of consumption of art is very high will be unwilling to forego the emotional pleasure derived from owning the art and will prefer to have a more direct investment into art. Investors, on the other hand, want to

reduce their artwork-specific risk by holding a diversified portfolio of artworks and are willing to lose out on the emotional dividend of owning the painting.

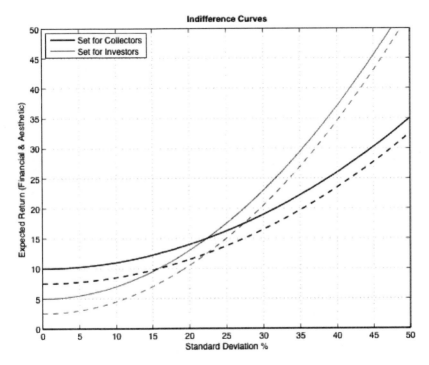

Figure 8.3 Indifference curve sets for investors and collectors

Collectors who obtain a high amount of utility from holding individual artworks will lose a corresponding amount of utility when they need to give up direct ownership of an artwork. Investors interested only in financial return have a much lower marginal utility from the consumption of art. The rate of substitution as captured by the set of indifference curves will be different for collectors and investors. The shape of the set of indifference curves is determined by the extent to which the individual values the emotional return and the level of risk aversion. The set of indifference curves will not cross when both investors and collectors are assumed to be economically rational with generally accepted risk preferences (GARP).

In the case where the fund owns and cares for the pieces, the aesthetic value from directly possessing the artefact is reduced to zero. Needless to say, the divergence of ownership and care of the artefact is left to the fund manager. This explains the successful development of many syndicated boutique funds who, with a small number of investors (who may well prefer to be called 'collectors'), are able to own a larger share in the pieces, and have access to those items while still obtaining a reduction in the financial risk of the overall diversified collection. Since (as noted above) the gains to diversification are greatest with the addition of the first few items to any portfolio, assuming imperfectly correlated movements (i.e. the marginal decrease in idiosyncratic risk quickly reduces as the number of stocks are added to an equity portfolio[12]) in a similar spirit, the gains to be had from investing in a small but slightly diversified boutique fund are substantial. Given that the structure of such a fund allows the syndicate to own and enjoy the pieces, the structure appears to maximise the aesthetic and emotional return to the members while still reducing the financial risk on the overall portfolio or collection of works enough that the structure remains favourable in many cases to individual investors.

Affective values

Investors have many other emotive reasons for investment, and these might not be reflected through the appreciation of the asset and the utility obtained from viewing the item. For many individuals, these are highly significant. In the psychology and marketing literature, these are referred to as 'affective' measures or expressive benefits. Recently, with the emergence of the behavioural field of finance, these concepts have sprung up in the finance literature.[13] According to the extent to which emotional assets are able to meet these emotional needs or affective responses, the individual will place a value on the emotional asset from investing in the asset:[14] these might include social status, reputation, social acclaim or a 'warm glow'. The more the boutique art fund can maintain these affective values whilst investing indirectly on behalf of the client, the less the reduction in emotional value as the individual moves from the direct to the more indirect form of investment. *Affect valence* captures the extent to which the individual is emotionally moved

by external emotive factors, such as status and reputation, rather than the artworks themselves. *Affect richness* depends on the emotive value derived from the artefacts themselves. If investors maintain affect valence characteristics when moving from a direct investment to an indirect form of investment, then the boutique art fund will meet the affective needs of the investors, even if the affect richness is lost.

Assuming that the emotional value of being a member of such a fund is a function of the affect valence of the investor or collector, and the emotional value gained from owning and being able to appreciate the works themselves is a function of the affect richness means, then the type of investor who is likely to be part of a boutique fund is going to have positive values for both affect richness and affect valence, and hence a positive emotional value is obtained from investing in the emotional asset. The reduction in the emotional value from not being the sole owner is more than offset by the reduction in financial risk and/or the additional utility gained from being part of the group. Collectors who derive a high level of affect richness from owning art are much less willing in this model to sacrifice emotional value for risk.

There appears to be a trade-off between the desire to actively participate in the emotional value of an emotional asset and the ability to reduce the objective financial risk, which can only be obtained by owning a large diversified portfolio of emotional assets (either across assets or across sectors from one particular asset). It is this trade-off which, I argue, is the difference – at two extremes – between investing in emotional assets for purely investment reasons and collecting for purely emotional returns. The cost of not being able to personally own and enjoy the emotional aspect of the asset itself comes with the benefit of reducing idiosyncratic risk of holding the diversified portfolio of emotional assets. In other words, the premium from not being able to diversify away all idiosyncratic risk within the emotional asset arena is the emotional value in the form of affect valence and affect richness which give the investor or collector additional positive utility, and this results in a less steep trade-off between risk and return. Since this manifests itself as lower risk aversion, the individual who has greater emotional value from investing in art appears to be less sensitive to risk. This finding is in line with the work by Rottenstreich and Hsee (2001) on 'risk as feelings'.

The optimal structure for a fund of emotional assets occurs when the marginal loss in utility from the loss in emotional value from no longer having access to or owning the objects in the portfolio or fund equals the marginal gain from the reduction in financial risk from diversifying the portfolio or fund across sectors or assets. The utility function of the individual investor or collector will determine where in this trade-off between financial risk and emotional value the investor or collector will choose to be.

Only funds large enough in size are capable of attracting investors who are less sensitive to affect richness but sensitive enough to affect valence to put their money in purely emotional asset funds, thus obtaining utility from the financial-risk-adjusted returns from the fund and from positive utility attributed to satisfying the investors affect valence. However, those investors who are also sensitive to the affect richness of the emotional asset will be unwilling to give up the utility associated from owning and having the pleasure of deriving emotional value from the object itself, and they may prefer to collect and invest for themselves. The marginal utility gained from the decrease in financial risk from holding a diversified portfolio is not sufficient to offset the loss in utility from giving up the ownership of the emotional asset. Since individuals' preferences are allowed to differ, we require knowledge of a person's utility function in terms of risk-adjusted returns, and emotional return stemming from both affect richness and affect valence. The first term is a pecuniary benefit, and the second two terms are both non-pecuniary benefits. At the other extreme, indirectly investing in art as an asset class with no contact to the art itself remains unpopular. The risk-adjusted financial returns are potentially not large enough to warrant a significant growth in this area of fund management. Although the idiosyncratic risk is diversified away when holding art indirectly via a boutique fund, other types of risk also need to be considered.

Risk and further uncertainty

What risks are found in an art investment fund and how do these funds manage these risks? There are three very important risks to consider when investing in a financial art fund:

1 the operation risk of the fund
2 the overall market risk
3 the liquidity risk

The operational risk can be high if there is insufficient information on the performance or track record of the art fund manager and of the fund in general. Further, the lack of regulation and the opaque nature of any information on investments can be a cause for concern. This risk can be mitigated by choosing to invest in art funds with both a reassuring track record and some evidence of the fund's performance. With the recent emergence of many funds, however, this is more easily said than done. This type of risk also incorporates other operating risks such as the likelihood of buying fakes or forgeries. The ultimate risk is that that the fund can go under and that the initial capital is all but lost. In terms of art price risk, investors have to realise that the sale prices of the artworks in the art fund may fall. If the art market struggles, then the value of the art fund will also drop. That said, the market risk will result in wiping out the total value of the art investment fund or collection *only* if society fails to place any value on our cultural heritage and the arts. We should also introduce the concept of liquidity risk for funds of emotional assets. If a fund is forced to sell artworks during such a period and to liquidate its position, liquidity risk would mean that the prices obtained during a quick sale are not as high as would be obtained normally, when there is greater time to market the artworks and secure the best possible price for them. Whatever the case, you should consider investing only if the risks are bearable *for you*, either through the rate of expected return on the price of the investment or through the aesthetic return from enjoying the art itself!

Conclusions

The dichotomy between collecting and investing in art can be understood in part by looking at the two extreme cases where a pure collector buys art for aesthetic reasons and a pure investor is interested only in financial gain. Most people have a foot in both camps and are part-collector, part-investor. It may be 'the fool' who is not concerned at all by the price paid for an artwork at auction, but it is the 'philistine' who

buys art and is indifferent to its aesthetic value. The continued interest in boutique art funds can be explained in terms of this dichotomy of collecting and investing. Emotional asset investors do not want to bear idiosyncratic risk, but also do not want to lose all aesthetic and emotional value from their investment. Such boutique funds enable collectors to reduce their idiosyncratic art price risk while still maintaining a great deal of emotional value from being associated with owning the artwork (in a consortium, or by renting the artworks to be able to view them at home). In as far as the financial risk adjusted returns are not high enough to encourage art investment for purely financial returns, the market is efficient in keeping the philistines at bay. Finally, these roles may be conditional on time. It is likely that in times of upward appreciation in art prices, the investor role becomes stronger; when the market moves downward (or dries up, becoming less liquid), the collector role takes precedence. Attribution biases have been observed in behavioural economics, when such asymmetric behaviour is observed.[15] The self-serving attribution bias, for example, refers to the tendency of people to attribute success to internal factors and failures to external events. In a similar manner, emotional assets generate the tendency to take on different roles as a collector or an investor according to the price level of the asset. Since the owner interprets an individual's tendency to inter-pret value as either emotional or due to price appreciation, I define this tendency a 'value attribution bias'. If owners of art tend to attribute art price appreciation to investor potential but can withstand depreciation because of emotional value, then such a bias would be prevalent. While we would all like to attribute price increases to having made a successful investment, it may be easier to admit that one bought an artwork or case of wine for its aesthetic beauty or for its taste when the price drops!

References

Ashenfelter, O. (1989) 'How auctions work for wine and art.' *Journal of Economic Perspectives*, 3(3): 23–36.

Bocart, F.Y. and Hafner, C.M. (2012) 'Volatility of price indices for heterogeneous goods.' Working paper. Université catholique de Louvain, Belgium.

Baumol, W. (1986) 'Unnatural value: Or art investment as floating crap game.' *American Economic Review*, 76(2): 10–14.

Bollen, N. (2007) 'Mutual fund attributes and investor behavior.' *Journal of Financial and Quantitative Analysis*, 42: 683–708.

Campbell, R.A. (2008a) 'Art as a financial investment.' *Journal of Alternative Investments*, 10(4): 64–81.

Campbell, R.A. (2008b) 'Fine violins as an alternative investment: Strings attached?' *Pensions*, 13: 89–96.

Campbell, R.A. and Pullan, J. (2006) 'Diversification into mutual art funds.' In *Performance of Mutual Funds: An International Perspective*. Edited by Greg N. Gregoriou. London: Palgrave Macmillan.

De Roon, F., Coedijk, C.K. and Pownall, R.A. (2013) 'Emotional assets with emotional dividends.' Working paper. TiasNimbas Business School, Tilburg University, The Netherlands.

Dimson, E. and Spaenjers, C. (2011) 'Ex-post: The investment performance of collectible stamps.' *Journal of Financial Economics*, 100: 443–458.

Frey, B. and Eichenberger, R. (1995) 'On the rate of return in the art market: Survey and evaluation.' *European Economic Review*, 39: 528–537.

Goetzman, W. (1993) 'Accounting for taste: Art and the financial markets over three centuries.' *American Economic Review*, 83: 1370–1376.

Graddy, K. and Margolis, P. (2011) 'Fiddling with value: Violins as an investment?' *Economic Inquiry*, 49(4): 1083–1097.

Heider, F. (1958) *The Psychology of Interpersonal Relations*. New York: Wiley.

Horowitz, N. (2011) *Art of the Deal*. Princeton, NJ: Princeton University Press.

Mandel, B. (2009) 'Art as an investment and conspicuous consumption good.' *American Economic Review*, 99(4): 1653–1663.

Markowitz, H. (1952) 'Portfolio selection.' *The Journal of Finance*, 7(1): 77–91.

Mei, J. and Moses, M. (2002) 'Art as an investment and the underperformance of masterpieces.' *American Economic Review*, 92(5): 1656–1668.

Pownall, R.A.J. (2013) 'Valuing the non-pecuniary benefits of assets using probability weighting functions'. Working paper, Maastricht University.

Rottenstrich, Y. and Hsee, C.K. (2001) 'Money, kisses, and electric shocks: On the affective psychology of risk.' *Psychological Science*, 12(3): 185–190.

Statman. M. (1987) 'How many stocks make a diversified portfolio?' *Journal of Financial and Quantiative Analysis*, 22 (3) (September): 353-363. New York: McGraw-Hill.

Statman. M. (2011) *What Investors Really Want*. New York: McGraw-Hill.

Stein, J. (1977). 'The monetary appreciation of paintings.' *Journal of Political Economy*, 85(5): 1021–1036.

1 In a similar manner, 'impact investing' and socially responsible investing offer investors an emotional return over and above the financial return.

2 Typical of what an investor or collector is able to afford.

3 See Horowitz (2011) for an overview of the development of investment in the art market.

4 A similar reasoning can be applied to long-term investment in general; sustainable and socially responsible investments which carry both emotional value to the investor in the form of a 'warm glow' without necessarily having to sacrifice risk-adjusted returns. See Pownall (2013).

5 The Fine Art Fund, Fernwood, China Fund, ArtVest and Aurora are just some of the larger funds which have been established, many of which subsequently did not raise sufficient capital or, for other reasons, have failed.

6 See the annual TEFAF reports for an overview.

7 The idiosyncratic risk of contemporary art is higher than for Old Masters. In a similar manner, technology stocks and small stocks bear more risk than their larger counterparts or blue-chip stocks.

8 Typically the period between sales is long and hence price indexes are used to measure general market movements. These can be tailored to specific genres of art or, when there are sufficient artworks by a particular artist, to the artist himself.

9 For example if the collection is not held in conjunction with other assets and hence the market risk is not reduced due to other diversification benefits from holding less than perfectly correlated assets of

other financial types. If the majority of a family's wealth is held in the form of an art collection, then the art portfolio from a financial perspective is likely to be highly undiversified.

10 There have been suggestions of a securitised market for artworks, where individuals can trade a share of an artwork rather than requiring a 100 per cent share in order to own the artwork. Syndicated boutique funds effectively are a step away from this type of structure.

11 See Markowitz (1952).

12 See Statman (1987).

13 Meir Statman's 2011 book, *What Investors Really Want*, provides an excellent overview of how the investment profession should be aware that investors want more than financial return, and are subject to their own emotional needs, such as status.

14 Similarly green investing and corporate social responsibility all meet particular investment profiles where there is an additional value over and above the purely financial value.

15 Attribution biases stem from the work by Fritz Heider (1958).

Microeconomics of art: Art, luxury goods and risk

Steve Satchell, Trinity College, University of Cambridge and The University of Sydney, and Nandini Srivastava, Christ's College, University of Cambridge and JP Morgan

Introduction

There is an important linkage between art (as a luxury good) and risk. Put in simple terms, art (as a luxury good) will be demanded by people with higher wealth; but higher wealth leads to higher risk tolerance through the principle of decreasing risk aversion. A distinction we shall make later on is that between initial wealth and discretionary wealth, the latter being wealth after basic needs are catered for.

The current period has seen traditional art markets such as auction houses becoming part of luxury good commercial enterprises (as examples, acquisition of Christie's by Artemis Group; of Philips by LVMH, later acquired by Russian luxury group Mercury; or Cartier's moving into art sponsorship). The commercialisation of the art market and its embedding within the luxury good market may be seen by many observers as undesirable; we take no stance on this issue. We do claim, however, that an understanding of the whole idea of a luxury good will help us understand how the art market works and how risk may be conceptualised.

To understand these cryptic remarks, we need to understand the modelling of risk attitudes. The framework we suggest is to look at how art and luxury goods have been analysed using the utility functions of economics. This will enable us to understand the decision-making

processes of agents who could either be collectors or investors, and who derive some utility from purchasing art. Utility functions in economics help model the relationship of the utility derived from ownership or consumption of goods and can be used to solve optimal decision-making by agents based on their preferences. The advantage of using utility functions is that we can characterise the risk tolerance or aversion of the individual connected with art in a measurable way, at least in theory. The analysis could well differ for investors, collectors or suppliers of art. The distinctions between these different agents seem more important as changes in the structure of the art market have led to what is perceived as a commercialisation of the sector: for evidence on this phenomenon, see El Helou (2012), Chapter 3.

With art, as with many other luxury goods, utility is derived from the quantity, price, status or expenditure which is incorporated into the utility function. Using utility functions, we can address a number of questions. For example, is art a consumption good (i.e. art is not the painting but the experience of viewing the painting) or a durable good (i.e. art is the painting that, bar some depreciation, acts as a provider of services through time)? A second example might be: can one meaningfully invest in art for its direct benefits or because of its portfolio characteristics? We hope that the requirement to include the quantity, price, status or expenditure of art into a utility function, as the literature has suggested, will help us sharpen our thinking about the above issues plus numerous others.

There is an extensive literature on luxury goods which we shall not review here as the purpose of this chapter is to survey these papers and provide a new taxonomy of them. The particular area we will focus on is the notion that art may be a luxury good. Before we get into technical detail, we note that this question is not as simple as it may seem. First, the concept of art consumption is very heterogeneous in its nature. Furthermore, the notion of a luxury good in the wider world has a number of different meanings than that used in economics. Economists define a luxury good as one whose demand elasticity of wealth (income) is greater than one. This means that if my wealth were to go up by 1 per cent, my demand for art will go up by more than 1 per cent. This idea seems quite straightforward if we were counting some simple commodity such as toothbrushes. However, in a world where art consumption

could include paintings of great heterogeneity as well as the purchase of art books and art lessons, not to mention attendance at galleries, then such an approach needs to be modified. It is possible to convert all these categories into expenditure on art but since many of them seem to have quite different characteristics, it would be inappropriate to do this without further consideration. For instance, researchers have found that attendance at cultural events is a normal good (see Gapinski, 1986). The debate about art being a luxury good or not is extensive and passionate. Many protagonists focus on either the market value of art or the cultural value. Other discussants (Fullerton, 1991) consider the public good nature of art. Treating art as a form of medicine in discussions of healthcare provides yet another way of thinking about value. The broad thrust of this chapter is to consider art in terms of market value but to note how social considerations can influence the price and indeed influence the nature and definition of luxury.

Bearing the above caveats in mind, we will present ways in which we can think about art as being a luxury good. The idea is to understand the dynamics of art consumption with respect to discretionary wealth. As described above, if discretionary wealth goes up by 1 per cent, demand for art will go up by more than 1 per cent. We look at whether this can be modelled using a simple representative agent model and utility function. To understand who or what the representative agent is, one needs to think of a fictitious individual whose demands for various goods is equal to the aggregate demand of the market. In a world where dealers, collectors, artists and the public all contribute to aggregate demand, this fictitious individual may be very hard to describe intuitively.

Next, we explore this idea of modelling the demand for art in more depth. First, we provide a review of the literature on existing utility functions that incorporate luxury goods. Building on this, we consider a case of solving a utility function to see whether we can derive the result that art is indeed such a good. This is a standard approach used by economists to try to capture the determinants of the quantity of goods that economic agents want (see Varian, 2010, Chapter 16, for more details).

After a theoretical analysis of the properties of art demand, in the next section we use an art index to test for these wealth effects. Wealth effects capture the impact of changes in (discretionary) wealth on the demand

for art. Pownall *et al.* (2013a) look at situations where aggregate wealth is proxied by stock market returns and document the necessary changes in definition required to reinterpret 'wealth' elasticity. In what follows, we use the words 'wealth' and 'income' interchangeably. From our empirical analysis, we find evidence of art being a luxury good in the calculations of elasticity. We also then consider the issue of measuring these effects with different indices and measuring the quantity of art. The penultimate section discusses inter-temporal issues in modelling art and wealth effects and also the supply of art; conclusions follow.

Art as a luxury good and risk

Definitions of basic goods using standard microeconomic theory

The framework that we assume here is the von Neumann–Morgenstern (VNM) utility theory (commonly known as 'expected utility theory'). However at some points, where the randomness of art prices is not the issue, we examine conventional deterministic models of utility. The VNM model is the basic building block in financial economics and is an appropriate tool in a book that addresses issues of art and risk. One of the key intuitive ideas that we wish to look at is the notion of discretionary wealth. The idea is intuitive; the individual first consumes the basics which may include necessities, the family's educational needs, saving for retirement etc. This is similar to a sequential choice framework: having allocated some of his or her wealth for these purposes, the rest of a person's wealth is then discretionary and the consumption of art comes out of this. To make the story very simple, everything other than art we shall refer to as 'food'. To capture the notion of sequential allocation in discretionary wealth, we will make the investor consume food first then in the next period consume art. This may not be the best way of addressing this problem, but it is an innovation and worth exploring.

Before explaining how we intend to place art in this sequential choice framework using its properties as a consumption good, we want to go over basic definitions of goods in consumer theory.

A normal good has positive income elasticity, i.e. a rise in income is associated with a rise in consumption. If income elasticity of demand of a commodity is less than one, it is a necessary good, also called a 'necessity'. What this means is that an increase in income leads to a less than proportionate increase in demand. Goods which violate this law of demand, i.e. whose consumption decreases as prices increase are called 'giffen' goods; therefore they have negative demand elasticity. A luxury or superior good is, on the other hand, associated with income elasticity greater than one, i.e. an increase in income leads to a greater proportionate increase in demand. This is an important definition for us as we shall see later whether art consumption has features of a luxury good with respect to discretionary income/wealth.

A sequential model of choice for luxury good consumption

The difficulty in analysing art lies in the fact that demand for it must be considered alongside demand for other goods, and we look at that in this section. In this simplified world, we have cash, art and food. Food and cash are essentially the same, except that food not consumed can be invested at a risk-free rate of interest. Our first approach is to consider an expected utility structure which involves consumption in period 0. The commodity consumed in the first period is denoted as food. We start by assuming that the investor consumes food in period 0 denoted by C_0 and art in period 1 denoted by C_1. Now, the budget constraint is given by $C_1 = (W_0 - C_0)(1 + r_f) + AX$ where $X = r_{A1} - r_f$, r_{A1} is the rate of return on art in period 1, r_f is the risk free rate of interest and W_0 is the initial total wealth in period 0. $W_0 - C_0$ will be discretionary wealth in this structure and, by setting this up in two periods, food is consumed first and discretionary wealth is then invested in either art or riskless bonds or a portfolio of both. The amount A is expenditure on art which can be interpreted as a quantity if we fix prices (for this exercise at least).

Of course some general remarks are possible prior to analysis; if we first consume food and then spend only the surplus exclusively on art, the proportion of discretionary wealth spent on art is a fixed 100 per cent and thus art elasticity with respect to discretionary wealth will be 1.[1] More generally, if the proportion spent on art is constant as wealth

increases, then wealth elasticity is 1. This is one of the well-known Arrow–Pratt theorems[2] and can be seen as follows.

If we take initial consumption as fixed and consider only discretionary wealth, then one of Arrow's theorems can be applied. If the investor has decreasing relative risk aversion, then if her discretionary wealth increases when initial consumption is fixed, she will increase the fraction of the portfolio held in the risky asset. Thus, in this context, $\frac{A}{W_0 - C_0}$ will increase as relative risk aversion decreases and the elasticity of art expenditure with respect to discretionary wealth will be greater than 1. This well-known result suggests a link between risk tolerance and the luxury good property. This linkage was referred to by us in the first paragraph of this chapter. The difference here is that because we are looking at relative risk aversion, we are looking at the proportion of discretionary wealth invested in art, not the money amount. However, the story is the same. We would expect luxury goods to be demanded by individuals whose risk tolerance, however defined, increases with their financial surplus. This is an important result to establish the link between discretionary wealth and demand for art that we proposed in the introduction.

We further explore elasticity issues using a sequential utility model. This involves rather a lot of mathematical detail, and can be found in Appendix 1.

We note that $A = pq$ – that is, A is art expenditure – but we fix the price of art as we vary wealth, so essentially, when prices are fixed, variations in art expenditure follow from variations in the quantity of art demanded. As we shall discuss, the quantity of art is a troublesome concept. In Appendix 2, we look at these ideas in more detail using a Stone–Geary utility function and a Bernoulli distribution (which we define) to model price variations in art.

Price and wealth effects in art

A taxonomic survey

In order to understand further how art behaves as a consumption good and to establish the existence of different price and wealth effects as

compared to a normal good, we go back to the basics. Here, we look at the price and wealth effects in art for various utility models in detail. We outline the main classes of utility functions that deal with the idea of luxury goods. We then examine how commonly used utility functions in this literature can be used to explain art as a luxury good. There is a large body of literature on luxury goods but the literature on art as a luxury good is virtually nonexistent, even though it is sometimes used as an example within a more general discussion. In what we present below, we return in more detail to our discussion adumbrated in the introduction that prices, quantities and status derived from ownership of luxury goods can be used as arguments of various utility functions. It is our contention that these concepts work equally well if we replace them by art. We make a note here that there is some disagreement amongst practitioners on whether art can be seen as a luxury good or not. It shares many of the same qualities but is different in some substantial ways. (See for example, *The Luxury Strategy* by Kapferer and Bastien: 2009: 26).

In what follows, we present a taxonomy based on different modelling approaches to luxury goods. We critically examine the different strands in the literature used to model the different properties of art as a luxury good. These can broadly be classified under four categories.

Case 1, the simple case of a standard utility function that explicitly models art

The models that explicitly consider luxury goods, for instance Ait-Sahalia *et al.* (2004), use an utility function $U(c_t, q_t)$ of the form

$$(12) \quad U(c_t, q_t) = \frac{(c_t - c_0)^{1-\phi}}{1-\phi} + \frac{(q_t + b)^{1-\psi}}{1-\psi}$$

where c_t, q_t are basic consumption and art consumption at time period t, and b, ϕ, ψ are positive constants and $\phi > \psi$. c_0 and b are the subsistence levels which are positive for basic goods and negative for art. So, we can see that art is not consumed by the poor by substituting q=0. Also, consumption of the rich is dominated by art. Using Ait-Sahalia *et al.*'s (2004) results, it can be shown that the ratio of art expenditure to total expenditure goes to 1 in the limit. This is an important result to establish the relationship between discretionary wealth (of the rich) and spending on art as a luxury good.

There is a luxury good literature, which focuses on the properties of art solely within a more general discussion of luxury goods. These properties include lower risk aversion and consumption by the wealthy, which implies spending from discretionary income. For instance, Ait-Sahalia *et al.* (2004) try to resolve the equity premium puzzle by distinguishing between the consumption of basic goods and luxury goods. They imply that luxury goods are not consumed by the less wealthy, and consumption of the wealthy is dominated by luxury goods. This is in accordance with their finding that wealth shocks affect consumption of luxury goods more than basic goods, as it is more responsive to stock returns and that the share of luxury goods in overall consumption rises as expenditures increase. This is consistent with the discretionary wealth effect in luxury goods to which we have referred and shall elaborate on later in our empirical analysis as well. Lower risk aversion for such goods is also observed. There is some evidence of this in the literature. For instance, Munk (2013: 358), Diacon (2006), Lochstoer (2009) and Ait-Sahalia *et al.* (2004) find higher risk aversion for basic or necessity goods.

Case 2, using price as utility generating

Here we can consider models like those discussed by Kalman (1968), where prices enter the utility function directly in the form $u(p_t, q_t)$.

Price effects are typically associated with luxury goods. This is like buying holidays in Cannes. Cannes is, arguably, no better or worse than many other holiday resorts but it is very expensive. Including the price of art in the utility function also addresses art as part of conspicuous consumption (see for example Tokuoka, 2012; Bakshi and Chen, 1996). Arrow and Hahn (1971, Chapter 6; see also Kalman, 1968) discussed a general equilibrium model in which agents care not only about the consumption but also about the price vector. This is because both the value of contemporaneous art possession, as well as future expected capital appreciation of art holdings, generates utility.

If price effects of art are separable, i.e. U(q,p)=U(p)+U(q), then the income and substitution effects are unaffected by the price term in utility. The above result does not apply to the Ait-Sahalia *et al.* (2004) model which involves setting U(q) to be displaced power functions in the quantities of normal and luxury goods, see equation (6) of their paper

and (12) of this chapter. We see that it does not involve a price term in utility. In fact, this utility function is completely classical in its structure. Nor does this apply to Mandel's utility function, see (14) of this chapter, since it is separable but in the money amount (expenditure) invested in art, not in the price. Kalman (1968) provides a general theory for this case which can be applied directly to art. We provide further discussion on Kalman in the next section.

Case 3, using wealth (status/ a concept of luxuriousness) directly in the utility

These models formalise this idea of including status or wealth directly as a luxury good. Within the framework of an extended Stone-Geary utility function, a luxury good can be included as follows

(13) $U(c_t, s_t, l_t) = \log(c_t) + \mu\log(l_t) + \dfrac{\theta}{1-\sigma}(s_t + \gamma)^{1-\sigma}$

where c_t, s_t, l_t are consumption, social status and leisure in period t.

The inclusion of $\gamma > 0$, has the effect of reducing the marginal utility of status by a greater amount, the smaller the wealth of the agent. Also, the risk aversion over status gambles can be reduced in the case when σ < 1. Of course the status variable could easily be art consumption or art ownership: readers may convince themselves of this by retracing the arguments above in terms of art.

Other papers that model utility from luxury goods similar to equation (13) include Luo and Young (2009, Carroll (2000, 2002) and Tokuoka (2012). Tokuoka (2012) also assumes a utility function separable in consumption and wealth. He notes that when marginal utility from wealth declines more slowly than marginal utility from consumption, wealth accumulation has a luxury good property. This is discussed in Carroll (2000) as well. He also defines luxury goods as having elasticity greater than 1 with respect to income as we have noted as wealth effects at several places in this chapter.

These models formalise the idea that luxury goods also have a wealth aspect related to the status associated with them. In 'capitalist spirit models', utility is derived because of direct preferences from the wealth or status acquired by possession of art. This is dealt with in the

assumption of the spirit of capitalism (soc), which is a demand for status (as a function of wealth) into a model of uninsurable idiosyncratic risk. So, wealth gives happiness directly not just through the consumption that it buys. This specification or 'soc' assumption dates back at least to Duesenberry (1949). An outcome of this discussed very commonly in the literature is the impact on wealth concentration. By placing wealth into the utility function, agents value wealth (art) because it gives them status which also acts as an additional incentive for agents to accumulate wealth (art). This idea has a long history in economics and is attributed to Weber (1905).

One could argue that the idea is even older. Veblen's *The Theory of the Leisure Class* (1899) formalises the satisfaction derived from the conspicuous consumption of high-priced luxuries. Thus, even though the price does not affect consumption decisions for other goods in some cases, it yields incremental utility when its price is high; effectively, an increase in the price of luxury goods is an upward shift in an agent's contemporaneous marginal utility of consumption. This could be seen as an amalgam of cases 2 and 3 or even pure case 2. Status is cited as an important motivator for consumption behaviour in affluent societies. These ideas are embedded in models that value consumers' desire for status; see Cole *et al.* (1998), Bernheim (1994) and Cooper *et al.* (2001). Abel (1990), Gali (1994), DeMarzo *et al.* (2004) and Roussanov (2010) amongst others develop and model ideas similar to 'keeping up with the Joneses' by controlling for relative wealth concerns. Duesenberry (1949) also points out that observed savings behaviour can be explained only if consumers care about relative rather than absolute consumption expenditure. Hirsch (1977) too referred to status-enhancing goods as 'positional' items that cannot be reproduced and are in fixed supply, like art. Therefore, utility is additionally derived from the fact that status confers utility at the expense of someone who consumes less of it. Status-seeking permeates other aspects of economic decision-making as well as, for instance, marriage and occupations.

For our purposes we can postulate consumption, art and wealth as three separate sources of utility. For the moment we shall ignore this more general issue and just focus on wealth. Thus we are trying to understand whether wealth accumulation contributes to our understanding of luxury goods. Suppose now that wealth W effects utility

directly; U=U(q,W). We find on solving that we get an additional substitution term, along with the traditional income term and a residual term. This is very similar to the result Kalman (1968) finds, which he calls the price off-setting income effect. We have derived these calculations in our work elsewhere. What it means essentially is that this term scales the impact of wealth on demand by the ratio of the direct marginal utility of price to the marginal utility of wealth, which seems more complicated to describe intuitively.

Case 4, using both prices and quantity, either separately, or combined i.e. expenditure in the utility function

Veblen coined the term 'conspicuous consumption' to describe consumption that is motivated by an attempt to advertise wealth. The cases that include both price and quantities, i.e. expenditures on goods as utility-generating, are related to the theory of conspicuous consumption; see, for example, Heffetz (2004, 2007). These models deal with the idea that individuals 'signal by consuming', i.e. they also value the effect of society observing their choice, and not just the effect of their choice on their own welfare.

As an example, we can look at Mandel (2009), who considers art as a conspicuous consumption good resulting from the utility derived from the signal of wealth that owning a masterpiece transmits. He assumes the utility function

$$(14) \quad U(c_t, A_t) = \frac{c_t^{\alpha}}{1-\alpha} + \frac{A_t^{\alpha}}{1-\alpha}$$

where c_t is the agent's choice of the consumption good at time t and A_t equals $q_t p_t^{\alpha}$, which is the value (expenditure) of their art collection and q_t is the quantity of art at time t. α is her coefficient of relative risk aversion. Utility is increasing and concave in the value of art and it persists without depreciation into the next period. This lack of depreciation is a common characteristic of many luxury goods such as art as noted by Piccione and Rubinstein (2008). We note here that risk tolerance for art and the consumption good are the same which is not supported by empirical evidence.

The literature does not consider additional cases where, for example, price, expenditure and wealth could enter utility separately. The above four cases will be referred to in our following subsections in the context of a broader discussion and implications of the literature.

For joint price and wealth effects, we can use our model as the agent has a utility function that depends upon both price and wealth directly. She is imbued with the capitalist spirit and likes luxury goods so U=U(q,p,W). Furthermore, we can explore income and substitution effects under different utility assumptions using the expenditure function, which we have done in additional research separately, not discussed here.

A subset of these models will now be explored in the context of the price and wealth effects more explicitly in the following section in the case of specific utility functions. We calculate the expenditure function using price and quantity, and follow our analysis to explore features of luxury goods by looking at elasticities and income and substitution effects within this.

Price and wealth effects in art utility functions

To illustrate many of the previous ideas, we shall work through an example that is rich enough to provide interesting results but not too complex technically. In this section we consider only deterministic utility problems. We begin our analysis by considering a Stone–Geary utility function where:

$$U = \alpha_1 \ln(c - \bar{c}) - (1 - \alpha_1) \ln(q)$$

and $0 < \alpha_1 < 1$. In fact, we don't need the constraint that both weights sum to 1 to ensure smoothness; we need only that both weights are positive. However, it is customary for this assumption to be made for this utility function.

Asset 1, c, is consumption, \bar{c} is the subsistence consumption and q, asset 2 is high culture (art). There is no subsistence diet of culture; this could be close to zero but for mathematical reasons we assume that demand for culture is positive. There is the usual budget constraint that

$$W_0 - cp_1 - qp_2 = 0$$

It is straightforward to show (and well known) that the demand functions are of the following form, written in terms of expenditure

$$e_1 = cp_1 = \alpha_1 W_0 + (1 - \alpha_1)\bar{e}_1$$
$$e_2 = qp_2 = (1 - \alpha_1)(W_0 - \bar{e}_1)$$

$\bar{e}_1 = \bar{c}p_1$ is defined as subsistence consumption expenditure and assumed less than W_0. Again we can anticipate that discretionary elasticity is 1 for reasons previously stated.

The term $(W_0 - \bar{e}_1)$ is called 'supernumerary income' in the expenditure literature and 'discretionary' wealth in the high-net-worth finance literature. This model says that for consumption, you demand the subsistence quantity plus a fixed proportion of your discretionary wealth whilst, for high culture, demand is a fixed proportion of your discretionary wealth.

With this set-up, we see that income effects are positive and consequently (Marshallian) demand is negatively sloped, cross-price effects are zero for the impact of a change in high culture prices on consumption demand but an increase in prices will bring about a fall in the demand for high culture – they are substitutes. Furthermore the income elasticities can be shown to be

$$\frac{\alpha_1 W_0}{q_1 p_1} = \frac{\alpha_1 W_0}{\alpha_1 W_0 + (1 - \alpha_1)\bar{e}_1}$$

and

$$\frac{(1 - \alpha_1)W_0}{q_2 p_2} = \frac{W_0}{W_0 - \bar{e}_1}$$

for asset 1 and 2 respectively.

We see that consumption is a necessity while high culture is a luxury in that their wealth elasticities are less than and greater than 1 respectively. We also note that with respect to discretionary wealth, as discussed, high culture has a discretionary wealth elasticity of 1; this latter result is a little annoying, we would prefer the results for wealth and discretionary wealth to be reversed. To remind readers what these results mean, a 1 per cent increase in wealth leads to 1 per cent increase in the number of paintings bought if the wealth elasticity is 1. The problem above can be

resolved by the choice of a slightly different utility function. In Appendix 4, using the Ait-Sahalia *et al.* utility function, we provide a framework which gives a discretionary wealth elasticity for art that is greater than 1.

There is a further linkage between the slope of the demand curve for art and wealth effects. We briefly set out the income and substitution effects in art ignoring randomness and considering the single-period consumption problem so we don't use any subscripts. The mathematical details are in Appendix 3. These effects, although important to economists, are secondary to our discussion here and we leave these ideas in the Appendix. This is based on the famous Slutsky equation (Varian, 2010) and we discuss these linkages in Appendix 3.

Measuring wealth elasticities for art: Some empirical issues

A note on measuring these effects: The case of art indices

It is worth noting here the practical aspect of measuring these effects. With respect to art, we recognise the difficulty in obtaining a direct measure for art prices because of issues of heterogeneity, transaction costs as well as fragmented markets. So the most common way of measuring is using a price index. Since we plan to use such an index to empirically compute elasticities, we should warn the reader of the problems associated with indices.

Indices are mostly constructed using the averaged and median auction prices of art sold (Renneboog and van Houtte, 2002). The assumption made here is that the distribution of quality of the paintings is relatively constant over time. The commonly named disadvantage of this method is the weakness of coverage where, for instance, primary sales by artists are seldom captured. There are several reasons why these indices might be biased, including during boom times, when better known or rarer paintings might be sold which can exacerbate price rises. Heterogeneity of quality of art might dictate variation in average prices rather than movements in prices of the same artworks.

Heterogeneity also implies that price of art to some extent depends on its own characteristics (Chanel and Ginsburgh, 1996). This has motivated construction of hedonic price indices, the first of which being Court (1939), that control for more permanent determinants of price variations, i.e. quality features of the artwork that add value and make it unique, which can then be separated from pure time effects. Anderson (1974) was the first to use hedonic regression on art prices. A problem with these indices is obviously the choice of these determinants as noted by Ginsburgh *et al.* (2006). Commonly used features are the artist, size, medium, material, artist's living status and auction house, all of which are easy to observe and quantify according to Renneboog and Spaenjers (2009).

The repeat sales regression approach estimates the average return on the set of assets in each period. However, the methodology relies on the frequency of sales, only those artworks that have been traded at least twice can be used which constrains the sample size. It also leads to a problem of sample selection bias as some artworks are not traded frequently at all and go on sale very rarely, which makes it very difficult to identify time effects (Kraeussl and Lee, 2010; Bourassa *et al.*, 2006; Zanola, 2007; Ashenfelter and Graddy, 2002). Another problem as a result is that there might be some unobservable characteristics of frequently traded artworks. These might be systematic or fixed, and can bias the results. A comparison of repeat sale and hedonic models by Chanel and Ginsburgh (1996) indicates that both regressions yield similar estimates of real rates of return in art assets over long intervals.

In other work, we have used an index constructed by Rachel Pownall based on a repeat sales methodology to examine wealth effects in art markets in Pownall *et al.* (2013a). The index is constructed using auction price data of art from 1895. However, as Ashenfelter and Graddy (2002) note, the auction institution itself, with commissions, experts, pre-sale estimates, reserve prices, and sequential sales, can have a profound influence on the price of art.

Measuring the quantity of art

It is clear that paintings are not homogeneous and that expenditure on art could include many different categories such as attendance at gallery exhibitions, purchase of art books etc., as discussed above.

There seems no solution here that will fit all possible situations but one way forward would be to classify expenditure into types and treat these as sub-categories.

Empirical measurements of wealth elasticity

We have annual data on the *Financial Times* All Shares (FTAS) and the London All Art price index from 1895–2011. The London All Art price index uses the London sales from the European Art Database and is constructed using the repeat sales approach used in Mei and Moses (2002), who use comparable data for the US art market. Sales of identical artworks are identified and art returns are constructed using the purchase and sales price over the holding period. The data includes over 10,000 repeat sales pairs for constructing the repeat sales index for London auction sales only. The London art market has been for many years – and remains – a very important auction market for the major collecting art classes. More details of the index construction are provided in Pownall *et al.* (2013a).

As with every art index, it is helpful to understand its limitations: not every index will include gallery sales, and all indices will exclude direct cash sales by artists to patrons. It is hard to know what proportion of expenditure is included. Some limited evidence presented in a report by Access Economics Ltd (2004: 6) based on a 1990–2000 ABS survey of Australian galleries estimate that gallery sales were in excess of double auction sales, that these were roughly 50 per cent secondary sales as opposed to primary sales. So a very rough estimate might be that auction art sales reflect a quarter of the market overall; that is, 50 per cent of repeat sales which in turn are about 50 per cent of the total sales. We acknowledge the crudity of our estimates although they are not uncommon for the industry.

We take a look here at the long run elasticities of art prices with respect to stock market returns including (ftastotal) and excluding dividends (ftas). This can easily be accomplished by running logarithmic regressions of art on the logarithm of the appropriate art price index; the results are presented below.

First, we run the regression on log of art index and ftastotal and ftas index which gives us the following:

$$\log(art) = -0.128 + 0.7189 \log(\text{ftastotal})$$

$$\log(art) = 0.6202 + 1.3918 \log(\text{ftas})$$

This indicates a higher elasticity with respect to stock prices excluding dividends. This could indicate what we have discussed previously as the different spending on luxury goods from discretionary wealth as opposed to non-discretionary wealth. Dividends have historically been treated as a more stable income flow and hence, a more stationary or less volatile source of wealth. On the other hand, capital gains are treated more like discretionary income or wealth and hence any increase in this wealth could have a significantly higher impact on spending on art. This is also recognised in the literature in behavioural finance, where investors distinguish between capital and dividends through a notion of mental accounting wherein dividends flow into the necessity account and capital gains enter the luxury account. These sorts of explanations have not enjoyed much popularity in a world dominated by the Modigliani–Miller (1958) theorem which claims that, under strong conditions, investors should be indifferent between dividends or capital gains as they can fabricate dividends by selling shares (see for example Meir Statman's 'Behavioral finance versus standard finance'; 1995: 3). It worth noting here the same calculations done in returns adjusted for inflation give a quite different picture.

Inter-temporal issues and the supply of art

So far we have discussed only single-period models in explaining the properties of art. However, many of the features of art are best understood in a multi-period context. Very little has been written about this, an exception being the work by Lévy-Garboua and Claude Montmarquette (1996). Their approach is to use multi-period utility functions in order to capture an aspect of cultural consumption, which can be described in terms of rational addiction. The idea being that as one 'consumes' more art, one's appreciation of art improves. Clearly, these sorts of patterns cannot be captured in a single period in an interesting way. Other versions do consider the utility of art but for an

infinitely lived agent in a stationary environment, and these assumptions convert the problem into a timeless one.

There are simpler issues to consider, however. The notion of the 'aesthetic dividend' – which can be defined as an unobservable flow of consumption that one experiences through the ownership or experiencing of art – is again more clearly understood in a multi-period context than a single period one. So if we were to ask how the consumption of art was to differ from the consumption of food over many periods, it would be reasonable to assume that utility is derived from the consumption of food at the point of ingestion but not after that point. If we think of this as a perishable, then there is a peak of utility in one period and zero utility afterwards. By contrast, art has the characteristic of a durable good and utility will be derived from the point of purchase through many periods after that.

Estimation of the aesthetic dividend is possible if we are prepared to make extra assumptions about how it fits into a broader structure; for example, if we were to assume that art and shares give investors the same expected utility in equilibrium once we have adjusted for risk etc., then we could define the aesthetic dividend as that certainty-equivalent return that equates expected utility of art with that of equity. The idea is simple but the details may not be and such a definition can always be criticised for assumptions made about the nature of the utility function, the assumptions about returns to the different asset classes and their temporal and cross-sectional dependence structure. For further discussion, see Pownall *et al.* (2013b).

Another important issue is to consider the supply side of art. So far, we have dealt only with the demand but the nature of supply is also worth commenting on. In general, within the different art markets (Old Masters and modern art, for example), there is great variability in the quantity of a particular type of art being offered. One way to deal with that could be to consider a cobweb-type model where wealth and price expectations impact both demand and supply. Non-linearities could be included whereby exogenous shifts in wealth could trigger qualitative changes in demand/supply, leading to dynamic regime-switching in prices as estimated by Pownall *et al.* (2013a). There is also a school of thought that considers the link between economic activity and

sentiment with art supply. In periods of economic boom, creativity becomes a scarce resource. There could be an opposing effect of greater investment in cultural activities and art capital, during boom times. On the other hand, periods of poverty are identified with surges in supply as creativity is stimulated. Cowen and Tabarrok (2000) use their model of labour supply to consider the economic forces behind the high/low culture split, why some artistic media offer greater scope for the avant-garde than others, why so many artists dislike the market and how economic growth and taxation affect the quantity and form of different kinds of art.

Conclusions

Investigating art as a luxury good is a growing theme in the art world. An enhanced understanding of art in this context is important not just for studying the properties of art but also the related question of risks stemming from these. To address these issues, there is a need for systematic theoretical and empirical analyses which our chapter aims to provide. Studying art starts off as being a simple issue to analyse and rapidly becomes more complicated. We outline a number of approaches to this that have, or could, be tried. We work through a number of simple cases where explicit analysis is possible. Our analysis focuses on discretionary wealth and we examine ways in which discretionary wealth impacts on art demand. Different economists have approached the role of luxury goods in a number of contrasting ways and we extend this analysis to get a better understanding of how to model art.

We expect the above models not to capture all the subtleties of art investment in the real world so we look at actual UK data. We estimate an expenditure function for UK art where we proxy wealth by a stock market index. This provides evidence that the luxury aspect of art is associated more with discretionary wealth (in this situation, the ex-dividends index) than with total wealth (the total returns index).

Concluding, in terms of this chapter's contribution to this volume on art and risk, we have found statistical evidence that art can be seen as a luxury good allowing for nominal measures of prices and wealth. This

provides the linkage between art and risk, as discussed in the introduction. Repeating this point, art is invested in largely by wealthy investors. Most economic theory suggests decreasing absolute risk aversion, meaning a higher tolerance for risk at higher wealth levels. This is the fundamental justification for a study of luxury goods, such as art, in the context of a broader study of art and risk.

In terms of investor risk tolerance, there seems to be an urban myth that art enjoys a higher risk tolerance than necessities; our results provide some support for this. Further work on these topics will investigate art's role as a hedging instrument, a store of value, an investment instrument and a source of inspiration.

References

Abel, A. (1990) 'Asset prices under habit formation and catching up with the Joneses.' *American Economic Review*, Papers and Proceedings, 80: 38–42.

Ait-Sahalia, Y., Parker, J.A. and Yogo, M. (2004) 'Luxury goods and the equity premium.' *Journal of Finance*, 59: 2959–3004.

Anderson, R.C. (1974) 'Paintings as an investment.' *Economic Inquiry*, 12: 13–26.

Arrow, K. and Hahn, F. (1971) *General Competitive Analysis*. San Francisco: Holden-Day.

Ashenfelter, O. and Graddy, K. (2002) 'Art auctions: A survey of empirical studies,' Princeton University, Department of Economics, Center for Economic Policy Studies, Working Papers: 121, 2002.

Bakshi, G.S., and Chen, Z. (1996) 'The spirit of capitalism and stock-market prices.' *American Economic Review*, 86: 133–157.

Bernheim, B.D. (1994) 'A theory of conformity.' *Journal of Political Economy*, 102: 841–877.

Bourassa, S.C., Hoesli, M. and Sun, J. (2006) 'A simple alternative house price index method,' *Journal of Housing Economics*, 15: 80–97.

Carroll, C.D. (2000) 'Why do the rich save so much?' In Joel B. Slemrod (ed.) *Does Atlas Shrug? The Economic Consequences of Taxing the Rich.* Cambridge, MA: Harvard University Press.

Carroll, C.D. (2002) 'Portfolios of the rich.' In *Household Portfolios: Theory and Evidence.* Cambridge, MA: MIT Press.

Chanel, O. and Ginsburgh, V. (1996) 'The relevance of hedonic price indices.' *Journal of Cultural Economics*, 20: 1–24.

Cole, H.L., Mailath, G.J. and Postlewaite, A. (1998) 'Class systems and the enforcement of social norms.' *Journal of Public Economics*, 70: 5–35.

Cooper, B., Garcia-Penalosa, C. and Funk, P. (2001) 'Status effects and negative utility Growth.' *The Economic Journal*, 111: 642–665.

Court, A.T. (1939) 'Hedonic price indexes with automotive examples.' *The Dynamics of Automobile Demand.* New York: The General Motors Corporation, pp.99–117.

Cowen, T. and Tabarrok, A. (2000) 'An economic theory of avant-garde and popular art, or high and low culture.' *Southern Economic Journal*, 67: 232–253.

DeMarzo, P.M., Kaniel, R. and Kremer, I. (2004) 'Diversification as a public good: Community effects in portfolio choice.' *The Journal of Finance*, 59: 1677–1716.

Diacon, S. (2006) 'Utility analysis, luxuries and risk', *Economic Letters*, 91: 402–407.

Duesenberry, J.S. (1949) *Income, Saving, and the Theory of Consumer Behavior.* Cambridge, MA: Harvard University Press.

El Helou, K. (2012) 'The synergies between art and luxury.' Masters Dissertation, Sotheby's Institute of Art.

Gali, J. (1994) 'Keeping up with the Joneses: Consumption externalities, portfolio choice, and asset prices.' *Journal of Money, Credit and Banking*, 26: 1–8.

Gapinski, J.H. (1986) 'The lively arts as substitutes for the lively arts.' *American Economic Review*, 76: 458–466.

Ginsburgh, V., Mei, J. and Moses, M. (2006) 'The computation of prices indices.' *Handbook of the Economics of Art and Culture*. Philadelphia PA: Elsevier.

Heffetz, O. (2004) 'Conspicuous consumption and the visibility of consumer expenditures.' Working paper, Princeton University.

Heffetz, O. (2007) 'Conspicuous consumption and expenditure visibility: Measurement and application.' Working paper, Cornell University.

Hirsch, F. (1977) *Social Limits to Growth*. London: Routledge & Kegan Paul.

Huang, C. and Litzenberger, R. (1988) *Foundations for Financial Economics*. Harlow: Prentice-Hall.

Kalman, P. (1968) 'Theory of Consumer Behavior When Prices Enter the Utility Function.' *Econometrica*, 36: 497-510.

Kapferer, J. and Bastien, V. (2009) *The Luxury Strategy: Break the Rules of Marketing to Build Luxury Brands*. London: Kogan Page.

Kraeussl, R. and Lee, J. (2010) 'Art as an investment: the top 500 artists.' Discussion paper, VU University, Amsterdam.

Levy-Garboua, L. and Montmarquette, C. (1996) 'A microeconometric study of theatre demand.' *Journal of Cultural Economics*, 20: 25-50.

Lochstoer, L.A. (2009) 'Expected returns and the business cycle: Heterogeneous goods and time-varying risk aversion.' *The Review of Financial Studies*, 22: 5251-5294.

Luo, Y. and Young, E.R. (2009) 'The wealth distribution and the demand for status.' *Macroeconomic Dynamics*, 13, 1-30.

Mandel, B.R. (2009) 'Art as an investment and conspicuous consumption good.' *American Economic Review*, 99: 1653-1663.

Modigliani, F. and Miller, M. (1958) 'The cost of capital, corporation finance and the theory of investment.' *American Economic Review*, 48: 261-297.

Munk, C. (2013) *Financial Asset Pricing Theory*. Oxford: Oxford University Press.

Piccione, M. and Rubenstein, A. (2008) 'Luxury prices: An expository note.' *Japanese Economic Review*, 59: 127–132.

Pownall, R., Satchell S.E. and Srivastava, N. (2013a) 'A random walk through Mayfair,' in mimeo.

Pownall, R. A. J, Satchell S.E., Srivastave, N. (2013), "The Estimation of Psychic Returns for Cultural Assets", Finance Discipline Discussion paper No. 2013-001, University of Sydney Business School.

Renneboog, L. and Spaenjers, C. (2009) 'Buying beauty: On prices and returns in the art market,' Discussion Paper 2009-004, Tilburg University, Tilburg Law and Economic Center.

Renneboog, L. and Van Houtte, T. (2002) 'The monetary appreciation for paintings, from realism to Magritte.' Working paper, Tilburg University.

Roussanov, N. (2010) 'Diversification and its discontents: Idiosyncratic and entrepreneurial risk in the quest for social status.' *Journal of Finance*, 65: 1755–1788.

Statman, M. (1995) 'Behavioral finance versus standard finance.' AIMR Conference Proceedings. Vol. 1995: 7. Association for Investment Management and Research

Tokuoka, K. (2012) 'Is wealth accumulation a luxury good?' *Economics Letters*, 115: 523–526.

Varian, H. (2010) *Intermediate Microeconomics: A Modern Approach*. 8th ed. New York: W.W Norton & Co.

Veblen, T. (1899 [1994]) *The Theory of the Leisure Class: An Economic Study of Institutions*. London: Unwin Books [New York: Dover Publications].

Weber, M. (1905) *The Protestant Ethic and the Spirit of Capitalism*. Trs. Talcott Parsons. Los Angeles: Roxbury.

Zanola, R. (2007) 'The dynamics of art prices: The selection corrected repeat-sales index.' Paper presented at the Art Markets Symposium, Maastricht, March 2007.

Appendix 1

Here we explore linkages between demand for luxury goods and initial wealth rather than discretionary wealth. Returning to the utility problem, where U() denotes the investor utility function in period 0 or period 1, we have the following problem. The consumer wants to maximise intertemporal utility as follows

$$\underset{C_0, C_1}{Max}\, U = U(C_0) + \beta U(C_1)$$

The first order conditions give us the following

(1) $$U'(C_0) = hE[U'(C_1)]$$

where $$h = \beta(1 + r_f) \ .$$

(2) $$E[U'(C_1)X] = 0$$

where $C_1 = (W_0 - C_0)(1 + r_f) + AX$

Differentiating with respect to initial wealth W_0, we see that equation (2) becomes,

(3) $$E[U''(C_1)X\left[1 - \frac{\partial C_0}{\partial W_0}\right](1 + r_f) + E[U''(C_1)X^2]\frac{\partial A}{\partial W_0} = 0$$

So,

(4) $$\frac{\partial C_0}{\partial W_0} = 1 + \frac{E[U''(C_1)X^2]\frac{\partial A}{\partial W_0}}{E[U''(C_1)X](1 + r_f)}$$

Equation (4) gives us an expression for the change in current consumption as a function of current wealth. We are interested in conditions that determine if art is a luxury good with respect to total wealth.

The key result is the sign of the denominator that is critical to the proof of the Arrow theorems. The result is proved in Huang and Litzenburger (1988) that if absolute risk aversion (ARA) is increasing in its argument, then the denominator is negative. If we define invested/discretionary wealth as $I = W_0 - C_0$; then

$$\frac{\partial A}{\partial(W_0 - C_0)} \frac{\partial(W_0 - C_0)}{\partial W_0} = \frac{\partial A}{\partial W_0}$$

$$\frac{\partial A}{\partial W_0} = \frac{\partial A}{\partial I}\left(1 - \frac{\partial C_0}{\partial W_0}\right)$$

which allows us to recapture the standard expression (see Huang and Litzenburger, 1988). This also informs us that if time zero consumption is a necessity with income elasticity less than 1 and if not all our wealth is consumed, (I>0) and if ARA is decreasing (DARA) in period 1 so that $\frac{\partial A}{\partial I}$ is positive, then $\frac{\partial A}{\partial W_0}$ is also positive. This means that as total wealth goes up expenditure for art goes up so that art is a normal good. This does not tell us if it is a luxury good or a necessity according to the definitions we discussed earlier although we can anticipate discretionary wealth elasticity to be 1.

If we now differentiate (1) in the same manner, we get

(5) $U''(C_0)\frac{\partial C_0}{\partial W_0} = h(1+r_f)E[U''(C_1)]\left(1 - \frac{\partial C_0}{\partial W_0}\right) + hE[U''(C_1)X]\frac{\partial A}{\partial W_0} = 0$

This can be rearranged as

$$\left(U''(C_0) + h(1+r_f)E[U''(C_1)]\right)\frac{\partial C_0}{\partial W_0} = h(1+r_f)E[U''(C_1)] + hE[U''(C_1)X]\frac{\partial A}{\partial W_0}$$

We now substitute from (4) into (5)

$$\left(U''(C_0) + h(1+r_f)E[U''(C_1)]\right)\left(1 + \frac{E[U''(C_1)X^2]\frac{\partial A}{\partial W_0}}{E[U''(C_1)X](1+r_f)}\right)$$

(6) $$= h(1+r_f)E[U''(C_1)] + hE[U''(C_1)X]\frac{\partial A}{\partial W_0}$$

Let $M = \frac{E[U''(C_1)X^2]}{E[U''(C_1)]}$ and $N = \frac{E[U''(C_1)X]}{E[U''(C_1)]}$. M>0 in all cases, N<0 if DARA.

We also note that if we set $\frac{U''(C_1)}{E[U''(C_1)]} = p(C_1)$, then, $p(C_1)$ can be interpreted as a probability function in that it is non-negative and integrates to 1. Then by the properties of the variance $N^2 - M > 0$. Furthermore,

$$\left(U''(C_0) + h(1+r_f)E[U''(C_1)]\right)\left(E[U''(C_1)X](1+r_f) + E[U''(C_1)X^2]\frac{\partial A}{\partial W_0}\right)$$

$$= h(1+r_f)^2 E[U''(C_1)X]E[U''(C_1)] + h(1+r_f)E[U''(C_1)X]^2\frac{\partial A}{\partial W_0}$$

Thus,

$$\left(P + h(1+r_f)\right)\left(N(1+r_f) + M\frac{\partial A}{\partial W_0}\right) = h(1+r_f)^2 N + hN^2(1+r_f)\frac{\partial A}{\partial W_0}$$

where P is the ratio of second derivatives of utility which is again positive.

$$PN(1+r_f) = (h(1+r_f)(N^2 - M) - PM)\frac{\partial A}{\partial W_0}$$

Thus, art is a normal good if we have DARA for period 2 utility since the numerator is negative and the denominator is negative.

$$\frac{\partial A}{\partial W_0} = \frac{PN(1+r_f)}{(h(1+r_f)(N^2 - M) - PM)}$$

$$\frac{\partial C_0}{\partial W_0} = \frac{h(1+r_f)(N^2 - M)}{(h(1+r_f)(N^2 - M) - PM)}$$

In this case, the numerator is unambiguously negative and the denominator consists of the same negative term minus a positive term. So the derivative is positive and less than one. Thus, initial consumption is a normal good which may be a necessity or a luxury where $M = \frac{E[U''(C_1)X^2]}{E[U''(C_1)]}$ and $N = \frac{E[U''(C_1)X]}{E[U''(C_1)]}$. We have further analysed this problem in the special case of quadratic utility functions although the results are long and tedious and we do not present them here. A clearer solution awaits further research.

Appendix 2

Stone–Geary utility function: An application

Following our previous analysis, we now consider a simple Stone–Geary function as an example to illustrate wealth elasticity. We do this because it allows us to consider discretionary wealth in a natural way.

We assume $U(C_0) + \beta U(C_1)$ can be represented as

$$lx2n(C_0 - \overline{C}) + \beta E\left[lx2n((W_0 - C_0)(1 + R_f) + A(R - R_f))\right]$$

where \overline{C} is the subsistence or necessary level of consumption.

Here, equation (1) from earlier becomes

$$(8)\ \frac{1}{C_0 - \overline{C}} = E\left[\frac{\beta(1 + R_f)}{(W_0 - C_0)(1 + R_f) + A(R - R_f)}\right]$$

$$(9)\ E\left[\frac{(R - R_f)}{(W_0 - C_0)(1 + R_f) + A(R - R_f)}\right] = 0$$

Equation (9) can be expressed as

$$\frac{1}{A} - \frac{(W_0 - C_0)(1 + R_f)}{A} E\left[\frac{(R - R_f)}{(W_0 - C_0)(1 + R_f) + A(R - R_f)}\right] = 0$$

Using (8),

$$\frac{1}{A} - \frac{(W_0 - C_0)}{\beta A(C_0 - \overline{C})} = 0$$

We see that

$$C_0 = \frac{W_0 + \beta \overline{C}}{1 + \beta}$$

$$W_0 - C_0 = \frac{\beta(W_0 - \overline{C})}{1 + \beta}$$

We can see immediately that initial wealth elasticity of time zero consumption is less than 1 (necessity) as we would expect. To answer the question as to whether culture/art is a luxury good, we need to make specific assumptions about the distribution of R.

Equation (9) becomes

$$(10) \quad E\left[\frac{(R - R_f)}{(W_0 - \overline{C})\beta + (1 + \beta)A(R - R_f)}\right] = 0$$

which can be solved for a given distribution of R.

This result does not seem terribly helpful without making specific distributional assumptions but what is clear is that, at least numerically, we can solve for A (art expenditure) from this equation. Knowledge of A as a function of either initial wealth or discretionary wealth will enable us to address elasticity issues which will resolve whether art is a luxury good or not.

For example, if we assume that the excess return of art is equal to d with probability p or -d with probability (1-p), then we can solve (10) above to show that

$$(11) \quad A = \frac{(W_0 - \overline{C})(2p - 1)\beta}{(1 + \beta)d}$$

Thus, for this distribution it is apparent that the discretionary wealth elasticity is 1 as anticipated here by earlier remarks whilst the initial wealth elasticity is $\frac{W_0}{(W_0 - \overline{C})}$ which is greater than 1 so at last art is a luxury good. If initial wealth is only slightly in excess of survival food expenditure, a small proportional increase in wealth will lead to a large proportional increase in art expenditure. The good is normal if p is greater than 0.5 which would require the art market to outperform cash more than 50 per cent of the time. The coefficient on discretionary wealth (the multiplier, alternatively the portfolio weight) may be greater than 1 if art is normal, for plausible values. So, if β=.9, d=.1 and p=.65, the

coefficient is about 1.4. This means that if discretionary wealth is 100, art expenditure is 140. This means that what we are doing is borrowing 40 to finance our art expenditure (shorting cash).

There has been some speculation as to whether there is any linkage between luxuriousness and risk. The Arrow results certainly link risk attitudes and luxuriousness. However, in the simple model that leads to (11), both of these are exogenous factors so we cannot talk about causal relationships but we can treat (11) as a given and compute some comparative statics. We present our result below as a proposition.

Proposition

If excess returns of art are given by a Bernoulli distribution with values d and -d and associated probabilities p and (1-p) so that the standard deviation scales with d and defining initial wealth elasticity of art expenditure (assuming fixed prices) to be ε and the proportion of initial wealth invested in art to be ω, then the following holds

$$d = \frac{(2p-1)\beta}{(1+h)\omega\varepsilon}$$

Proof

We simply take (11) divide both sides by initial wealth and rearrange.

Comment

This result is a comparative static and is looking at the comovements of two parameters given an optimal demand relationship but what it is saying is that if demand is fixed, then there is a trade-off between volatility of art returns and the initial wealth elasticity of art expenditure.

A more general interpretation would be that the utility function corresponds to the representative agent (the art market) and the supply of art is fixed which seems reasonable in the short-run and/or for non-modern art. In which case it is the price of art that is determined by the equilibrium and thus the return distribution is determined by the supply of art through movements of the price. However such calculations do not appear fruitful for this rather trivial assumed returns distribution.

Appendix 3

Case 1 is the standard case discussed above. Let q be the (nx1) vector of quantities, p the vector of prices, W income (wealth). As mentioned above, we ignore randomness and therefore expected utility and return to the single-period consumption problem. Let q be the (nx1) vector of quantities, p the vector of prices, W income (wealth).

$$W = p'q$$

The investor maximises

$$U(q) - \lambda(p'q - W)$$

The first order conditions are given as follows

$$U_1 - \lambda p = 0$$

$$W - p'q = 0$$

Suppose we consider a perturbation in price and wealth so that utility is unchanged, then using our first order conditions,

$$\partial U = 0 = U_1 \partial q = \lambda p' \partial q = \lambda (\partial W - q' \partial p) \text{. So, } \partial W = q' \partial p \text{.}$$

So that under these conditions, substituting and simplifying,

$$\begin{pmatrix} \partial q \\ \partial \lambda \end{pmatrix} = \begin{pmatrix} U^{11} \lambda - U^{11} pp' \lambda / A \\ -\lambda p' U^{11} / A \end{pmatrix} \partial p$$

The matrix dq/dp must be negative definite from the assumptions about the bordered Hessian made in the standard utility maximisation. In particular, the Hicksian demand curve must be downward-sloping. We call this matrix H.

We can then return to our equation above to decompose the change in Marshallian demand due to price changes in terms of Hicksian demand and income.

$$\partial q = H \partial p + U^{11} p / A (\partial W - q' \partial p)$$

Suppose, $\partial p' = (0, 0, .., \partial p_i, ... 0, 0)$ and ∂W. Let $C = U^{11} p$, then

$$\partial q_i = (H_{ii} - q_i C_i / A) \partial p_i$$

This first term is negative; the second term is the income term. We can then generalise this analysis by considering utility functions which include wealth, price, expenditure etc. and consider different perturbations to price, wealth expenditure or combinations thereof.

Appendix 4

We shall now discuss the Ait-Sahalia *et al.* (2004) model as it has some similarities to the example discussed above. They assume a utility function of the form which we parameterise slightly differently to conform with the Stone–Geary:

(15) $U = (c - \bar{c})^{\alpha_1} + \beta(q - \bar{q})^{\alpha_2}$

This model is standard (case 1) but its contribution is to explicitly separate necessities from luxuries. Whilst there appears to be no closed-form solution for demand functions of this model, it is possible to solve for demand in the special case that the two exponents are equal, $\alpha_1 = \alpha_2 = \alpha$ which is assumed to lie between 0 and 1 to satisfy smoothness conditions. Following standard arguments, we see that

$$e_1 = c p_1 = k(W_0 - \bar{e}_2) + (1 - k)\bar{e}_1$$

$$e_2 = q p_2 = (1 - k)(W_0 - \bar{e}_1) + k\bar{e}_2$$

where $g = \frac{\beta^{\frac{1}{a}} p_1^{\frac{1}{a-1}}}{p_2^{\frac{1}{a-1}}}$ is positive and k=g/(1+g) so that k lies between 0 and 1.

It is straightforward to show that if one good is a luxury, then the other must be a necessity so that, if $\frac{e_1}{e_2}$ increases, good 1 becomes a luxury whilst below some level ((1-k)/k) it is a necessity. Likewise for good 2, at low levels of this ratio it is a luxury.

We can show the following. For Ait-Sahalia utility, if good 1 is a luxury good 2 is a necessity

Proof let $x = \frac{e_1}{e_2}$, then the income elasticities are k(1+x) and (1-k)(1+1/x) respectively. If k(1+x)>1(good 1 a luxury) then 1/x<k/(1-k) or(1-k)1/x<k or(1-k)(1/x+1)<1 (good 2 a necessity) QED.

The notion that at high relative levels of food expenditure art is a necessity does not accord with intuition. The critical point at which relative expenditure 'flips' is $1/g=(1-k)/k$. The problem is resolved, as we saw above, if we set $\bar{q}=0$ in which case high culture becomes a luxury good at all wealth levels.

This can be seen from a different representation of wealth elasticity

$$\eta_1 = \frac{kW_0}{k(W_0 - \bar{e}_2) + (1-k)\bar{e}_1}$$

$$\eta_1 = \frac{kW_0}{(1-k)(W_0 - \bar{e}_1) + (1-k)\bar{e}_2}$$

In that respect, setting the expenditure on 'subsistence art' to zero is analogous to the result we found for Stone-Geary utility. However, now we have the appealing feature that discretionary wealth elasticity will be greater than one.

1 Let a be the proportion of art invested which is defined as $\frac{A}{W_0}$. If this is constant, then setting the derivative with respect to W_0 equal to zero, the numerator of the derivative gives us $\frac{\partial A}{\partial W_0} W_0 - A = 0$; $\frac{\partial A}{\partial W_0} \frac{W_0}{A} = 1$, which proves the result that the wealth elasticity of art will equal 1.

2 Arrow-Pratt theorem states that when their measure of local risk aversion (associated with VNM utility function) rises, economic behaviour becomes more risk-averse.

The investment performance of art and other collectibles

Elroy Dimson, London Business School and Cambridge Judge Business School, and Christophe Spaenjers, HEC Paris

Introduction

In 1796, the shell of a 'Carinaria Cristata' – a type of sea snail – sold for the small fortune of 299 guilders at auction in Amsterdam. A Johannes Vermeer painting that originated from the same estate, 'Woman in Blue Reading a Letter', sold for roughly seven times less (Grout, 2011). The popularity of seashells was not new. Already in the early 17th century, shells were bought by wealthy Dutch collectors craving aesthetically pleasing, unique and exotic naturalia. Because of these preferences, collectors of seashells often acquired tulips – novel, strange, beautifully coloured flowers – as well (Goldgar, 2007; Conniff, 2009). In the 1630s, a burst of demand even led to a strong run-up in the prices of tulips. Later generations would often ridicule 'tulip mania'; after all, is it not completely irrational to pay a lot of money for something that has no intrinsic value? But tulips can be considered as the 17th-century equivalent of Jeff Koons' artworks of sculptured flowers today: objects that are much desired by an elite which moreover puts them at the centre of its social life (Goldgar, 2007).

Collectibles have thus long attracted high prices – and have been perceived as potentially interesting investments. Goldgar (2007) notes that at least six companies were set up in the 1630s to buy and sell tulips. Art historian David Solkin (1993) writes that in 18th-century England 'paintings became an object of widespread capital investment'.

But possibly the first, and definitely one of the most famous, business ventures designed to invest in art dates from the early 20th century. In 1904, a French financier set up an art investment club called 'La Peau de l'Ours' ('The Skin of the Bear'). The participants' investment was used to buy paintings – about one hundred items, mainly by then-contemporary artists like Picasso and Matisse – which were sold off at auction in 1914 (Horowitz, 2011). A century later, there are not only art funds, but also investment funds specialising in musical instruments, wine, diamonds, and other collectible 'emotional assets' (Pownall, Koedijk and de Roon, 2009) or 'investments of passion'.

However, the history of seashells and tulips also hints that investments in collectibles come with unique risks, over and above the price volatility that characterises each marketplace. Although tulips (and hyacinths) continued to demand high prices until at least the early 18th century (Goldgar, 2007), changes in tastes and in supply slowly eroded their status. Similarly, there was a decline in seashell values in the 19th and 20th centuries. In contrast, Vermeer's oil paintings are today considered priceless.

In this study, we examine the historical investment performance of high-end collectibles. We first analyse the long-run returns on three types of objects: art, stamps and musical instruments (violins). These are collecting categories for which a lot of historical price data are available, because they have been trading at large auction houses and dealers for a long time. Art, stamps and instruments also share some characteristics: they are man-made and durable objects that do not diminish with consumption. We also touch upon the long-run investment performance of two different types of collectibles, namely wine and diamonds, at the end of the first section below. For most other collectibles, information on their long-run price evolutions is less widespread, and research has focused on shorter time frames – see Burton and Jacobsen (1999) for a review.

We then go on to compare the investment performance of collectibles to the returns on financial assets. We briefly discuss the different costs that may impact net returns, and collectibles' correlations with the stock market. We also shed light on the risks that come with investments in emotional assets. Just as in the past, buyers of high-end collectible goods

today face the danger of volatility in prices or changes in tastes, and there is of course the possibility of forgeries and frauds. We review these dangers and pitfalls. In our conclusions, we argue that, even if art, stamps or musical instruments are dominated by financial assets in their risk–return characteristics, they can still constitute rational investment choices because of the non-financial dividends reaped by their owners.

The long-term returns on collectible emotional assets

Art

Since the first studies by Anderson (1974) and Stein (1977), an expanding literature has investigated the returns to investing in art; examples include Baumol (1986), Pesando (1993), Goetzmann (1993), Mei and Moses (2002), Campbell (2008), Goetzmann, Renneboog and Spaenjers (2011) and Renneboog and Spaenjers (2013). We here use data from Goetzmann, Renneboog and Spaenjers (2011), who collect high-end art auction transaction data for the UK between 1765 and 2007 from a historical resource (Reitlinger, 1961) and an online sales database (Art Sales Index). They then construct an annual art price index starting from purchase and sale prices of identical items. We chain-link these returns to five years of returns on the UK art market index of Artprice. com (2013) to get an index until end 2012. The annualised (geometric mean) nominal return in British Pounds (GBP) for the period 1900–2012 is equal to 6.4 per cent, while the geometric average real return equals 2.4 per cent. Figure 10.1 displays the nominal art returns and UK inflation rates from Dimson, Marsh and Staunton (2013) against the left axis, and the deflated art price index against the right axis.

Figure 10.1 shows strong price appreciations in the late 1960s and early 1970s, during the art market boom at the end of the 1980s, and in the mid-2000s. In contrast, prices dropped substantially (in real terms) during World War I, over the Great Depression, in the years after the 1973 oil crisis, during the early 1990s recession and also at the time of the 2008 financial crisis. The negative shocks to wealth or top income levels during those periods clearly depressed high-end art prices.

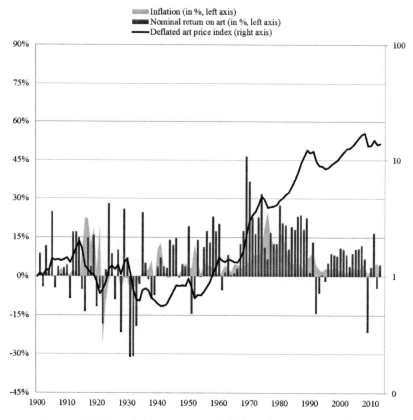

Figure 10.1 Nominal returns and deflated price index of art

Figure 10.1 shows the nominal GBP returns on art over the time frame 1900–2012, based on Goetzmann, Renneboog and Spaenjers (2011) and Artprice.com (2013). It also presents UK inflation in each year, and the deflated art price index. The index is set equal to one at the beginning of 1900. Inflation data come from Dimson, Marsh and Staunton (2013).

Stamps

Philately – stamp collecting – has been popular almost since the introduction of the Penny Black, the world's first prepaid adhesive stamp, which was issued in the UK in 1840 (Johnson, 1920). The hobby's first participants were mainly women and children who took an aesthetic

interest in stamps. But trading gradually became a more important aspect of collecting, leading to an 'intense market-based subculture' (Gelber, 1992). At the start of the 20th century, a journalist and stamp collector argued that 'it is impossible to get away from the necessity of regarding stamps as an investment' (Nankivell, 1902). Today, stamp dealers argue that 'with stamps, you can diversify assets, and beat inflation' (Shamash, 2010). A variety of pre-packaged portfolios and structured products provide economic exposure to investment-quality postage stamps.

We are the first to examine the long-term price trends of investment-quality stamps. Stamp catalogues and price lists have been published for at least 145 years. The longest continuous series of stamp catalogues is that published by a British stamp dealer, Stanley Gibbons. We use all catalogues printed over the period 1900–2008. We start in January 1900 by identifying the 50 most valuable (regular) British stamps, whether unused or not. We then update our list of collectible stamps every nine years until end 1998. For each stamp identified, we track the prices from that point forward. We use these price data to estimate the returns in the stamp market. Full details of our data collection procedure and estimation methodology are provided in Dimson and Spaenjers (2011). To enable an analysis until end 2012, we chain-link our long-term annual index to the returns on Stanley Gibbons' Great Britain 30 Rarities Index for the most recent years. The annualised nominal return in GBP over the period 1900–2012 is equal to 6.9 per cent. The annualised return on the real (inflation adjusted) price index is 2.8 per cent.

Figure 10.2 illustrates the annual nominal returns on stamps over the period 1900–2012. The strongest price increases occur in the second half of the 1960s, throughout the 1970s and in the 2000s. Particularly in 1976 (+77.7 per cent) and 1979 (+83.2 per cent), the returns are impressively high. Figure 10.2 shows that negative nominal returns are rare. However, the return distribution shows a clustering just above zero: we find nominal returns of 0 per cent to 1 per cent in about a quarter of all years. This suggests downward stickiness in nominal prices, but simultaneously implies that stamps can depreciate in real value over extended time periods.

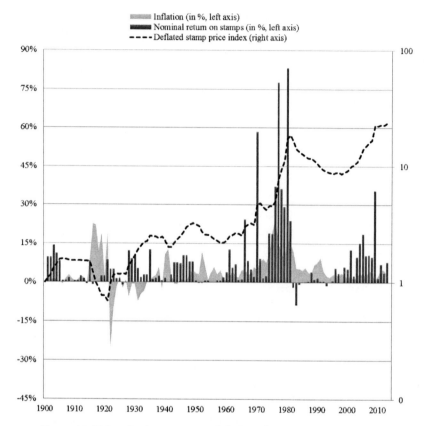

Figure 10.2 Nominal returns and deflated price index of stamps

Figure 10.2 shows the nominal GBP returns on stamps over the time frame 1900–2012, based on Dimson and Spaenjers (2011) and Stanley Gibbons. It also presents UK inflation in each year, and the deflated stamp price index. The index is set equal to one at the beginning of 1900. Inflation data come from Dimson, Marsh and Staunton (2013).

Figure 10.2 also shows the rate of inflation per year, and the deflated stamp price index. Interestingly, in the inflationary second half of the 1970s, we record not only the highest nominal, but also the highest real returns on stamps. At the time, many tangible assets became attractive as hedges, and therefore experienced relatively high returns (Ibbotson and Brinson, 1993). In recent years, too,

collectible British stamps have appreciated substantially in value in both nominal and real terms. In 2008, the real stamp price index increased by more than 30 per cent. The largest drops in deflated stamp prices can be observed over World War I (when stamps lost half of their value in real terms) and in the early 1980s, but there are several other time intervals over which the real price level decreased. For example, between end 1948 and end 1957, we record nominal returns on stamps of 1 per cent or lower, and inflation rates of 3 per cent or higher, in every year.

Violins

A third collecting category for which long-run data exist is musical instruments. High-quality stringed instruments, like the violins built in the 18th century by Giuseppe Guarneri del Gesù and Antonio Stradivari, are admired for many related reasons: the appealing design, the exceptional craftmanship, the long history and the excellent sound. One very well preserved Stradivarius violin sold for the record price of almost £10 million at auction in 2011 (Majendie and Bennett, 2011). Several investment funds that specialise in musical instruments have emerged in recent years. Such investors often lend out their investments to musicians, as a wooden instrument needs to be played regularly in order to retain its acoustic properties.

To construct a price index, we borrow data on repeated sales of violins, both at dealers and at auction houses, from Graddy and Margolis (2011). Because of the small number of observations, the authors estimate returns for decade-long intervals. In contrast, we construct a real annual price index for the period 1900–2009 by applying the same repeat-sales regression method as Goetzmann, Renneboog and Spaenjers (2011). Most purchases and sales were recorded in GBP, and therefore an index in that currency is constructed, in line with the previous two subsections. We update the index until end 2012 with yearly returns from Graddy and Margolis (2013), converted to GBP. The deflated average price appreciation since end 1899 equals 2.5 per cent, which is very similar to the long-run performance of stamps and art. (The nominal equivalent is 6.5 per cent.) The results can be found in Figure 10.3.

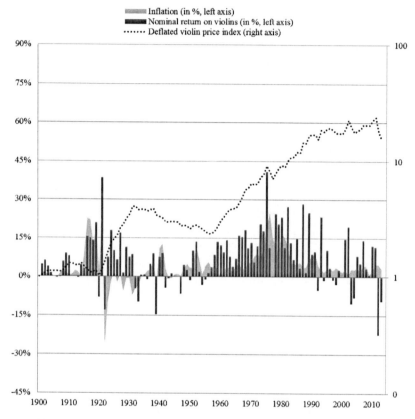

Figure 10.3 Nominal returns and deflated price index of violins

Figure 10.3 shows the nominal GBP returns on violins over the time frame 1900–2012, estimated from data from Graddy and Margolis (2011, 2013). It also presents UK inflation in each year, and the deflated violin price index. The index is set equal to one at the beginning of 1900. Inflation data come from Dimson, Marsh and Staunton (2013).

Figure 10.3 shows strong increases in the price level of violins over the 1920s and after 1960, with temporary declines in the mid-1970s, the early 1990s, the early 2000s and especially 2011–2012. Returns were generally negative for longer periods during World War I and between 1930 and the late 1950s.

Other collectibles

Two other collectibles for which longer-run data exist are wine and diamonds. Dimson, Rousseau and Spaenjers (2013) use auction and dealer price data on five long-established Bordeaux reds to estimate the long-term trends in the wine market. Abstracting from the impact of aging on prices, they find changes in wine valuations close to the returns on art, stamps or musical instruments since the start of the 20th century. The effect of aging on financial returns varies over the wine's life cycle, but is generally positive.

For diamonds, some historical data are available for the United States. In 1900, the retail price of a one-carat stone was close to $100 (Farrington, 1903; McCarthy, 1942); at the end of 2010, the average retail price for a nearly colourless diamond (colour grade G) with very small inclusions (clarity grade VS1) was around $6,400 (USGS, 2012). Converted to GBP, these data points imply an annualised nominal return of almost 5 per cent – very close to the average price appreciation of Treasury Bills or gold over the same period (cf. infra). Renneboog and Spaenjers (2012) report that diamond prices showed a boom–bust pattern over the late 1970s and early 1980s, just like stamps (and gold).

Comparison with financial assets

Now that we have established a detailed history of the returns on art, stamps and violins, we can compare these returns with those on UK Treasury Bills, government bonds and equities. The return data for these financial asset classes are from Dimson, Marsh and Staunton (2013). We also look at gold, using prices from the World Gold Council (2013) for all years since 1978 and from Global Financial Data for the period before. The real price evolutions since year-end 1899 for all assets are shown in Figure 10.4.

Intriguingly, the geometric average returns on art, stamps and instruments are virtually identical over the 1900–2012 period. Yet, despite the similarity in long-term returns, short-term trends can vary substantially across the different types of collectibles. For example, stamps outperformed art and violins in the inflationary 1970s, while art did best in the 1980s.

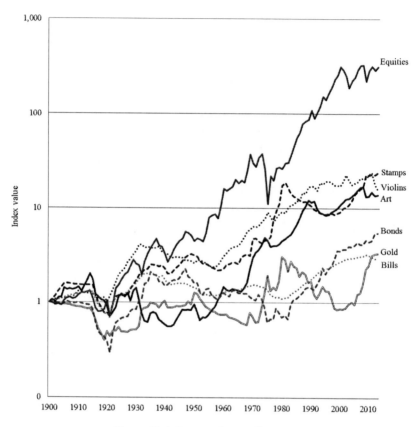

Figure 10.4 Comparison of returns

Figure 10.4 shows the deflated index values for different emotional and financial asset classes over the time frame 1900–2012. Each index is set equal to one at the beginning of 1900. The data for art, stamps and violins are shown in Figures 10.1–10.3. The data for equities, bonds and bills come from Dimson, Marsh and Staunton (2013). Gold prices come from Global Financial Data and the World Gold Council (2013).

Figure 10.4 also shows that equities have outperformed all other asset categories, including art, stamps and violins, over the period 1900–2012. Equities have realised a yearly average real return of 5.2 per cent, while our collectibles have appreciated by between 2.4 per cent and 2.8 per cent per year in real terms. However, over the very long term, collectibles have enjoyed higher returns than bonds or bills, which record

average real returns of 1.5 per cent and 0.9 per cent, respectively. Gold realised an average real return of 1.1 per cent. A full overview of the distribution of the nominal and real returns on the assets included in this study can be found in Table 10.1.

	Mean returns p.a.		Dispersion of annual returns				
	Geometric	Arithmetic	S.D.	Lowest		Highest	
Nominal returns							
Art	6.4%	7.2%	13.2%	-31.2%	1930	46.6%	1968
Stamps	6.9%	7.6%	13.5%	-8.8%	1982	83.2%	1979
Violins	6.5%	7.0%	10.1%	-22.4%	2011	41.0%	1974
Equities	9.4%	11.2%	21.6%	-48.8%	1974	145.6%	1975
Bonds	5.5%	6.1%	11.9%	-17.4%	1974	53.1%	1982
Bills	4.9%	5.0%	3.8%	0.3%	2012	17.2%	1980
Gold	5.1%	6.4%	18.7%	-19.0%	1990	108.3%	1979
Inflation	3.9%	4.2%	6.5%	-26.0%	1921	24.9%	1975
Real returns							
Art	2.4%	3.1%	12.4%	-29.7%	1915	38.4%	1968
Stamps	2.8%	3.5%	12.3%	-19.2%	1915	56.3%	1979
Violins	2.5%	2.8%	8.5%	-25.9%	2011	23.9%	1986
Equities	5.2%	7.1%	19.8%	-57.1%	1974	96.7%	1975
Bonds	1.5%	2.4%	13.7%	-30.7%	1974	59.4%	1921
Bills	0.9%	1.1%	6.3%	-15.7%	1915	43.0%	1921
Gold	1.1%	2.2%	16.6%	-30.5%	1975	77.7%	1979

Table 10.1 Distributions of returns

Table 10.1 reports the geometric and arithmetic mean returns per annum (p.a.), the standard deviation (S.D.), and the lowest and highest recorded return for different emotional and financial asset classes over the time frame 1900–2012.

Of course, there are also important differences in transaction costs between assets; auction house fees and dealer mark-ups on collectibles can be high. For stamps, Dimson and Spaenjers (2011) demonstrate that a 25 per cent transaction cost at sale has historically only been covered by the appreciation in nominal value after four years or more. Given the similarities in average returns and transaction costs, the same probably applies to many other collectibles.

Then there is the issue of illiquidity – a hidden transaction cost. Artworks and other collectibles typically cannot be sold quickly, at least not without a substantial discount. Auction houses do not hold sales continuously,

and need time to authenticate an object, prepare a catalogue, etc. Also searching for potential buyers outside the auction circuit is time-consuming. So forced sales are often associated with depressed prices. This may be especially problematic if illiquidity in the art market increases in times of financial crisis, when 'fire sales' of art are more likely.

Other costs that impact the returns on collectibles are the expenses related to storage, insurance, etc. But how high these costs are may depend on whether the object is bought purely as an investment (in which case it can be cost-efficiently locked away) or also a source of pleasure (in which case costs will surely be higher).

To evaluate whether emotional assets have a place in a diversified investment portfolio, one should not only consider their net-of-cost returns, but also their correlations with other asset classes. Table 10.2 provides an overview of real return correlations based on our data. As expected, the correlations (which pick up short-term co-movements) between the different collectibles are not very large. Also the correlations between collectibles and equities are low. However, the same-period correlations may underestimate the importance of systematic risk, as it can take time for changes in financial wealth to have an impact on the values of our price indices. Indeed, the correlations with previous-year equity returns show that a relation exists between wealth creation in the equity market and collectibles prices.

	Pairwise correlations						Corr. with lagged equities
	Art	Stamps	Violins	Equities	Bonds	Bills	
Real returns							
Art	-						0.34
Stamps	0.14	-					0.20
Violins	0.25	0.07	-				0.14
Equities	0.22	0.00	0.02	-			-0.07
Bonds	0.08	0.24	0.03	0.51	-		-0.11
Bills	0.23	0.36	0.35	0.26	0.63	-	0.06
Gold	0.06	0.37	0.14	-0.18	-0.01	0.14	0.04

Table 10.2 Correlations

Table 10.2 reports the pairwise correlations between different emotional and financial asset classes over the time frame 1900–2012. It also shows correlations with lagged equity returns.

Investment risks

Return volatility

We could evaluate the historical riskiness of investments in collectibles by considering standard deviations. Table 10.1 shows standard deviations of the nominal returns on art, stamps and violins of 13.2 per cent, 13.5 per cent, and 10.1 per cent, respectively, while we record standard deviations of 11.9 per cent for bonds and 21.6 per cent for equities. A problem with the raw standard deviations of the art, stamp and violin returns is that they underestimate the true volatility of collectibles values, for a number of reasons. First, appraisals of an infrequently traded item's value, such as stamp catalogue prices, are typically persistent (Geltner, 1991). Second, the regression methodology used to estimate the returns on art and violins may induce positive autocorrelation (Goetzmann, 1992). Third, as the indices are aggregating information over 12-month periods, the variance of the returns can be expected to be underestimated (Working, 1960).

A potential remedy is to 'unsmooth' the returns. Although the revised series will have an average return that lies very close to that of the original series, the standard deviation will be substantially higher. For example, Dimson and Spaenjers (2011) report that the riskiness of stamp investments, as measured by the volatility of the unsmoothed returns, is not much different from that of investments in equity markets. Renneboog and Spaenjers (2013) come to a similar conclusion for the art market.

Changes in tastes

If the supply stays constant – which is not always the case, as illustrated by the history of seashells and tulips – returns on collectibles ultimately depend on (expectations of future) demand. This demand may be hard to predict, since tastes change over time. Johannes Vermeer, for example, was completely 'absent in art-historical literature prior to his "discovery" during the 1850s and 1860s' (De Laet, van Dijck, and Vermeylen, 2013). As late as 1881, the painting 'Girl with a Pearl Earring', albeit in poor condition, sold for not more than two guilders in Amsterdam. However, a shift in fashion made Vermeer a very popular

artist in the late 20th century, and his works more valuable than nearly all other paintings produced in the 17th century. Over time, whole collecting categories can become more or less fashionable. Reitlinger (1963) documents the astonishingly high prices paid for silverware – some of it 'inconceivably hideous' – at the end of 19th century, and for tapestry in the early 20th century. At the time, prices paid for the highest-quality 'objets d'art' were many times those laid out for the most expensive art works. Art only gradually became a more valuable collecting category, eventually leading to the price levels observed in recent decades.

Wealth distributions may also change, with important consequences for collectibles prices. The Japanese boom in the late 1980s caused a bubble in those kinds of art favoured by Japanese collectors (Hiraki, Ito, Spieth and Takezawa, 2009). And as the world has witnessed the emergence of several economies as global players over the last two decades, art markets have emerged as well. Renneboog and Spaenjers (2011) argue that 'changing wealth patterns and the corresponding changes in demand based on the cultural and regional affinities of these new collectors may have a significant impact on changes in relative art valuation'.

The previous paragraphs point to the danger of survivorship bias in every study of emotional assets. We may inadvertently be estimating returns on the artists and types of assets that have not fallen out of fashion with wealthy western collector-investors in recent times, upwardly biasing results (Goetzmann, 1996). Over the 20th century, the financial returns on seashells or silverware were probably lower than those on art, stamps or musical instruments. Today, one must wonder whether all collectibles that have been important over recent decades will hold their appeal in the future. For example, it is telling that between 1982 and 2007, the average age of the members of the American Philatelic Society rose from 44 to 63 (American Philatelic Society, 2007). Moreover, although the inflow of new collectors from emerging economies can somewhat compensate for the lower interest in stamps among younger generations in developed economies, their focus may be on own-country stamps and on different types of issues (Huang, 2001).

Forgeries and frauds

Although scams also exist in financial markets, investors in emotional assets need to be especially cautious. The possibility of fakes can, for example, be a worry for buyers of art. Despite their in-house expertise and advanced technology, even reputable auction houses occasionally make mistakes. In 2004, Christie's and Sotheby's both brought the same Gauguin painting to the market, only one of which was genuine (Bennett, 2004).

Forgeries have historically also been a danger in philately (Moens, 1862; Lewes and Pemberton, 1863; Lake, 1970). In 1961, one particular stamp type was deleted from the Stanley Gibbons catalogue 'as all copies [were] believed to be manipulated' (Stanley Gibbons, 1960). More recently, there have been examples of fraudulent stamp systems (Crawford, 2005, 2006).

Even the violins market has not been free of fraud. In 2012, a Stradivarius violin dealer was found guilty of selling fake violins; a forestry expert who examined the instruments found that they had been made from trees felled after Stradivari's death (Paterson, 2012).

Lately, there have been concerns about counterfeit wines as well. *The Economist* (2011) reported that 'by some estimates 5% of fine wines sold at auction or on the secondary market are not what they claim to be on the label'. Full wine bottles can be relabelled, and empty bottles are sometimes refilled with cheaper wine. One of the reasons that wine fraud is alleged to be widespread is that 'many buyers wait years before opening their fraudulent bottles, if they open them at all' (Koch, 2007). And even if they do, they may not have the experience to realise that they have been duped.

Conclusions

We have reviewed the long-term investment performance of three important categories of emotional assets – stamps, art and musical instruments – and drawn comparisons with the returns from investing in financial assets. Even though they do not generate any financial income, the long-run returns on collectibles have been superior to the total return from government bonds and Treasury bills (and gold).

However, the transaction costs in these markets are substantial. Moreover, the price volatility of emotional assets is larger than is suggested by their raw standard deviations, and the investment risk is further augmented by their exposure to fluctuating tastes and vulnerability to frauds. When choosing an investment horizon, one needs to trade off high transaction costs and the risk of short-term, cyclical underperformance on the one hand, against the risk of longer-run shifts in the tastes of the dominant investors in the market on the other. Finally, the heterogeneity of collectibles – largely unaddressed here – may make asset selection challenging, since it is not possible to simply buy the art, stamp or violin price indices as a portfolio. Renneboog and Spaenjers (2013) provide evidence of variation in performance across art mediums, movements and quality categories. Cross-sectional differences in the sensitivity to changes in demand may be partially responsible, but more research on return determinants is clearly needed.

In this discussion, we have abstracted from the 'non-financial dividends' that the buyers of collectibles receive while enjoying ownership of a unique and aesthetically pleasing object. It is clear that, even if art, stamps or musical instruments are dominated by financial assets in their risk–return properties, they can still be rational investment choices. The observation that after-cost risk-adjusted financial returns are low may even be seen as evidence that the 'psychic return' of holding collectibles is indeed substantial (Mandel, 2009; Dimson, Rousseau and Spaenjers, 2013). In other words, investors are willing to forego financial returns in exchange for pleasure. And pleasure is ultimately what collectibles are all about.

References

American Philatelic Society. (2007) *APS Stamp Collector Survey 2007: Report Executive Summary*.

Anderson, R. (1974) 'Paintings as an investment.' *Economic Inquiry,* 12: 13–26.

Artprice.com. (2013) Artprice Global Indices [imgpublic.artprice.com/pdf/agi.xls].

Baumol, W. (1986) 'Unnatural value: Or art investment as floating crap game.' *American Economic Review (AEA Papers and Proceedings)*, 76: 10–14.

Bennett, W. (2004) 'Two versions of Gauguin work on sale at same time.' *The Telegraph*, 12 March.

Burton, B. and Jacobsen, J. (1999) 'Measuring returns on investments in collectibles.' *Journal of Economic Perspectives*, 13: 193–212.

Campbell, R. (2008) 'Art as a financial investment.' *Journal of Alternative Investments*, 10: 64–81.

Conniff, R. (2009) 'Mad about seashells'. *Smithsonian Magazine*, August. 40(5): 44–51.

Crawford, L. (2005) 'Cheque is in the post in stamp scheme.' *The Financial Times*, 27 September.

Crawford, L. (2006) 'Stamp groups "ran Spain's biggest scam".' *The Financial Times*, 12 May.

De Laet, V., van Dijck, M. and Vermeylen, F. (2013) 'The test of time: Art encyclopedias and the formation of the canon of seventeenth-century painters in the Low Countries.' *Empirical Studies of the Arts*, 31: 81–105.

Dimson, E., Marsh, P. and Staunton, M. (2013) *Global Investment Returns Yearbook 2013*. Zurich: Credit Suisse Research Institute.

Dimson, E., Rousseau, P. and Spaenjers, C. (2013) 'The price of wine.' Working paper.

Dimson, E. and Spaenjers, C. (2011) 'Ex post: The investment performance of collectible stamps.' *Journal of Financial Economics*, 100: 443–458.

Farrington, O. (1903) *Gems and Gem Minerals*. Chicago: A.W. Mumford.

Gelber, S. (1992) 'Free market metaphor: The historical dynamics of stamp collecting.' *Comparative Studies in Society and History*, 34: 742–769.

Geltner, D. (1991) 'Smoothing in appraisal-based returns.' *Journal of Real Estate Finance and Economics*, 4: 327–345.

Goetzmann, W. (1992) 'The accuracy of real estate indices: Repeat sale estimators.' *Journal of Real Estate Finance and Economics*, 5: 5–53.

Goetzmann, W. (1993) 'Accounting for taste: Art and the financial markets over three centuries.' *American Economic Review*, 83: 1370–1376.

Goetzmann, W. (1996) 'How costly is the fall from fashion? Survivorship bias in the painting market.' In V. Ginsburgh and P.-M. Menger (eds) *Economics of the Arts: Selected Essays*. Amsterdam: Elsevier.

Goetzmann, W., Renneboog, L. and Spaenjers, C. (2011) 'Art and money.' *American Economic Review (AEA Papers and Proceedings)*, 101: 222–226.

Goldgar, A. (2007) *Tulipmania: Money, Honor, and Knowledge in the Dutch Golden Age*. Chicago: University of Chicago Press.

Graddy, K. and Margolis, P. (2011) 'Fiddling with value: Violins as an investment?' *Economic Inquiry*, 49: 1083–1097.

Graddy, K. and Margolis, P. (2013) 'Old Italian violins: A new investment strategy?' *Rosenberg Institute Brief* (Brandeis University).

Grout, J. (2011) Conchylomania. *Encyclopedia Romana* [penelope.uchicago.edu/~grout/encyclopaedia_romana].

Hiraki, T., Ito, A., Spieth, D. and Takezawa, N. (2009) 'How did Japanese investments influence international art prices?' *Journal of Financial and Quantitative Analysis*, 44: 1489–1514.

Horowitz, N. (2011) *Art of the Deal*. Princeton, NJ: Princeton University Press.

Huang, S. (2001) 'Asymmetric participation in China's stamp market: Hobbyists and investors.' *Applied Economics*, 33: 1039–1044.

Ibbotson, R. and Brinson, G. (1993) *Global Investing: The Professional's Guide to the World Capital Markets*. New York: McGraw-Hill.

Johnson, S. (1920 [2009]) *The Stamp Collector: A Guide to the World's Postage Stamps*. New York: Dodd, Mead & Co.

Koch, B. (2007) Quoted in *The New Yorker*. The Jefferson bottles. 3 September.

Lake, K. (1970) *Stamps for Investment*. London: W.H. Allen.

Lewes, T. and Pemberton, E. (1863) *Forged Stamps: How to Detect Them.* Edinburgh: Colston & Son.

Majendie, A. and Bennett, S. (2011) 'Stradivarius sells for $15.9 million to help Japan quake relief.' *Bloomberg,* 20 June.

Mandel, B. (2009) 'Art as an investment and conspicuous consumption good.' *American Economic Review,* 99: 1653–1663.

McCarthy, J. (1942) *Fire in the Earth: The Story of the Diamond.* New York: Carper & Brothers.

Mei, J. and Moses, M. (2002) 'Art as an investment and the underperformance of masterpieces.' *American Economic Review,* 92: 1656–1668.

Moens, J.-P. (1862) *De la falsification des timbres-poste, ou Nomenclature générale de toutes les imitations et falsifications, ainsi que des divers timbres d'essais de tous pays.* Brussels: Misonne et Bonnet.

Nankivell, E. (1902) *Stamp Collecting as a Pastime.* London: Stanley Gibbons.

Paterson, T. (2012) 'Dietmar Machold: The renowned violin dealer who duped clients with fake Stradivarius.' *The Independent,* 9 November.

Pesando, J. (1993) 'Art as an investment: The market for modern prints.' *American Economic Review* 83: 1075–1089.

Pownall, R., Koedijk, K. and de Roon, F. (2009) 'Emotional assets and investment behavior.' Working paper.

Reitlinger, G. (1961) *The Economics of Taste: The Rise and Fall of Picture Prices 1760–1960.* London: Barrie and Rockliff.

Reitlinger, G. (1963) *The Economics of Taste: The Rise and Fall of Objets d'Art Prices since 1750.* London: Barrie and Rockliff.

Renneboog, L. and Spaenjers, C. (2011) 'The iconic boom in modern Russian art.' *Journal of Alternative Investments,* 13: 67–80.

Renneboog, L. and Spaenjers, C. (2012) 'Hard assets: The returns on rare diamonds and gems.' *Finance Research Letters,* 9: 220–230.

Renneboog, L. and Spaenjers, C. (2013) 'Buying beauty: On prices and returns in the art market.' *Management Science,* 59: 36–53.

Shamash, J. (2010) Stamps do not always deliver top investment returns. *The Guardian, 7* August.

Solkin, D. (1993) *Painting for Money: The Visual Arts and the Public Sphere in Eighteenth-Century England.* New Haven, CT: Yale University Press.

Stanley Gibbons (1960) *Stanley Gibbons Postage Stamp Catalogue.* London: Stanley Gibbons, London.

Stein, J. (1977) 'The monetary appreciation of paintings.' *Journal of Political Economy,* 85: 1021–1036.

The Economist, 2011. Château Lafake, 16 June.

USGS (2012) *2010 Minerals Yearbook.* Washington, DC: US Department of the Interior.

Working, H. (1960) 'Note on the correlation of first differences of averages in a random chain.' *Econometrica,* 28: 916–918.

World Gold Council (2013) Interactive gold price chart and downloads [gold.org/investment/statistics/gold_price_chart].

Dealing with uncertainties: The art market as a social construction

Laurent Noël, Audencia Nantes-School of Management

Introduction

The objectives of this chapter are to shed light on the inner workings of the art market by using the example of the market for the Art Deco style. By limiting the scope of the chapter in this way, it is possible to study that sub-market from its inception at the beginning of the last century until the year 2004. External factors, such as historic economic conditions, have played an important role in the market's development, but the impact of market participants is most significant. The primary focus of this chapter is therefore the analysis of how actors construct, maintain and develop their given market.

Uncertainty about the quality of artistic goods and consequences for transactions

Theoretical approaches

Economic analysis

The conditions for an efficient market as defined by neo-classical economists are generally not respected in the art market. With few exceptions, works of art are unique items and therefore cannot be compared

to items for sale in other markets. As such, the seller of such an object often holds the upper hand and is able to set a price. That said, the assumption of perfect information in microeconomic models implies quality is shared by everyone and defined as exogenous to the market, without the influence of commercial actors. In practice, the actors are not independent of each other and define product quality by working together (MacDonald, 1988).

In the art world in France, the collapse of the academic system[1] in the late 19th century increased uncertainty regarding 'quality' and intensified collaboration between art world participants. Until then, the 'quality' of the output of an artistic workshop was determined by an evaluation made by the selection committee of the Salon. With the advent of 'modern art', which was symbolically recognised in 1863 at the *Exhibition of Rejects*, the conditions for 'quality' suddenly changed. Artists proposed innovative works of art, which made the existing evaluation criteria obsolete (see below).

The measure of quality is in itself uncertain, and just as unpredictable as the future. Economically, artistic creation from 1863 onwards was characterised by information asymmetries (Akerlof, 1970; McCain in Hendon *et al.*, 1980). Different players in the markets – producers, buyers and resellers, for example – do not always have the level of information regarding the quality of works and this can destabilise the market, sometimes fatally. If doubt is too pervasive, buyers prefer not to take risks and do not enter the market at all. In Akerlof's (1970) famous economic analysis of markets with asymmetric information, the seller is assumed to have better information than the buyer. In the art market the reality is even more complex, in that the artist can never know just how talented he will prove to be, and the gallery which supports him must also make a bet on the future; neither has a guarantee of success. The art market is characterised by the fact that information asymmetries are shared by both the supply and the demand side, where one or the other (or both) may have missed the information essential for transactions to take place.

Works of art are both experience goods (Nelson, 1970) and confidence goods (Darbi and Karny, 1973). When they look at the work of art, buyers can be either emotionally or intellectually stimulated, but their choices are also based on information provided (for example, speeches,

writings or events regarding the work). To help individuals in their choice, it is in the best interest of the sellers to send 'signals' (Spence, 1973) regarding the quality of the work. These may include the work's price level, which indicates a level of demand, the existence of legal/contractual clauses, which guarantee the transaction and communication about the reputation of the seller. But such price signals are only partial indicators of quality (Stiglitz, 1987) because they are set and can be manipulated by sellers themselves.[2] Several mechanisms explain the construction of the market for reputation, even the star system, where demand is focused on only a few artists.[3] On the supply side, artists whose talent is not recognised withdraw gradually from the marketplace (MacDonald, 1988).

On the demand side, buyers focus on qualifying just a few aspects relating to quality because they operate within a risky environment and they have limited time to research and acquire information (Rosen, 1981). For Adler (1985), getting information directly from the consumer has a higher cost than collecting information from indirect observation of more integrated market agents. Keynes (1936), in the parable of the beauty parade, shows the rationality of mimetic behaviour and speculative phenomena. But such context-dependent evaluation is not infallible; there is always an element of chance (Adler, 1985; Ginsburgh and Van Ours, 2003). Speculation amplifies both the recognition of talent and errors in assessment, and both have negative consequences for the market.

The history of art analysis

The artistic value of a work of art does not depend (or depends very little) on the emotional judgment of the spectator, which by its nature is subjective. Kulka (1981) proposed that artistic value is based primarily on knowledge of its place in the discipline that has made art its field of study, the history of art. One of the landmarks of the history of art is the existence of styles. What is a style? A style is a system of forms (Shapiro, 1982) that are shared by a community of artists and can be definitively linked to a given time. Style is also defined as an analytically useful tool. But it has its limitations and each work to which it is attached cannot be reduced to it.

In general, styles are not defined in a strict sense. It is like language: definition specifies the time and place of origin of a style, or

author, or the historical relationship it maintains with other styles rather than its own characteristics. The characteristics of styles vary constantly and they are resistant to a systematic classification with each group perfectly distinct. Trying to find out exactly when ancient art ends and medieval art begins is a meaningless question. There are, of course, breaks and backlash in art, but the survey shows that, again, there are as often expectations, mixtures and continuities. By convention, we set some clear boundaries to simplify the study of historical problems or isolate a type (Shapiro, 1982: 38).

The method suggested by Kulka consists of an evaluation of the works of art in terms of a known set of criteria for quality or, failing that, by focusing on the process of the author, the artist.

However, as noted previously, consensus regarding the appropriate criteria to assess quality disappeared during the 19th century with the emergence of modern art. The main complications were: the obsolescence of the figurative character (as in abstract art); the fact that technical and traditional requirements became less important; the fact that the direct intervention of the artist (e.g. Duchamp, Warhol) in the production process was no longer necessary; and increased variance in the material of the work itself (conceptual art).

The uncertainties observed in the art market and associated risks

The overall 'quality' of a work of art is sub-divided into many items to which potential buyers pay attention before the final sale. However, determining 'quality is a whole' (Camard, Interview, 2008, in Noël, 2009) is a similar assessment to that suggested by Lancaster (1966) on the diversity of features that make up an economic product.

Amongst the information to be collected, three key features of a work of art which will normally determine the decision of the buyer are:

1 artistic quality
2 authenticity
3 condition of conservation (Noël, 2009)

But what happens if one of these three features is underspecified or unavailable? In such cases, the level of uncertainty corresponds to a risk for buyers who will either require a discount (for example, on price) or withdraw from the market completely.

There is therefore a significant risk that the market will disappear completely, as in the case described by Akerlof (1970) regarding the market for used cars.

The emergence, evolution and dynamism of an art market: A study of the Art Deco furniture market

Issues and methodology

This chapter proposes a multidisciplinary study of quality and combines quantitative and qualitative analysis by means of interviews with key market players in the Art Deco furniture market that first emerged in the 1910s and 1920s. This segment was chosen for the following reasons:

1 It has thus far not yet been studied and is very specific (painted furniture).
2 Information about this market is available in abundance, although it is difficult to collect and check the relevant data.
3 It can be studied from its inception in the 1910s to the present day.
4 It is an international market whose 'centre of gravity' seems to be France.

For this study, a database was constructed from an exhaustive consultation of the information collected in historical auction catalogues. The first traces of Art Deco furniture sales occurred in the late 1950s. The resulting database lists furniture offered at auction between 1959 and 2004 in France and from 1992 to 2004 in London and New York. To form a homogeneous database, underrepresented furniture (e.g. beds) or objects created by artists which are very rare (e.g. Rose Adler) or atypical in style (e.g. Armand Albert Rateau) are excluded from the dataset. Naturally, the most popular objects (e.g. chairs or office furniture) and

the most sought-after artists (e.g. Emile Jacques Ruhlmann and Pierre Chareau) are relatively over-represented in the total population.

Finally, after eliminating inconsistent or incomplete data, the database contains 2,894 results from auctions, including prices and complete descriptions of works, divided into 25 categories of artists (22 artists and three other categories: 'anonymous', 'assigned to . . .' and 'in the style of . . .').

The study does not include prices from galleries or dealers, and as such it only includes Art Deco furniture available at auction after 1959.

Description of the market and its evolution

The emergence of an innovative style

The Art Deco style flourished on the foundation laid by its predecessor, Art Nouveau, but was also a reaction against some of its aesthetic choices which were considered excessive. Art Nouveau integrates a social or even a political dimension as embodied by William Morris, who aimed to create a style with new aesthetic characteristics which differed from older styles, a return to a high quality of fabrication, the end of the hierarchy between the arts in favour of a total art encompassing all disciplines and, finally, the democratisation of a style that could be accessed by as many people as possible.

Some of the ideals of Art Nouveau were not to be reached, but nevertheless its progress was notable; this was especially the case in Germany, where artists became closer to industrialists, representing a first step towards industrial production which allowed for a rationalisation of the manufacturing process while maintaining a certain level of quality. As such, Germany had a competitive edge, one that the French authorities were aware of as early as 1910. They decided to organise a major exhibition in 1916 which allowed six years for (French) national designers to catch up. Their achievements were presented first in 1912 and received a reserved – in fact sometimes very bad – reception from art critics in influential newspapers.

The exhibition of decorative arts was delayed several times due to the international political situation but was finally held in Paris in 1925.

This period of 13 years between 1912 and 1925 certainly provided an important opportunity for artists of the future Art Deco style, as it allowed them to mature and create more successful objects, to reach diverse audiences and to familiarise themselves with new trends and consumer needs.

The 'International Exhibition of Decorative Modern and Industrial Arts' conveyed a strong political message. The organisers required that all items submitted be new; the 'old styles' were prohibited the presence of old styles and French artworks promoted.

Looking for business opportunities, the participating artists chose between two distinct directions: the elitism of private orders or the wider circulation to the public through department stores and companies specialising in the distribution of consumer goods. Choosing between the production of unique pieces and limited edition models was not without impact on the trajectory of each artist and on the art market itself. If the emergence of a new 'modern' style seemed to win unanimous support, some commentators denounced the fact that many of the proposed creations were interesting, but not suitable for industrial production.

Artists and works of art: Are style and supply homogeneous?

While almost all of the artists of the 1925 Exhibition declared themselves motivated by a vigorous modern mindset, others retained some aesthetic sense of the time, while still others, fewer in number and mostly led by Le Corbusier (1887–1965), were guided by social meaning.

The artworks exhibited were mostly reserved for the wealthy elite and were inaccessible to any other consumers, particularly the working class. The group of artists who produced for this elite should further be subdivided according to the more and less radical forms of modernity adopted and the materials used. In the end, three main trends emerge.

First, according to Bouillon (1985), the group of 'contemporary artists' which Ruhlmann (1879–1933) led, offered a renewed aesthetic with a direct affiliation to previous French styles, especially those of the 18th century. Second, the group of 'modern artists', which Chareau

(1883–1859) and Gray (1878–1876) represent, clearly looked for a completely new aesthetic and used plastic materials and the possibilities offered by emerging products such as metal and glass. Of impeccable quality, their works were for rich consumers. Third, the avant-garde aesthetic of 'modern artists' was the only thing shared with the 'functionalists' led by Le Corbusier and Herbst (1891–1982). For the latter, their achievements are only prototypes of models that they wished to produce on an industrial scale.

Demand on the primary market?

Elite clients and success on the international market

Despite critical talk of an imbalance between the decorative and industrial purposes of the objects created, neoclassical designers achieved undeniable success at the art exhibition and won over rich French and overseas customers alike (Camard, 2002, in Noël, 2009; Kjellberg, 2000). Primary consumers included the elite fashion designers. For these customers, artists mostly produced unique pieces (Camard, 2002, in Noël, 2009).

The second broad category of consumers included the shipping companies that needed to decorate important and prestigious sites. In the context of a limited clientele, these sites played an important economic role. Directly, the commissions from these companies provided working incomes to artists and designers and indirectly, they allowed for the diffusion of the new style to a rich and international clientele which was precisely the target market.

In the 1930s, the avant-garde functionalists also had a prestigious client list. Two large orders were placed: first, that of the Maharajah of Indore for the building of a modernist palace and second, that of the prince Aga Khan for the renovation and decoration of his Parisian private mansion by René Herbst.

The US government had declined an invitation to participate in the 1925 Exhibition, believing that their artists' work lacked the modernity needed to square off against European artists (Pepall, in Foucart, 2001: 127). However, an official delegation of observers *was* sent to the Exhibition. The US Secretary of Commerce, Herbert Hoover, sent a Commission, headed up by Charles Russell Richards, director of the

American Association of Museums (AAM) and two artistic directors of US manufacturers of furniture, H. Créange (Cheney Brothers) and F. G. Holmes (Lenox Inc.), as well as 92 delegates to represent the various branches of the furniture trade in the US.

Impressed by the French achievements, Richards chose 400 works from the 1925 Exhibition to be exhibited in eight American museums, the first showing of which opened at the Metropolitan Museum of Art (MET) on 22 February 1926. His short-term goal was to offer an alternative market for those objects and to contribute to their historical footprint. In the medium term, it was hoped that the Exhibition might ultimately modernise US artistic/design production and improve its quality. Richards also recreated some of the 1925 Exhibition, to show US artists its scope.

Joseph Breck, Curator of Decorative Arts of the MET, feared a hostile reception from the public towards these new forms[4] but his fears went unfounded.[5] This was probably because the promotion of the 1925 Exhibition by Hoover's Commission and the media was important and it produced the desired results (Friedmann, 2006). During its US 'phase', the first purchases were made by both institutions and individuals.[6]

Friedmann (ibid.: 111) draws a interesting economic conclusion:

> Any market is made up of the forces of supply and demand. The Hoover Commission (sic) addressed the supply side of the equation, attempting to demonstrate to manufacturers and educators the importance of gearing up to produce modern design. Richards understood, however, that for the efforts of the manufacturers to be rewarded, the public would have to be educated to appreciate modern design . . .

This reveals the tension between innovation and its reception given by non-professional publics. How can one assess new proposals with old references?

Influences of the economic crisis and state support

The 1930s and the first half of the 1940s were years of economic crises and social and political unrest (the Great Depression, the rise of

totalitarianism in Europe and World War II). These events affected the art market and other markets (Buelens and Ginsburgh, 1993). By the 1930s, the Art Deco market had been significantly affected. Many artists had the state to thank for the survival of their workshops, whether through international exhibitions or subsidising their shipping transportation. Nonetheless, many of the pioneers of Art Deco style eventually left the scene.[7]

An outdated style

The war years geographically dispersed artists. Some, like Mallet-Stevens (1886–1945), lived in 'free' zones within France but ceased their activity. Others left the country altogether.[8] By the end of World War II, the three main segments of the decorative arts market consisted of the functional and inexpensive furniture of the Reconstruction, the furniture of the 18th and early 19th centuries, the majority of which was supplied by antique dealers and finally contemporary objects of quality. For the latter, the sources of inspiration had changed and were shared between a return to classicism and a new formal approach, more organic in style (as with the work of Royère), and completely opposed to the aesthetic lines of 1925. Nonetheless, the Art Deco style did survive and as a term was first applied in the late 1930s. But following this period, a new aesthetic replaced it. The emergence of new materials allowed for the emergence of 'design'.[9] And just as crucially, most of the artists who had been at their peak in 1925 were dead. Those who survived and remained active (like Leleu or Printz) evolved with their younger contemporaries. By 1939, the primary market for Art Deco had disappeared and the secondary market for second-hand objects had not yet appeared. This market, which really only took off again as late as 1972, lay dormant for over 30 years.

A renewal of interest in the Art Deco style and the appearance of a secondary market

The collective memory[10] of the art market takes the date of the sale of the collection of couturier Jacques Doucet on 8 November 1972 as its rebirth. Sales totalled 1.2 million francs (€983,616 as of 2004). A lacquer screen by Eileen Gray, entitled 'Fate' and bought by an American

collector, achieved a remarkable 170,000 francs (€139,346 as of 2004). The high bids[11] reflected a keen competition between buyers of all kinds: dealers, individuals (especially American collectors) and institutions (Camard, interview, in Noël, 2009). Indeed, until the late 1960s, there was very little Art Deco furniture offered at auction.[12] In the early 1970s, although such auctions were rare, several offered furniture from the 1920s, including a thematic auction entitled, for the first time, 'Art Nouveau – Art Deco'. In addition, in 1971, the Brooklyn Museum of Art acquired a complete set of furniture from 1923, designed by Ruhlmann.[13]

The sale of the collection of actress Jane Renouard in Paris on 5 May 1972, at which the furniture achieved remarkable prices for the time, represented a key turning point in public awareness and signalled to potential buyers the reawakening of interest in, and a taste for, the Art Deco style.[14]

Evolution of sales, quantities and prices

For this study, the results of objects and furniture sold in the above paragraph transactions were collected at several sale locations (Paris, London, New York, Monaco and the French provinces) and prices have been converted into a common currency (the euro at its 2004 level). The first catalogued auctions of Art Deco furniture took place in 1959 and 1960. But after that, between 1961 and 1967, no sales of Art Deco furniture appear in auction catalogues. From 1968, sales were held each year until 2004 (the last year of this study), at a pace accelerated steadily over the study period. The increasing international offer of objects peaked in terms of volume in 2003, with 223 lots offered, and in terms of value in 2000, with almost €12.6 million of annual revenue.

The total turnover for the period 1959–2004 was €84,064,057. The average number of lots offered each year was about 63 (62.9), the average annual turnover €1,827,479 and the average rate of return 24 per cent. However, those averages mask significant changes over those 46 years. Figure 11.1 below shows that the market grew, but was also marked by cyclical fluctuations.

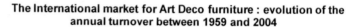

The International market for Art Deco furniture : evolution of the annual turnover between 1959 and 2004

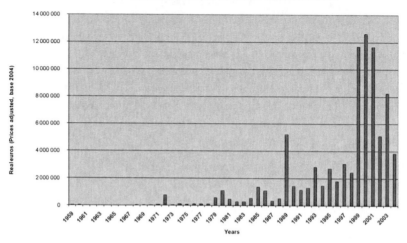

Figure 11.1 Evolution of annual turnover of the international market for Art Deco furniture between 1959 and 2004

Peaks in the cycle correspond to years when either a major collection was sold, there was a period of sustained economic growth or a combination of both events. In 1972 and 2003 respectively, the Doucet and Lagerfeld collections were sold, which accounted for respectively 86 per cent and 24 per cent of the total turnover of the relevant year. In 1989, the first sale of the collection of merchant Alain Lesieutre (76 per cent of the total annual turnover of this segment of the market) benefited from a favourable economic climate. 1989 and 2000 also saw strong economic growth. Generally, market trends were punctuated by sales of collections which boosted annual turnover figures.

The steady increase in annual proceeds is due to both increases in the volume of transactions (Table 11.1) and the average level of prices excluding inflation (Table 11.2).

The strong increase of transactions during the second period of 1973–1989 (+ 686 per cent) can be explained by very low trading volumes over the previous period (an average of five transactions per year in the first period, as compared to an average of about 40 transactions in the second period). In contrast, the growth rate of the market in the third and fourth periods is much more significant and shows a continuous development of supply over the period between 1973 and 2004.

	Average number of sales each year (number of items offered to auction)	Annual Growth rate (in %)
Period 1959 - 1972	5,1	
Period 1973 - 1989	39,9	+ 686%
Period 1990 - 1998	77,0	+ 93%
Period 1999 - 2004	125,8	+ 73%

Table 11.1 Number of annual transactions
per period between 1959 and 2004

Median price evolves (Table 11.2) at lower levels than average prices because of the existence of a small proportion of very high prices. The period 1973–1989 is an exception: it includes the very high prices obtained by the sale of the Doucet collection in 1972 and the fact that it would take until 1989 to return to such price levels, which explains the decrease in median price (-14 per cent) between the first and the second periods.

	Average of furniture annual price (in EUR 2004)	Evolution of annual average price (in %)	Median of furniture annual price (in EUR 2004)	Evolution of annual median price (in %)
Period 1959 - 1972	2 602		3324	
Period 1973 - 1989	11 172	+ 329%	2851	-14%
Period 1990 - 1998	23 089	+ 107%	10767	+278%
Period 1999 - 2004	62 867	+ 172%	25552	+137%

Table 11.2 Average and median price per period between 1959 and 2004

Increases, however, are not regular (Figure 11.2). Three peaks can be distinguished in 1972, 1989 and 1999. The year after a peak year, there is always a strong decrease in the average and median prices, followed by fluctuations on an upward trend until the next peak.

Figure 11.2 Graph of annual average changes in prices and median market price for Art Deco furniture between 1959 and 2004

The study of geographical markets covers the period from 1992 to 2004. Five geographic areas were selected: Paris (including a proportion of less than 1 per cent of sales made in Île-de-France, outside of Paris), the French provinces, New York, London and Monaco. Three lots were offered in Geneva, but none was sold.

Paris largely dominates the Art Deco market, with an average 74 per cent market share over the study period; New York takes second place with an average of 18 per cent – more than four times lower than Paris. The geographical structure of the Art Deco furniture market is interesting. Paris, New York and London each have their specialities. It is in New York that Impressionist and modern works of quality are sold, while London specialises more in paintings. Contemporary art is dynamic both in New York and London, but with a certain regionalism according to the nationality of the artists. The Art Deco furniture market has its centre of gravity in Paris, which is ahead of New York. Furthermore,

Years	Paris	Province	New York	London	Monaco	TOTAL
1992	79%	0%	21%	0%	0%	100%
1993	95%	0%	5%	0%	0%	100%
1994	78%	0%	22%	0%	0%	100%
1995	64%	0%	14%	0%	22%	100%
1996	87%	0%	8%	5%	0%	100%
1997	75%	1%	16%	8%	0%	100%
1998	58%	0%	36%	6%	0%	100%
1999	84%	0%	9%	7%	0%	100%
2000	53%	2%	28%	17%	0%	100%
2001	67%	11%	11%	11%	0%	100%
2002	83%	10%	6%	0%	0%	100%
2003	86%	1%	13%	0%	0%	100%
2004	54%	2%	44%	0%	0%	100%
Average (period 1992 - 2004)	74,0%	2,1%	18,0%	4,2%	1,7%	

Table 11.3 Distribution of sales in the market for Art Deco furniture between 1992 and 2004 (in % of annual total)

Paris is a key market both in terms of volume and value. On average, over the period 1992–2004, 75 per cent of the annual turnover of this art market segment was achieved in Paris, where the highest prices were usually obtained.[15]

Market players and their activities

Artists

Kjellberg (2000) lists just under 200 furniture designers, working under their own name or (rarely) under that of a company, but often in combination. Most designers didn't succeed to become famous. Regarding the quantities produced, most designers created prototype models, usually (but not always) in small quantities.[16] For style 'leaders', like Ruhlmann and Chareau, it was unusual for more than 10 copies of each model to be produced. That said, it is nigh on impossible to have a clear idea of the total number produced of each model and thus of overall production numbers. In terms of quality, curators, dealers and experts are unanimous in addressing significant variations between designers (Brunhammer, Camard, interviews, in Noël, 2009), both in terms of shape and technical execution.

Buyers

The profession of specialist dealer revolves around two concerns: developing a supply network and building a reputation in order to sell objects at the best price. The entire population of traders helps to fuel the art market in Art Deco furniture. Small- and medium-sized dealers, antique hunters and antique shops often do not have the opportunity to resell their finds directly to collectors and therefore achieve the highest prices, because they do not have a solid reputation in the specialised Art Deco market. As a result, they have to use two distribution channels: galleries or specialist auctions. Galleries allow a rapid resale but at a depreciated price; auctions may achieve higher profits, but there is still a significant risk that objects will remain unsold. The market for international galleries is almost exclusively located in France, even though the US has a very important gallery, DeLorenzo, founded in 1980. A significant number of customers are located in the US and the two most important Parisian galleries, Vallois and Arc en Seine, have each opened a gallery in New York. A hierarchy exists within the galleries that professionals identify.[17] The medium and high ranges are discrete markets, where products and customers are distinct, and behave very differently. The gallery market comes in the form of an oligopoly with a 'fringe' (Benhamou et al., 2001), some important galleries being fed by smaller gallery players.

Auctioneers

The key issue for a house auction is to access the quality of artworks and then to encourage interest from potential buyers and competition amongst them during the ensuing sale. Access to work is facilitated through owners of the work. The auctioneer profession is primarily a business with access to networks of collectors. Since its re-emergence in the 1970s, competition has increased in the segment of the market dedicated to Art Deco style. Table 11.4 shows the evolution of competition between auction houses between 1959 and 2004.

During the 1960s, in the early years of the secondary market, the market was not dominated by any one player: two thirds of sales (64 per cent) were made by a large number of intermediate sellers. But with the success of this style in the early 1970s, the market became structured around a

		Periods				
		1959 - 1969	1970 - 1979	1980 - 1989	1990 - 1999	2000 - 2004
Market competition (market shares, in %)	Auction houses selling sporadically Art Deco furniture	64%	26%	17%	6%	700%
	Market leader	21%	45%	44%	34%	29%
	Second seller of the market	15%	9%	8%	17%	27%
	Third seller of the market	0%	8%	700%	14%	17%
	Fourth seller of the market	0%	6%	700%	6%	12%
	Fifth seller of the market		2%	3%	5%	2%
	Other auction houses selling Art Deco furniture on a regular basis	0%	4%	14%	18%	6%
Size of the market	Number of items sold	22	177	694	1053	948
	Turnover (adjusted euros, base 2004)	28,751	1,714,902	11,070,858	29,823,045	41,404,970

Table 11.4 Evolution of the competitive market structure of Art Deco furniture at auction

dominant firm (Ader Picard Tajan, became Ader in the 1990s) which represented 45 per cent of total turnover in the1970s, 44 per cent in the 1980s and 34 per cent in the 1990s.

Far behind the market leader during these three decades are two or three other auction houses. The 1990s, however, showed a convergence between the leader (34 per cent market share) and its two closest competitors (17 per cent and 14 per cent). The market structure is oligopolistic: the leading three companies have a combined market share of 65 per cent. The sales organised in France by Christie's and Sotheby's from July 2001 significantly increased competition in the market, which became a duopoly. The leading two companies represented 56 per cent of the market (29 per cent and 27 per cent respectively) and the third and fourth 17 per cent and 12 per cent respectively. Thus, four auction houses currently hold 85 per cent of the international auction market (London, New York and Paris), while occasional sales by non-specialist auction houses represent only 7 per cent of the global market.

Experts

In the art market, experts perform three key tasks: authentication of artistic goods, assessment of their conservation status and estimation

of their potential sale price. Their function is to reduce uncertainty by guaranteeing the quality and the likely price level. Application of expertise is a difficult exercise. Authentication of objects takes place on the basis of the knowledge available at a given time, but the advancement of knowledge can cause changes in attribution. 'The difficulty of the analysis of art markets (. . .) highlights the uncertainty and information asymmetry which characterizes them' (Moulin, 2003: p10).

The database (see above) identifies the existence of 15 experts in Art Deco furniture (including firms or departments of auction houses) who specialised in this style between 1959 and 2004. Only 5.15 per cent of the transactions did not involve experts. Sales without experts were rare and coincide with the first Art Deco auctions.[18] In the market for Art Deco furniture, the use of expertise is a given. From the rebirth of the market in the 1970s, more than two thirds of transactions are valued only by one or the other of the two expert firms: Camard (40.6 per centof total) and Felix Marcilhac (29.6 per cent).[19]

Private buyers

In the market, a distinction is made between unskilled consumers, decorators and collectors. The unskilled consumers are by and large a heterogeneous group, although they do share some characteristics. Purchases are driven by a love of art, often with the objective of decoration but governed by a limited budget. The decorators form an intermediate category between the general art lovers and the specialist collectors, and they often target wealthy clients. The selection of furniture and works can operate in the range of middle to high quality, according to the interests and resources of the buyers. By unifying (customer power) and prescribing (tastes), decorators may help a style or an artist to become fashionable, which in turn increases demand in the market with consequences for prices if supply is limited.

It is, of course, the serious collector who is the object of most attention. These people make regular purchases and if they have a good local knowledge of the market, are willing to pay the asking price and even to participate in the establishment of record prices, if necessary, for the best works. They are often passionate fans of the works themselves and

of their history and they are able to pick up on differences of quality between specific works, as well as knowing their market prices. The activity of collecting can therefore not be reduced to its accumulative dimension. 'Collecting not only raises prices but makes sets, only one item of which may be less valuable than those of the full set' (Thomas, 1997: 8). Ongoing research and improvement in the average quality of a collection is the concern of an ongoing collector. 'Collecting is also to select' (Fuchs, interview, 2008, in Noël, 2009).

In the Art Deco furniture market, high-net-worth collectors, significant patrons (such as Jacques Doucet and Jeanne Lanvin) and individuals with large fortunes created in the early decades of the 20th century (including Eugène Schueller, the founder of the cosmetics company L'Oréal, The Maharaja of Indore, etc.) have from the 1970s superceded other collectors. The accessible prices in the past attracted collectors of more modest means, such as the lawyer Pierre Hebey or art dealers Alain Lesieutre and Jean-Claude Brugnot. 'Thanks to a handful of loyal customers, Pierre Bergé and Yves Saint Laurent, Karl Lagerfeld and Hélène Rochas, we succeeded (in the 1970s) to survive' (Vallois, interview, 2006, in Noël, 2009).

The publicised success of sales, particularly sales of collections since the 1970s, has attracted a different clientele, which allowed the market to move to a new phase of its development.

> The very large prices emerging from a decade ago are due to a renewal of customers. Essentially, it is a clientele composed of collectors of old furniture and works of art of the eighteenth century and the changing domain of interest has led to a favorable shift in the price level; the Art Deco furniture purchases are of high quality while being on average significantly less expensive than the equivalent quality in the furniture of the eighteenth century (Camard, interview, 2008, in Noël, 2009).

Since the late 1990s, the market has also become more international. 'We have customers throughout Europe, but also in Asia and Russia. But many of our customers are American' (Vallois, interview, 2006, in Noël, 2009).

Museums

Museums have the function of transmitting cultural heritage from generation to generation, through the preservation of works of art. Conservation and exhibition follow the preliminary steps of selection. A museum selects works to which it assigns qualities; these can be visible, invisible and special. Rejected objects are doomed to (historical) oblivion while the chosen objects acquire a high value. The legitimacy of the selection and distinction procedure is derived from the eminence of those involved in decision-making, including experts such as art historians and curators, and their selfless (non-commercial) attitude towards art and mercantile interests, which is expressed in the opening of collections to the public.

Uncertainties and how players manage risks

How institutional and market interplay raises public awareness of quality

The selection and exposition choice involved in the writing of art history establishes a classification and hierarchy of artists and styles (Pomian, 1992). A museum's valuation of a work of art, and hence its creator, comes from its selection, the time spent on it and the space dedicated to it. The hierarchy of museum artistic values influences art market estimates.[20] Museums' relative values are reflected in the relative scale of prices, which is obviously dependent on the budget buyers who themselves are subject to a climate of economy (Goetzmann, 1990) and market trends.

As noted above, the return of the Art Deco style is often dated to the sale of the collection of fashion designer Jacques Doucet in 1972. Although this sale was symbolic, in reality there was a more complex emergence and evolution of the marketplace. In particular, this involved the development of strong interactions between the institutional and commercial spheres (Moulin, 1992). The re-assessment of Art Deco began in 1966 with the publication of two books by leading art historians[21] coupled with the organisation of an exhibition entitled 'The 1920s' by the

Museum of Decorative Arts in Paris.[22] According to Yvonne Brunhammer, author of one of these books and co-organiser of the exhibition, these research efforts had some impact, but only on a relatively small audience. There could well have been a limited effect on the 'general public', but what about the *specialist* public? We know that during the 1960s, there were American customers, collectors and institutions interested in Art Deco. Moreover, many galleries that specialised in the Art Deco style were launched during this decade, or early in the next, like the Vallois Gallery, established in 1971. It is very likely that institutions and individuals who become major players in the market saw the Art Deco exhibition and read these publications which, in turn both refined their knowledge and validated their choice and interest in the Art Deco style. In the early 1970s, numerous exhibitions were held by museums.[23]

The 1972 Doucet sale brought widespread recognition with the media's obsession with prices, which were seen as a signal of both strength and quality. The qualitative research begun by art historians established a scale of values which has encouraged consumers to participate in the market and help determine prices.

The market is also a force for discovery and rediscovery (Haskell, 1976). Indeed, the artist Eileen Gray, absent from the exhibition in 1966,[24] was completely rediscovered during the 1972 sale.

Today, three internationally renowned museums are distinguished by the size and quality of their Art Deco collections: the Metropolitan Museum in New York, the Victoria and Albert Museum in London and the Museum of Decorative Arts in Paris. Although not as renowned, the Musée des Années 30 in Boulogne-Billancourt also has a first quality collection. These museums have a permanent collection, but also organise special exhibitions which showcase the Art Deco style or one of its artists.[25]

Museums, therefore, have an indirect role in determining the market for Art Deco items, influencing the interests and tastes of the public, some of which are also consumers and collectors.[26] This assessment is based on a consensus accepted by a range of market participants:

> The exhibitions organized by museums have largely contributed to the development of the market (Camard, interview, 2008, in Noël, 2009).

While prices for Ruhlmann's works were stable for a long time at the top end of the market, consecutive exposure by the Metropolitan and Musée des Années 30 left Ruhlmann's prices rising (Verdier, Sotheby's, interview, 2008), in Noel, 2009).

As determiners of artistic quality, museums are also buyers in the market, thus exerting a direct influence on prices. Not all museums, however, have the resources to make purchases, especially since the late 1990s, when the craze around Art Deco reached new levels and the development of museum collections increasingly depended on private donations.[27]

Whatever the mode of acquisition, purchase or donation, a work of art that goes into a public collection rarely returns to the market. In France, the imprescriptible and inalienable character of collections make it nearly impossible to remove from access, or dispose of, works from permanent public collections. In the US and UK, even if most museums may in theory remove public access to artworks, re-sale is rare. This results in fewer quality works being available over time as scarcity increases (Ashenfelter and Graddy, 2003). At the same time, through their choices of collection and exhibition, museums stimulate private demand and ultimately impact price increases. In the long term, if this process continues, the market for some goods may disappear altogether. The 'high-quality' category, with which leading public and private collections are concerned, is the most threatened. Since the 2000s, given the very limited quantities of objects still available, the market for Art Deco works has begun to falter.[28]

Authenticity and condition risk management: Expertise and guarantees

The perceived quality of a work of art, as perceived by global consumers, is only one aspect which determines its value. Other uncertainties to be overcome surround art transactions. These include in particular questions regarding authenticity and the state of preservation of the work (Noël, 2009). These two components are critical, mainly in the context of the secondary market for art, when significant time has elapsed since the initial creation of the work.

A work's condition can deteriorate and if the artist has met with success, copies or forgeries of the work may exist. [With rising] prices in the field of art (. . .) the incentive to produce false and counterfeit pieces increases, which in turn increases the level of uncertainty in the art market. Transaction costs also increase because it is necessary to invest more effort and money to maintain the same level of certainty (Frey and Pommerehne, 1993).

It is often difficult to accurately assess the state of an artwork's conservation, and fakes and forgeries are not always easy to detect. Intermediate specialists are essential to reduce the level of uncertainty (Benhamou, [1996] 2004: 17) in these regards. To feel confident enough to complete a sale, both sellers and buyers need these qualities to be properly assessed.

On the demand side, as much as people search for the perfect object, they also want transparency. For example, in the market for Art Deco furniture and technical objects, which are fragile, whose prices usually range from €100,000 to €1m, relevant information should be acquired prior to the transaction. Art Deco furniture is for a buyer like a 'black box' whose secrets must be unlocked before the sale price is agreed and the purchase made. Trust is at the heart of a well-functioning art market. If the experts, auctioneers and dealers each have some responsibility towards carrying out this investigative work, then they are part of the transaction and must contribute to price transparency.

For a reliable diagnosis of the authenticity and condition of a piece, it is still necessary that the expert involved is credible and can offer guarantees, whether they be commercial or legal. In France, experts are, apart from some rare exceptions, generally independent from the auction houses who use their services.[29] Independent experts owe their reputation to their knowledge and experience, often reinforced by the production of literature and publications. 'Experts' used by UK or US auction houses tend to be employees who have a different 'specialist' status. Their views are expressed through the auction house's editorial catalogues, and it is these which undertake responsibility for the entire company in that the reputation of the firm is more important than that of the individual expert.

What type of expertise is the most objective? Neither of the approaches outlined above is completely satisfactory. The 'independence' of experts is partly artificial, because most of them are also merchants/dealers (Schmitt, 2008: 146)[30] and therefore conflicts of interest exist. When expertise is integrated, it is often dependent on the business strategy of the auction house and the need to source works for thematic sales. These needs are exacerbated if the competition for objects is high; encouraging overestimation of the value of works may be considered in order to obtain them from consignors/vendors. Overestimation increases the likelihood of lots going unsold, which is a risk the seller bears (albeit not necessarily consciously), leading in the long run to a less liquid market. The empirical study by Bauwens and Ginsburgh (2000) on a segment of the English silver market confirms the existence of such estimation bias under some conditions.

The French, UK and US approaches also differ in terms of the protection of transactions. The French model has strong regulatory protection of the consumer. The Anglo-Saxon model, liberal by nature, gives primacy to the contractual terms agreed and recognises the existence of a hazard and therefore risk taken by the buyer. But this risk is largely offset by the commercial guarantees provided by UK or US auction houses, anxious to preserve one of their main intangible assets – their reputation. The twin pillars of regulation are first, the precision of information codified in catalogues and of their legal significance (Decree of 3 March 1981)[31] and second, the possibility for the buyer or seller to request a cancellation of a transaction in cases of 'errors of substance' (Article 1110 of the Civil Code).

The legal situation of the experts is different in the UK. Anglo-Saxon law tradition relies on contractual clauses. Basically, when the UK expert writes that his description is only an expression of 'opinion', the British court will consider that the buyer had to forge his own opinion before buying, while the French judge considers that a description cannot only be an opinion but is a statement that commits the expert (Schmitt, 2008: 147–148).

So are Anglo-Saxon commercial guarantees or French legal guarantees the most protective? According to professionals interviewed in 2009 (see Appendix), French legislation appears to be very protective, but as

the case law shows, the procedure is very long and therefore expensive. In contrast, the commercial guarantees practised by, for example, Christie's and Sotheby's, are not automatic but these auction houses are so vigilant about their reputation (which must be impeccable[32]) that they often show magnanimity in cases of difficulty and cancel the contract or compensate the injured party.

Regulation of market by players

The market for dealers and auctions is not strictly partitioned: the works that go to auction do not necessarily exclude dealers, who may act as sellers, buyers or brokers. 'The relationship between dealers and auctioneers is narrow (...) Everyone knows that in the various lots offered for auction, dealers are an important source' (Nordmann, Interview, 2008, in Noël, 2009). If the seller is a known gallery of the market place, there is a need to move the object geographically because potential buyers saw it and the work of art lost its attraction power.[33]

Auctions are also a source of supply for dealers, but a relatively minor one. A work of quality is often 'marked' by many buyers and if competition is too intense, the margin is reduced or even cancelled out. Above all, auctions are public, so procurement (and price) is visible. Offering an item purchased at auction to a consumer is tricky since they might know its origin, the price previously paid and thus the margin of the gallery or dealer. Dealers prefer to reach an agreement prior to a sale with an interested client and achieve a brokerage fee; the margin is therefore transformed into a commission, but the collection of cash is immediate. This practice (of a dealer bidding at auction on behalf of their customer) is even more common in cases where the consumer has difficulty in assessing the state of conservation or quality of an object,[34] there is a need for consumer anonymity or a need for professional advice – confidence in the auction house may otherwise be poor.[35]

Brokering by dealers has been going on for many years. It is an old phenomenon. The issue of trust lies at the heart of the client's relationship with the broker. It is now one of the core strengths of specialist galleries to be recognised for their quality and expertise and to develop their customer relationships on trust. It is not uncommon for a client to call on one gallery to validate a purchase decision they intend to

transact at another gallery. Although there are some cultural differences, brokerage practices seem to exist naturally in both the US and across Europe.[36]

When a market matures, it can continue to develop through auctions because of strong and recurring demand. Specialised galleries emerge as competitors that are able to establish a direct link between private sellers and buyers. Brokering is a way for dealers to stay in the game and prevent losing control of the market. In practice, many large purchases are made by dealers authorised by their clients. The commissions charged by the professional expert broker can be understood as an 'insurance premium' paid by the individual buyer. The rationale for this bonus is to safeguard against a lack of information regarding the quality of the good.

The two markets (auction and dealer/gallery) are closely linked. For Jean-Marcel Camard, an expert and director of the auction house Camard, 'a market will not be strong in public [auction] sales unless dealers are active in it. Paris benefits from the presence of the most important galleries specializing in Art Deco in the world' (interview, 2008, in Noël, 2009). According to Cheska Vallois, gallery director of Vallois, 'Public sales confirm the work of galleries. Prices obtained at auction not only confirm prices in the gallery, they can show collectors that the galleries are not wrong. But auctions are not the [whole] marketplace; that includes the work of the galleries.' (interview, 2006 in Noël, 2009). This view is shared by Cécile Verdier, director of 20th Century Decorative Arts at Sotheby's, France: 'If the market for Art Deco exists, this is because of the work galleries do. They launch and support the auction market, buying on their own account or on behalf of their clients. I am here to lead the department of 20th Century Decorative Arts at Sotheby's, and it is thanks to Cheska Vallois [it exists]: she made the market' (interview, 2008, in Noël, 2009).

Paradoxically, galleries and auction houses compete with each other to obtain works of art from individuals yet complement each other in selling them. For purchases, the service provided to the seller is different: dealers buy for cash at a price generally lower than that obtained at auction. The auctioneer aims to secure sales at the best (market) price by encouraging competition between the buyers, but the seller assumes

the risk of their item going unsold and having to wait longer to get paid.[37] For the seller, the power of communication and the auction itself are promoted by auction house, but the risks of market liquidity and the timing of the sale are important. An influx of works at any one time involves a strong commitment by the auction house to find buyers for (all of) them. If the media finds out about high rates of return, it can be disastrous. A negative signal is sent to the market; buyers retreat or become more cautious. All parties suffer, auction houses as much as dealers.[38]

Conclusions

This chapter shows the interdependence of key players in the art market. As a case study, it makes use of the history, evolution and dynamics of the market for Art Deco style objects. While the scope of the art market as a whole is vast, many specific niches exist for particular styles and objects. Within these, all the key players tend to know each other. These players must work together: they include collectors, dealers, experts and auction houses, but also – contrary to conventional wisdom and ethical considerations – established curators. As such, the art market is a perpetually dynamic social construct.

This form of organisation stems from the nature of a work of art itself. Art raises more questions than it answers. To the uncertainty of an object's artistic merit is added uncertainty regarding authenticity and condition. Consensus on its artistic merit or quality is determined (more or less) slowly and over time, through an interaction amongst the many art world actors, both public and private, and a given succession of relevant events. Individuals, the art market and art world institutions interact in parallel to define and determine artistic quality and aesthetic and cultural value as well as the quantitative aspects of a work such as the price.

This collaboration is reinforced by the limited nature of the objects on offer, which are original and often rare, and their steadily decreasing supply over time. Given such dynamics, the market can eventually disappear through scarcity of supply and/or because of changing consumer tastes (Baumol, 1986; Frey and Pommerehne, 1989), reflecting an evolution of demand preferences.

Market regulation essentially depends on market professionals – dealers, galleries and auction houses. Given the narrow nature of the Art Deco market, its regulation involves the active collaboration of all the actors. But the potential for strategic market manipulation exists in a narrow market where there is a small community of professionals. Nonetheless, safeguards do exist. This includes extensive media coverage of auctions and publicly available (price) information and also the fact that the market for the Art Deco style attracts a limited number of non-professional buyers who can limit, if not ban outright, illicit practices. Unfortunately, those who are alarmed by the prices reached should better consider that Art Deco is a fantastic artistic period but one that was very short and with too small a production range to satisfy so big an interest all around the world.

References

Adler, M. (1985) 'Stardom and talent.' *American Economic Review*, 75(1): 208–212.

Akerlof, G.A. (1970) 'The market for "lemons" : Quality, uncertainty and the market mechanism.' *The Quarterly Journal of Economics*, 84(3): 488–500.

Ashenfelter, O. and Graddy, K. (2003) 'Auctions and the price of art.' *Journal of Economic Literature*, 41(3): 763–787.

Ballon, F. (2004) 'Expertise: modalités et techniques.' In *Art et droit, L'authenticité d'une œuvre d'art : les enjeux*. Paris : Editions Petites Affiches, 18 March 2004, pp.4–5.

Baumol, W.J. (1986) 'Unnatural value: art investment as a floating crap game.' *American Economic Review*, 76: 10–14.

Bauwens, L. and Ginsburgh, V. (2000) 'Art experts and auctions: Are pre-sale estimates unbiased and fully informative?' *Recherches Economiques de Louvain*, 66: 131–144.

Becker, H.S. (1982) *Les mondes de l'art*. Berkeley, CA: University of California Press (French edition, Champs Flammarion, 1988).

Benhamou, F. ([1996] 2004) *L'économie de la culture*. Paris: Editions La découverte, collection Repères.

Benhamou, F., Moureau, N. and Sagot-Duvauroux, D. (2001) *Les galeries d'art contemporain en France*. Paris: La documentation Française.

Bouillon, J.-P. (1985) *Le Journal de l'Art Déco*. Paris: Skira.

Brunhammer, Y. (1987) *Le Style 1925*. Paris: Payot.

Brunhammer, Y. (1997) *Le mobilier français, 1930–1960*. Paris: Massin.

Buelens, N. and Ginsburgh, V. (1993) 'Revisiting Baumol's "art as floating crap game."' *European Economic Review*, 37 (7): 1351–1371.

Cabanne, P. (1986) *Encyclopédie Art déco. Paris:* Editions Somogy.

Chatelain, F., Chatelain, J. and Pattyn, C. (1997) *Œuvres d'art et objets de collection en droit français*. Paris: Berger-Levrault.

Darby, M. and Karni, E. (1973) 'Free competition and the optimal amount of fraud.' *Journal of Law and Economics*, 16: 67–88.

Frey, B.S. and Pommerehne, W.W. (1989a) *Muses and Markets*. Oxford: Basil Blackwell, London.

Frey, B.S. and Pommerehne, W.W (1989b) 'Art investment: An empirical inquiry.' *Southern Economic Journal*, 56: 538–548.

Frey, B.S. and Pommerehne, W.W (1993) *La culture a-t-elle un prix ?* Paris: Editions Plon.

Ginsburgh, V. and Van Ours, J.C. 'Expert opinion and compensation: Evidence from a musical competition.' *American Economic Review*, 93(2003): 289–298.

Goetzmann, W. (1990) *Accounting for Taste : An Analysis of Art Returns over Three Centuries*. New York: Columbia University Press.

Haskell, F. ([1976] 1993) *La norme et le caprice : Redécouvertes en art*. Paris: Champs Flammarion.

Hendon, W.S., Shanahan, J.L and McDonald, A.J. (1980) *Economic Policy for the Arts*. Cambridge, MA: Art Books.

Keynes, J.M. ([1936] 1968) *Théorie Générale de l'emploi, de l'intérêt et de la monnaie*. Paris: Payot.

Kjellberg, P. (2000) *Art déco, Les maîtres du mobilier: Le décor des paquebots.* Paris: Les éditions de l'amateur.

Kulka, T. (1981) 'The artistic and the aesthetic value of art.' *British Journal of Aesthetics,* 21(4).

McCain, R.A. (1980) 'Markets for works of art' and 'Markets for lemons.' In Hendon *et al., Economic Policy for the Arts.* Cambridge, MA: Art Books.

MacDonald, G. (1988) 'The economics of rising stars.' *American Economic Review*, 78(1).

Moulin, R. ([1992] 1997) *L'artiste, L'institution et le marché.* Paris: Flammarion.

Moulin, R. (1995) *De la valeur de l'art.* Paris: Flammarion.

Moulin, R. (2003) Le marché de l'art, Mondialisation et nouvelles technologies. Paris: Champs Flammarion.

Moureau, N. and Sagot-Duvauroux, D. (1992) 'Les conventions de qualité sur le marché de l'art, d'un académisme à l'autre.' *Esprit*, October pp.43–54.

Moureau, N. (2000) *Analyse économique de la valeur des biens d'art, la peinture contemporaine.* Paris: Economica.

Nelson, P. (1970) 'Information and Consumer Behaviour.' *Journal of Political Economy*, Chicago: The University of Chicago Press.

Noël, L. (2009) 'Emergence, construction et dynamique du marché de l'art. Le cas du marché du mobilier Art Déco', Thesis for the PhD in economics supervised by Pr. Françoise Benhamou, presented and defended in 2009, 13 October, Paris: University of Paris.

Pepall, R. (2001) 'Ruhlmann et son rayonnement en Amérique du Nord.' In B. Foucart (ed.) *Ruhlmann, un génie de l'Art déco.* Paris: Editions Somogy, pp.126–131.

Pepall, R. (1991) 'Les arts décoratifs des années 20.' In P. Theberge (ed.) *Les années 20, l'âge des métropoles*, Catalogue d'exposition, Editions Musée des Beaux-Arts de Montréal. Gallimard, pp.183–207.

Pomian, K. (1992) 'L'art entre le musée et le marché.' In L. Bertrand-Dorléac (ed.) *Le commerce de l'art*. Paris: Edition La Manufacture, pp.9–31.

Rosen, S. (1981) 'The economics of superstars.' *American Economic Review*, 71(5): 845–858.

Seuphor, M. (1966) *Le commerce de l'art*. Bruxelles: Desclée De Brouwer.

Schapiro, M. ([1953] 1982) *Style, artiste et société*. Paris: Gallimard.

Spence, M. (1973) 'Job market signaling.' *Quarterly Journal of Economics*, 87: 355–374.

Stiglitz, J.E. (1987) 'The causes and consequences of the dependence of quality on price.' *Journal of Economic Literature*, XXV, March: 1–48.

Thomas, M. (1997) *Un art du secret: Les collectionneurs en France*. Nîmes: Jacqueline Chambon.

APPENDIX : Interviews undertaken with key players in the market

Interview 1: Cheska VALLOIS, Vallois Gallery, Paris and New York.

Interview 2: Jean-Marcel CAMARD, expert and Chief Executive Officer of Camard & Associées SVV, Auction house, Paris.

Interview 3: Yvonne BRUNHAMMER, Curator, Museum of Decorative Arts, Paris.

Interview 4: David NORDMANN, Auctioneer, ADER SVV Auction House, Paris.

Interview 5: Cécile VERDIER, Director of the XXth Decorative Arts Department, Sotheby's, Paris.

Interview 6: Gilles FUCHS, Le Journal des Arts.

1 Founded in the 17th century, the Académie Française (French Academy) was an institution which organised the system of fine arts, including: the training of artists, artistic standards and technical rules

(including the hierarchy of genres) and organisation of Salons (fairs with a selection committee). In the 19th century, academicism opposed modernity.

2 The sellers manipulate prices whenever they can, to control the information transmitted. However, buyers, for their part, are not fooled by these manipulations. The fear that the seller will try to sell them a lower quality product discourages them to buy (Stiglitz et al., [1993] 2007: 318).

3 And some galleries, enjoyed past successes.

4 'In the 1926 Bulletin of the museum, Breck posited that because the work would be unfamiliar to a majority of the museum's visitors, it would be met "at first with indifference, even with hostility", but he hoped that it would give "food for thought". Breck admired the ability of France to incorporate its design history in the new style, he praised the effort to "embody old principles in new forms of beauty, and to meet new conditions of living with frankness and understanding"' (Friedmann, 2006: 113).

5 'The Commission submitted its report on 18 March, 1926, and it was distributed to the public free of charge. The first printing was sold out by November 1926, and more copies were available by February 1927. The Department of Commerce received hundreds requests for the report from schools of fine and industrial art, chambers of commerce, manufacturers, printers, architects and museums. Among those requesting copies were the designer Gilbert Rhode, the printer R.R. Donnelly and Sons, and the Metropolitan Museum of Art' (ibid.: 110).

6 Thus, the St. Louis Museum bought creations in glass and ceramics. In New York, a man named George Booth left orders for more than 20 pieces.

7 Legrain died in 1929, Mare 1932, Ruhlmann in 1933 and Iribe in 1935. Ruhlmann, provisionally banned the production of his furniture after his death; only a few models could subsequently be made with his consent, by his nephew, Alfred Porteneuve.

8 This is the case of Frank (1895-1941) and Chareau, who emigrated to the US, and Charlotte Perriand (1903-1999), invited to Japan by the Ministry of Commerce and Industry.

9 'Design', facilitated by the development during the war of synthetic materials, appears in the late 1940s. In 1948, Charles Eames (1907-1978) created his famous chair with a cantilever tubular steel hull reinforced with polyester fibreglass. It was manufactured by Hermann Miller and later produced in millions of copies.

10 (cf. interviews (Vallois, 2006; Camard, 2008; Nordmann, 2008; Verdier, 2008) in Noël, 2009).

11 'Who could imagine (. . .) a small coffee table in ebony by Clement Rousseau to trigger, as we wrote, "a fit of madness possessive", the representative of the Metropolitan Museum finally triumphant at 70,000 francs (€57,378 as at 2004)' (Cabanne, 1986: 244).

12 'If the glory of Ruhlmann began during his lifetime, his furniture reached unknow peaks of sales in recent years. Research is needed to find a few sales prior to 1960 (. . .).' (Roussin, in Foucart, 2001: 141). Consultation of all sales catalogues from Paris in the 1950s can find only a single sale in 1959, entitled 'Collection and Modern Paintings, E.J. Ruhlmann'. In the 1960s, there was a sale in March 1960 of Ruhlmann furniture and in 1968 another sale of his Art Deco furniture and finally, the last in 1969.

13 The set was made for a house built by architect and designer Michel Roux-Spitz (1888-1957) in Lyon, also exhibited at the Exposition of 1925 (Pepall, in Foucart, 2001: 131).

14 A sun bed 'Ruhlmann in macassar ebony, a pair of chairs', cave 'and a table in bronze and marble' were sold at auction to Rateau, respectively at 30,000, 45,000 and 27,000 francs (in current currency €24,590, €36,886 and €22,131 euros as at 2004).

15 In the 13 years of the study period (1992-2004), a record price for the year was achieved 10 times in Paris and three times in New York.

16 'While she (Eileen Gray) has wanted to see her works (mass) produced, they are still, with few exceptions, unique pieces' (Kjellberg, 2000: 110).

17 'At the same, Vallois (DeLorenzo gallery) is one of the two largest Art Deco galleries in the world. Tony and Adriana DeLorenzo were alone in the US for four or five years before the Arc en Seine and Vallois in association with Barry Friedman, arrived in New York. Previously only DeLorenzo offered Art Deco to the huge US market. The largest galleries for Art Deco in Paris are Vallois, Arc en Seine and Doria (The Paris market account of eight leading galleries, Camard, interview, 2008, in Noël, 2009).

18 On 25 March 1959, eight pieces of Ruhlmann furniture were sold without expert advice in Paris.

19 Jean-Pierre and Florence Camard trained in art history (as did Felix Marcilhac) and in the course of their careers published reference books on Art Deco furniture designers. Florence Camard published two monographs devoted to Ruhlmann (1983) and the other to Süe and Mare (1993). For their part, the monographs written by Felix Marcilhac of Jean Dunand (1991) and André Groult (1997) are authoritative.

20 'Both art museums and the art market establish hierarchies of values. But the museum is established by the qualitative result of the imposition its set of works of an order relation that makes manifest their spatial distribution. That established by the art market is quantitative but requires a unit of measurement provided by the currency and distance expressed in multiples of this unit' (Pomian, 1992: 15).

21 'In 1966, *Stile 1925* was published, a remarkable work by the Italian art historian Giulia Veronesi. That same year, Brunhammer published in the 1925 editions Fratelli Fabbri Milan. At the time, there was no raw material and research on Art Deco was limited almost exclusively to reading magazines and Decoration Art and meeting artists who were still alive, their spouses or their heirs' (Brunhammer, interview, 2008, in Noël, 2009).

22 'In 1966, (. . .) style in 1925 and was barely worth the purgatory imposed by generations anxious to impose their own conception of a lifestyle. The exhibition at the Musée des Arts Décoratifs in Paris in the spring of that year, had been a mediocre success. But it had provoked a sometimes violent reaction on the part of the players in the grand spectacle of the "Art Deco" who were still alive. François Mathey, who returned to his design, had highlighted the complexity of the 20s and its contradictions: an Art Deco side which claimed the national tradition, while taking into account the findings of the Fauves and Cubists, the other, the Bauhaus, De Stijl, L'Esprit Nouveau, open to the contemporary world, and technological innovations in plastic. Two lifestyles, two lives of arts, were quickly eliminated by the next generation who responded to the crisis and the sounds of war by a return to the French tradition and ornament' (Brunhammer, 1987: 7).

23 Dates of exhibitions and auction sales in Art Deco between 1973 and 1980: 1973 Eileen Gray exhibition at the Royal Institute of British Architects in London, Paris exhibition Dunand; 1975 sale of the Lagerfeld collection; 1976 Retrospective Exhibition of Decorative Arts in 1925, curated by Yvonne Brunhammer; 1979 Eileen Gray retrospective at the Victoria and Albert Museum in London; 1980 sales of furniture, Monaco Palace and Maharaja of Indore in India.

24 '(. . .) there was, in fact, conspicuously absent during this exhibition in 1966 at the Museum of Decorative Arts, Eileen Gray. Not there, she had been forgotten. She had disappeared from the art scene and had left little trace of her passage, including some referencing of her work and her customers. She has always worked on a small margin, even when she had Galerie Jean Désert, rue du Faubourg Saint-Honoré. Eileen Gray was actually rediscovered by antiquarians' (Brunhammer, interview, 2008, in Noël, 2009).

25 'It was in 1967 that a collector had discovered her while flipping through a magazine in the immediate post-war period, and he immediately began hunting, imitated by some merchants and friends. Eileen Gray, who was then 94 years old, became known after the extraordinary revelation of a star Doucet sale, and her creations were soon to experience a growing success. At the same sale, a table set with green lacquer sold for 61,000 francs and a round table with two trays in black lacquer for 48,000 francs (respectively €50 000 and €39,345 euros in 2004)' (Cabanne, 1986: 244).

26 Exhibitions at the Museum of Decorative Arts in Paris began in the 1960s. In 2004, the Metropolitan organised an exhibition of Ruhlmann which was mounted in conjunction with the Musée des Années 30 in Boulogne-Billancourt. It was then transferred to the Musée des Beaux-Arts in Montreal. The installation of the exhibition made use of the permanent collections of the two museums, 225 furniture items and objects belonging to the MET and elements of the collection of drawings and watercolours by Ruhlmann belonging to the Musée des Années 30, but also public and private loans from the US and Europe. In 2003, the Victoria and Albert Museum held an exhibition entitled 'Art Deco 1919 –1939'.

27 'I believe that museums have had a major influence on the bull market for the Art Deco style. In June 2004, for example, at the time of the exhibition "Ruhlmann, Genius of Art Deco" at the Metropolitan Museum of Art in New York, were exhibited two large lamps by Ruhlmann, silvered bronze with their shade curtains glass beads. At the same time, Christie's offered a lamp of the same model in its sale of 15 June 2004 in New York. It was sold for $420,000 (€330,000 euros), while we thought it would go for about $200,000. (. . .) I think (also) the reopening of the Paris Museum of Decorative Arts had a significant influence on the market, not only with dealers and collectors, but also the general public. The museum collections are important and impact the greatest designers of the period. I know that many of our customers were eager to visit [the exhibition]' (Adriana Friedmann, DeLorenzo gallery director in New York, specialising in Art Deco furniture, as part of an interview with Armelle Malvoisin, journalist. Paris: Le Journal des Arts No. 243, published 22 September 2006.)

28 '[The collection of the Museum of Decorative Arts was formed] almost exclusively by donations because there was almost no acquisition budget. The only purchases were those made at the exhibition of 1925. The Decorative Arts Museum subsequently received several very large donations. In 1958, the "Donation Doucet" was made by the nephew of his widow, Mr. Dubrujeaud. There was also the gift of the whole decoration of the apartment of fashion designer Jeanne Lanvin by Prince de Polignac' (Brunhammer, interview, 2008, in Noël, 2009).

29 'As for auctions, it is very quiet. The goods do not turn up really any more in New York and Paris. In fact, there is more demand than supply. Art Deco is a victim of its own success. Now this speciality extends over 20 years of creation, unlike the 18th-century furniture, which covers an entire century. Art Deco objects of average quality do not sell' (Jean-Marcel Camard, Expert, Gazette Drouot, April 2005).

30 The French auction houses employ experts for the organisation of thematic sales or specific expertise and pay them fees, on the basis of a commission of 3% to 5% calculated on the 'hammer price'.

31 Combining the two functions is often an economic necessity: 'revenues expertise is often insufficient to ensure the operation of a specialized firm' (Schmitt, 2008: 146).

32 'With the Decree of 3 March 1981, French legislation sought to eliminate the hazard that permeates transactions on cultural goods. Standard descriptions have to be used and have precise meaning regarding authenticity' (Schmitt, 2008).

33 'Confidence is the strength of the Anglo-Saxon auction houses such as Christie's or Sotheby's, which have developed a brand. And customers are reassured by this brand. Many people do not know Cécile Verdier, who said "I am not like my friend Felix Marcilhac, Artcurial expert, the author of numerous reference monographs on artists Art Deco". However, everyone knows Sotheby's. And in the Anglo-Saxon houses' sales, great attention is paid to the quality of services provided to the client' (Verdier, interview, 2008, in Noël, 2009).

34 'The probability of selling [Art Deco] furniture at an auction in Paris is lower than if you move the object to London and especially to New York. Especially, in cases where the furniture is passed to a gallery, it is restored and therefore presented at auction in perfect condition, which meets with a positive response from American consumers, who love furniture in good condition' (Verdier, interview, 2008, in Noël, 2009).

35 'In the market for antique weapons, almost all purchases are made through merchant intermediaries. This is very much linked to the difficulty to properly assess the quality of the parts, including technical components and difficulty in diagnosing that all parts are authentic and original' (Nordmann, interview, 2008, in Noël, 2009).

36 They bid directly themselves. These bids are confidential: some buyers prefer not to appear to be seen directly on board; two heads are always better than one; but I believe the main reason is simply a lack of trust in the auctioneer. When you live in the wilds of Texas and the furniture that interests you goes on sale in France, you look at what the auction house sells and if you do not know the auction house and you do not have enough confidence in it, you go through a middleman you know who will verify that all settings are green on the key issues: quality, authenticity and condition in particular.

37 'When Tony and Adriana (DeLorenzo) purchase in our sales on behalf of their clients, they ask us to send invoices directly to their customers, by providing us their names and addresses. Conversely, when Cheska (Vallois) bought for clients in our auctions, she does not tell us who they are. She works in a very compartmentalised way, even if we often suspect who the client is' (Camard, interview, 2008, in Noël, 2009).

38 There are exceptions to this rule. The higher the value of a work of art, the more the auction house will be ready to give an advance on the outcome of the upcoming sale.

39 '(. . .) auction houses have the power of communication through sales catalogs that cannot be expected by dealers (. . .) However, during the sale of a collection by auction, the risks are high because if the sale goes wrong the future of the market (for that work) is affected. Collaboration between auction houses and dealers is needed, and are complementary. The stakes are too high for the big sales to happen without collaboration between vendors, experts and auction houses. It is the interest of them all' (Camard, interview, 2008, in Noël 2009). This opinion is shared in the gallery: 'Shortage is less penalising than abundance. The market would be in danger if a sudden influx of quality works could not be absorbed by buyers. The danger comes from the media coverage that accompanies the sale of objects' (Vallois, interview, 2006, in Noël, 2009).

Without uncertainty, there is no art market

Professor Arjo Klamer, Erasmus University, Rotterdam

Introduction

This chapter will attempt to draw on a range of contributions in this volume and beyond. It will focus on four key points; the first two directly address the subject of risk and uncertainty while the final two draw on the metaphors and concepts of other fields to better comprehend the art world and art market.

Uncertainty involves more than risk

My first point concerns the difference between risk and uncertainty. It boils down to the observation that when it comes to the art field, speaking of uncertainty makes more sense than speaking of risk.

People join discussions about the art market often when they are planning to invest in art. Recent research, focusing on the volume of trade in the market is critically important in affecting assessments of how the markets perform. From research on the returns of investment in art, we learn that art markets are not only difficult to predict and rife with risk and uncertainty, but over extended periods many art sectors generally perform less well than bond markets. Therefore, investors focused on simple returns are often better off putting their money in bonds and stocks and the like. This, however, suggests that people invest in art for reasons other than financial return.

The art market, therefore, is more than an investment vehicle. Contemporary accounts of the world of art fairs, and the intricacies of what the dealers actually do as part of their business in the context of both permanent spaces and temporary events, highlight the degree of uncertainty in art markets at multiple levels. This is a characteristic that equally applies to other creative sectors such as the movie industry and publishing as well as new, innovative products, and scientific articles. For every artwork or scientific article there is a one in 10 chance that it will get noticed in the marketplace. One of the 10 that do get noticed, get a lot of attention. The corollary is that 99 out of 100 will, in effect, be ignored or hardly noticed at all.

In discussions of the art market, there has been a great deal of focus on those pieces that fetch record prices at auction. Much less attention is paid to the many artists who work incredibly hard to produce items and who do anything they can to get noticed in a crowded marketplace. Some do, but most receive little (or no) attention. These artists work locally, in small settings and confined physical and geographic areas. Most of them have an embarrassingly low income. Based on research conducted in the Netherlands, I would consider an artist with an annual income of €10,000–15,000 as doing quite well. Of course, such artists have not discounted their costs and the opportunity costs of their time (taking into account their high level of education) in which case they might be making an overall loss. The huge prices achieved for the work of 'star' artists such as Jeff Koons and Damien Hirst are significant exceptions in the sense that they receive a disproportionate amount of attention.

From the artists' point of view, their uncertainty is such that speaking of 'risks' is meaningless. Risks are quantifiable while uncertainty is, by definition, an unknown. Many creatives, including artists, have no idea when they write a book or produce an artwork what will happen or whether it will be noticed at all. All the evidence in this area suggests that the chances are pretty big that it will make little impression on the world.

The limitations of standard economics regarding the uncertain conditions in the art world

My second point concerns the limitations of the approach and the language of standard economics when we try to make sense of what is happening in the world of the arts.

Let me use the example of the situation in the Netherlands. In 2012, the then-incumbent Dutch government decided to cut its spending. Its already small budget for the arts was cut by 30 per cent. , The cuts will be even greater when we consider the spending of municipal authorities on the arts. The budgets of those authorities will be affected as well and they may decide to reduce their support for the local arts as a consequence. The cuts are focused mainly on performing arts and theatres but also on museums and other arts organisations; visual artists, too, will be severely affected. Many people are expected to lose their jobs. The discussions and (heated) arguments that these actions have generated tend to gravitate to questions about the relevance of the arts. Champions of the arts are on the defensive and clearly have difficulties justifying the arts as worthy of public support. Critics point at the elitist character of the arts, at the high level of education of those visiting museums and attending the performance arts, and at the high level of income of those attending concerts and the opera.

A key argument that the protagonists have embraced over the last few years was an economic one. They read the books of cultural economists, especially those of Richard Florida, and concluded that a thriving creative sector is important for the economy. They picked up the notion of the multiplier and asserted that the amount of public money spent on the arts would have a multiple effect on the economy as a whole. Unfortunately, the argument does not work that way, as any economist could have foretold. The problem is that the money spent is withdrawn from other activities and becomes a negative multiplier. The end result may be still positive (especially when the money comes from outside by way of foreign visitors, for example) but could just as well be negative. Furthermore, the multiplier of expenditures on, say, education, might be greater. In any case, the issue is complex.

The economic argument also backfired. When the leader of a subsidised festival supported his request for extra funding by suggesting that festival generated a great deal of economic value by encouraging visitors and tourists to spend more in local restaurants, hotels and so on, the responsible liberal politician responded that the restaurants and hotels should contribute to the festival, rather than society through government funding. His thesis was fatally holed.

The paradigm change that the cultural sector in the Netherlands and many other countries appears to be experiencing compels leaders of cultural institution to reorient themselves, and to reconfigure their rhetoric. They now have to direct their persuasive powers towards potential buyers as well as to donors and supporters. They have to develop new networks and enter other conversations. They will have to find out how to position themselves and their art, and flesh out the arguments and narratives that work in the new settings. All this involves uncertainty more than risk. As people in the cultural sector lost their moorings, alternative strategies eluded them. There is no way of calculating one's risks; a new framing, another *language*, in fact, is called for.

Standard economics is furthermore of limited importance in the arts world – and for individuals and organisations operating within in it – because it is mainly directed at policy. Policy-makers are supposed to be the main beneficiaries; all others are left out. Consumers, workers, citizens, artists and artistic organisations all have virtually no use for standard economics. They can do little with a discussion that is framed in terms of rationalising schemes, decision-making, which is focused on 'risk assessments' and choices based on cost–benefit analysis. The underlying assumption of these kinds of instruments is that there really is a 'rational' solution. This has been a central presumption of the discipline since the 1930s, and most economists rationalised or provided rational schemes for politicians, policy-makers and managers during those years. But in times of uncertainty, when there is no basis for risk calculations, such schemes do not help. Artists do not decide, choose or work this way. Most people do not work this way. It is not realistic; it does not do justice to what people do. Anecdotal evidence suggests that most people do not do a risk analysis when they make an emotional investment, for example, when they get married. (Given divorce rates, however, maybe they should.)

I see good reasons to resist the common inclination to adopt the language or the logic of a competitive marketplace wholesale or to speak in the language of 'business models' and 'marketing strategies'. Although there may be opportunities to build a bridge between the disciplines of art and business, they are not necessarily always compatible. The art world needs a vocabulary of its own, a vocabulary that does justice to what the artists, arts organisations and creative communities are actually about. The great danger is that we fall into the trap of embracing economic logic and language and forcing it on the cultural sector as if that is the way for it to survive. This seems short-sighted.

The need for another language takes us to the cultural economic perspective

We next need to consider an alternative way of looking at the arts world, a way that appears to do more justice to its idiosyncrasies and to be more productive for those working within it. I call it the 'cultural economic perspective' as it draws both on economic and cultural or philosophical conversations.

The cultural economic perspective presented here references Aristotle, looks back to Adam Smith, and proposes to revive the notion of 'values'. In this case, I do not mean values in the sense of prices, but values in the sense of what people consider important, relevant, right, interesting or beautiful, including the anthropological sense of values that people share and that constitute a culture. Individuals within groups act on the basis of certain values which they hold – things that they find important. To understand how they deal with uncertainty, it is important to understand the underlying values of cultural organisations.

People employed by such organisations are usually not able to openly define the ultimate values that they want to realise – their goals, in other words. In my experience with these organisations, a clear sense of those ultimate values is critical for the determination of its strategy, including the financing of its activities. Without those goals, it is hard

to motivate co-workers and to persuade and win over relevant stakeholders.

On the basis of my research, I have identified four key types of values:

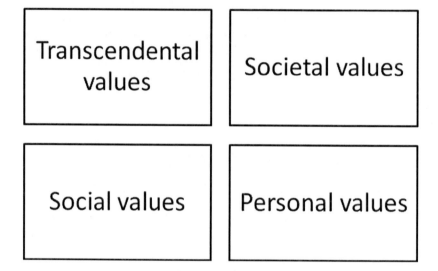

Figure 12.1 The four types of values

The first one, and the one that preoccupies most cultural organisations, and certainly also artists, is the realm of transcendental values. These include artistic and spiritual values. Artists want to be part of, and contribute to, something that transcends the material and certainly the pecuniary; they want to experience the 'luminal', the space 'in between', the sublime or however they name the transcendental.

For some – in particular community artists, political artists or national arts institutions – societal values are important. These people use the arts to contribute to the society at large, or to individual communities by means of urban regeneration projects or identity campaigns. In the Netherlands, the societal relevance of the arts became an important issue which the arts world could not convincingly address. Education is another societal value that the arts may facilitate. The arts are an important part of civilisation. Learning about and participating in conversations about them is, therefore, a good way to learn about and

contribute to a civilisation. The arts also contribute to a climate and culture of creativity that is important for the development of a creative economy.

The arts also generate social values, in terms of relationships. The arts bring people together; friendships are made, clubs are formed. Artists derive social status from working in their creative sphere. The arts are good for conversations, for sharing with others. In cultural economics, we speak of art as social or shared goods. People become 'shareholders' in such a good only when they contribute in some way, whether it be by introducing work, by supporting or financing others, by organising exhibitions and so on. In this way, they become part of a social setting.

And finally there is the realm of personal values: the arts also provide ways for individuals to develop their talents, to do what they are good at, to get inspired, to discover and to experience – in short, to flourish. All these effects are relevant to individuals and are therefore personal (but with possible cross-overs to the other realms).

Whether we are considering individuals, groups of people or organisations or societies, the principle 'goal' values come first. They determine the purpose of that social endeavour. All human activity is directed at some good, as Aristotle points out in the very first sentence of the *Nichomachean Ethica*. Not everyone will be conscious of what that good is, or be able to articulate it, but without a clear vision, our actions become aimless and meaningless.

Money is not a goal to strive for, whatever businesspeople and even some in the art world are suggesting. Money, or profit, does provide a means of realising other values, however. If a seller of an artwork received a record price for it at auction, what should he or she do with the money? Buy a yacht? What is that good for? To impress people? What is that good for? Keep on asking 'what is that good for' and you will end up in one of the four realms of values specified above.

The tendency is to confuse instruments and goals. When I was working with partners of a law firm, they kept telling me that what motivates them was their monetary compensation. I would point out that ultimately, money does not motivate. There must be something else. As

Dan Pink so nicely shows in his clever YouTube clip (RSA motivation), what does ultimately motivate are a sense of autonomy, dexterity (being skilled, doing what you are good at) and being able to make a contribution to a significant purpose, or good. In the research that I did at the law firm, I discovered that some lawyers are motivated by the knowledge of the law – they love the law, they love to work with and on their knowledge of it and, when possible, contribute to its development. Some of the other lawyers were not all that interested in the law itself but *were* motivated by their ability to help out people in distress. They derived satisfaction from helping a client through a divorce, for example, saving a firm from bankruptcy or helping to resolve a labour dispute. Finally, there were some lawyers who didn't care all that much for either the law or their clients: they just wanted to win! They saw their work as a sport or game and for them, winning was the driver. They loved the challenge of difficult cases because they enabled them to show off their skills, aptitude and ability to win.

While this research focused on lawyers, there is evidence to suggest that similar traits and motivating factors can be found in other groups – including artists. In the end everyone is in some way or another seeking to realise transcendental, societal, social and personal goals, usually several such goals at the same time.

When we look at the world of the arts from this perspective, we might notice what I would call a 'transaction fixation'. People investigating the art market, like many other markets, are fixated, if not obsessed, with the transaction. This is a curious phenomenon – why are people so focused on that moment when a buyer and seller come together, make a deal and set a price? There is so much else going on. Like artists at work, capturing their ideas and experiences in some form or another. Like people experiencing that work. Like the endless conversations that bring artworks alive, that render them meaningful. Like daily life, with all its interactions, social occurrences and transcendental experiences. Why then all the focus on transactions? Because that is what standard economics tells us to do?

Let us do a little thought experiment to see whether we can dissociate ourselves from this fixation on transactions. Ask yourself: 'What is the most important possession I have?'

You tell me. The answers I get vary but usually include: family, friends, health, the ability to think, one's freedom and so on. Some of these are functional variables (such as the ability to think, which enables other activities) and therefore have a functional value. However, almost never do people name objects – such as a painting, a piece of jewellery, financial wealth, a house, an iPhone or something similar. In a religious setting, people may mention their faith as their most important possession.

Now note that the 'greatest' possessions that people mention are always goods that cannot be bought. You cannot buy your family, your mind or your faith. Effectively, these goods are not for sale. They may cost a lot of money in terms of expenditure – my family certainly costs me a lot of money – but that is not the same as buying a family. We cannot buy and we cannot sell friendships, although in some ways it would make a great deal of sense if you could: if you are busy and you have too many friends, while so many lonely people desperate for a friend, a transaction seems obvious. How much do you offer? But in reality that would not work.

To make the point differently, let's consider someone's house, rental apartment or room in a student house. Those people who 'bought' their house most likely are still paying for it. They can say a great deal about their house, or apartment. They can tell its value in monetary terms, more or less; they can tell when something is wrong with it, and others can tell how to make the repairs. The house and the apartment are concrete. But having a house is not our goal, it is not what our lives are about, or at least I hope not. I, at least, own a house because I want to have a home. What really matters to me, however, is how well my wife and I are succeeding in creating a good and warm atmosphere, a safe and stimulating environment for our children, a home that is open to friends and guests – a good home, in short. The same applies to a room in a student house. What good is that room if you do not feel safe there, or have a bad relationship with your housemates? It takes a lot of work to build a good home. A *house* we can buy; a *home* we have to create.

Art is not that different. We can buy objects or the right to sit in a chair in a theatre, but art we have to create ourselves. I have to make music out of the sound that the people on stage produce. I have to see the art

in the canvas on the wall. In truth, we cannot buy or sell art. The metaphor of the market, of the buying and selling, does not do justice to what art is all about. Art is in the first place a conversation, I'd say with another metaphor, or all kinds of conversations. (Sometimes, when the silence around an artwork is deafening we would wish that there really was a conversation.)

The ongoing, varied, multiple conversations that constitute the world of the arts attest to the fundamental uncertainty in which the arts come about. Artists do not know whether their work will catch on. As noted above, the chances of getting attention is slim. People interested in the arts do not really know what art is good, what art will last, which artist will keep up the good work or how others will think and act. Everyone sharing in the world of art is in need of conversation. People working at auction houses, for example, spend a great deal of their time talking and reading. They need to know what is going on, they need to find out who is doing what, and who is interested in what. They contribute as experts and taste-makers to the consensus in the conversation. Also critical is the role of technology in facilitating these conversations and bringing new and existing characters into them. Likewise, collectors want to meet and speak to people, knowledgeable people to know what is 'hot', who is doing what, and who is interested in what.

The need for encounters, for conversations, is the most important reason that art fairs have become so important. The hustle and bustle, the concentration of the sheer number of people involved in the conversation, feeds that conversation and encourages people to act. Auction houses and galleries have the same function, although they each perform it differently. It is through these constant discussions and conversations, in all these different settings, that the arts are created and valued.

The sale, or moment of transaction, is clearly not what the painting is about, or what the life of the painting is about. Once it is sold then it continues its life. A good gallery is interested in more than the transaction and cares about the life of an artwork. When people assess a work's value, they need to take into account its whole life, including the involvement of galleries and dealers. This is why many galleries are not willing to sell to just anyone who is willing to pay the price because each

individual owner contributes to the life of the painting – and indirectly to that of the artist – and those owners may either contribute to or detract from the painting's life. In many cases, the gallery will prefer to sell the painting to a collector or ideally to a museum where its life can proceed, it will stay in circulation and conversation about it can continue.

Serious galleries are therefore very interested in the economic 'conversation' that surrounds art. They want to make sure that the artwork keeps performing in that conversation. I would suggest that the notion of a 'conversation' – both in terms of creating value and mitigating uncertainty – could be a leading metaphor for understanding the art world. In using it, it should be clear that the discussion should be not only about buyers and sellers but about the full range of people contributing to the conversation. It is important to realise all that is done to focus attention on artworks, and that every piece is a contribution to the conversation in itself. Buyers are then not just buyers in the strict sense but also participants; they also contribute to the conversation. Theatre-goers are the same: they are not just simply passive consumers and because they interact with the performance, they can bring it into a wider conversation too. People who view art, who consume it in myriad different ways, actually engage with it, contribute to the conversations about it and thereby affect it.

Conclusions

I would like to suggest a challenge, that when we talk about risk and uncertainty in the art world, our focus on the notion of uncertainty should compel us to think about how people cope. This chapter would suggest it may be helpful to get much closer to what people actually do when considering the underlying values of an object or a field. This would do more justice to what happens within it, to what people working in it want to accomplish and to what motivates them. It also seems important to avoid the trap 'transaction fixation' and to realise that the exchange of money is just one part of the life of an artwork. The critical focus should be on the conversations, and the quality of the conversations that revolve around and constitute the arts; all of the people (or

stakeholders) who take part in that conversation shape it in their own way, mitigating the underlying uncertainly on the one hand and creating value and opportunity on the other.

In short, the quality and the extent of conversations are the key. The sales are merely moments within those conversations.

Index